DAS GOLDENE JAHRHUNDERT / THE GOLDEN CENTURY

THE GOLDEN CENTURY

DUTCH MASTER DRAWINGS FROM
THE FITZWILLIAM MUSEUM CAMBRIDGE

Catalogue by David Scrase

German/English edition

Edited by Thea Vignau-Wilberg

Staatliche Graphische Sammlung München
Schirmer/Mosel

Diese Publikation erscheint als deutsch/englische Ausgabe
anläßlich der Ausstellung
DAS GOLDENE JAHRHUNDERT
Holländische Meisterzeichnungen
aus dem Fitzwilliam Museum Cambridge

München, Staatliche Graphische Sammlung,
zu Gast in der Städtischen Galerie im Lenbachhaus,
15. November 1995 bis 14. Januar 1996

Heidelberg, Kurpfälzisches Museum,
11. Februar bis 8. April 1996

Braunschweig, Herzog Anton Ulrich-Museum,
1. Mai bis 30. Juni 1996

Cambridge, The Fitzwilliam Museum,
8. Oktober bis 22. Dezember 1996

This German/English edition is being published
to coincide with the exhibition
THE GOLDEN CENTURY
Dutch Master Drawings
from The Fitzwilliam Museum Cambridge

Munich, Staatliche Graphische Sammlung,
at the Städtische Galerie im Lenbachhaus,
15 November 1995 to 14 January 1996

Heidelberg, Kurpfälzisches Museum,
11 February to 8 April 1996

Brunswick, Herzog Anton Ulrich-Museum,
1 May to 30 June 1996

Cambridge, The Fitzwilliam Museum,
8 October to 22 December 1996

Ausstellungsorganisation/Exhibition organisers
Gesamtorganisation/General Organisation:
Thea Vignau-Wilberg, David Scrase
München/Munich: Thea Vignau-Wilberg
Heidelberg: Ulrike Andersson
Braunschweig/Brunswick: Thomas Döring
Cambridge: David Scrase, Thyrza Smith

INHALT/TABLE OF CONTENTS

Simon Jervis
7 Vorwort

9 Preface

David Scrase
10 Dank

11 Acknowledgements

David Scrase
12 Einführung

13 Introduction

Thea Vignau-Wilberg
17 Die Bildwelt der holländischen Kunst
im 17. Jahrhundert

27 The Pictorial World of Dutch Art
in the Seventeenth Century

37 **Katalog/Catalogue**

1–35
Holländische Landschaften: Stadt und Land
Dutch Landscapes: Town and Country

36–49
Holländische Künstler in der Fremde
Dutch Artists Abroad

50–61
Seestücke
Seascapes

62–75
Tiere und Pflanzen
Animals and Flowers

76–95
Figuren und Genre
Figure and Genre Drawings

96–108
Religiöse Darstellungen
Drawings with a Religious Context

252 Bibliographie/Bibliography

254 Index

VORWORT

Die Sammelgebiete des Fitzwilliam Museums sind international angelegt. Unser koreanisches Porzellan wurde als das kostbarste außerhalb Ostasiens bezeichnet; unser Bestand an griechischen Münzen wird zu den weltweit führenden sechs Sammlungen gezählt, und wir können stolz sein auf den Rang unserer – um nur einige Bereiche herauszugreifen – italienischen Majolika, deutschen Druckgraphik, mittelalterlichen Stundenbücher und der altägyptischen Kunst. Auch in der Zusammenarbeit mit anderen Institutionen ist das Museum international aktiv. Wir leihen ständig Exponate für Ausstellungen in der ganzen Welt aus, und allein in den vergangenen fünf Jahren haben wir komplette Ausstellungen venezianischer Zeichnungen nach Venedig, britischer Gemälde nach Japan und Zeichnungen von Burne-Jones nach Frankreich und Belgien gegeben. Nun also schicken wir diese holländischen Zeichnungen auf ihren Weg nach Deutschland.

Die Geschichte dieses Projektes ist ein Beispiel für die heutige Internationalität in der Welt der Kunstmuseen. Im Winter 1988/89, noch während meiner Tätigkeit am Victoria & Albert Museum in London, arbeitete ich als „guest scholar" am J. Paul Getty Museum in Malibu, wo ich Frau Dr. Thea Vignau-Wilberg begegnete, die dort ebenfalls ein „scholarship" wahrnahm. Ihre Forschungen konzentrierten sich auf Joris Hoefnagel, meine auf Möbel in den Verkaufsinventaren des Commonwealth aus der Zeit von Charles I. Kurz nachdem ich die Leitung des Fitzwilliam Museums übernommen hatte, besuchte Frau Dr. Vignau-Wilberg das Museum, allgemein angezogen von dessen Ruf und insbesondere von einer außergewöhnlichen allegorischen Miniatur des Joris Hoefnagel, die wir als anonyme Leihgabe zeigen. Zu dieser Zeit bearbeitete sie die holländischen Landschaftszeichnungen der Staatlichen Graphischen Sammlung München, und so nahm sie das Angebot meines Kollegen David Scrase gerne wahr, den Bestand an holländischen Zeichnungen des Fitzwilliam Museums durchzusehen. Nur weniges aus dieser Sammlung wurde bisher veröffentlicht, und sie war überrascht von der Qualität der Zeichnungen. So entwickelte sich die Idee, daß eine Ausstellung von Blättern des Fitzwilliam Museums die Ausstellung *Das Land am Meer* ergänzen könnte, die sie 1993 aus den Beständen der Staatlichen Graphischen Sammlung in München konzipiert und durchgeführt hatte.

David Scrase stellte die Zeichnungen zusammen, Frau Dr. Vignau-Wilberg traf die letzte Auswahl der Blätter, die mein Kollege Scrase dann für den Katalog bearbeitete. Als ich mich 1994 wegen eines Vortrags am Zentralinstitut für Kunstgeschichte in München aufhielt, besprach ich die Organisation und Lokalität der Ausstellung mit Herrn Dr. Tilman Falk, Direktor der Staatlichen Graphischen Sammlung, mit Frau Dr. Vignau-Wilberg, Herrn Dr. Helmut Friedel, Direktor der Städtischen Galerie im Lenbachhaus, und Herrn Dr. Rudolf Wackernagel, seinem stellvertretenden Direktor. Wir sind unseren Münchner Kollegen besonders dankbar für ihren Enthusiasmus und ihre Kooperation.

Die Ausstellung wird von München nach Heidelberg, der Partnerstadt von Cambridge, wandern. Herr Dr. Jörn Bahns, Direktor des Kurpfälzischen Museums, hatte sich 1991 an das Fitzwilliam Museum gewandt, um Möglichkeiten einer Zusammenarbeit zu prüfen. Es freut uns sehr, daß seine Initiative auf diese Weise Früchte getragen hat. Die Organisation der Ausstellung in Heidelberg übernahm Frau Dr. Ulrike Andersson. Die letzte Station in Deutschland wird das Herzog Anton Ulrich-Museum in Braunschweig sein. Der Austausch mit Herrn Dr. Jochen Luckhardt, dem Direktor, und Herrn Dr. Thomas Döring, dem Konservator des Kupferstichkabinetts, der zur Zeit einen Katalog der holländischen Zeichnungen in Braunschweig vorbereitet, hat sich als offen und fruchtbar erwiesen.

Holland spielt für das Fitzwilliam Museum historisch und sammlungsgeschichtlich eine große Rolle. Unser Gründer, Richard 7th Viscount Fitzwilliam of Merrion, verdankte seinen Wohlstand seinem Großvater mütterlicherseits, Sir Matthew Decker, einem Holländer, der 1679 in Amsterdam geboren wurde. Wir besitzen eine Sammlung von Rembrandt-Radierungen, die größtenteils auf unseren Gründer zurückgeht und zu den bedeutendsten

der Welt gehört. Diese Ausstellung zeigt, daß auch unsere holländischen Zeichnungen, dank des großzügigen Vermächtnisses von Sir Bruce Ingram aus dem Jahr 1963, eine erstrangige, umfassende Sammlung bilden. Wir freuen uns, daß die Ausstellung und der zweisprachige Katalog diese bisher ungehobenen Schätze vor einem neuen, größeren Publikum ausbreiten wird, in Deutschland und in Cambridge, wo die Ausstellung abschließend im Oktober 1996 gezeigt wird.

Schließlich möchte ich Thea Vignau-Wilberg und David Scrase danken, die gemeinsam das Projekt konzipierten und es zu einem großartigen, ausgewogenen Ergebnis führten.

Simon Jervis Cambridge, Juni 1995
Director and Marlay Curator
The Fitzwilliam Museum

PREFACE

The international scope of the Fitzwilliam Museum's collections is wide. Our Korean porcelain has been called the finest in the West, our Ancient Greek coins have been numbered among the world's top six collections, and we can boast, to take a few instances, remarkable strengths in Italian majolica, German prints, medieval Books of Hours, and ancient Egyptian art. We are also internationally active. We constantly lend individual works to exhibitions all over the world, and in the past five years we have sent complete exhibitions of Venetian drawings to Venice, British paintings to Japan, and Burne-Jones drawings to France and Belgium. And now we are lending this exhibition of Dutch drawings to Germany.

How this arose is an exemplar of the international nature of the art museum world today. In the winter of 1988 to 1989, while still at the Victoria & Albert Museum, I was a guest scholar of the J. Paul Getty Museum in Malibu, where I met Dr Thea Vignau-Wilberg, also a guest scholar. Her research was concentrated on Joris Hoefnagel, mine on furniture in the Commonwealth sale inventories of Charles I. Soon after I had taken over as Director of the Fitzwilliam Museum, Dr Vignau-Wilberg visited the Museum, drawn both by its general reputation and the fact that we display, on anonymous loan, a remarkable allegorical miniature by Hoefnagel. As she was by then working on the Dutch drawings in the Graphische Sammlung in Munich she took the opportunity offered by my colleague, David Scrase, to inspect the Fitzwilliam's Dutch drawings. They have been all too little published and their quality came as a revelation to her. The idea of an exhibition from Cambridge which would complement Dr Vignau-Wilberg's 1993 exhibition of Dutch prints and drawings from the Munich collection, *Das Land am Meer*, then began to take root.

David Scrase selected a range of drawings from which Dr Vignau-Wilberg chose the exhibits, which Mr Scrase then catalogued. In 1994, while lecturing at the Zentralinstitut für Kunstgeschichte in Munich, I was able to meet Dr Tilman Falk, Director of the Graphische Sammlung, with Dr Vignau-Wilberg, and Dr Helmut Friedel, Director of the Städtische Galerie im Lenbachhaus, with his Deputy Director, Dr Rudolf Wackernagel, to discuss the organisation and location of the exhibition. We are very grateful to these colleagues in Munich for their enthusiasm and cooperation.

From Munich the exhibition will move to Cambridge's twin city, Heidelberg. Dr Jörn Bahns, Director of the Kurpfälzisches Museum, approached the Fitzwilliam about possible collaboration in 1991. It is very pleasing that his initiative should have thus come to fruition. The organisation in Heidelberg was carried out by Dr Ulrike Andersson. The final German showing will be at the Herzog Anton Ulrich-Museum in Brunswick, where the Director, Dr Jochen Luckhardt, and the Curator, Dr Thomas Döring, who is working on a catalogue of the Dutch drawings in Brunswick, have been both efficient and receptive.

At the Fitzwilliam Museum Dutch connections and collections are deep and wide. The wealth of our Founder, Richard 7th Viscount Fitzwilliam of Merrion, derived from his maternal grandfather, Sir Matthew Decker, a Dutchman born in Amsterdam in 1679. Our collection of Rembrandt etchings, deriving in large part from our Founder, is one of the world's finest. And as this exhibition shows, our Dutch drawings, thanks to Sir Bruce Ingram's munificent bequest of 1963, are a comprehensive collection of the highest quality. We are delighted that the exhibition and its bilingual catalogue will introduce these riches to a new audience both in Germany and here in Cambridge, for that is where the exhibition will have its final showing in October 1996.

My final thanks are to Thea Vignau-Wilberg and David Scrase, who, between them, conceived the project and have brought it to triumphant and harmonious conclusion.

Simon Jervis Cambridge, June 1995
Director and Marlay Curator
The Fitzwilliam Museum

DANK

Ein Katalog wie dieser beruht immer auf der Vor- und Zusammenarbeit mehrerer Kollegen. An erster Stelle sind zu nennen meine Vorgänger im Fitzwilliam Museum, Carlos van Hasselt, heute Honorary Keeper of Dutch Drawings des Museums, und Malcolm Cormack. In München erhielten wir die nie versagende Unterstützung von Thea Vignau-Wilberg und Tilman Falk. Meine Kollegen in London und Amsterdam, Martin Royalton-Kish und Ger Luijten, halfen uns mit ihrer Fachkenntnis und erwiesen sich als Freunde durch die Geduld, mit der sie meine vielen Wünsche und Fragen beantworteten. Christopher Brown, Elizabeth McGrath, Christopher Page, Anthony Radcliffe, Gregory Rubinstein, Peter Schatborn, Christopher White, Penny Wilson und die Mitarbeiter der Witt Library am Courtauld Institute in London haben ihr Wissen mit der ihnen eigenen Großzügigkeit geteilt. Im Fitzwilliam Museum unterstützten und ermutigten mich meine Kollegen Craig Hartley und Jane Munro; Cor de Graaf und Paul Woudhuysen halfen bei der Klärung holländischer Inschriften und Texte, und unser Syndikus John Brown identifizierte Schmetterlinge. Bryan Clarke erweiterte beträchtlich meine nautischen Kenntnisse und ist zudem mit Celia Withycombe großenteils verantwortlich für die Analyse künstlerischer Techniken. Andrew Norman und Andrew Morris photographierten die Zeichnungen für den Katalog. Sean Fall, Andrew Bowker und Roger Stretch stellten die Passepartouts her und rahmten die Exponate. Thyrza Smith und Eleanor Smith von der Museumsverwaltung entwirrten die Fäden meines Manuskripts. Für alle anderen, die uns ihre Unterstützung in vielfacher Weise gewährten, seien Nick Burnett und Andrew Farley, damals vom *Sems*, stellvertretend genannt. So erhielt ich von vielen Seiten Hilfe, und ich spreche dafür meinen tiefen Dank aus. Die Verantwortung für alle Fehler im Katalogtext liegt bei mir allein.

David Scrase
Konservator der Gemälde, Zeichnungen und Druckgraphik
The Fitzwilliam Museum

ACKNOWLEDGEMENTS

The compilation of a catalogue of this nature depends on the work of several people. First are my predecessors at the Fitzwilliam Museum, Carlos van Hasselt, now Honorary Keeper of Dutch Drawings, and Malcolm Cormack. At Munich we have had unfailing encouragement from Thea Vignau-Wilberg and Tilman Falk. My colleagues in London and Amsterdam, Martin Royalton-Kish and Ger Luijten, have proved their worth as friends and scholars with their patience at my many demands and questions. Christopher Brown, Elizabeth McGrath, Christopher Page, Anthony Radcliffe, Gregory Rubinstein, Peter Schatborn, Christopher White, Penny Wilson and the staff of the Witt Library, Courtauld Institute, London have shared their knowledge with characteristic generosity. Within the Fitzwilliam my colleagues, Craig Hartley and Jane Munro, have been supportive and encouraging, Cor de Graaf and Paul Woudhuysen helped with Dutch inscriptions and texts and our Syndic, John Brown, identified butterflies. Bryan Clarke greatly increased my awareness of matters nautical and he and Celia Withycombe are responsible for much of the technical analysis of the drawings and their conservation. Photography was done by Andrew Norman and Andrew Morris. The preparation of the mounts and the framing was the lot of Sean Fall, Andrew Bowker and Roger Stretch, and them I should like to thank no less than our Registrar, Thyrza Smith, and Eleanor Smith, who unscrambled my manuscript. Others who have helped in various ways include Nick Burnett and Andrew Farley, then of *Sems*. Help has been manifest from many quarters and I owe a debt of gratitude for this; responsibility for any mistakes can only be mine.

David Scrase
Keeper of Paintings, Drawings and Prints
The Fitzwilliam Museum

EINFÜHRUNG

Als Richard, 7th Viscount Fitzwilliam, seiner alten Alma Mater Cambridge im Jahre 1816 seine Sammlungen hinterließ, enthielten diese nur wenige Zeichnungen. Unser Gründer besaß einen zu Recht hochgeschätzten Bestand an druckgraphischen Blättern, von denen viele der holländischen Schule entstammten, und etliche Rembrandt-Radierungen, die seinerzeit als unübertroffen galten. Die einzigen niederländischen Zeichnungen, eine Folge der *Vier Jahreszeiten* des Maerten de Vos (1532–1603) von 1587, hatte er wahrscheinlich als Beigabe zu den nach ihnen gestochenen Kupfern des Adriaen Collaert (um 1560–1618; Hollstein 457–460) erworben.

Da der Gründer an Zeichnungen nicht interessiert gewesen war, baute die Sammlung diesen Bereich im 19. Jahrhundert auch weiterhin nicht systematisch aus, ganz im Gegensatz zum Museum in Oxford. Dort profitierte die Universität erheblich durch die Ankäufe von Meisterzeichnungen Raffaels und Michelangelos in den Woodburn-Versteigerungen im Jahr 1860, während die Universität Cambridge lediglich druckgraphische Blätter erwarb. Damit verdankt das Fitzwilliam Museum die Zeichnungen, deren Zugang es im 19. Jahrhundert verbuchen konnte, ausschließlich Schenkungen und Stiftungen. 1817 überließ der Sohn von George Romney der Sammlung eine Anzahl von Zeichnungen seines Vaters und 1821 Reverend J. W. Whittaker eine Mappe mit Zeichnungen von Charles-Louis Clérisseau. Die ersten bedeutenderen Zeichnungen Alter Meister erhielt das Museum 1862 von A. A. VanSittart; unter den 94 Blättern befanden sich die drei Blumenbilder von Maria Sybilla Merian in Deckfarben auf Pergament und die *Milchverkäuferin* von Nicolaes Maes, die in der Ausstellung gezeigt werden. Weitere Zeichnungen Alter Meister vermachte 1872 Reverend R. E. Kerrich aus der Sammlung seines Vaters Thomas Kerrich, ehemaliger Bibliothekar der Universität und Verfasser einer grundlegenden Arbeit über Maerten van Heemskerk; allerdings ist keines seiner Blätter in dieser Ausstellung zu sehen. 1876 wurden einige Zeichnungen, zusammen mit etlichen herausragenden Rembrandt-Radierungen, aus der Universitätsbibliothek dem Museum zugeführt; unter ihnen befanden sich das Blatt von Jacob Adriaensz. Backer (Kat. 96) und das reizende Portrait von der Hand des Jan de Bray (Kat. 84).

Trotz dieser Zugänge und John Ruskins bedeutender Schenkung von Turner-Aquarellen im Jahre 1861 erlebte die Sammlung ihre eigentliche Entwicklung auf dem Gebiet der Handzeichnung erst im 20. Jahrhundert. Sie begann 1901 mit dem Erwerb von 33 Zeichnungen aus dem Besitz von Dr. Lazarus Belleli, unter ihnen Abraham Bloemaerts *Jesusknabe in den Armen des greisen Simeon*. Hinzu kamen 1912 Esaias van de Veldes *Musizierende Gesellschaft*, vermacht von Charles Brinsley Marley, und 1913 Claes Cornelisz. Moeyaerts *Jakobs Kampf mit dem Engel* – damals Claude Lorrain zugeschrieben – aus der Schenkung G. T. Clough, die auch Zeichnungen von Raffael und Michelangelo umfaßte. Die Sammlung wuchs durch einzelne Zeichnungen, die geschenkt oder vermacht wurden, wie eine Muller-Zeichnung von Darcy Kitchen 1913 und eine Merian-Zeichnung von A. J. Griffith 1926, die das Museum aus Mitteln des National Art Collections Fund erhielt. 1927 überließ Mrs. Fuller Maitland dem Museum Zeichnungen von Piazzetta und Jan de Bisschop aus der Sammlung ihres Bruders, der dies verfügt hatte.

Mit dem Vermächtnis von Charles Shannon 1937 konnte das Museum den nächsten großen und den wichtigsten Zuwachs an Zeichnungen vor Ausbruch des Zweiten Weltkrieges verbuchen. Shannon hatte diese Sammlung gemeinsam mit seinem Künstlergefährten und Freund Charles Ricketts mit Kennerschaft und liebevoller Sorgfalt zusammengetragen; sie enthält u. a. Zeichnungen von Rembrandt, Rubens, Tizian, Tintoretto und Watteau. Während des Krieges stiftete ein weiterer Maler, Frank Brangwyn, eine Reihe von Zeichnungen, unter ihnen die *Studie von Bäumen im Wald*, die im Katalog Adam Pijnacker zugeschrieben wird. Der ehemalige Direktor des Fitzwilliam Museums Louis Clarke schenkte

INTRODUCTION

When Richard, 7th Viscount Fitzwilliam, bequeathed his collections to his old University of Cambridge in 1816, they included but few drawings. The Founder had a justly acclaimed collection of prints, many from the Dutch school, and a group of Rembrandts which, in his day, was thought second to none, but the only drawings of the Netherlandish school which he possessed were four, representing *The Seasons*, by Maerten de Vos (1532–1603). Dated 1587, he had presumably acquired them with the engravings after them by Adriaen Collaert (c. 1560–1618; Hollstein 457–460).

Because of the Founder's fundamental lack of interest in drawings this aspect of the Collections was not increased in a systematic way in the nineteenth century; whereas Oxford was enormously to benefit by the purchase of masterworks by Raphael and Michelangelo from the Woodburn sales, in 1860, the University of Cambridge only purchased prints. The drawings which entered the Museum in the nineteenth century were thus gifts and benefactions. A group of drawings by George Romney was given by his son in 1817 and a portfolio of drawings by Clérisseau by the Reverend J. W. Whittaker in 1821. But the first group of Old Masters of any significance came amongst the ninety-four drawings presented by A. A. VanSittart in 1862, represented here by three vellums of Maria Sybilla Merian and Nicolaes Maes' *Milkseller*. More Old Master drawings were bequeathed by the Reverend R. E. Kerrich in 1872, from the collection of his father, Thomas Kerrich, formerly the University Librarian and renowned for his work on Maerten van Heemskerk, but none is included in this exhibition. Some drawings were transferred from the University Library in 1876, together with a superlative group of Rembrandt's prints, including the Backer (cat. no. 96) and the charming portrait drawing by de Bray (cat. no. 84).

Despite these benefactions and the important gift of watercolours by J. M. W. Turner from John Ruskin in 1861, the real expansion of the collection of drawings has taken place in the twentieth century. The purchase in 1901 of thirty-three drawings from Dr Lazarus Belleli, which included the Bloemaert of *Simeon*, was a good beginning. From the bequest of Charles Brinsley Marlay in 1912 came Esaias van de Velde's *Musical Party* and in 1913 from the gift of G. T. Clough, which included drawings by Raphael and Michelangelo, was Moeyaert's *Jacob wrestling with the Angel*, then attributed to Claude Lorrain. Individual gifts and bequests, like that of Darcy Kitchen's Muller in 1913 and A. J. Griffith's fine Merian, given in 1926 through the National Art Collections Fund, augmented the collection; and in 1927 Mrs Fuller Maitland gave drawings by Piazzetta and de Bisschop from her brother's collection at his request.

The next large influx of drawings and the most important before the war was with the bequest of Charles Shannon in 1937. This consisted of the collection amassed with a keen eye and loving care by Shannon together with his co-artist and friend Charles Ricketts, amongst which were drawings by Rembrandt, Rubens, Titian, Tintoretto and Watteau. During the war, another artist, Frank Brangwyn gave several drawings, including the beautiful *Study of trees* here attributed to Pijnacker. The former director of the Museum, Louis Clarke, gave the de Vlieger *Group of fisherfolk* in 1948 and his bequest of 1960, which included marvellous drawings by Leonardo and Correggio brought us more Rembrandts, including the *Holy Family sleeping, with angels appearing to Joseph in his dream*.

The year 1963 was the *annus mirabilis* for the aggrandisement of the collection of Netherlandish drawings with the bequest of more than 900 drawings, eighty-four of which are included here, by Sir Bruce Ingram. Ingram, who was editor of *The Illustrated London News*, was fascinated by the truthful realism of the Dutch school. Passionately interested in the seascapes of the two Willem van de Veldes, his scope extended to figure drawings and landscapes. He collected works by Italian, English and French artists as well as those of the Netherlands, although these latter were the most important area of his collection.

dem Haus 1948 Simon de Vliegers *Gruppe von Fischern*; sein Vermächtnis von 1960 enthielt neben herausragenden Zeichnungen von Leonardo und Correggio weitere Blätter von Rembrandt, z.B. die *Schlafende Heilige Familie mit den Engeln, die Joseph im Traum erscheinen*.

Das Jahr 1963 ging als *annus mirabilis* für die Sammlung niederländischer Zeichnungen in die Geschichte des Fitzwilliam Museums ein; in ihm konnte das Vermächtnis von Sir Bruce Ingram mit mehr als 900 Zeichnungen aufgenommen werden, aus dem allein 84 der hier gezeigten Auswahl von 108 Blättern stammen. Ingram, Herausgeber der *Illustrated London News*, war fasziniert vom naturgetreuen Realismus der Holländer. Sein persönliches, leidenschaftliches Interesse galt zwar den Seestücken der beiden Willem van de Velde, doch erweiterte er den Rahmen seiner Sammlung auf Figuren- und Landschaftsdarstellungen und auf italienische, englische und französische Künstler, obwohl die Niederländer den wichtigsten Platz einnahmen.

Glücklicherweise lassen Schenkungen und Stiftungen den Bestand weiterhin anwachsen. John Tillotson schenkte der Sammlung 1968 die *Himmelfahrt des Elija* von Leonaert Bramer und hinterließ dem Museum 1985 auch seine Gemälde und Zeichnungen der Schule von Barbizon. Schließlich vermachte Major Henry Broughton, 2nd Lord Fairhaven, dem Haus seine Sammlung von über 1500 Pflanzenzeichnungen, die 1973 aufgenommen wurden und von denen drei in dieser Ausstellung gezeigt werden.

Der Schwerpunkt der Sammlung liegt auf dem Gebiet der Landschaftszeichnung, aber um der Vielfalt und dem Rang holländischer Zeichenkunst im 17. Jahrhundert gerecht zu werden, haben wir uns entschieden, in der Ausstellung auch andere Gattungen einzubeziehen. Wir haben daher den Katalog in sechs Abschnitte gegliedert. Zunächst werden Landschaft und Städte Hollands vorgestellt, gefolgt von Landschaftszeichnungen, die holländische Künstler in der Fremde fertigten, wo sie neue Anregungen aufnahmen. Nach den Seestücken im dritten Abschnitt werden im vierten nur einige wenige Tierstudien gezeigt, bevor die Pflanzendarstellungen, die wir ausgewählt haben, ihre Farbenpracht entfalten können. Die fünfte Abteilung ist der Figurenzeichnung gewidmet und die letzte religiösen Themen. In jedem Abschnitt sind die Zeichnungen alphabetisch nach Künstlern geordnet. Kurzbiographien stellen die Künstler jeweils vor, wenn ihr Name erstmals erscheint, unabhängig von den genannten Abschnitten. Einige unserer bedeutendsten holländischen Zeichnungen, unter ihnen Blätter von Rembrandt, eine Landschaft von Buytewech und das *Tekenboek* des Abraham Bloemaert, konnten nicht in die Ausstellung aufgenommen werden. Dennoch sind die hier gezeigten Zeichnungen repräsentativ für die Vielfalt und die Bedeutung der Sammlung holländischer Zeichnungen im Fitzwilliam Museum.

David Scrase

The flow of gifts and benefactions continues, happily, to enrich the museum; in 1968 John Tillotson, who was to bequeath his collection of paintings and drawings of the Barbizon school in 1985, gave Bramer's fine *Ascension of Elijah* and last, but by no means least was the bequest in 1973 of more than 1500 flower drawings collected by Major Henry Broughton, 2nd Lord Fairhaven, three of which are included in this exhibition.

The main strength of the collection is in landscape, but to do justice to the range of Dutch draughtsmanship in the seventeenth century it was decided to include other types of drawing. The catalogue is thus conceived in six sections. It begins with the landscape and townscape of Holland; the second section shows the achievement in landscape of Dutch artists who went abroad and the third comprises seascapes. A small interlude of animal drawings is followed by a riot of colour with a selection of flower drawings. The fifth section is devoted to figure drawing and the last to drawings with a religious context. Within each section the drawings are arranged alphabetically by artist, and a potted biography of each artist appears under the first entry for his name, regardless of which section. A few of our most important drawings, some of the Rembrandts, the Buytewech landscape and the Bloemaert *Tekenboek* have not been included, but the choice of what is exhibited gives a good idea of the range and relative strengths of this area of the Fitzwilliam's collections.

David Scrase

DIE BILDWELT DER HOLLÄNDISCHEN KUNST IM 17. JAHRHUNDERT

1 Bericht von John Evelyn, 1641, zitiert in: Hanns Floerke, *Die Formen des Kunsthandels, das Atelier und die Sammler in den Niederlanden vom 15.–18. Jahrhundert.* München/Leipzig 1905, S. 20; zum wirtschaftlichen Aspekt siehe neuerdings: Marten Jan Bok, De sociaaleconomische benadering van de Nederlandse zeventiende-eeuwse schilderkunst. *De Gouden Eeuw in Perspectief. Het beeld van de Nederlandse zeventiende-eeuwse schilderkunst in later tijd,* hrsg. von Frans Grijzenhout und Henk van Veen. Heerlen 1992, S. 330 ff.

2 Johan van Gool, *De Nieuwe Schouburg der Nederlantsche kunstschilders en schilderessen,* Bd. 1. Den Haag 1750, S. 2 f.

3 Hans-Ulrich Beck, *Jan van Goyen 1596–1656. Ein Œuvreverzeichnis,* Bd. 1. Amsterdam 1972, Nrn. 195–557e.

4 Roger de Piles, *Abrégé de la vie des peintres, avec des réflexions sur leurs ouvrages, et un traité du peintre parfait, de la connaissance des dessins, et de l'utilité des estampes.* Paris 1699, S. 66.

5 Zum Adel siehe Michael North, *Kunst und Kommerz im Goldenen Zeitalter. Zur Sozialgeschichte der niederländischen Malerei des 17. Jahrhunderts.* Köln/Weimar/Wien 1992, S. 55 ff.

Bildungsreisende aus dem Ausland staunten seit je über den Umfang der niederländischen Kunstproduktion im 17. Jahrhundert und die Verbreitung gezeichneter, gestochener und gemalter Kunstgegenstände.[1] Auch im eigenen Land war man sich bereits im 18. Jahrhundert dieses Reichtums bewußt: „Ähnlich wie unsere gesegneten Niederlande keinem anderen europäischen Land darin nachstehen, berühmte Männer zu zeugen, erwies sich das Land besonders fruchtbar, namhafte Maler hervorzubringen. Zahlreiche Werke in den berühmtesten Kunstkabinetten Europas beweisen, daß es auf diesem Gebiet, an seiner geringen Größe gemessen, alle anderen Staaten Europas übertraf."[2]

Die Fakten lösen diese von Nationalstolz geschwollenen Töne durchaus ein. Schon öfter wurde darauf hingewiesen, daß sich die Käufer von Gemälden aller Preisklassen in unterschiedlichen Bevölkerungsschichten fanden. Bilder konnten zu Zahlungsmitteln, Exportartikeln – besonders nach England – und sogar zu Spekulationsobjekten werden. Die Maler arbeiteten nicht länger ausschließlich für einen Auftraggeber, sondern größtenteils für den freien Kunstmarkt, den sie direkt oder über einen Kunsthändler belieferten. Gemälde wurden auf den Verkaufsausstellungen der Gilde und auf Jahrmärkten feilgeboten. Das Arbeiten für den Markt erforderte und förderte bei dem Maler Spezialisierung und Arbeitsteilung.

Weniger häufig als Gemälde wurden Zeichnungen für den freien Markt gefertigt. Die fabrikmäßig anmutende Produktion von Landschaftszeichnungen, wie sie beispielsweise Jan van Goyen in den frühen fünfziger Jahren entwickelte[3], ist eher als eine Ausnahme aus wirtschaftlicher Not heraus zu sehen. So entstand ein Teil auch der hier ausgestellten Zeichnungen als „inventio", als „prima idea" einer späteren Komposition (vgl. Kat. 103). Roger de Piles bezeichnete sie als „les pensées que les Peintres expriment ordinairement sur du papier pour l'exécution d'un ouvrage qu'ils méditent".[4] Bei dem Kunstkenner hatten diese Bildnotizen, die das Werk bereits *in nuce* beinhalten, mitunter einen größeren Stellenwert als das ausgeführte Gemälde. Weitere Zeichnungen dienten als Studie zur beliebigen späteren Verwendung in (vor allem gemalten) Kompositionen; sie wurden häufig direkt vor dem Gegenstand gefertigt (vgl. Kat. 53, 63, 79, 88). Andere Zeichnungen wiederum entstanden als unabhängige, autonome Kunstwerke, zum Teil für den Markt (vgl. Kat. 6, 45, 86, 92).

In der vorwiegend städtisch-bürgerlichen Kultur der Vereinigten Provinzen im 17. Jahrhundert waren die Auftraggeber und Käufer der Gemälde und Zeichnungen mehrheitlich wohlhabende Stadtbürger und bürgerliche Institutionen (Schützenvereine, Stadtrat, Gilde). Im Laufe des Jahrhunderts entwickelte sich aus der Bürgerschicht in den größeren Orten ein Regentenpatriziat und speziell aus dem Kaufmannsstand eine Art von bürgerlicher Geldaristokratie. Gleichzeitig erhielt auch die alte Aristokratie[5], die sich am Hof der Statthalter (Friedrich Heinrich 1625–1647, Wilhelm III. 1672–1702) konzentrierte, als Auftraggeber einen größeren Einfluß auf die bildende Kunst und ihre Thematik, zunächst vorwiegend bei flämischen, dann auch bei Utrechter Malern. Darin folgte sie dem Beispiel des englischen und französischen Hofes.

Mit welchen Themen befaßten sich die holländischen Maler und Zeichner dieser Zeit? Der Franzose Eugène Fromentin, der 1875 in *Les Maîtres d'autrefois* die niederländische, speziell die holländische Malerei innerhalb ihres europäischen Umfelds betrachtete und einfühlsam charakterisierte, bemerkte „das völlige Fehlen dessen, was wir heute ein ‚Sujet' nennen". Denn die Bildwelt der holländischen Malerei war ja im Vergleich zur Kunst anderer Länder gänzlich unspektakulär, und noch Fromentin empfand die wenigsten ihrer Gegenstände als „bildwürdig". Von der bildenden Kunst eines Landes, das im 17. Jahrhundert von militärischen Auseinandersetzungen geprägt war, die schließlich zur Loslösung der Sieben Vereinigten Provinzen vom Habsburgischen Reich führen sollten, und von Kämpfen an den Grenzen und bürgerkriegsähnlichen Religionskonflikten geschüttelt wurde, würde man eine wesentlich martialischere und weniger friedliche Ikonographie erwarten. Doch war die

Historienmalerei, der auf der Scala der Themengattungen allgemein der höchste Rang zugewiesen wurde, im Holland des 17. Jahrhunderts nicht am meisten gefragt. Am internationalen Geschmack gemessen, wirken zudem manche der von nordniederländischen Malern gefertigten Historienbilder mit biblischen, mythologischen und allegorischen „Sujets" eher unheroisch und bürgerlich. Erst gegen Ende des Jahrhunderts, in der Zeit von Statthalter Wilhelm III. (1672–1702), der zugleich König von England war (1689–1702), schließen sie thematisch und stilistisch an den internationalen französischen Hofstil an. Wenn man aber die Inventare aus der Zeit Rembrandts liest, bezeugen die Bezeichnungen der Gemälde trotz des – wenigstens offiziell herrschenden – permanenten Kriegszustandes friedfertige Aufmerksamkeit für das Unscheinbare: „Een harderinnetje" (Hirtin), „een oude vrou's tronie" (Gesicht einer alten Frau), „een wintertge" (kleines Winterbild), „een maneschijntje" (kleines Nachtstück), „een boerekermis" (Bauernkirmes), „een blompotje" (kleine Blumenvase), „een kint in de kackstoel" (Kind im „Kack"-Stuhl), „een lantschap" (Landschaft), „een cleyn stuckie met schepen" (kleines Seestück). Die Verkleinerungsform der Titel deutet auf das kleine Format als Charakteristikum der Gemälde. Kabinettformat und Thematik unterscheiden die holländische Malerei grundlegend von jener in Italien und in Frankreich.

Die von der Kunst im übrigen Europa abweichende Thematik, die von Anfang an in der Kunstbetrachtung registriert wurde, basierte nach Fromentin auf den Bedürfnissen der Bevölkerung: „Es war ein Volk von Bürgern, praktisch, nicht gerade sehr träumerisch, sehr beschäftigt, ohne jede mystische Geistesrichtung, nicht romanisch, mit unterbrochenen Traditionen, einem Kultus ohne Bilder und sparsamen Gewohnheiten. Zu finden war eine Kunst, die ihm gefiel, deren Angemessenheit ihm begreiflich war und die eine Darstellung seines Lebens lieferte [...]. Die holländische Malerei, das merkte man sehr rasch, konnte nur das Portrait von Holland sein, sein äußeres, treues, genaues, vollständiges Bild ohne jede Verschönerung. Ein Portrait der Menschen und der Orte, der bürgerlichen Sitten, der Plätze, der Straßen, des flachen Landes, des Meeres und des Himmels – das mußte, auf seine einfachen Elemente zurückgeführt, das Programm sein, das die holländische Schule aufstellte, und das war es vom ersten Tag an bis zu ihrem Verfall."[6]

Obwohl Fromentin, der selbst Maler war und zur Zeit des Impressionismus lebte, viel an den für die holländische Malerei charakteristischen „valeurs" des Kolorits gelegen war, sieht er den Realismus in Darstellungen des Alltags als ihre eigentliche Errungenschaft an. Die Frage, inwiefern Alltagsszenen, Landschaft und Stilleben tatsächlich das damalige Leben spiegeln, beschäftigte seitdem mehrere Generationen von Kunsthistorikern.[7] Am Ende des 19. Jahrhunderts herrschte die Überzeugung, die holländische Malerei des 17. Jahrhunderts und speziell die Genreszenen seien Abbild der Realität. Doch während zunächst stilkritische Kriterien zum Ausgangspunkt der Bildbetrachtung gemacht wurden, bewegte sich die Betrachtungsweise nach dem ersten Viertel des 20. Jahrhunderts durch die Studien von Aby Warburg und seinem Kreis in eine andere Richtung: Die Darstellungen wurden zwar weiterhin als realistisch definiert, wurden aber in ihren kulturhistorischen Kontext gestellt und als Bedeutungsträger angesehen, als ein Mittel, um eine über das unmittelbar Abgebildete hinausweisende Aussage zu machen. Die Reaktion auf die zunehmende Neigung, in einem Bild in erster Linie ein Bilderrätsel zu sehen, und die Gefahr eines Hinein- oder Überinterpretierens zeigte sich in einer gegenläufigen Kunstbetrachtung, die in Svetlana Alpers (The Art of Describing, 1983) ihre Wortführerin fand.[8] Alpers sieht die Malerei der Nördlichen Niederlande – im Gegensatz zu der erzählenden Kunst der Südlichen Niederlande und Italiens – vor allem als eine Kunst, die mit dem Pinsel registrierend aufzeichnet, was das Auge entdeckt; sie erkennt dabei aber durchaus die Verdienste der Warburg- und Panofsky-Schule auf gewissen Gebieten an.

Die Konfrontation dieser zwei Betrachtungsweisen löste in den achtziger Jahren heftige Diskussionen aus. Die Gereiztheit beider Lager wird verständlicher, denkt man an ihre Parallele in der frühen Neuzeit: Bereits damals wurde eine Kontroverse ausgefochten zwischen gelehrten Anhängern zweier Richtungen, deren Ansichten in unterschiedlichen philosophischen Traditionen wurzelten. Im 15. und 16. Jahrhundert betrachteten einerseits die (Neo)Platoniker das, was sich dem Auge manifestiert, als ein Mittel zur Erkenntnis des

6 Eugène Fromentin, Die alten Meister. Belgien – Holland. Potsdam [1919], S. 142 f.

7 Einen guten Überblick über diese Problematik gibt der Band mit Texten verschiedener Autoren De Gouden Eeuw in Perspectief, 1992 (siehe Anm. 1).

8 Svetlana Alpers, The Art of Describing: Dutch Art in the Seventeenth Century. Chicago/London 1983.

Urbildhaften; die Aristoteliker sahen andererseits, vereinfacht gesagt, jede Form in erster Linie als einen durch die Sinne wie Tast- und Sehvermögen umreißbaren Gegenstand, ohne den Dualismus zwischen Idee und realem Gegenstand in ihre Betrachtung einzubeziehen. Während Anhänger der beiden Richtungen heftig polemisierten, waren sich die Humanisten des späten 16. Jahrhunderts aber durchaus der Stärke der durch Aristoteles-Übersetzungen neu zugänglich gemachten Erkenntnistheorie bewußt und strebten eine Versöhnung der beiden kontroversen Auffassungen an, die sie zu einer Synthese führen wollten. Bemerkenswerterweise kann gerade Constantijn Huyghens d. Ä. (1596–1687), ein Bewunderer der Malerei seiner Zeit, der von Alpers als Verfechter der von ihr als neu propagierten Betrachtungsweise der Nördlichen Niederlande ins Feld geführt wird, durch die ausschließlich flämische Verwandtschaft mütterlicherseits und seine tief humanistische Bildung als die ideale Verkörperung einer solchen Synthese gelten.

I. Holländische Landschaften: Stadt und Land

Naheliegend in dieser verstädterten Kultur war es, die Stadt in ihren verschiedenen Aspekten darzustellen.[9] Die Stadtansicht entwickelte sich in den Niederlanden zu einer eigenen Kunstgattung. Die Stadt wird innerhalb ihrer schützenden Wälle, Mauern und Stadttore gezeigt, wie in Berckheydes Zeichnung der *Wittevrouwenpoort in Utrecht* (Kat. 1) und Herman Saftlevens *Wallanlage von Utrecht* (Kat. 26). Abraham Bloemaert stellt die verschachtelten Anbauten niederländischer *Hinterhäuser* (Kat. 3) dar, die sich wohl in derselben Stadt befinden. Ihre ruinösen Mauern sind zu Flächen abstrahiert, deren Farben malerisch ineinanderfließen und leuchten. Auch in den Häusern in *Hoge Zwaluwe* (Kat. 23) entdeckt Saftleven nicht nur topographisch interessante, sondern auch pittoreske Objekte.

Holland – besonders Amsterdam – war bereits zu einem Zentrum der Kartographie geworden, bevor sich hier die eigentliche Landschaftsmalerei entwickelte.[10] So ist in der Landschaftsdarstellung häufig ein starkes Interesse für topographische Gegebenheiten feststellbar. Die Ortschaften, die in den weiten Panoramalandschaften am Horizont erscheinen, sind allerdings oft nur in den markanten Details „naturalistisch". Im Bilde angeordnet wurden die Baudenkmäler eher nach kompositorischen als nach topographischen Gesichtspunkten. Das Bild wird bestimmt vom Licht und vom Schatten, die durch Sonne und Wolken am weiten Himmel hervorgerufen werden und sich ausgewogen über dem ausgedehnten, häufig von Wasser durchschnittenen Flachland verteilen. So zum Beispiel in Eeckhouts holländischer Panoramalandschaft (Kat. 6), in Furnerius' Zeichnung *Amsterdam im Nebel* (Kat. 8) und in Saftlevens *Panoramablick bei Wageningen* (Kat. 25). Im Vergleich zu diesen Panoramen ist Aelbert Cuyps *Leuchtturm von Egmond aan Zee* (Nr. 5), eine seiner seltenen Dünenlandschaften, gleichsam umgekehrt gesehen. Die den Ort bestimmenden Baulichkeiten stehen hier im Vordergrund, dahinter weitet sich das Meer in endlose Ferne.

Das Auge des Stadtbewohners weidet sich in den Zeichnungen am Leben auf dem Lande und an der Weitläufigkeit der Landschaft und der Naturwege, die in krassem Gegensatz zur Enge der Stadtgassen steht (Esaias van de Velde, *Freudenfeuer in einem Dorf*, Kat. 28; derselbe, *Dorfstraße mit Kirche*, Kat. 27). Verfallene Schuppen und Bauernhäuser (Rembrandt, Kat. 18; van de Velde, Kat. 29) suggerieren die Hinfälligkeit menschlicher Mühe. Rutgers' festungsartiger Bauernhof mit Wirtschaftsgebäuden strahlt dagegen Geborgenheit aus (Kat. 22). Die Arbeit auf dem Felde inspirierte denselben Künstler zu einer Komposition voller Harmonie, Rhythmus und menschlicher Ordnung (*Feld mit Garbenbündeln*, Kat. 21).

Wie in der Malerei von Salomon van Ruysdael und anderen erscheinen auch in der Zeichenkunst – bei Jan van Goyen (Kat. 13) – bildmäßig und mit lockerem Strich ausgeführte sommerliche Flußlandschaften mit tätigen Menschen in Fischerbooten. Bei den lediglich angedeuteten Häusern am Ufer herrscht heitere, nie hektische Betriebsamkeit – eine urholländische Ideallandschaft.

Gleichsam in Analogie zu den atmosphärisch gezeichneten Stadtlandschaften entstehen die Waldstücke, bei denen die Bäume in erster Linie zu Stimmungsträgern werden (Jan Lievens, Kat. 15; Pijnacker, Kat. 17; Simon de Vlieger, Kat. 31; Waterloo, Kat. 32, 34). Das Sonnenlicht wird von Stamm und Laub aufgefangen, gefiltert und reflektiert. Farbiges oder eingefärbtes Papier kann die malerische Wirkung einer solchen Zeichnung steigern.

9 Immer noch grundlegend: Wolfgang Stechow, *Dutch Landscape Painting of the Seventeenth Century*. Oxford 1966.

10 Alpers betont diesen Aspekt in ihrem Buch, S. 119 ff., als „The Mapping Impulse in Dutch Art".

II. Holländische Künstler in der Fremde

Das Dokumentieren der charakteristischen Gestalt oder Lage einer Ortschaft spielte, wie bereits hervorgehoben, bei der realistischen Landschaftsdarstellung seit je eine wichtige Rolle. Bereits im 16. Jahrhundert reisten Niederländer in fremde Länder und hielten sehenswerte Städte, in die Landschaft eingebettet, in Zeichnungen fest. Manche dieser Städtebilder wurden in Kupfer gestochen und im Druck verbreitet, wie in den *Civitates Orbis Terrarum*, dem vielbändigen Unternehmen von Georg Braun und Frans Hogenberg. Auch Jacob Esselens und Lambert Doomer unternahmen Reisen, die sie nach England, Frankreich und Italien führten. Esselens, der als Kaufmann tätig war und wohl beruflich nach England reiste, machte kartographisch genaue Skizzen der englischen Küstenlandschaft, wie sein *Blick auf Dover* (Kat. 41) und auf *Rye* (Kat. 42) zeigen. Doomers stimmungsvolles Aquarell der *Weinpresse von Monsieur Dittyl bei Nantes* (Kat. 40), das er nach seiner Rückkehr aus Nantes, 1646, nach Skizzen fertigte, ruft eine Impression seiner Frankreichreise in Erinnerung.

Allaert van Everdingen hielt sich auf seiner Reise nach Skandinavien in den vierziger Jahren einige Zeit in Norwegen auf und entdeckte die urwüchsige Natur in diesem Land als künstlerisches Motiv. Ihre Aufnahme in sein Bildrepertoire entwickelt in gewisser Weise die manieristischen Felsenlandschaften seines ersten Lehrers Roelandt Savery konsequent weiter und knüpft an die gewittrige Stimmungslandschaft des mittleren 17. Jahrhunderts an (*Felsige Landschaft*, Kat. 43).

Das Land, das die schöpferische Phantasie der Künstler in erster Linie anregte, war jedoch Italien. Auf der „grand tour", der Kavaliers- und Bildungsreise, wurden in den kulturellen Zentren antike und neuzeitliche Kunstwerke studiert. Die Landschaft unterwegs hielt man in Ansichten fest (Jan Asselijn, *Landschaft mit Kastell und Häusern am Steilufer*, Kat. 37) oder es wurden die durch Skizzen dokumentierten Landschaftssituationen erst nach der Rückkehr frei und bildmäßig nachgeschaffen (Jan Lapp, *Gebirgslandschaft*, Kat. 44). Es führen viele Wege nach Rom; der frequentierteste Weg führte damals über Venedig. Abraham Storck vereinigt in seinem *Venezianischen Architekturcapriccio* (Kat. 45) in freier Komposition verschiedene beliebte venezianische Gebäude, staffiert mit Gondeln und Handelsschiffen. Andere italienische „capricci" erinnern mit ihren malerischen ruinösen Motiven zugleich an die Vergänglichkeit alles Irdischen, wie Jacob van der Ulfts *Ruinenlandschaft* (Kat. 46) und Jan Worsts *Kolosseum* (Kat. 48). Dagegen ist Jan Asselijns Zeichnung des *Konstantinsbogens* (Kat. 36) in Rom nicht nur ein malerisches Monument, sondern auch ein archäologisches Dokument.

Am häufigsten klingt das Italien-Erlebnis erst nach der Rückkehr in die Heimat in stimmungsvollen pastoralen Ideallandschaften nach, deren lichtdurchflutete, sanfte Hügel von arkadischem Hirtenvolk bewohnt werden, wie besonders in den Zeichnungen von Nicolaes Berchem (Kat. 38, 39) und Thomas Wyck (Kat. 49). Diese „italianisante" Landschaftskunst wurde in den Niederlanden mindestens so hoch geschätzt wie jene mit einheimischen Motiven. Aus Bildmotiven und -kompositionen dieser Art entwickelte sich im Laufe des 17. Jahrhunderts eine Tradition, die bis ins 19. Jahrhundert – in die Kunst der Deutschen in Rom – nachwirken sollte.

III. Seestücke

Das Spektrum der Marinedarstellungen[11] reicht von den temperamentvoll geschwungenen, graphisch-linearen Federzeichnungen des Cornelis Claesz. van Wieringen aus dem frühen 17. Jahrhundert (Kat. 61) bis zu den beschaulichen, pittoresken Stimmungsbildern mit kaum bewegtem Meeresspiegel von Ludolf Backhuizen (Kat. 51) an der Wende zum 18. Jahrhundert. Die Bewohner der Nördlichen Niederlande hatten von jeher ein sehr enges Verhältnis zum Wasser, existierte doch ein Teil des Landes bereits im 17. Jahrhundert nur dank dem Schutz der Deiche. Während die in fahrigen Linien aufgelösten Schiffe bei van Wieringen und bei den frühen Zeichnungen des Simon de Vlieger (Kat. 59) als Spielbälle der Elemente aufgefaßt sind, vermittelt Hendrick Cornelisz. Vrooms ruhige, klare Zeichnung von *Elsinore* (Kat. 60) eher das Bild einer geordneten „Seestraße", wo regelmäßig Handelsschiffe verkehren. Die Provinz Holland, speziell Amsterdam, besaß in dieser Zeit

11 Literatur zur frühen Marine: M. Russell, *Visions of the Sea. Hendrick C. Vroom and the Origins of Dutch Marine Painting*. Leiden 1983. Allgemein: Laurens J. Bol, *Die Holländische Marinemalerei des 17. Jahrhunderts*. Braunschweig 1973; George S. Keyes, *Mirror of Empire. Dutch Marine Art of the Seventeenth Century* (= Ausstellungskatalog Minneapolis/Toledo/Los Angeles 1990/91).

nahezu eine Monopolstellung im Welthandel auf dem Wasserweg. Auch als Fischereimacht nahm Holland eine wichtige Position ein.

Mit aktuellen Ereignissen befaßt sich die Zeichnung, die Claes Jansz. Visscher nach dem Stich nach Jacques de Gheyn fertigte: *Die Segelwagen des Prinzen Moritz von Nassau* (Kat. 58). Zeitgeschehnisse gehen häufig ein in die Gemälde und Zeichnungen von Willem van de Velde d. Ä. und d. J., Vater und Sohn, bei denen es sich öfter um Auftragsbilder handelt. Diese maritimen Ereignisbilder berichten reportagenartig von Ein- und Ausschiffungen, Landungen und Seeschlachten. Das thematisch bedingte extreme Querformat ermöglichte die Darstellung vieler simultaner Ereignisse. Das Auge wandert von links nach rechts (*Einschiffung der Prinzessin Maria von Modena in Gravesend*, Kat. 56). Während die getreue Wiedergabe der Schiffe durch die beiden van de Veldes in Studien bis in die Einzelheiten vorbereitet wurde, waren die Künstler freier in der Anordnung der Boote, die vor allem von der Gesamtkomposition abhing. Viele Darstellungen von Schiffen auf hoher See oder in den weniger bewegten Küsten- und Flußgewässern des jüngeren van de Velde sind eher als sonnige Stimmungsbilder denn als traditionelle Seestücke aufzufassen.

Eine eigene Gruppe bilden detaillierte Schiffsstudien, mit denen zum Beispiel Abraham Casembroot Marinestücke vorbereitete (Kat. 52, 53). Insbesondere die beiden van de Veldes beweisen in ihren überdimensionierten, minuziös ausgeführten Schiffsportraits ihre genaue Kenntnis der Schiffskonstruktion (Kat. 54, 55). Die Künstler mußten im Schiffbau und Navigieren bewandert sein und fertigten ihre Studien vor Ort von einem Boot aus oder nach einem Schiffsmodell.

IV. Tiere und Pflanzen

Die natürliche Umwelt mit ihren Pflanzen und Tieren wird eindringlich beobachtet und für die Kunst neu erschlossen. Abraham Bloemaert hat das *Pferd* in dessen Eigenart als Zugpferd und Arbeitstier eindrücklich festgehalten (Kat. 62). Seine Zeichnung zeigt außerdem das Interesse, das die eher linear gestaltenden Künstler der Zeit um 1600 der Oberflächenstruktur, den Hebungen und Senkungen der Muskel- und Hautpartien entgegenbrachten; dasselbe Interesse manifestiert sich auch in den Bildnissen älterer Menschen aus dieser Zeit (vgl. Bloemaert, *Simeon*, Kat. 97). Die Bloemaert-Zeichnung ist (wohl allseitig) beschnitten worden, was heute die Wirkung des Motives steigert. Bei diesem Blatt handelt es sich wahrscheinlich um eine Studie nach der Natur, während das Pferd, das Aelbert Cuyp fest umrissen in seiner Grobschlächtigkeit charakterisiert (Kat. 63), eher zur Anwendung als Staffage für seine Gemälde entstand. Dasselbe gilt für Cuyps Zeichnung eines Reit- oder Kavallerie-Pferdes, das von einem Knecht geführt wird (Kat. 64).

Eine Kuriosität bildet der trompetende *Elefant* von Cornelis Saftleven (Kat. 65). Es handelt sich wohl um eine Skizze nach der Natur, denn die Wiedergabe entspricht nicht der standardisierten Darstellung dieses Tieres. Auch Rembrandt zeichnete in lockeren Kreidestrichen einen Elefanten (1637), wie es heißt, ein Tier aus einem Wanderzirkus. Elefanten wurden durch die West- und Ostindische Handelskompanien per Schiff aus anderen Kontinenten nach Amsterdam transportiert und von dort weiter verfrachtet. Sie endeten häufig in den fürstlichen Menagerien.

Einen besonderen Platz nimmt die *Fliegende Stockente* von Aert Schouman (Kat. 66) aus der Mitte des 18. Jahrhunderts ein: In seinem Aquarell gab Schouman den Vogel in der natürlichen Anspannung des Fluges wieder. Er plazierte ihn – in einer Bildkomposition, die er öfter wählte – großformatig vor einem breiten Fluß mit einer verschwommen sichtbaren Ortschaft am Ufer, vielleicht seiner Heimatstadt Dordrecht. Die delikate stoffliche Wiedergabe der Federn hatte Tradition, allerdings hauptsächlich im Rahmen des Küchen- und Jagdstillebens, der „nature morte", während das Tier hier quicklebendig eingefangen ist.

Seitdem im 16. Jahrhundert die exakte Erfassung von Pflanzen und Insekten eingesetzt hatte und um 1600 von Künstlern wie Joris Hoefnagel und Jacques de Gheyn II. zu einem elitären Bildthema erhoben worden war, wurden Blumen in verschiedenster Weise und zu unterschiedlichen Zwecken dargestellt. Die eindrucksvollen Aquarelle der in Frankfurt geborenen Maria Sybilla Merian belegen, wenn sie auch im späten 17. Jahrhundert entstanden, diese frühe Tradition noch am deutlichsten (Kat. 70, 71, 72, 73). Maria Sybilla

interessierte sich nicht nur als Künstlerin für seltene Pflanzen und Insekten, sie erforschte sie auch. Bei ihrem Aufenthalt in Surinam dokumentierte sie die einheimische Flora und Insektenwelt in Zeichnungen, die später teilweise in Kupfer gestochen wurden und in dieser Weise Verbreitung fanden. Ihr Vater Matthäus Merian d.Ä. war der Schwiegersohn des Stechers und Verlegers Johann Theodor de Bry, der um 1600 in Frankfurt im Kreis von Hoefnagel und Georg Flegel verkehrte.

Es gab kunstvolle Blumenbücher, speziell Tulpenbücher, die unterschiedliche Funktionen erfüllten. Die Alben, gebunden oder aus losen Blättern bestehend, dienten Blumen- und Kunstliebhabern zur Dokumentation ihrer Sammlung, entstanden als Sammelobjekt per se oder waren als aufwendige Verkaufskataloge vorgesehen. Die grazilen Pflanzenportraits von Pieter Withoos (Kat. 74, 75) gehören dieser letzten Kategorie an.

Blumenstilleben waren beliebt und gefragt, wie aus den Einträgen in zeitgenössischen Inventaren sowie aus der noch vorhandenen Anzahl der Bilder mit diesem Thema zu schließen ist. Die hier ausgestellten gezeichneten Stilleben von Jan van Huysum (Kat. 67, 68, 69), die alle wohl nach 1700 entstanden, sind weniger als Vorzeichnungen für Gemälde zu betrachten, sondern als bravouröse Studien, als kompositionelle Variationen zum Thema Stilleben. In dieser Spätzeit werden Fülle und Reichtum der Flora weniger durch Artenvielfalt dokumentiert als durch die spielerische Anordnung verschiedenster üppiger Formen. Unterschwellig bleibt auch bei diesen Stilleben immer – neben der Vielfalt der Schöpfung und des Schöpfers Lob – der Gedanke an die Vergänglichkeit aller irdischen Schönheit bestehen.

V. Figuren und Genre

Einen wichtigen Stellenwert innerhalb der holländischen Zeichenkunst des 17. Jahrhunderts nehmen die Figurenzeichnungen und Genreszenen ein.[12] Abraham Bloemaert hat Haltung, Kleidung und Gestik von einfachen Bauern in Studien nach der Natur festgehalten (Kat. 83) und beweist seinen Blick für die charakteristische Körperhaltung junger und alter Menschen bei ihrer Arbeit. Der etwa der gleichen Generation angehörende Hendrick Avercamp machte Studien von winterlich gekleideten Städtern auf der Eisfläche (Kat. 77) und von Fischern am Strand (Kat. 78). Seine zart lavierten Kompositionen sind zwar als eigenständige, anekdotisch erzählende Zeichnungen konzipiert, sie können aber auch in Avercamps volkreichen Gemälden Aufnahme finden. Als völlig autonome Zeichnung gilt die absonderliche Szene Gnadenstoß von Esaias van de Velde (Kat. 92), wo nach der Schlacht zu Wasser die Verwundeten vom Gegner in die Tiefe gestoßen werden. Nach dem Ende des Zwölfjährigen Waffenstillstandes im Jahr 1621 wurden vermehrt Scharmützel, Reiter- und Seegefechte und andere Soldatenszenen ins Repertoire aufgenommen. Dagegen verbildlicht Esaias van de Veldes Musizierende Gesellschaft (Kat. 93) ein Thema, das in Gemälden besonders in Haarlem zur Entfaltung kam. Als „Konversationsstück" möchte es nicht nur erzählen und amüsieren, sondern auch erbauen, und kann zudem als ermahnender Hinweis auf das Laster der Unmäßigkeit auf vielerlei Gebieten gesehen werden.[13]

Figurengruppen wie die Soldaten auf einer Zeichnung von Willem van de Velde d. Ä. (Kat. 94) waren bei Bedarf gesamthaft in Gemälden einsetzbar oder man übernahm einzelne Gestalten aus ihnen. Die Gruppe ist häufig dichtgedrängt und klar umrissen gezeichnet. Derartige Figurenzeichnungen hatten die Funktion von Musterblättern. Auch Simon de Vliegers Fischer (Kat. 95) zeigen eine versatzstückhafte Geschlossenheit; ihre Gruppe ist aufgebaut aus einzelnen typisierten Figuren aus der Welt der Fischer: ein alter Mann, der einen großen Fisch hinter dem Kiemen hält, ein Fischer, der einen Fisch ausnimmt, Frau und Kind mit Körben.

Hendrick Goltzius' Schüler Jacques de Gheyn II. zeichnete eine Serie von Soldaten, die mit unterschiedlichen Waffen hantieren (Kat. 85). Die detailliert gezeichnete Folge bildete die Vorlage für die Illustrationen zu einem Handbuch über den Gebrauch der Waffen für Infanterie und Kavallerie, das de Gheyn im Auftrag von Graf Jan von Nassau gegen 1600 erstellte. In die Spuren seines Lehrers Goltzius trat auch Jan Harmensz. Muller bei dem Portrait eines Mannes mit phrygischer Mütze (Kat. 90). Jan de Bray zeichnete im März 1655 ein einfühlsames Portrait seines jüngeren Bruders Dirck (Kat. 84), in dem er an die Hell-

12 Zur Figurenzeichnung: Peter Schatborn, Dutch Figure Drawings from the Seventeenth Century. Den Haag 1981.

13 Seit der Ausstellung Amsterdam 1976, Tot Lering en Vermaak, Betekenissen van Hollandse genrevoorstellingen uit de Zeventiende Eeuw, ist die Literatur zu der ermahnenden Funktion der Genredarstellung umfangreich.

dunkel-Technik der Malerei der Rembrandt-Schule anschließt. Die Portraitmalerei in ihren verschiedenen Ausprägungen (Einzel- oder Gruppenbildnis) gehörte in den Nördlichen Niederlanden zu den bedeutendsten Auftragsbereichen der Maler.

Studienblätter, die in kondensierter Form Perfektion zeigen, wurden Liebhaberstücke und gesuchte Sammelobjekte: zum Beispiel *Rückenansicht eines Reiters* von Jan Asselijn (Kat. 76) und Dirck Hals' *Geigenspieler* (Kat. 87). Das farbige Papier der beiden Zeichnungen ermöglichte bei Weißhöhungen stärkere Licht- und Schattenkontraste, wodurch sie noch malerischer wirken.

VI. Religiöse Darstellungen

Die religiösen Darstellungen beschränken sich in den protestantischen Städten der Provinzen Holland und Seeland fast ausschließlich auf biblische Themen. Da in den calvinistischen Kirchen – in strenger Befolgung des Zweiten Gebotes – jegliches Kultbild verboten war, wurden Gemälde nur für die private Andacht geschaffen und entsprechend kleinformatiger als Altarbilder ausgeführt. Doch waren auch diese Provinzen nicht rein calvinistisch gesinnt, und der Calvinismus wurde nie zur Staatsreligion, wie es bei der Anglikanischen Kirche in England der Fall war.[14] Innerhalb der Vereinigten Provinzen war das Bistum Utrecht dagegen Bollwerk des Katholizismus, zuerst geleitet von der Nuntiatur in Köln, später von Brüssel. Die Stadt Utrecht hatte im 17. Jahrhundert mehr katholische als protestantische Einwohner.[15] Auch hier gibt es aber mehr Kultgegenstände für den privaten Gebrauch als momumentale religiöse Malerei.

Die religiöse Historienmalerei befaßt sich hauptsächlich mit Szenen des Alten und des Neuen Testamentes. Die Geschichte der Heiligen und Märtyrer fehlt nahezu ganz bei jenen Malern, die in erster Linie für protestantische Auftraggeber tätig waren. Propheten und alttestamentarische Helden treten gleichsam an ihre Stelle. Obwohl sie im späten 16. und im 17. Jahrhundert auch in anderen Orten thematisiert wurde, florierte die Darstellung biblischer Szenen am meisten in Amsterdam zur Zeit Rembrandts. Einen großen Einfluß hatte Rembrandt als Schöpfer und Vermittler einer neuen Auffassung der biblischen Geschichten, indem er sie nicht nur als Ausdruck bestimmter Glaubensinhalte, sondern auch als archetypischen Ausdruck bestimmter Affekte darstellte.

Unter den biblischen Darstellungen finden sich im Vergleich zur älteren Kunst wesentlich mehr alttestamentarische.[16] Die Vorliebe für sie hat verschiedene Gründe. Der Protestantismus berief sich auf den „Urtext", auf die Quellen. Der Text der Bibel war seit der Mitte des 16. Jahrhunderts durch neue Übersetzungen für Angehörige aller Gesellschaftsschichten ohne Vermittlung zugänglich, und seit 1637 gab es die amtliche „Statenbijbel". Die Bibel stand in nahezu jedem Haushalt und wurde bei der gemeinsamen Mahlzeit gelesen. Man kannte den Text somit wesentlich besser und hatte zu ihm ein anderes Verhältnis. Das Interesse für bisher nicht dargestellte alttestamentarische Szenen erforderte eine neue Ikonographie für ihre Wiedergabe. Andere Szenen des Alten Testamentes waren in der *Biblia Pauperum*, im *Speculum Humanae Salvationis* und in ähnlichen Werken bereits gestaltet. Dabei wurden die alttestamentarischen Erzählungen als Vorabspiegelung, als Präfiguration der neutestamentarischen Geschehnisse gesehen und in Stichreihen als Exempel beispielhaften Benehmens didaktisch eingesetzt. Darüber hinaus zogen die abtrünnigen Provinzen in ihrem Kampf gegen die Großmacht Habsburg eine Parallele zu dem bedrängten Volk Israel, das dank Gottes Schutz gerettet wurde, und stellten so alttestamentarische Ereignisse in einen zeitgenössischen politischen Kontext[17]: Das Alte Testament wurde gleichsam als Chronik eines Volkes interpretiert, das dazu auserwählt war, durch seinen Kampf und Sieg Gottes Licht zu verbreiten.[18] Die Geschichte der Juden wurde zur Rechtfertigung der eigenen Handlungsweise herangezogen.[19] Dazu kommt, daß einzelne alttestamentarische Helden durchaus allgemeine christlich-philosophische Aussagen verkörpern konnten.

Die alttestamentarische Malerei konzentrierte sich in Amsterdam und wird als eine Errungenschaft der Prä-Rembrandtisten betrachtet.[20] Allerdings hatte die Darstellung *Abraham und die drei Männer im Hain von Mamre* (Genesis 18, 1–16) von Hoogstraten (Kat. 100) im 17. Jahrhundert bereits eine längere Bildtradition. Die intime Atmosphäre machte diese Mahlzeit bei alten Leuten, die im Freien in einer idyllisch-ländlichen Umge-

14 Zur Religion im 17. Jahrhundert: Ausstellungskatalog Utrecht 1979, *De kogel door de kerk. De Opstand in de Nederlanden en de rol van de Unie van Utrecht 1559–1609*, S. 176 ff.; Ausstellungskatalog Utrecht 1986, *De eeuw van de Beeldenstorm. Ketters en Papen onder Filips II.*

15 Paul Huys Janssen, *Schilders in Utrecht 1600–1700*. Utrecht 1990, S. 22.

16 Zu den alttestamentarischen Darstellungen vor allem: Ausstellungskatalog Amsterdam 1991, *Het Oude Testament in de Schilderkunst van de Gouden Eeuw* (Christian Tümpel u.a., mit Lit.); Volker Manuth, Denomination and Iconography: the Choice of Subject Matter in the Biblical Painting of the Rembrandt Circle. *Simiolus 22*, 1993/94, S. 235 ff.

17 Siehe auch Ausstellungskatalog Amsterdam 1991, S. 146 ff.

18 Simon Schama, *The Embarrassment of Riches. An Interpretation of Dutch Culture in the Golden Age*. Berkeley/Los Angeles/London 1988, S. 68.

19 H. van de Waal, *Drie eeuwen Vaderlandsche Geschied-Uitbeelding 1500–1800. Een iconologische studie*, Bd. 1. Den Haag 1952, S. 22 ff.; vgl. Schama 1988, S. 93 ff.

20 Ausstellungskatalog Amsterdam 1991, S. 11.

bung stattfindet, zu einem beliebten Thema in der Graphik, und die Bibelillustrationen von Tobias Stimmer und Matthäus Merian wirken in Hoogstratens Zeichnung noch nach.

Der von Rembrandt beeinflußte, mit ihm etwa gleichaltrige Moeyaert zeichnete *Jakobs Kampf mit dem Engel* (Genesis 32, 22–32), ein relativ selten dargestelltes Thema (Kat. 103).[21] Jakob wird zur Verkörperung des Menschen schlechthin, den Gott stählt, indem er ihn auf die Probe stellt. In Nicolaes Maes' *Joseph erzählt seine Träume* (Kat. 102, Genesis 37), ein Thema, das in Rembrandts Umkreis beliebt war und oftmals aufgegriffen wurde, verrät sich die Rembrandt-Schule durch die Wiedergabe der emotionalen Beziehungen zwischen den drei Protagonisten: Dem nachdenklichen alten Vater und der aufmerksam lauschenden Mutter (die anachronistisch die Bibel auf dem Schoß hält, ein Motiv von Rembrandts Radierung des gleichen Themas aus dem Jahr 1638, Münz 175) erzählt Joseph, naiv und selbstbewußt, den Traum, der seine ihm feindlich gesinnten Brüder in Wut bringen wird.[22] Die Joseph-Geschichte spielte nicht nur in Rembrandts Kunst, sondern auch in der holländischen Literatur dieser Zeit eine Rolle. Möglicherweise ist Joseph als Prototyp des umsichtigen Führers anzusehen, der sein Land sicher und unter Gottes Schutz aus dem Verderben in die Freiheit führen soll, ähnlich wie es als Pflicht des Statthalters oder des Rats der Stadt angesehen wurde.[23]

Bei Moeyaerts Darstellung des Dulders *Hiob* (Kat. 104) steht dessen Fähigkeit, Leiden zu ertragen, im Mittelpunkt. „Patientia", die diese alttestamentarische Gestalt als Exemplum vorführt, galt als eine der Haupttugenden des stoischen Weisen. Widrigkeiten mit innerer Ruhe und unerschütterlich zu erdulden war ein Ideal, das in den Niederlanden, im Süden wie im Norden, unter dem Einfluß der Schriften von Seneca und Cicero durch Gelehrte wie Justus Lipsius im Lateinischen und durch Dirck Volkertsz. Coornhert in der Volkssprache seit dem späten 16. Jahrhundert Anhänger gefunden hatte. Hiobs Leidensfähigkeit setzte sein Wissen um den höheren Sinn seines Leidens und sein Vertrauen in Gott voraus – ein Grund, weshalb Hiob außerdem als eine Präfiguration Christi gesehen werden konnte.

Leonaert Bramer gestaltete in der *Himmelfahrt des Elija* (Kat. 98, 2 Könige 2, 11–12) durch Helldunkeleffekte kongenial die in der Bibel geschilderte Szene. Die Propheten Elija und Elisa wurden jäh getrennt, als vom Himmel „ein feuriger Wagen mit feurigen Rossen" kam und Elija im Wetter gen Himmel fuhr. Elija wurde in der *Biblia Pauperum* als eine Präfiguration Christi betrachtet, seine Himmelfahrt als Gleichnis für den Tod Christi, der im Gewitter am Kreuz verschied.

Simeon im Tempel mit dem Christuskind, gezeichnet von Bloemaert (Kat. 97), verbindet durch seinen Lobgesang („Herr, nun lässest du deinen Diener im Frieden fahren", Lukas 2, 29) das Alte mit dem Neuen Testament. In dieser Szene ist Gottes Erlösungsversprechen eingelöst, der Alte Bund sieht nun seine Hoffnung im durch Christus verkörperten Neuen Bund erfüllt. Die Vorliebe der Manieristen für das vom Leben gezeichnete Antlitz alter Menschen, die man auch in der Kunst des jungen Rembrandt sieht, ist in die eindrucksvolle Figur von Simeon eingegangen. Das Blatt entstand als Vorzeichnung für einen malerisch wirkenden Kupferstich.[24]

Auch in den Darstellungen des Neuen Testamentes erzeugt der direkte, persönliche Bezug zur biblischen Geschichte eine eigene holländisch-protestantische Ikonographie. Auch wenn sich Rembrandt graphischer Vorlagen bediente, schuf er – und der von ihm beeinflußte Kreis – aus der herkömmlichen Ikonographie neutestamentarischer Szenen etwas völlig Neues. Traditioneller ist noch die kunstvolle Komposition *Anbetung der Hirten* (Kat. 101) von Rembrandts Lehrer Pieter Lastman, die er nach einem Gemälde von Paolo Veronese fertigte. Rembrandt dagegen konzentriert sich auf die Emotionen, die ein Geschehen bei den Figuren auslöst, und verbildlicht deren innere Bewegtheit. Damit entfernt er sich oft stark von den gängigen Bildformeln, wie in *Schlafende Hl. Familie mit den Engeln, die Joseph im Traum erscheinen* (Kat. 107). Es hat schon die Zeitgenossen berührt, wie zeitgemäß, nahe und intim Rembrandt seine Darstellungen des Neuen Testamentes formulierte, so, als fände das Geschehen „hier und jetzt" statt. Die Mutter, die in der Wärme des Kaminfeuers eingeschlafen ist, erfährt nichts von dem, was dem Vater erscheint, der sich im Schlaf träumend bewegt hat. Rembrandt durchbricht die Bildtradition der religiösen Historienmalerei und erweckt im Betrachter das Gefühl eindringlicher Nähe, indem dieser alltägliche Situa-

21 Ausstellungskatalog Amsterdam 1991, S. 40 und Nr. 13.

22 Ausstellungskatalog Amsterdam 1991, S. 41, Abb. 35.

23 Vgl. van de Waal 1952, S. 216.

24 Crispijn de Passe d. Ä., F. 249; Hollstein 16 ad.

tionen wiedererkennt. Mehr noch als für die Gemälde gilt das für Rembrandts Zeichnungen und Radierungen. Das Wörtlich-Nehmen des Bibeltextes spricht auch aus Rembrandts bildhaft komponiertem *Mahl zu Emmaus* (Kat. 106). Die einfachen Wanderer sind bei Einbruch der Dunkelheit eingekehrt und in ein Gespräch mit dem Fremden, der sie begleitet hat, über Jesus' Kreuzestod verwickelt. Als er das Brot bricht, erkennen sie ihn, und „er verschwand vor ihnen" (Lukas 24, 31). Die Gestalt von Jesus, dem „Licht der Welt", löst sich vor ihren Augen in Licht auf. Während Jesus in Rembrandts Gemälden der gleichen Szene stets körperhaft anwesend und durch starkes Gegenlicht verklärt ist, wagt Rembrandt in seinem graphischen Werk eine ungewöhnlichere Darstellungsweise.

Rembrandts Zeichnungen und Radierungen sollten im 18. Jahrhundert zu beliebten Sammelobjekten werden. Auch seine Erneuerung der biblischen Ikonographie wirkte weit über das 17. Jahrhundert hinaus.

Thea Vignau-Wilberg
Konservatorin der Niederländischen Zeichnungen und Druckgraphik
Staatliche Graphische Sammlung München

THE PICTORIAL WORLD OF DUTCH ART
IN THE SEVENTEENTH CENTURY

1 As reported by John Evelyn in 1641, cited after Hanns Floerke, *Die Formen des Kunsthandels, das Atelier und die Sammler in den Niederlanden vom 15.–18. Jahrhundert*, Munich, Leipzig, 1905, p. 20. On the economic aspects, see the recent publication by Marten Jan Bok, *De sociaal-economische benadering van de Nederlandse zeventiende-eeuwse schilderkunst*, *De Gouden Eeuw in Perspectief. Het beeld van de Nederlandse zeventiende-eeuwse schilderkunst in later tijd*, ed. Frans Grijzenhout and Henk van Veen, Heerlen, 1992, pp. 330ff.

2 Johan van Gool, *De Nieuwe Schouburg der Nederlantsche kunstschilders en schilderessen*, vol. 1, The Hague, 1750, pp. 2–3.

3 Hans-Ulrich Beck, *Jan van Goyen 1596–1656. Ein Œuvreverzeichnis*, vol. 1, Amsterdam, 1972, nos. 195–557e.

4 Roger de Piles, *Abrégé de la vie des peintres, avec des réflexions sur leurs ouvrages, et un traité du peintre parfait, de la connaissance des dessins, et de l'utilité des estampes*, Paris, 1699, p. 66.

5 On the aristocracy, see Michael North, *Kunst und Kommerz im Goldenen Zeitalter. Zur Sozialgeschichte der niederländischen Malerei des 17. Jahrhunderts*, Cologne, 1992, pp. 55 ff.

From the moment that foreign travellers began extensive educational tours of the continent, the scale of art production in the Netherlands during the seventeenth century, and the wide distribution of art objects, particularly in the form of drawings, prints and paintings, was a matter of astonishment to them.[1] There was an awareness that the scale of the production of Dutch art was extraordinary even in its homeland as early as the eighteenth century: 'Just as no other country in Europe can match our blessed Netherlands in the breeding of famous men, so equally the land has been particularly fruitful in bringing forth painters of renown. As the numerous works in the most famed art collections of Europe prove, the country – taking its small size into consideration – has surpassed every other state in Europe.'[2]

The facts are even more eloquent than such sentiments of national pride, however. It has often been noted that people of varying social classes bought paintings, in every possible price range. Pictures might become a means of payment; they were used as articles of export – particularly to England; and even as objects of speculation. By the seventeenth century painters no longer worked exclusively for a patron or a single client, but usually for the free art market, which they supplied either directly or through an art dealer. Paintings were available to purchasers at selling exhibitions organized by the guild of painters and at fairs. Working for the market both demanded and encouraged specialization and a division of labour among the painters.

Drawings were produced for the free market less often than paintings. What appears to be a production-line of landscape drawings developed by Jan van Goyen during the 1650s,[3] for example, should be seen as an exception based on economic necessity rather than as the norm. Some of the drawings exhibited here represent the 'inventio', the 'prima idea' for a composition (cf. no. 103). Roger de Piles describes them as 'les pensées que les Peintres expriment ordinairement sur du papier pour l'exécution d'un ouvrage qu'ils méditent'.[4] Amongst connoisseurs, these drawings sometimes were rated higher than the finished paintings dependent on them. Some of the drawings were created as independent, autonomous works of art – mostly for the market (cf. nos. 6, 45, 86, 92); some were studies, often made directly from the object, for subsequent use in finished compositions, usually paintings (cf. nos. 53, 63, 79, 88).

The culture of the United Provinces during the seventeenth century was primarily an urban, bourgeois one, and those commissioning and purchasing paintings and drawings were for the most part wealthy citizens and civic institutions, like military regiments, town magistrates and guilds. In the larger towns during the seventeenth century, a ruling patrician élite developed from the burgher class, and from the merchant class, in particular, there emerged a bourgeois, moneyed aristocracy. At the same time, the old aristocracy,[5] centred on the Stadtholder's court (Frederick Henry 1625–1647, William III 1672–1702), acquired even greater influence on the fine arts and their subject matter – initially mostly with Flemish painters, but later also with artists from Utrecht. This development was based on the example of the courts of France and Britain.

The subject matter of Dutch painting is worth considering. The nineteenth century contemporary of the French Impressionists, Eugène Fromentin, who produced a sympathetic account of painting in the Netherlands, and particularly of Dutch painting, in his *Les Maîtres d'autrefois*, published in 1875, placed Dutch art in its European context, remarking that it had a 'complete lack of what today we call a "sujet"'. Because the pictorial world of Dutch painting is completely unspectacular, very few of the objects chosen were then (1875) considered 'worthy of depiction'. In a period that was marked by military enterprises that were ultimately to lead to the separation of the Seven United Provinces from the Habsburg Empire, and by border skirmishes and religious conflicts approaching the scale of civil

war within the country itself, one might have expected a much more martial, less pacific, iconography in the country's fine arts. History painting, to which, in the scale of thematic genres, the highest value was attached in seventeenth-century Holland, was not, however, the most popular topic. Measured by international standards, some of the history paintings – be they biblical, mythological, or allegorical – produced by artists in the Northern Netherlands are rather unheroic and bourgeois in style. It was only as the seventeenth century neared its close, during the stadtholdership of William III (1672–1702), who was simultaneously King of Great Britain (1689–1702), that painters in the Netherlands caught up with the thematic content and artistic fashions of the international style of the French court. What, however, emerges from reading the inventories of Rembrandt's time, in spite of the predominant and officially permanent state of war, is that paintings obviously show a predilection for subjects which are tranquil, serene, light-hearted or trivial: 'een harderinnetje' (a shepherdess); 'een oude vrou's tronie' (an old woman's face); 'een wintertge' (a winter landscape); 'een maneschijntje' (a moonlight landscape); 'een boerekermis' (a country fair); 'een blompotje' (a pot of flowers); 'een kint in de kackstoel' (a child on a closestool); 'een lantschap' (a landscape); 'een cleyn stuckie met schepen' (a small sea-piece). To judge by the diminutive forms used in many of these descriptions, a characteristic of these paintings is that their format was small. This smallness of size and the type of subject matter, typical of 'cabinet pictures', is what differentiates the Dutch school fundamentally from the French and Italian painters of this period.

The content of Dutch paintings, always noted as being different from that of the art of the rest of Europe, was based, according to Fromentin, on what ordinary people wanted: 'It was a population of town dwellers, practical people, not particularly imaginative, extremely busy, with no mystical tendencies whatsoever, anti-latin, whose traditions had been disrupted, whose religion had no images, and who were habitually thrifty. What had to be found was a form of art that would appeal to them, one that was comprehensible and appropriate to them, and would provide an illustration of their style of living... Dutch painting, it was soon realized, could only be a portrait of Holland, an external, accurate, exact, complete image, with no embellishment. A portrait of the people and their towns, of the citizens' customs, of the squares, the streets, the flat countryside, the sea, and the sky – traced back to its simplest elements, this had to be the programme that the Dutch school proffered. And so indeed it proved, from its very first day until its decline.'[6]

Although Fromentin, a painter himself, was equally concerned with 'painterly values' and with the harmony of the colouring in Dutch painting, he analyses the particular quality of Dutch art as the realism of its depiction of everyday life. The question of the extent to which the everyday life, landscapes and still-lifes depicted genuinely reflect the everyday life of the time, has preoccupied several generations of subsequent art historians.[7] At the end of the nineteenth century, the view prevailed that Dutch seventeenth-century paintings, in general, and genre scenes, in particular, were portrayals of reality. Subsequently, stylistic critical criteria became the starting-point for the examination of paintings; and, after the first quarter of the twentieth century, the approach changed again under the influence of Aby Warburg and his circle. The scenes now were recognized as being realistic, but they were also placed in their context within cultural history and considered as conveyors of meaning, as a means of making a statement that would transcend what was actually depicted. Later still, there was a reaction to the growing tendency in this approach to see the image primarily as being a pictorial enigma, and to the dangers of reading too much into a picture and over-interpreting it. These reactions were reflected in a contrasting approach to art whose leading exponent is Svetlana Alpers (The Art of Describing, 1983).[8] Alpers sees the painting of the Northern Netherlands – in contrast to the narrative art of the Southern Netherlands and Italy – as being primarily a form of art that uses the brush to register and record what the eye discovers. Alpers does, however, allow recognition of the contributions made by the Warburg and Panofsky schools in certain specific areas.

The confrontation between these two approaches led to lively controversies during the 1980s. The extent to which the two parties' views clashed can perhaps best be understood by references to the past: once again, as in the Early Modern period, a controversy was being

6 Eugène Fromentin, *Les Maîtres d'autrefois. Belgique – Hollande*, Basel, 1947, p. 149.

7 A good overview of this problematic area, with essays by various authors, is provided in Grijzenhout and van Veen's *De Gouden Eeuw in Perspectief* (footnote 1 above).

8 Svetlana Alpers, *The Art of Describing: Dutch Art in the Seventeenth Century*, Chicago, 1983.

fought out between two groups of scholars, each of whose views was rooted in a different philosophical tradition. In the fifteenth and sixteenth centuries, it was the (neo-)Platonists, on the one hand, who viewed what manifests itself to the eye as being an epistemological means of discovering an archetype; while on the other hand, the Aristotelians – to put it rather simply – saw each form primarily as being an object capable of being outlined by sensory impressions, e.g. through the sense of touch or the sense of sight, without any consideration needing to be given to the dualism between the idea and the real object. Supporters of each of these views continued the polemic throughout the sixteenth century. The humanists of this period, however, were well aware of the significance of the epistemology which had become accessible again through new translations of Aristotle, and they sought to reconcile the two differing views under debate and raise them to a new synthesis. It is in the critical writings of Constantijn Huyghens the E. (1596–1687), an admirer of contemporary painting, whom Alpers, however, considers as a champion of the new approach of the Northern Netherlands, that the ideal embodiment of this type of synthesis can be seen. A fact which, considering that he had connections on his mother's side which were exclusively Flemish and his own education was profoundly humanist, is all the more remarkable.

I. Dutch Landscapes: Town and Country

For city dwellers, the view of the city, in all its variations, is an obvious candidate for depiction.[9] In the Netherlands, the city-view developed to become an artistic genre in its own right. In Berckheyde's *Gateway of the White Ladies at Utrecht* (no. 1) and Herman Saftleven's *On the Ramparts of Utrecht* (no. 26) the city is shown within its protective ramparts, walls, and city gates. Abraham Bloemaert's *Kitchen Quarters at the Side of a House* (no. 3), probably also drawn in Utrecht, shows interlocking blocks of building extensions in a back courtyard. The dilapidated shapes are abstracted to form surfaces whose mingling colours glow in a painterly manner. As Saftleven shows in the way he composes the *Old House at Hoge Zwaluwe* (no. 23) his interest is not just topographical, but bears in mind pictorial possibilities as well.

Before landscape painting as such developed in Holland the country, and in particular Amsterdam, already had become a centre for cartography.[10] A strong interest in topographical elements manifests itself in depictions of Dutch landscape. The towns that appear on the horizon in the broad panoramic landscapes favoured by the Dutch, however, are often 'realistic' only in their most striking details. Architectural monuments are arranged with a view to compositional merit rather than with a strict attention to topographical verisimilitude. In these the light and shade created by the sun and clouds in an expansive sky is balanced by a broad panorama of flat countryside, often criss-crossed by waterways. Examples of this type are Eeckhout's *Distant View of a Dutch Town* (no. 6), Furnerius's *Amsterdam in the Fog* (no. 8), and Saftleven's *Panoramic View near Wageningen* (no. 25). In comparison with these panoramas, Aelbert Cuyp's rare dune landscape *Lighthouse at Egmont on Sea* (no. 5) has a contrary effect, as the buildings are here prominent in the foreground, whilst the sea extends to an infinite distance in the background.

The town dweller's eye delights in country life, and drawings record the spaciousness of natural roads, which are in stark contrast to the narrowness of city alleyways (Esaias van de Velde, *A Village Bonfire*, no. 28; *A Village Street with a Church*, no. 27). Dilapidated old sheds and farmhouses (Rembrandt, no. 18; van de Velde, no. 29) suggest the pointlessness of human strivings. By contrast, Rutgers's fortress-like farmhouse with working quarters (no. 22), radiates a sense of security. Work in the fields inspired the same artist to create a piece full of harmony, rhythm, and human order (*Cornfield*, no. 21).

Loosely drawn, but pictorially composed, landscapes of rivers in summer, typical of the paintings of Salomon van Ruysdael and others, also developed in graphic art. An example showing figures working in fishing boats by Jan van Goyen (no. 13) hints at housing on the banks of the river; there is apparent a cheerful bustle, never hectic, which is the quintessence of an ideal Dutch landscape.

Forest scenes were produced as a kind of counterpart to urban landscape; in these atmosphere and mood are conveyed primarily by the trees (Jan Lievens, no. 15; Pijnacker, no. 17;

9 The basic work is still Wolfgang Stechow, *Dutch Landscape Painting of the Seventeenth Century*, Oxford, 1966.

10 Alpers emphasizes this aspect in her book, pp. 119 ff., as 'The Mapping Impulse in Dutch Art'.

Simon de Vlieger, no. 31; Waterloo, nos. 32, 34). Sunlight is caught by the trunks and in the foliage; it is filtered and reflected. Coloured or tinted paper can be used to enhance the pictorial effects of the work.

II. Dutch Artists Abroad

As was noted above, the documentation of the characteristic forms or location of a town have always played an important part in the realistic depiction of landscape. Even in the sixteenth century, Netherlanders travelling abroad recorded noteworthy towns embedded in the landscape in their drawings. These were often made to serve as sketches for prints and for publication, as in the *Civitates Orbis Terrarum*, a work in several volumes produced by Georg Braun and Frans Hogenberg. Dutchmen regularly travelled abroad, Jacob Esselens and Lambert Doomer both visited England, France, and Italy. Esselens, a merchant who probably went to England on business, made cartographically accurate sketches of the country's coastal landscape, *View of Dover* (no. 41) and *Rye from Point Hill* (no. 42) are examples. Doomer's atmospheric wash drawing of the *Winepress of Monsieur Dittyl, Outside Nantes* (no. 40), which he produced from sketches after he had returned to Holland from Nantes in 1646, is a recollection of his journey to France.

On his trip to Scandinavia during the 1640s, Allaert van Everdingen stayed in Norway for a time, and discovered the country's untouched natural scenery, which he developed as an artistic motif. The way in which he incorporated this into his pictorial repertoire is, in a sense, a consistent further development of the rocky Mannerist landscapes of his first teacher, Roelandt Savery, and forms a link with the thunder-laden atmospheres dear to landscapists of the mid-seventeenth century (*Rocky Landscape with Two Bridges*, no. 43).

The country that most stimulated the artists' creative imagination was Italy. On the 'grand tour', an educational journey through the continent made by the gentry, works of Antiquity and of the modern period were studied in various cultural centres. The landscape actually observed during the journey might be recorded in sketches (Jan Asselijn, *Landscape with a Castle and Buildings on an Outcrop Beside a River*, no. 37), or scenes documented in sketches might be imitated freely and worked up into finished compositions once the traveller had returned home (Jan Lapp, *Mountainous Italianate Landscape*, no. 44). Many roads lead to Rome; the most frequented of them at that time was via Venice. A free compilation of various favourite Venetian buildings, equipped with a staffage of gondolas and trading vessels, is shown by Abraham Storck in his *Venetian Capriccio* (no. 45). Other Italian caprices, consisting of motifs whose picturesquely ruinous condition simultaneously suggests the transience of all earthly existence, are seen in Jacob van der Ulft's *Italianate Landscape with Ruined Buildings* (no. 46) and Jan Worst's *Ruins of the Colosseum* (no. 48). By contrast, Jan Asselijn's *Arch of Constantine* in Rome (no. 36) is not only a picturesque monument, but also a document of archaeological importance.

Once the traveller had returned home, the experience of Italy was reflected for the most part in atmospheric pastorals; ideal landscapes whose light-flooded, rolling, hilly landscapes are populated by an Arcadian shepherd people, as exemplified in the drawings of Nicolaes Berchem (nos. 38 and 39) and Thomas Wyck (no. 49). This 'Italianizing' landscape was valued at least as highly in the Netherlands as landscapes with motifs from the artists' native country. In the course of the seventeenth century pictorial motifs and compositions of this sort created a tradition that was to be influential until the nineteenth century, notable in the art of Germans working in Rome.

III. Seascapes

The broad range of sea pictures[11] stretches from the temperamentally vibrant line drawings, often executed in pen and ink, of the early seventeenth century, seen in the work of Cornelis Claesz. van Wieringen (no. 61), to the contemplative images, atmospherically and compositionally calculated of Ludolf Backhuizen (no. 51), drawn at the turn of the eighteenth century, showing a glassy, almost motionless sea. Inhabitants of the Northern Netherlands have always had a very close relationship to the element of water, particularly

11 Studies of early marine painting: M. Russell, *Visions of the Sea: Hendrick C. Vroom and the Origins of Dutch Marine Painting*, Leiden, 1983. General: Laurens J. Bol, *Die Holländische Marinemalerei des 17. Jahrhunderts*, Braunschweig, 1973; George S. Keyes, *Mirror of Empire: Dutch Marine Art of the Seventeenth Century*, Exhib. Cat., Minneapolis/Toledo/Los Angeles, 1990/91.

because, even in the seventeenth century, part of the country existed only thanks to the protection of dikes. While the agitated line used to define sea and ships in the work of van Wieringen and in the early drawings of Simon de Vlieger (no. 59) gives the impression that man is a plaything of the elements, Hendrick Cornelisz. Vroom's quiet, clear drawing of *Elsinore* (no. 60) shows by contrast an ordered 'sea lane' in which trading ships regularly ply their way. The province of Holland, and Amsterdam in particular, at this period enjoyed a virtual monopoly in the world's sea trade. Holland also held an important position as a power in the fishing industry.

The drawing that Claes Jansz. Visscher made, inspired by an engraving by Jacques de Gheyn, *The Landyachts of Prince Maurice of Nassau on the Beach at Scheveningen* (no. 58), reflects a topical event. Current events are also recorded regularly in the paintings and drawings of Willem van de Velde the Elder and Younger (father and son), and often these were commissioned works. Their depictions of marine events record, in a journalistic fashion, embarkations and disembarkations, landings, and sea battles. The extreme oblong format required by the subject matter made it possible to depict many events simultaneously. The eye wanders from left to right (*Mary of Modena Embarking at Gravesend*, no. 56). Whilst the two van de Veldes produced studies for the portrayal of individual ships accurate to the last detail, in the disposition of the boats on the paper they exercized some artistic license – the overall composition was the determining factor. Particularly in the work of the van de Velde the Younger, depictions of ships on the high seas, or in quieter coastal and river waters, are often shown as sunny, atmospheric pictures rather than as traditional seascapes.

A group of its own is formed by the detailed studies made for marine pieces, examples of which are the ship studies of Abraham Casembroot (nos. 52, 53), and, even more so, the large scale minutely documented portraits of ships produced by the two van de Veldes, which display their precise knowledge of ship construction (nos. 54, 55). Such pictures presuppose a familiarity with shipbuilding and navigation, and they were produced on location, either from a ship or from a model for it.

IV. Animals and Flowers

The natural environment, with its plants and animals, is approached with a sharp eye. The horse as Nag, as draught horse or working animal, is captured impressively by Abraham Bloemaert (no. 62). His drawing also shows the fascination with surface structure that is characteristic of Dutch artists around 1600. The rise and fall of muscle and tissue is created through line in this drawing no less well than in portraits of old age from this period (cf. Bloemaert, *The Infant Christ in the Arms of Simeon*, no. 97). But the effect of the motif in Bloemaert's *Horse* has been intensified by the fact that the drawing has been cropped (probably on all sides). While Bloemaert's drawing is probably a study from nature, the horse that Aelbert Cuyp has outlined firmly, accentuating its inelegant build (no. 63), seems more likely to have been intended as a staffage figure for a painting. The same applies to the rather nobler riding or cavalry horse by the same artist, which is being led by a servant (no. 64).

The trumpeting *Elephant* by Cornelis Saftleven (no. 65) is a curiosity. It was probably drawn from the life as it does not correspond with the standardized way of representing this animal. Rembrandt also drew an elephant, which was said to have come from a travelling circus; that was in 1637 and he drew it with loose strokes of chalk. Elephants were transported from other continents to Amsterdam by ship by the West India and East India Trading Companies, and then dispatched to further destinations. Often they ended up in the menageries of various princes.

Aert Schouman's *Mallard Duck Flying over an Estuary* (no. 66), drawn in the mid-eighteenth century, has a special quality. In his watercolour, he has given the bird the natural tension of flight, and has placed it, as was his regular custom, in a large format in front of a wide river with a coastal town visible in a haze: this may depict his home town of Dordrecht. The delicate way he has captured the material effect of the feathers belongs to a tradition that is represented principally in the genre of culinary and hunting still-lifes, that of 'nature morte'– although here the bird seems to be bursting with life.

Since the exact artistic recording of plants and insects, which was raised to the status of an élite pictorial subject by the endeavours of artists as brilliant as Joris Hoefnagel and Jacques de Gheyn II around 1600, became fashionable, flowers were depicted in a wide variety of ways and for different purposes. The impressive watercolours by Maria Sybilla Merian, born in Frankfurt, show the continuation of early interest in botanical accuracy at its clearest, even though they date from late in the seventeenth century (nos. 70, 71, 72, 73). Maria Sybilla was interested not only in the rare beauty of plants and insects, she also carried out research into them. During her visit to Surinam, she recorded the local flora and insect life in drawings, some of which were later engraved and published. Her father, Matthäus Merian, was the son-in-law of the engraver and publisher Johann Theodor de Bry, who moved in the circle of Hoefnagel and Georg Flegel in Frankfurt.

Artistic floral books, and particularly tulip books, had a different function. These were albums, consisting of loose or bound sheets, drawn for lovers of flowers and of art to document their collections, or as collector's items *per se*, although they sometimes served as elaborate sales catalogues as well. The exquisite plant portraits of Pieter Withoos (nos. 74 and 75) belong to this category.

As can be seen from inventories of the period and can be deduced from the number of pictures which have survived, the floral still-life was a popular genre, much in demand. The still-life drawings of Jan van Huysum (nos. 67, 68, 69), all of which probably were produced after 1700, should be seen, not so much as preliminary sketches for later still-life paintings, but as brilliant studies, compositional variations on still-life. At this late period, wealth and abundance are documented more through the playful arrangement of luxuriant forms than the variety of rare species. Alongside the aspects of recording the variety of creation and praising the Creator in these still-lifes, an undertone always remains of the idea of the transience of all earthly beauty.

V. Figure and Genre Drawings

Figure and genre drawings[12] have an important place in seventeenth-century Dutch art. Abraham Bloemaert's drawing recording the postures, clothing, and gestures of ordinary peasants in studies from life (no. 83) documents the artist's sharp eye for characteristic physical postures of young and old people at work. Hendrick Avercamp, of almost the same generation, made studies of city dwellers in winter clothes on the ice (no. 77) and of fishermen on the beach (no. 78). His delicately washed compositions are conceived as independent, anecdotal narrative drawings; but they must have been intended as studies for the figures with which Avercamp's paintings are filled. By contrast, the ghoulish scene *The Coup de Grâce* by Esaias van de Velde (no. 92), in which the wounded are being pushed under by their enemies after a sea battle, is an independent work of art. At the end of the Twelve Year's Truce in 1621, skirmishes, cavalry battles, sea battles, as well as other military scenes return to the popular repertoire. Esaias' *Musical Party* (no. 93) contrasts in mood with these, depicting a subject that was particularly developed by painters in Haarlem. As a 'conversation piece', it attempts not only to tell a story and to amuse, but also to edify; it can be interpreted as an admonition to avoid the vice of intemperance.[13]

The arrangement of figures in groups, as with the soldiers drawn by Willem van de Velde the E. (no. 94), was useful as a resource to the artist when he needed to include figures in his paintings. Either the whole group could be used or individual figures could be taken from them at will. Groups like these often are compressed closely together and drawn with clear outlines. Drawings with sketches of random figures functioned as pattern models. Simon de Vlieger's *Fisherfolk* (no. 95) has a set-piece quality of solidity; the group is constructed from individual figures that typify the world of fishing: an old man with the large fish which he holds behind the gills, a fisherman gutting a fish, a woman and a child carrying baskets.

Hendrick Goltzius's pupil, Jacques de Gheyn II, drew a series of figures of soldiers brandishing various types of weapons (no. 85). The series, with its accurately detailed drawings, was used for the illustrations of a manual on the use of weapons for infantry and cavalry that he produced on commission for Count John of Nassau around 1600. Jan Harmensz. Muller also followed in the footsteps of his teacher, Goltzius, in his *Portrait of a Man in a Phrygian*

12 On figure drawing: Peter Schatborn, *Dutch Figure Drawings from the Seventeenth Century*, The Hague, 1981.

13 Since the 1976 Amsterdam exhibition *Tot Lering en Vermaak, Betekenissen van Hollandse genrevoorstellingen uit de Zeventiende Eeuw*, there have been extensive studies of the way in which genre depictions function as moral admonitions.

Cap (no. 90). The portrait that Jan de Bray made of his younger brother Dirck (no. 84) in march 1655 adopts the chiaroscuro techniques of Rembrandt's school, and is a sympathetic portrait of the young man. For painters in the Northern Netherlands, portraiture in its varying forms (individuals, groups) remained one of the most important fields for commissions.

Study sheets which show condensed qualities of perfection – Jan Asselijn's *Horseman Seen from Behind* (no. 76) and Dirck Hals's *Seated Man, Playing the Violin* (no. 87), for example – were much sought after as collector's items. Coloured paper made possible a greater variety of effects, giving greater and more subtle contrast to light and shade and magnifying the pictorial brilliance with the use of white heightening.

VI. Drawings with a Religious Context

In the Protestant cities of the provinces of Holland and Zeeland, religious images are restricted almost exclusively to biblical subjects. In these provinces paintings with religious themes were always intended for private meditation and, therefore, were smaller in format than paintings for altars. In Calvinist churches, any kind of religious imagery was taboo, in strict accordance with the Second Commandment. But even these two provinces were not entirely Calvinist, and Protestantism was never adopted as a State Religion, as it was in England with the Anglican Church.[14] On the contrary, in the United Provinces, the bishopric of Utrecht was a bulwark of Catholicism, ruled first by the Papal Nuncio in Cologne, and later from Brussels. In the seventeenth century, the city of Utrecht had more Catholic inhabitants than Protestant ones.[15] But even here religious paintings were produced more regularly for private use, and monumental religious pictures were unusual.

Religious history painting was concerned above all with reproducing scenes from the Old and New Testaments. The artists who worked primarily for Protestant clients eschewed the stories of Saints and Martyrs and chose tales of the Prophets and Old Testament heroes in their stead. Although Biblical subjects were part of the repertoire of artists in all parts of the Netherlands in the late sixteenth and seventeenth centuries, in Rembrandt's time they flourished most in Amsterdam. Indeed it was Rembrandt in particular who was the most significant practitioner in this field. The influence of his own fresh approach to Bible stories both as expressions of specific articles of faith and also as archetypes of representation of specific emotions cannot be exaggerated.

Compared with previous generations, Old Testament subjects became far more popular,[16] for several reasons. Principally, Protestantism appealed to the 'original text', to the sources. The text of the Bible had been available in the vernacular to people in every class of society since the new translations made in the mid-sixteenth century, and, since 1637, in the form of the official *Statenbijbel* as well. There was a copy of the Bible in almost every household, and it was read at family meals. So the text was known very much better than it had been earlier, and people had a new relationship to it. Interest in Old Testament subjects led to the development of a new iconography for scenes which had not been depicted before. Hitherto the scenes taken from the Old Testament, in the *Biblia Pauperum*, in the *Speculum Humanae Salvationis*, and in similar works, had been chosen as prefigurations of events in the New Testament. In series of engravings, they were used as 'exempla', for didactic purposes. Furthermore, in their fight against the Habsburg power, the renegade provinces drew parallels between themselves and the oppressed Children of Israel, who were saved through God's protection; so the events of the Old Testament were placed in a contemporary political context.[17] The Old Testament became, as it were, the chronicle of a people chosen to spread God's light through their struggle and through their victory.[18] Thus the story of the Jews was used to justify the actions of the seventeenth-century Dutch Protestants.[19] Finally, several Old Testament heroes were suited well to serve as embodiments of Christian and philosophical points.

Interest in Old Testament subjects was centred in Amsterdam, and was a feature of the artistic production of Rembrandt's immediate predecessors.[20] The subject of *Abraham Entertaining the Angels* (Genesis 18: 1–16) already had a long pictorial tradition behind it in the seventeenth century. The intimate atmosphere of a meal, with old people eating in the open air in an idyllic country setting, made it a favourite subject in graphic art. The influence of

14 On religion in the seventeenth century: *De kogel door de kerk. De Opstand in de Nederlanden en de rol van de Unie van Utrecht 1559–1609*, Exhib. Cat., Utrecht, 1979, pp. 176 ff.; *De eeuw van de Beeldenstorm. Ketters en Papen onder Filips II.*, Exhib. Cat., Utrecht, 1986.

15 Paul Huys Janssen, *Schilders in Utrecht 1600–1700*, Utrecht, 1990, p. 22.

16 On Old Testament depictions, see principally Christian Tümpel et al., *Het Oude Testament in de Schilderkunst van de Gouden Eeuw*, Exhib. Cat., Amsterdam, 1991, with bibliography; Volker Manuth, Denomination and Iconography: the Choice of Subject Matter in the Biblical Painting of the Rembrandt Circle, *Simiolus*, 22, 1993/94, pp. 235 ff.

17 See also the exhibition catalogue from Amsterdam, 1991 (note 16 above), pp. 146 ff.

18 Simon Schama, *The Embarrassment of Riches: an Interpretation of Dutch Culture in the Golden Age*, Berkeley, 1988, p. 68.

19 H. van de Waal, *Drie eeuwen Vaderlandsche Geschied-Uitbeelding 1500–1800. Een iconologische studie*, vol. 1, The Hague, 1952, pp. 22 ff. Cf. Schama 1988 (note 18 above), pp. 93 ff.

20 Amsterdam, Exhib. Cat., 1991 (note 16 above), p. 11.

the series of biblical illustrations made by Tobias Stimmer and Matthäus Merian can be felt still in Hoogstraten's drawing of the subject (no. 100).

Jacob Wrestling with the Angel (Genesis 32: 22–32) is a relatively rare subject.[21] In the drawing by Moeyaert (no. 103), a contemporary of Rembrandt, who was influenced by him, it is depicted as the pure embodiment of man being strengthened as God puts him to the test. The humanity in the interpretation of Bible stories characteristic of Rembrandt and his followers is exemplified in Nicolaes Maes's *Joseph Recounting his Dreams* (Genesis 37, no. 102). This was a favourite subject in Rembrandt's circle, and one that could be treated in a number of ways. Here, Joseph, between a pensive old father and an attentive, pious mother (anachronistically reading the Bible, a motif drawn from Rembrandt's etching of the same subject of 1638 [Münz 175]) stands naïve and self-confident, to tell the stories of his dreams, unaware that he will anger his hostile brothers.[22] The story of Joseph was important not only in Rembrandt's work, but also in contemporary Dutch literature. Joseph should be seen, perhaps, as a prototype of the prudent leader who, under God's protection, brings his country safely from ruin to freedom – the duty of a Stadtholder and of a city council.[23]

In his depiction of the patient *Job* (no. 104), Moeyaert focuses not so much on the individual but on the timeless ability to bear suffering exemplified by this Old Testament figure. Stoic philosophers considered patience one of the most important virtues. Under the influence of the writings of Seneca and Cicero, and through scholars like Justus Lipsius, who wrote in Latin, and Dirck Volkertsz. Coornhert, who wrote in the vernacular, imperturbability, the preservation of inner tranquillity in the midst of adversity, had become an ideal that had won many supporters since the late sixteenth century in both North and South Netherlands. Job's capacity to bear suffering presupposes, as it does also with the figures of sages, his own awareness of the higher significance of his suffering and his faith in God – which is why Job was seen also as prefiguration of Christ himself.

Leonaert Bramer's *Ascension of Elijah* (II Kings 2: 11–12; no. 98) uses chiaroscuro effects in its sympathetic presentation of the eerie scene described in the Bible. The prophets Elijah and Elisha are separated abruptly as a 'chariot of fire and horses of fire' descend, and Elijah is whisked up 'by a whirlwind' into heaven. In the *Biblia Pauperum*, Elijah is seen as prefiguring Christ, and his ascension as a parable of the death of Christ, which was followed by an earthquake.

Bloemaert's *Simeon with the Infant Christ* (no. 97) links the Old Testament with the New in his song of praise (The 'Nunc Dimittis', 'Lord, now lettest Thou Thy servant depart in peace,' Luke 2: 29). In this scene, God's promise of salvation has been kept, and the hopes of the Old Covenant are being fulfilled by the New Covenant, embodied in Christ. The Mannerist fascination with older people's faces, faces marked by the cares and experience of life – a fascination which was to live on in the young Rembrandt's work – is manifest in the impressive figure of Simeon. The drawing was used in the preparation of a painterly engraving.[24]

It is the direct, personal reference to the religious message that is the mark of Dutch Protestant iconography in depictions of the New Testament, no less than the Old. Although Rembrandt could be inspired by his predecessors' imagery, both painted and graphic, it was he – and the circle influenced by him – who overturned the traditional iconography of New Testament scenes. Pieter Lastman's *Adoration of the Shepherds* (no. 101) can be seen as an example of a more traditional viewpoint; a carefully worked out, finished composition, which Lastman, Rembrandt's teacher, based on a composition by Paolo Veronese. In Rembrandt's work, the story is depicted through the emotions which are released by the events, which he captured by portraying the inner feelings of the participants in a way to compel participation on the part of the observer – a process in which Rembrandt often distances himself strikingly from traditional pictorial formulas. His *Holy Family Sleeping, with Angels appearing to Joseph in his Dream* (no. 107) is a case in point. Even to his contemporaries, Rembrandt's mean of formulating images for New Testament scenes was moving for its contemporary relevance, its familiarity, its intimacy – as if the events were taking place 'here and now'. The mother, who has fallen asleep in the warmth of the fireplace, sees nothing of what is happening to the father, who stirs in his dreams, whilst he sleeps. Rembrandt

21 Amsterdam, Exhib. Cat., 1991 (note 16 above), p. 40 and no. 13.

22 Amsterdam, Exhib. Cat., 1991 (note 16 above), p. 41, Fig. 35.

23 Cf. van de Waal 1952 (note 19 above), p. 216.

24 Crispijn de Passe the Elder, F. 249; Hollstein 16 ad.

broke out of the pictorial tradition of religious history painting and aroused in the specta-
tor, through the recognition of everyday situations, a urgent sense of the familiar. This is
even more true of Rembrandt's graphic work, his drawings and his etchings, than of his
paintings. A similarly literal approach to the text is apparent in Rembrandt's painterly *Sup-
per at Emmaus* (no. 106). The ordinary travellers have gone indoors as evening falls, and are
talking about Jesus's crucifixion with the stranger who has accompanied them. When He
breaks the bread, they recognize Him, and 'He vanished out of their sight' (Luke 24: 31).
The figure of Jesus, the 'Light of the World', dissolves into light in front of their eyes; in
paintings of the same scene, Christ is always physically present, with the effect of transfig-
uration created by strong backlighting; in his graphic work Rembrandt risks effects of more
startling subtlety.

Rembrandt's drawings and engravings became sought-after collector's items during the
eighteenth century. His renewal of biblical iconography, too, was influential well beyond
the end of the seventeenth century.

Thea Vignau-Wilberg
Curator of Dutch and Flemish Prints and Drawings
Staatliche Graphische Sammlung München

KATALOG/CATALOGUE

HOLLÄNDISCHE LANDSCHAFTEN:
STADT UND LAND

DUTCH LANDSCAPES:
TOWN AND COUNTRY

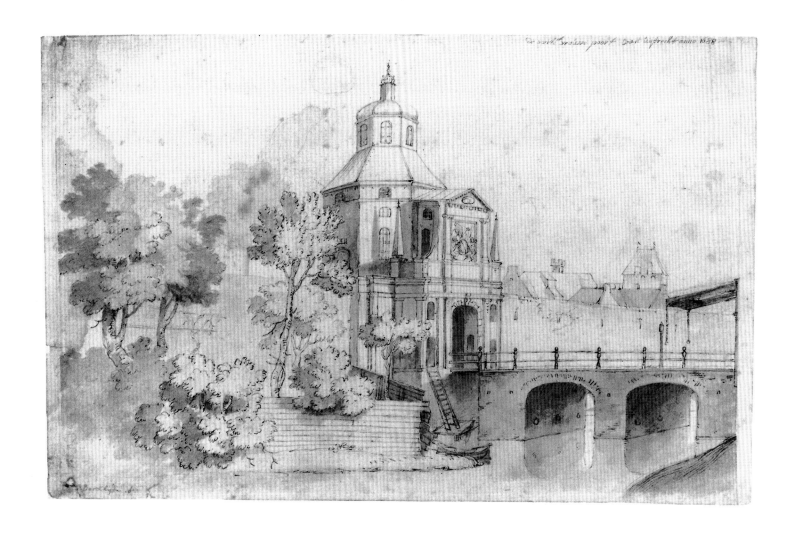

JOB ADRIAENSZ. BERCKHEYDE
Haarlem 1630–1693 Haarlem

Das Torhaus der Weißen Frauen in Utrecht (Wittevrouwenpoort)

Feder und braune Tusche, graue Lavierung über Spuren von schwarzer Kreide
194 x 312 mm (Blattgröße unregelmäßig)
Zwei alte Ausbesserungen im Himmel links von der Mitte
Oben rechts in brauner Tusche beschriftet ‚de witte vrouwe poort van uijtrecht anno 1688; unten links in Graphit ‚Berkhyde. fec‘
Vermächtnis Sir Bruce Ingram, 1963. PD. 144–1963
Provenienz: Es ist nicht bekannt, wo Ingram (Lugt 1405a) diese Zeichnung erwarb
Literatur: Ausstellungskatalog *Het kleine bouwen.* Utrecht 1983, Nr. 9, S. 48 ff.; Cynthia Lawrence, *Gerrit Adriaensz. Berckheyde.* Doornspijk 1991; J. J. Terwen und K. A. Ottenheym, *Pieter Post, Architect.* Zutphen 1993, S. 193 ff.
Bisher noch nicht öffentlich ausgestellt

Job Berckheyde wurde als zweites Kind der Cornelia Gerrits und des Adriaen Berckheyde, eines Fleischers aus Katwijk aan de Rijn bei Leiden, geboren und am 27. Januar 1630 in Haarlem getauft. Er ging anfänglich zu einem Buchbinder, später zu Jacob Willemsz. de Wet (um 1610–um 1675), einem Genre- und Landschaftsmaler, in die Lehre, der kurzzeitig im Atelier Rembrandts tätig gewesen war. Job Berckheyde seinerseits war, wie man annimmt, der Lehrer seines jüngeren Bruders Gerrit (1638–1698). Beide Maler spezialisierten sich auf Stadtlandschaften und Architekturveduten. In den fünfziger Jahren reisten sie den Rhein hinauf bis nach Heidelberg, wo sie als Hofmaler in die Dienste des pfälzischen Kurfürsten Karl Ludwig traten. Nach ihrer Rückkehr nach Haarlem, um 1660, lebten sie zusammen mit ihrer unverheirateten Schwester Aechje in einem Haus an der Jansstraat. Beide Brüder bekleideten in den achtziger und neunziger Jahren Ämter in der Haarlemer Gilde. Job starb am 23. November 1693; Gerrit ertrank am 10. Juni 1698. Keiner der beiden Brüder war verheiratet.

Die Beschriftung am rechten oberen Blattrand bezeichnet die Architektur als Torhaus der Weißen Frauen (der Karmelitinnen) in Utrecht. Das Blatt zeigt das 1649 dem Architekten Pieter Post (1609–1685) in Auftrag gegebene neue Gebäude. Den Vorgängerbau überliefert eine 1646 datierte Radierung von Herman Saftleven (1609–1685; Hollstein 19). Posts Modell des neuen Torhauses von 1650 wird im Centraal Museum in Utrecht aufbewahrt; die letzte Zahlung an ihn für das Gebäude erfolgte 1656; 1858 wurde es abgerissen. Am rechten Bildrand erkennt man das Ende einer Zugbrücke über den Kanal.

Stilistisch leiten sich die klaren Umrißlinien der Architektur, verbunden mit einer Lavierung, die dem Gebäude Tiefenstruktur verleiht, von Pieter Saenredam (1597–1665) her, der hauptsächlich in Haarlem ansässig war.

The gateway of the White Ladies at Utrecht (Wittevrouwenpoort)

Pen and brown ink, grey wash over traces of black chalk
194 x 312 mm, irregular
Two old repairs in the sky, left of centre
Inscribed, upper right, in brown ink: 'de witte vrouwe poort van uijtrecht anno 1688'; lower left in graphite: 'Berkhyde. fec'
Bequeathed by Sir Bruce Ingram, 1963. PD. 144–1963
Provenance: It is unknown where Ingram (Lugt 1405a) acquired this drawing
Literature: Exhib. Cat., *Het kleine bouwen*, Utrecht, 1983, no. 9, pp. 48 ff.; Cynthia Lawrence, *Gerrit Adriaensz. Berckheyde*, Doornspijk, 1991, *passim*; J. J. Terwen, K. A. Ottenheym, *Pieter Post, Architect*, Zutphen, 1993, pp. 193 ff.
Not previously exhibited

Job Berckheyde was the second child of Cornelia Gerrits and Adriaen Berckheyde, a butcher from Katwijk aan de Rijn near Leiden. Baptised in Haarlem on 27 January 1630, he was apprenticed originally to a book-binder and later became a student of painting under Jacob Willemsz. de Wet (c.1610–c.1675), a genre and landscape artist who had studied briefly with Rembrandt. Berckheyde is credited with having taught his younger brother, Gerrit (1638–1698). Both artists specialised in townscapes and architectural vistas. During the 1650s they journeyed up the Rhine as far as Heidelberg and they became court painters to Elector Karl Ludwig, of the Palatinate. On their return to Haarlem (c.1660), they lived with their unmarried sister, Aechje, in a house on the Jansstraat. Both brothers held office in the Haarlem guild during the 1680s and 1690s. Job died on November 23 1693 and Gerrit was drowned on June 10 1698. Neither brother was married.

The inscription, upper right, identifies the scene as the Gateway of the White Ladies (Carmelite Nuns) at Utrecht. This shows the new building commissioned from the architect Pieter Post (1609–1685) in 1649. The old gateway is known from the print by Herman Saftleven (1609–1685) dated 1646 (Hollstein 19). Post's model for it, made in 1650, is still extant (Centraal Museum, Utrecht); he received a final payment for the building in 1656. It was demolished in 1858. At the right edge of the drawing can be seen the end of a lift-bridge over the canal.

Stylistically the clean lines of the drawing of the architecture, combined with a wash applied to give a sense of mass, derive from the example of Pieter Saenredam (1597–1665) who was mainly resident in Haarlem.

ABRAHAM BLOEMAERT
Gorinchem 1566–1651 Utrecht

Gebirgslandschaft mit Brücke über einem Wasserfall, rechts ein Mann

Schwarze Kreide, blaue und graue Lavierung und Spuren roter Kreide, allseitig doppelte Randlinie mit Pinsel in Braun
201 x 293 mm
Verso mit brauner Tusche bezeichnet ‚blom' und ‚Abra Bloemaert'
Vermächtnis Sir Bruce Ingram, 1963. PD. 149–1963
Provenienz: Paul Sandby (Lugt 2112); Teil des ‚Sandby Album',
Auktion Sotheby's, London, 9. Juli 1936, Lot 38; hier für Ingram
(Lugt 1405a) von Kunsthandlung P. & D. Colnaghi, London, im Juli
1936 erworben
Literatur: C. van Hasselt, *Rembrandt and his century*. Ausstellungskatalog Paris / New York 1977/78, S. 20, Anm. 6; Marian Bisanz-Prakken, *Die Landschaft im Jahrhundert Rembrandts*. Ausstellungskatalog Wien, Albertina, 1993, S. 32, Nr. 10; Marcel G. Roethlisberger, *Abraham Bloemaert and his Sons*. Gent 1993, I, S. 423
Bisher noch nicht öffentlich ausgestellt

Bloemaert begann seine Lehrzeit bei seinem Vater Cornelis, einem Bildhauer, und ging dann zu dem Utrechter Maler Joos de Beer (gest. 1595). Zwischen 1580 und 1583 arbeitete er in Paris bei Hieronymus I. Francken (1540–1610). Nach seiner Rückkehr nach Holland ließ er sich in Utrecht nieder, wo er bis zu seinem Tode blieb, abgesehen von einem neunjährigen Aufenthalt in Amsterdam (1591–1600). Hier heiratete er 1592 Judith van Schonenburgh, die 1599 starb. 1600 ehelichte er Gerarda de Roy. Er hatte vierzehn Kinder; vier von ihnen ergriffen ebenfalls den Künstlerberuf.

Bloemaert hatte viele Schüler, und sein Einfluß reichte weit in das 18. Jahrhundert hinein, wo er vor allem in Frankreich beachtliches Ansehen genoß. Sein Sohn Frederick (nach 1610–1669) veröffentlichte mehrere Ausgaben des *Tekenboek* des Vaters; das Original befindet sich im Fitzwilliam Museum in Cambridge (PD. 166–1963) und wird von Roethlisberger um 1645/50 angesetzt (siehe Kat. 83).

Obwohl Roethlisberger, im Vergleich mit datierten Zeichnungen von 1650, unser Blatt spät innerhalb des Schaffens Bloemaerts einordnet, besteht kein Grund, es nicht in der gleichen Zeit wie die ähnlichen Landschaftszeichnungen der Sammlung Lugt (Fondation Custodia, Paris) anzusetzen, die 1605 bzw. 1606 datiert sind. Diese wiederum bilden mit zwei Zeichnungen in Wien (Albertina) und Weimar (Goethe-Museum) eine geschlossene Gruppe. Die frühen Zeichnungen Bloemaerts zeigen den starken Einfluß seiner Vorgänger und Zeitgenossen, besonders den des Hendrick Goltzius (1558–1617), und eher eine manieristische Übersteigerung der Landschaftsformen als jene Naturtreue, für die Bloemaert eigentlich bekannt ist.

Mountainous landscape with a bridge over falls and a figure on the right

Black chalk, blue and grey wash and traces of red chalk, bordered on each side by two lines of brown wash
201 x 293 mm
Inscribed, *verso*, in brown ink: 'blom' and 'Abra Bloemaert'
Bequeathed by Sir Bruce Ingram, 1963. PD. 149–1963
Provenance: Paul Sandby (Lugt 2112); part of the 'Sandby Album', London, Sotheby's, 9 July 1936, lot 38; with P. & D. Colnaghi, London, from whom bought by Ingram (Lugt 1405a), July 1936
Literature: C. van Hasselt, *Rembrandt and his century*, Exhib. Cat., Paris / New York, 1977/78, p. 20, note 6; Marian Bisanz-Prakken, *Die Landschaft im Jahrhundert Rembrandts*, Exhib. Cat., Vienna, Albertina, 1993, p. 32, no. 10; Marcel G. Roethlisberger, *Abraham Bloemaert and his Sons*, Ghent, 1993, I, p. 423
Not previously exhibited

Bloemaert was first apprenticed to his father, Cornelis, a sculptor and then to the Utrecht painter, Joos de Beer (died 1595). Between 1580 and 1583 he was in Paris working with Hieronymus I Francken (1540–1610). On his return to Holland he settled in Utrecht where he remained until his death, apart from a few years in Amsterdam. He married Judith van Schonenburgh in 1592. She died in 1599, and Bloemaert remarried in 1600, Gerarda de Roy. He had 14 children, four of whom became artists.

He had very many pupils and his influence continued well into the eighteenth century, where he had considerable fame in France. His son, Frederick (after 1610–1669), published several editions of Abraham's *Drawing Book*, the original of which is in the Fitzwilliam Museum (PD. 166–1963), dated by Roethlisberger c.1645/50 (s. Cat. no. 83).

Despite Roethlisberger's dating of this drawing to late in Bloemaert's career by comparison with dated drawings of 1650, there is no reason why it should not have been drawn at the same time as the landscapes of similar type in the Lugt Collection (Fondation Custodia, Paris) dated 1605 and 1606 respectively. Together with two other drawings at Vienna (Albertina) and Weimar (Goethe-Museum) they form a compact group. These early drawings by Bloemaert show the strong influence of his predecessors and contemporaries, particularly that of Hendrick Goltzius (1558–1617), and show a Mannerist exaggeration rather than the attention to natural detail for which Bloemaert is best known.

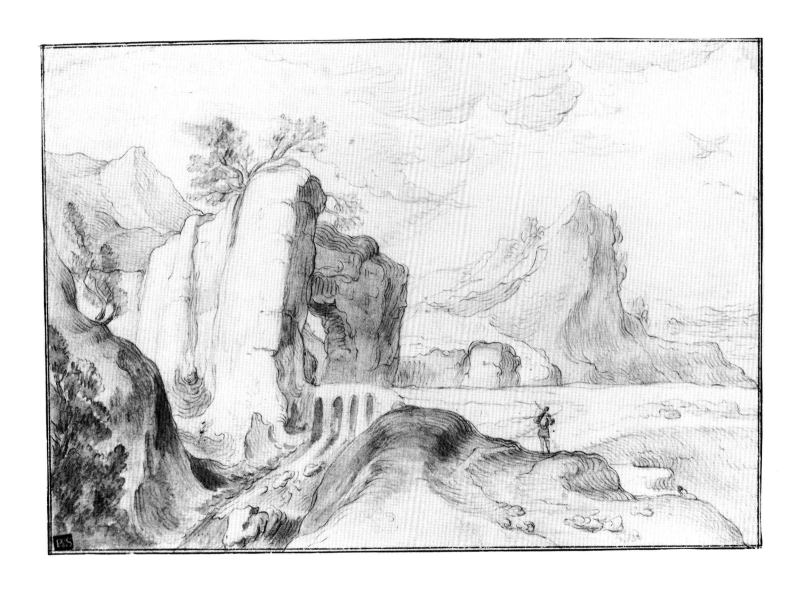

ABRAHAM BLOEMAERT
Gorinchem 1566–1651 Utrecht

Hinterhäuser

Feder und braune Tusche, farbige Lavierungen, weiß gehöht
über schwarzer Kreide, allseitig Randlinie mit Pinsel in Braun
142 x 168 mm

Verso: Studien eines Stuhles, einiger Körbe und eines breitkrempigen Frauenhutes
Feder und braune Tusche über roter Kreide

Vermächtnis Sir Bruce Ingram, 1963. PD. 162–1963
Provenienz: Kunsthandlung P. & D. Colnaghi, London; hier von
Ingram (Lugt 1405 a) im Februar 1943 erworben
Ausstellungen: London, Colnaghi, 1956, Nr. 20; Rotterdam / Amsterdam 1961/62, Nr. 16

Wahrscheinlich eine Seite aus einem Skizzenbuch, gezeichnet
um 1610. Das Blatt ist deutlich vor der Natur entstanden und
ein schönes Beispiel für den aufmerksamen Blick des Künstlers
für das realistische Detail. Ein weiteres doppelseitig gezeichnetes
Blatt befindet sich ebenfalls im Fitzwilliam Museum, die *Studie
einer Bauernhütte* (PD. 161–1963); ähnliche Zeichnungen werden unter anderem auch in Berlin (Kupferstichkabinett, KdZ
237–252, 257, 262) und Hannover (Kestner-Museum) aufbewahrt. Eine genaue Kopie unserer Zeichnung, Ploos van Amstel
(1726–1798) zugeschrieben, befindet sich ebenfalls im Fitzwilliam Museum (PD. 162 a–1963).

Kitchen quarters at the side of a house

Pen and brown ink, coloured washes, heightened with white
over black chalk, bordered on all sides by a line of brown wash
142 x 168 mm

Verso: Studies of a chair, several baskets and a woman's broad-brimmed hat
Pen and brown ink over red chalk

Bequeathed by Sir Bruce Ingram, 1963. PD. 162–1963
Provenance: with P. & D. Colnaghi, London, from whom acquired by
Ingram (Lugt 1405 a), February 1943
Exhibited: London, Colnaghi, 1956, no. 20; Rotterdam / Amsterdam, 1961/62, no. 16

Probably a leaf from a sketch-book, drawn c.1610. This is clearly
drawn from nature and is a fine example of Bloemaert's attention
to realistic detail. Another double-sided leaf is in the Fitzwilliam
(*Study of a cottage*, PD. 161–1963), and several similar drawings
are known, for example those in Berlin (Kupferstichkabinett,
KdZ 237–252, 257, 262) and Hanover (Kestner-Museum). An
exact copy of the drawing, attributed to Ploos van Amstel
(1726–1798), is in the Fitzwilliam (PD. 162 a–1963).

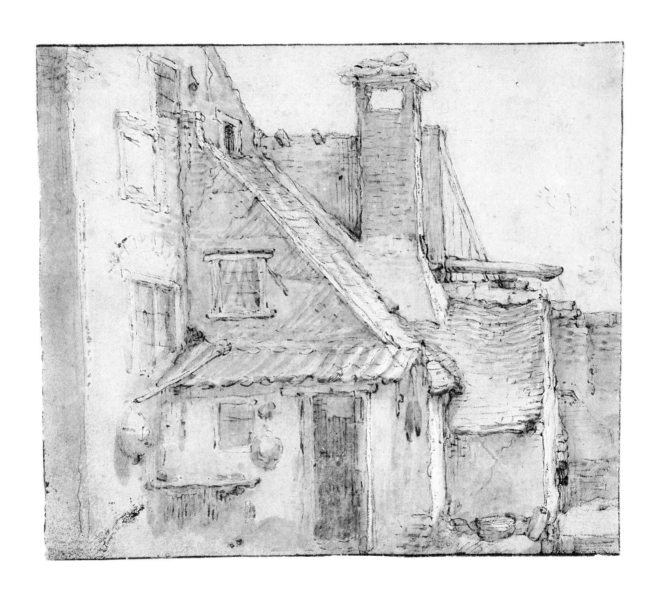

AELBERT CUYP
Dordrecht 1620–1691 Dordrecht

Bauernkate im Wald

Schwarze Kreide, graue und gelbbraune Lavierungen mit Gummi
Arabicum, allseitig Randlinie mit Pinsel in Braun
141 x 194 mm
Vermächtnis Sir Bruce Ingram, 1963. PD. 254–1963
Provenienz: J. M.W. Turner; Kunsthandlung P. & D. Colnaghi, London;
hier von Ingram (Lugt 1405 a) im Februar 1946 erworben
Ausstellungen: London, Colnaghi, 1952, Nr. 44; Bath 1952, Nr. 44;
London 1953, Nr. 349; Bedford 1958, Nr. 14; Washington u. a.
1959/60, Nr. 25; Rotterdam / Amsterdam 1961/62, Nr. 29

Aelbert lernte zuerst bei seinem Vater, dem Portraitmaler Jacob
Gerritsz. Cuyp (1594–1651). In seinem Frühwerk zeigt sich
außerdem der Einfluß Jan van Goyens (1596–1656). Später, um
1645, orientierte sich Cuyp an den Utrechter Italianisanten wie
Jan Both (um 1615–1652); er begann mit einer leuchtenderen
Farbpalette zu malen, so daß seine Bilder den Eindruck
erwecken, in Italien gemalt worden zu sein, obwohl Cuyp offen-
bar dieses Land nie besucht hat. 1658 heiratete er Cornelia
Boschman, Witwe des Patriziers Johan van den Corput, und
hatte mit ihr eine Tochter, die 1659 geboren wurde. Cuyps Frau
starb 1689. Obwohl er am meisten für seine Landschaften mit
Kühen bekannt ist, trat Cuyp auch als Portraitmaler und Stille-
benmaler hervor.

Die vier Stangen, die rechts neben dem Strohdach der Kate
über die Baumkronen ragen, gehören wohl zu einer Heumiete.
Haverkamp-Begemann (mündl. Mitt. 1986) datierte die Zeich-
nung um 1645 und vermutete, daß sie zu einer Folge gehört. Da
Cuyp bei seinen Arbeiten auf Papier ausgeprägte Querformate
bevorzugte, kann man annehmen, daß unser Blatt rechts und
links beschnitten ist. Typisch für Cuyp ist die Verwendung von
Gummi Arabicum im Vordergrund, wohl um die schwarze Kreide
zu fixieren und die dunklen Flächen zusätzlich herauszuheben.
Durch den Kontrast zwischen Vorder- und Hintergrund entsteht
eine stärkere Tiefenräumlichkeit.

A cottage in a wooded landscape

Black chalk, grey and yellow-brown wash, with gum Arabic, bordered
on all sides by a line of brown wash
141 x 194 mm
Bequeathed by Sir Bruce Ingram, 1963. PD. 254–1963
Provenance: J. M.W. Turner, R.A.; with P. & D. Colnaghi, London,
from whom bought by Ingram (Lugt 1405 a), February 1946
Exhibited: London, Colnaghi, 1952, no. 44; Bath, 1952, no. 44; Lon-
don, 1953, no. 349; Bedford, 1958, no. 14; Washington and American
Tour, 1959/60, no. 25; Rotterdam / Amsterdam, 1961/62, no. 29

Taught by his father, the portrait painter, Jacob Gerritsz. Cuyp
(1594–1651), Aelbert's early style is influenced by Jan van
Goyen (1596–1656). Later, c.1645, Cuyp came under the in-
fluence of Italianate artists in Utrecht, like Jan Both
(c.1615–1652), and began to paint with a more luminous pal-
ette, so that his pictures look as though they were painted in
Italy, although apparently he never visited that country. In 1658
he married the widow of the patrician Johan van den Corput,
Cornelia Boschman. They had one daughter, born in 1659. His
wife died in 1689. Although best known as a painter of land-
scapes with cows, Cuyp was also a painter of portraits and still-
lifes.

The four poles rising above the trees to the right of the
thatched roof of the cottage suggest the supports of a hay-stack.
The drawing has been dated c.1645 by Haverkamp-Begemann
(orally 1986), who suggested it was one of a series. As Cuyp
favoured a clearly horizontal format in his works on paper it is
likely that this has been cut down at both the left and the right.
Characteristic of Cuyp is the use of gum Arabic in the fore-
ground, probably to fix the black chalk and to give extra em-
phasis to the darks, thereby enhancing the contrast between
foreground and background to achieve an impression of depth.

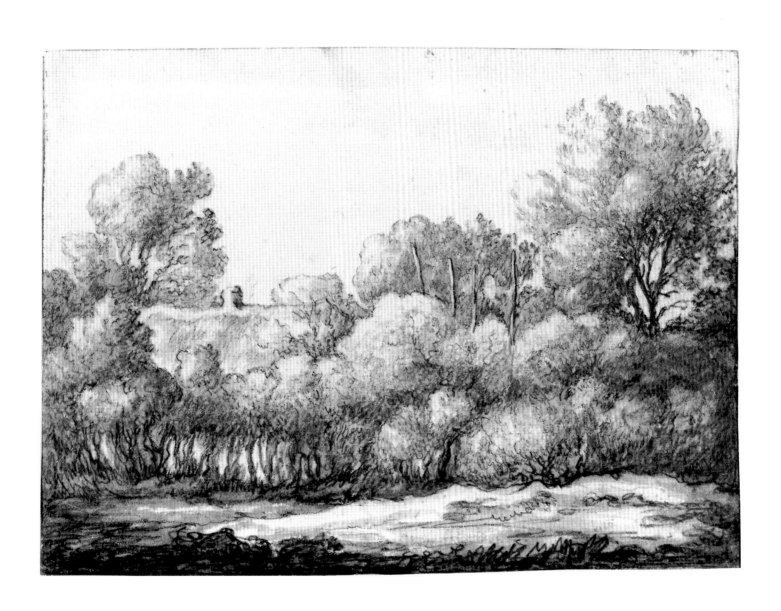

AELBERT CUYP
Dordrecht 1620–1691 Dordrecht

Die Küste mit dem Leuchtturm von Egmond aan Zee

Schwarze Kreide, Spuren roter Kreide, dünner Pinsel und graue Lavierung
133 x 192 mm (Blattgröße unregelmäßig)
Auf der alten Montierung mit Tusche bezeichnet, verso ‚J. B. No. 823‘,
mit Bleistift ‚fawcett 28/105‘ und ‚Cuyp‘
Vermächtnis Sir Bruce Ingram, 1963. PD. 260–1963
Provenienz: John Barnard (Lugt 1420); Kunsthandlung P. & D. Colnaghi, London; hier von Ingram (Lugt 1405 a) im Juli 1936 erworben
Bisher noch nicht öffentlich ausgestellt

Wahrscheinlich allseitig beschnitten; die Lavierungen in den Dünen scheinen authentisch zu sein, während die Lavierungen im Meer, wie Haverkamp-Begemann wohl zu Recht vermutet, spätere Zutaten sind. Haverkamp-Begemann identifizierte auch den Leuchtturm als denjenigen in Egmond aan Zee, acht Kilometer westlich von Alkmaar.

The sea–shore with the lighthouse at Egmond on Sea

Black chalk, point of the brush and grey wash with traces of red chalk
133 x 192 mm, irregular
Inscribed on the former mount in ink, *verso*: 'J.B.No. 823',
in pencil: 'fawcett 28/105', and 'Cuyp'
Bequeathed by Sir Bruce Ingram, 1963. PD. 260–1963
Provenance: John Barnard (Lugt 1420); with P. & D. Colnaghi, London, from whom bought by Ingram (Lugt 1405 a), July 1936
Not previously exhibited

Probably cut down on all sides; the washes in the dunes in the foreground appear authentic, but Haverkamp-Begemann is most likely correct in thinking that the washes in the sea were added at a later date. The lighthouse was identified as that at Egmond on Sea, five miles to the west of Alkmaar, by Haverkamp-Begemann.

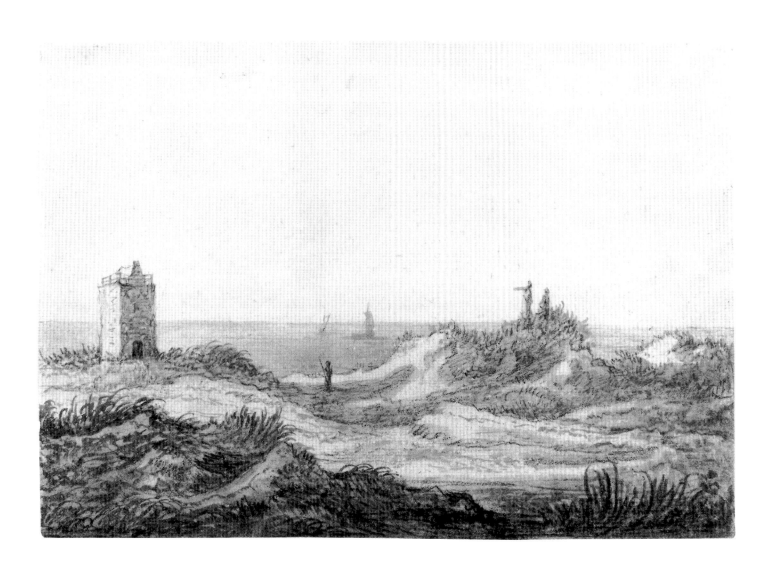

GERBRAND VAN DEN EECKHOUT
zugeschrieben / attributed to
Amsterdam 1621–1674 Amsterdam

Ansicht einer holländischen Stadt aus der Ferne

Feder und braune Tusche, graue, braune, gelbe und grüne Lavierungen,
schwarze Kreide, allseitig Randlinie mit Pinsel in Braun
186 x 298 mm
Alte Übermalungen im Himmel, um Flecken zu verdecken
Vermächtnis Sir Bruce Ingram, 1963. PD. 286–1963
Provenienz: E. Desperet (Lugt 721); Auktion Desperet, Clément,
Paris, 6. Juni 1865, Lot 226 (als Eeckhout); A. W. M. Mensing; Auk-
tion Mensing, Amsterdam, 27. April 1937 (als Borssom); Kunsthand-
lung P. & D. Colnaghi, London; hier von Ingram (Lugt 1405 a) im Mai
1937 erworben
Ausstellungen: London 1946/47, Nr. 6; Cambridge, Fitzwilliam
Museum, 1951 (o. Kat.); London 1953, Nr. 325; Rotterdam / Amster-
dam 1961/62, Nr. 36; Cambridge 1966, Nr. 24

Eeckhout war Sohn des Goldschmiedes Jan Pietersz. van den
Eeckhout. Zwischen 1635 und 1640 arbeitete er im Atelier von
Rembrandt (1606–1669) und war – wie es heißt – dessen Lieb-
lingsschüler und lebenslanger Freund. Als vielseitigster Vertre-
ter der Rembrandt-Schule schuf er Gemälde und Zeichnungen
mit biblischen und historischen Inhalten, Genreszenen, Einzel-
und Gruppenportraits sowie Landschaften. Zu seinen Vorbildern
gehörte auch Pieter Lastman (1583–1633); mit Roelant Rogh-
man (1627–1692) war er befreundet. In Eeckhouts späteren
Arbeiten zeigen sich flämische Einflüsse, dem Amsterdamer
Zeitgeschmack entsprechend.

Die farbigen Lavierungen sind zeitgenössisch. Sie sind jedoch
für Eeckhouts Technik nicht unbedingt typisch, obwohl er hin
und wieder in den fünfziger und frühen sechziger Jahren farbige
Lavierungen verwendete (vgl. eine weitere Zeichnung im Fitz-
william Museum, PD. 283–1963, *Blick auf den Rhein bei Arnhem*).
Sumowski hat jedenfalls unsere Zeichnung nicht aufgenommen.
Unserem Blatt am engsten verwandt und bei Sumowski (III,
Nr. 686) verzeichnet ist *Flachland mit Dünen und Ansicht von
Haarlem* in Berlin, aber die Umrisse sind weicher und die Feder-
striche nicht so grob. In der Sammlung Desperet wurde unsere
Zeichnung Eeckhout zugeschrieben, doch spätere Besitzer zogen
eine Zuweisung an Anthonie van Borssom (1629/30 – 1677) vor.
Weite Panoramablicke sind jedoch bei van Borssom selten so
klar angelegt wie in dieser Zeichnung (vgl. Sumowski II,
Nrn. 290, Plymouth, Cottonian Collection, und 339*, London,
British Museum, 1836–8–11–52). Obwohl die Art der Feder-
schraffur im Vordergrund bei van Borssom nicht ausgeschlossen
ist, kann man Boons Rückgabe der Zeichnung an Eeckhout
nachvollziehen. Martin Royalton-Kish schlug als Zeichner unse-
res Blattes Jacob Esselens (1626–1687) vor, eine Idee, die man-
ches für sich hat; allerdings sollte auch der Rembrandt-Schüler
Pieter de With (gest. nach 1689) als Autor in Betracht gezogen
werden (vgl. dessen *Landschaft bei Arnhem* in Stockholm, Natio-
nalmuseum, Z 378/1957).

Distant view of a Dutch town

Pen and brown ink, grey and brown, yellow and green washes,
with black chalk, bordered on all sides by a line of brown wash
186 x 298 mm
Old discolouration in the sky, masking stains
Bequeathed by Sir Bruce Ingram, 1963. PD. 286–1963
Provenance: E. Desperet (Lugt 721), his sale, Paris, Clément, 6 June
1865, lot 226 (as Eeckhout); A. W. M. Mensing, his sale, Amsterdam,
27 April 1937 (as Borssom); with P. & D. Colnaghi, London, from
whom bought by Ingram (Lugt 1405 a), May 1937
Exhibited: London, 1946/47, no. 6; Cambridge, Fitzwilliam Museum,
1951 (no handlist); London, 1953, no. 325; Rotterdam / Amsterdam,
1961/62, no. 36; Cambridge, 1966, no. 24

Eeckhout was the son of a goldsmith, Jan Pietersz. van den Eeck-
hout. He studied with Rembrandt (1606–1669) from 1635 to
1640 and is said to have been Rembrandt's favourite pupil and
lifelong friend. He was the most versatile member of the Rem-
brandt circle and his paintings and drawings include biblical and
historical subjects, genre scenes, individual and group portraits
as well as landscapes. He was also influenced by Pieter Lastman
(1583–1633) and was a friend of Roelant Roghman (1627–
1692). His later works show a Flemish influence, which reflects
contemporary taste in Amsterdam.

The coloured washes are contemporary. Technically this is not
entirely characteristic of van den Eeckhout, although he uses
coloured washes in the 1650s and early 1660s (*cf.* another draw-
ing in the Fitzwilliam [PD. 283–1963], *View of the Rhine in the
vicinity of Arnhem*), and Sumowski does not include the drawing
in his *Corpus*. The work most similar to it included by Sumow-
ski (III, no. 686), *Flatland with dunes and a view of Haarlem*, is in
Berlin, but the contours are softer and the pen strokes less
jagged. The drawing was attributed to Eeckhout when it was in
the Desperet collection but subsequent owners preferred an
attribution to Anthonie van Borssom (1629/30–1677). Panor-
amic views by van Borssom rarely are defined so clearly as in this
drawing (*cf.* Sumowski, II, nos. 290 [Plymouth, Cottonian Col-
lection], 339* [British Museum, 1836–8–11–52]). Although the
penmanship of the hatching in the foreground is not impossible
for van Borssom, Boon's reinstatement of van den Eeckhout's
authorship is comprehensible. Martin Royalton-Kish has sug-
gested that the drawing may be by Jacob Esselens (1626–1687),
an idea which has much in its favour, but Rembrandt's pupil,
Pieter de With (died after 1689), should also be considered as
the possible artist (see, for example, his *Landscape near Arnhem*
at Stockholm, Nationalmuseum, Z 378/1957).

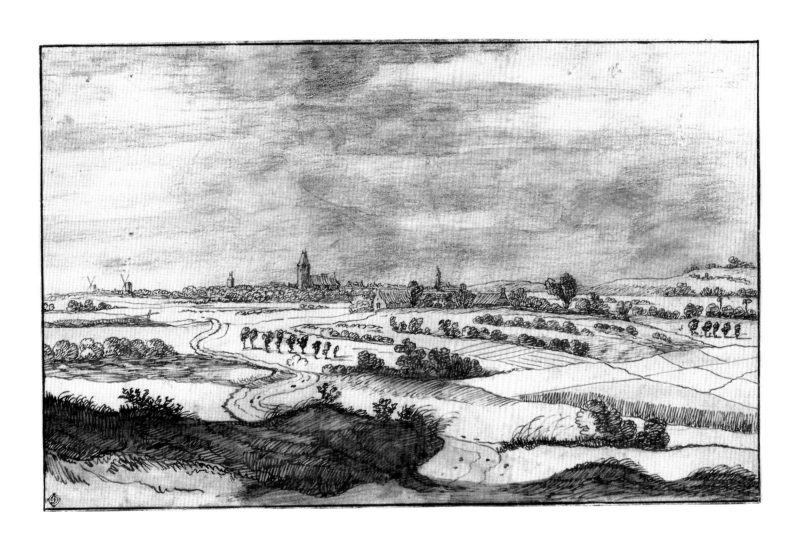

ALLAERT VAN EVERDINGEN
Alkmaar 1621–1675 Amsterdam

Ein ummauerter Garten im Frühling

Dünner Pinsel, braune Lavierung über leicht eingedrücktem Graphit,
allseitig Randlinie mit Pinsel in Braun
158 x 209 mm
Signiert mit den Initialen ‚AVE' unten rechts
Verso in Bleistift bezeichnet ‚No. 421 everdinge' und numeriert ‚602'
Vermächtnis Sir Bruce Ingram, 1963. PD. 326–1963
Provenienz: Goff; Sir Robert Witt (Lugt 2228 b); Kunsthandlung
P. & D. Colnaghi, London; hier von Ingram (Lugt 1405 a) im Januar
1936 erworben
Literatur: J. Byam Shaw, Drawings by minor masters in the collection
of Sir Robert and Lady Witt. The Studio 98, 1929, Nr. 437, S. 545 und
548 (m. Abb.)
Ausstellungen: London, Colnaghi, 1952, Nr. 40; Bath 1952, Nr. 47;
Gent, Musée des Beaux-Arts, 1960, Fleurs et Jardins dans l'art Flamand
(nicht im Kat.); Rotterdam / Amsterdam 1961/62, Nr. 38; Cambridge
1977, Nr. 35

Seinen ersten Unterricht erhielt Everdingen von Roelandt
Savery (1576–1639) in Utrecht, dann von Pieter Molijn
(1595–1661) in Haarlem; 1645 wurde er hier in das Verzeichnis
der Meister aufgenommen. Nur wenig ist über sein Leben
bekannt, doch wissen wir, daß er von kurz nach 1640 bis um
1644 in Schweden und Norwegen reiste, wo er ausgiebig nach
der Natur zeichnete. Nach seiner Rückkehr verwendete er zahl-
reiche skandinavische Motive in seinen Arbeiten, vor allem
Felsformationen, Wasserfälle und Holzhütten; diese Motivwahl
war von beachtlichem Einfluß auf die Kompositionen seines
Zeitgenossen Jacob van Ruisdael (1628/29–1682). Everdingen
trat hauptsächlich als Zeichner und Radierer hervor, während
Ölgemälde von seiner Hand verhältnismäßig selten sind. Er war
Diakon der Holländischen Reformierten Kirche und hinterließ
zwei Söhne, die beide dem Beruf des Malers nachgingen.

Die leicht eingedrückten Umrisse der Zeichnung legen die
Vermutung nahe, daß sie als Vorlage für eine Radierung
bestimmt war. Der Tulpentopf im Vordergrund verweist auf den
Frühling als dargestellte Jahreszeit; möglicherweise haben wir es
hier mit einem Blatt für eine Folge der vier Jahreszeiten oder für
eine Folge der zwölf Monate zu tun. Aus stilistischen Erwägun-
gen kann die Zeichnung um 1650/60 angesetzt werden.

A walled garden in spring

Point of the brush, brown wash, over graphite, lightly incised,
bordered on all sides by a line of brown wash
158 x 209 mm
Signed with initials: 'AVE', lower right
Inscribed, *verso*, in pencil: 'No. 421 everdinge' and numbered '602'
Bequeathed by Sir Bruce Ingram, 1963. PD. 326–1963
Provenance: Goff; Sir Robert Witt (Lugt 2228b); with P. & D. Colna-
ghi, London, from whom bought by Ingram (Lugt 1405 a), January
1936
Literature: J. Byam Shaw, 'Drawings by minor masters in the collec-
tion of Sir Robert and Lady Witt', The Studio, 98, 1929, no. 437,
pp. 545, 548 (repr.)
Exhibited: London, Colnaghi, 1952, no. 40; Bath, 1952, no. 47;
Ghent, Musée des Beaux-Arts, 1960, Fleurs et Jardins dans l'art Flamand
(not in the Exhib. Cat.); Rotterdam / Amsterdam, 1961/62, no. 38;
Cambridge, 1977, no. 35

Taught first by Roelandt Savery (1576–1639) at Utrecht and
then by Pieter Molijn (1595–1661) at Haarlem, where Ever-
dingen was registered as a master in 1645. We know little about
his life, but from shortly after 1640 until about 1644 he travelled
in Sweden and Norway, drawing extensively from nature. On his
return he incorporated many Scandinavian themes into his
paintings, notably rocks, waterfalls and wooden huts: these had
considerable influence on the compositions of his contemporary
Jacob van Ruisdael (1628/29–1682). A prolific draughtsman
and etcher, his oil paintings are relatively uncommon. He was a
deacon of the Dutch Reformed Church and was survived by two
sons, each of them a painter.

The light incision around the outlines of the drawing suggests
that it may have been intended for etching. The season is spring,
as witness the tulip in the flowerpot on the right. This may have
been intended as one of four drawings to illustrate the seasons,
or possibly as a series of twelve, representing the months of the
year. On stylistic grounds it can be dated c.1650/60.

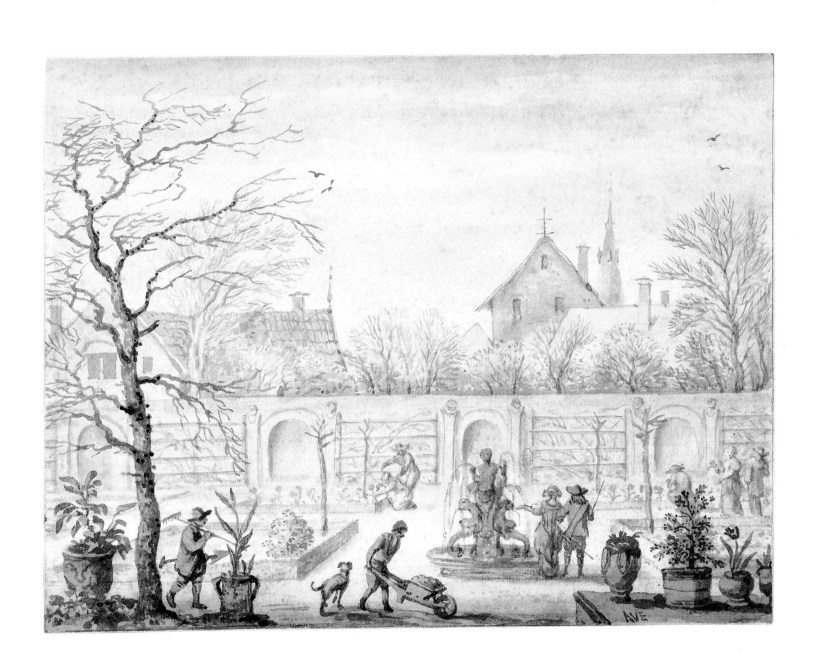

ABRAHAM FURNERIUS
Rotterdam um/*c.* 1628–1654 Rotterdam

Blick auf Amsterdam im Nebel

Feder und braune Tusche, braune und graubraune Lavierung
103 x 209 mm
Unten links in brauner Tusche bezeichnet ‚abraham furnerius fecit‘
und darunter ‚Myrinck‘
Vermächtnis Sir Bruce Ingram, 1963. PD. 340–1963
Provenienz: Lord Knutsford; Auktion Knutsford, Sotheby’s, London,
11. April 1935, Lot 112; Kunsthandlung P. & D. Colnaghi, London;
hier von Ingram (Lugt 1405a) im April 1935 erworben
Literatur: K. T. Parker, *Catalogue of the Collection of Drawings in the
Ashmolean Museum* I. Oxford 1938, s. v. 132; J. Bolten, *Dutch Drawings
from the Collection of Dr. C. Hofstede de Groot*. Utrecht 1967, S. 80, s.v.
Nr. 44, Anm. 4; Sumowski IV, S. 2174, Nr. 987**; J. Giltay, Abraham
Furnerius en Gerrit van Battem. *Essays in Northern Art presented to
Egbert Haverkamp-Begemann on his sixtieth birthday*. Doornspijk 1983,
S. 98, Anm. 9
Ausstellungen: Cambridge 1966, Nr. 30; Cambridge 1977, Nr. 32;
Cambridge 1985, handlist, S. 17

In den frühen vierziger Jahren war Furnerius gleichzeitig mit
Samuel van Hoogstraten (1627–1678) in Rembrandts Atelier
tätig. Er spezialisierte sich auf Landschaften, doch sind keine sei-
ner überlieferten Gemälde erhalten. Man nimmt an, daß ihn
Philips de Koninck (1619–1688) beeinflußte, der 1640 sein
Schwager wurde. Auf Grund einiger weniger Zeichnungen mit
alten Zuschreibungsvermerken wird er aus stilistischen Gründen
mit etlichen weiteren Zeichnungen in Verbindung gebracht.

Eine Zeichnung im Ashmolean Museum in Oxford mit einem
Blick auf Amsterdam aus der Ferne (Sumowski IV, Nr. 984**)
zeigt eine Beschriftung von der gleichen Hand, die beide Zeich-
nungen jeweils Furnerius zuweist. Da keine authentischen Zeich-
nungen von Furnerius bekannt sind, beruhen Zuschreibungen
ausschließlich auf solchen alten Bezeichnungen. Die beiden
Zeichnungen im Fitzwilliam Museum und im Ashmolean
Museum sind mit Sicherheit von derselben Hand, und es ist
anzunehmen, daß der Zeichner beider Ansichten Furnerius ist.

Malcolm Cormack identifizierte den Blickpunkt der Ansicht
südwestlich von Amsterdam, unmittelbar hinter dem Bollwerk
De Rose. Ein anderer Furnerius zugeschriebener Blick von dem
Bollwerk De Rose aus befindet sich in Haarlem (Sumowski IV,
Nr. 1022**). Die Gebäude auf unserer Zeichnung sind wohl, von
links nach rechts die Windmühlen des Bollwerks De Anjelier;
der Turm der Westerkerk und die Windmühle des Bollwerks De
Rose; der Turm der Torenschleuse und weiter im Hintergrund
der Gebäudekomplex der Nieuwekerk; rechts der Börsenturm
oder, auf Grund seiner Größe, der Turm der Zuiderkerk.

Amsterdam through the fog

Pen and brown ink, brown and grey-brown wash
103 x 209 mm
Inscribed, in brown ink, lower left: ‘abraham furnerius fecit’
and, below: ‘Myrinck’
Bequeathed by Sir Bruce Ingram, 1963. PD. 340–1963
Provenance: Lord Knutsford, his sale, London, Sotheby’s, 11 April
1935, lot 112; with P. & D. Colnaghi, London, from whom bought by
Ingram (Lugt 1405a), April 1935
Literature: K.T. Parker, *Catalogue of the Collection of Drawings in the
Ashmolean Museum*, I, Oxford, 1938, s.v.132; J. Bolten, *Dutch Drawings
from the Collection of Dr. C. Hofstede de Groot*, Utrecht, 1967, p. 80,
s.v. no. 44, note 4; Sumowski, IV, p. 2174, no. 987**; J. Giltay, ‘Abra-
ham Furnerius en Gerrit van Battem’, *Essays in Northern Art
presented to Egbert Haverkamp-Begemann on his sixtieth birthday*,
Doornspijk, 1983, p. 98, note 9
Exhibited: Cambridge, 1966, no. 30; Cambridge, 1977, no. 32;
Cambridge, 1985, handlist, p. 17

Furnerius studied with Rembrandt in the early 1640s, at the
same time as Samuel van Hoogstraten (1627–1678). He special-
ised in landscapes, but all his recorded paintings are lost. He is
thought to have been influenced by Philips de Koninck
(1619–1688), who became his brother-in-law in 1640. A num-
ber of drawings have been attributed to him on the basis of styl-
istic comparison with a few which have old written ascriptions
to him.

A drawing in the Ashmolean Museum, Oxford, showing a
Distant view of Amsterdam (Sumowski, IV, no. 984**), has an
inscription in the same hand as that on this drawing, likewise
attributing the drawing to Furnerius. As no authentic drawings
by Furnerius have been identified it is possible to attribute draw-
ings to him only on the basis of early attributions. Both the Fitz-
william and Ashmolean drawings are clearly by the same hand
and it is likely that the artist is Furnerius.

The viewpoint of this drawing, identified by Malcolm Cor-
mack, is from the land side of Amsterdam (South West), just
beyond the bulwark ‘De Rose’. Another view near the bulwark
‘De Rose’ attributed to Furnerius is in Haarlem (Sumowski, IV,
no. 1022**). The buildings shown seem to be, from left to right:
the windmills of the bulwark ‘De Anjelier’; the tower of the
Westerkerk, and the windmill of the bulwark ‘De Rose’; the
tower of the Torensluis and further away the bulk of the Nieuwe-
kerk; while at the right, either the tower of the Stock Exchange,
or, because of its relative size, the tower of the Zuiderkerk.

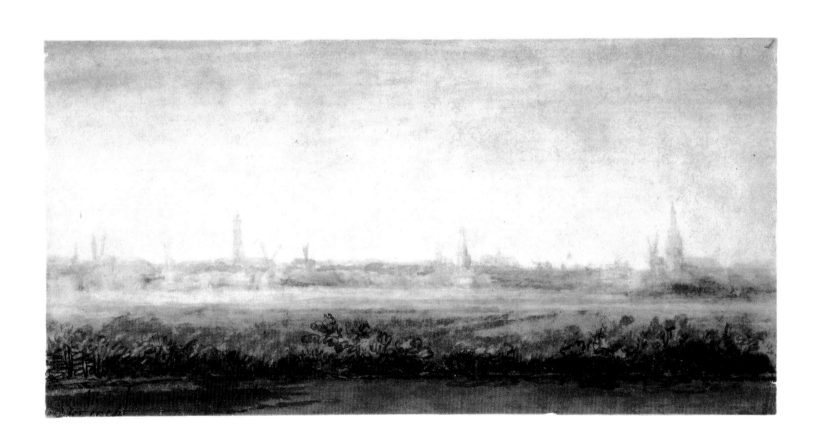

JAN VAN GOYEN
Leiden 1596–1656 Den Haag / The Hague

Landschaft mit einem Heuwagen und Schnittern

Schwarze Kreide und graue Lavierung, allseitig Randlinie mit Pinsel in Braun
111 x 194 mm
Links unten in schwarzer Kreide mit Initialen signiert und datiert ‚VG 1631'
Vermächtnis Sir Bruce Ingram, 1963. PD. 357–1963
Provenienz: (?) Auktion Sotheby's, London, 21. Februar 1934, in Lot 97; Kunsthandlung P. & D. Colnaghi, London; hier von Ingram (Lugt 1405 a) im Februar 1934 erworben
Literatur: Beck I, Nr. 100
Ausstellungen: Leiden, De Lakenhal, und Arnhem, Gemeentemuseum, 1960, *Jan van Goyen*, Nr. 71; Rotterdam / Amsterdam 1961/62, Nr. 43, Abb. 30; Cambridge 1985, handlist, S. 25

Nach einer Lehre bei Coenraet Adriaensz. van Schilperoort (1577–1635) und Isaac Claesz. Swanenburgh (um 1538–1614) in Leiden und bei Willem Gerritsz. in Hoorn reiste van Goyen wahrscheinlich 1615 nach Frankreich. 1617 ist er in Haarlem in der Werkstatt von Esaias van de Velde (1587–1630) bezeugt, der als Pionier der reinen Landschaftsmalerei einen beachtlichen Einfluß auf ihn ausübte. 1618 kehrte van Goyen nach Leiden zurück, wo er Anna Willemsdr. van Raelst ehelichte, mit der er drei Töchter hatte. 1634 zog er nach Den Haag; in seiner Werkstatt unterrichtete er zahlreiche Schüler, unter ihnen Nicolaes Berchem (1620–1683) und Jan Steen (1626–1679). Van Goyen starb verarmt im Jahre 1656.

Ihm verdankt die holländische Landschaftsmalerei eine neue Orientierung, die sich häufig in der Beschränkung auf monochrome Töne äußert. Die meisten seiner Zeichnungen entstanden vor der Natur, und eine große Anzahl ist erhalten geblieben, darunter vier Skizzenbücher mit Zeichnungen in Feder und Tusche aus seinen Jugendjahren und drei Bücher mit Zeichnungen in schwarzer Kreide aus den Jahren 1648–1651. Er bereiste ausgiebig die Niederlande und die Gegend um Kleve. Seine Gemälde sind nur selten mit Zeichnungen in Verbindung zu bringen. Eine unserem Blatt vergleichbare Zeichnung mit einem Heuwagen zur Linken, ebenfalls signiert und 1631 datiert, wurde bei Sotheby's, London, am 23. März 1972 als Lot 28 verkauft.

Landscape with a hay waggon and harvesters

Black chalk and grey wash, bordered on all sides by a line of brown wash
111 x 194 mm
Signed with initials and dated in black chalk, lower left: 'VG 1631'
Bequeathed by Sir Bruce Ingram, 1963. PD. 357–1963
Provenance: (?) London, Sotheby's, 21 February 1934, part of lot 97; with P. & D. Colnaghi, London, from whom bought by Ingram (Lugt 1405 a), February 1934
Literature: Beck, I, no. 100
Exhibited: Leiden, De Lakenhal, and Arnhem, Gemeentemuseum, 1960, *Jan van Goyen*, no. 71; Rotterdam / Amsterdam, 1961/62, no. 43 (plate 30); Cambridge, 1985, handlist, p. 25

After an apprenticeship with Coenraet Adriaensz. van Schilperoort (1577–1635) and Isaac Claesz. Swanenburgh (c. 1538–1614) at Leiden and with Willem Gerritsz. at Hoorn, van Goyen travelled to France, probably in 1615. By 1617 he was at Haarlem, studying with Esaias van de Velde (1587–1630), who had a considerable influence on him as a pioneer of pure landscape painting. In 1618 van Goyen was back in Leiden, where he married Anna Willemsdr. van Raelst, by whom he had three daughters. In 1634 he moved to The Hague, where he had a considerable number of pupils, including Nicolaes Berchem (1620–1683) and Jan Steen (1626–1679); he died in poverty in 1656.

Van Goyen gave a new orientation to Dutch landscape painting, often confining his work to an almost monochrome. Most of his drawings were done from nature and a large number survive, including four books of pen and ink sketches from his youth and three books of black chalk drawings dating from 1648–1651. He travelled extensively within the Netherlands and the region near Cleves. His paintings rarely relate to his surviving drawings. A similar drawing, with a haycart on the left, also signed and dated 1631, was sold at Sotheby's, London, 23 March 1972, lot 28.

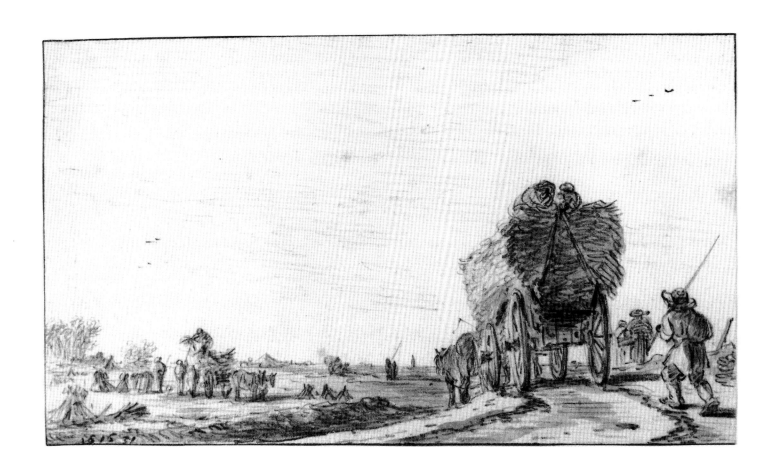

JAN VAN GOYEN
Leiden 1596–1656 Den Haag / The Hague

Flußlandschaft mit Windmühle

Schwarze Kreide
148 × 261 mm
Rechts unten in schwarzer Kreide mit Initialen signiert und datiert
,VG 1644'
Vermächtnis Sir Bruce Ingram, 1963. PD. 382–1963
Provenienz: Baron L. d'Ivry; Auktion d'Ivry, Paris, 7. Mai 1885,
Nr. 85; Kunsthandlung Lasquin; Mrs. Evans; Maurice Ruffer; Auktion
Ruffer, Sotheby's, London, 29. April 1931, Lot 6; Kunsthandlung
Larsen; Kunsthandlung P. & D. Colnaghi, London; hier von Ingram
(Lugt 1405a) erworben
Literatur: J. G. van Gelder, *Prenten en Tekeningen.* Amsterdam 1958,
S. 96, Abb. 99; Beck I, Nr. 151
Ausstellungen: London 1946/47, Nr. 11; London, Colnaghi, 1952,
Nr. 47; Bath 1952, Nr. 32; London 1953, Nr. 355; Bedford 1958, Nr. 22;
Washington u. a. 1959/60, Nr. 14; Leiden, De Lakenhal, und Arnhem,
Gemeentemuseum, 1960, *Jan van Goyen,* Nr. 78; Rotterdam / Amster-
dam 1961/62, Nr. 44; Wanderausstellung USA und Cambridge
1976/77, Nr. 73; Cambridge 1985, handlist, S. 25–26

Unser Blatt gehört zu einer Reihe von Zeichnungen des Jahres
1644, die alle ähnliche Maße und ähnliche Motive einer Szene-
rie am Flußufer aufweisen, welche jedoch mit keinem der
bekannten Gemälde van Goyens in Verbindung zu bringen ist.
Wie in der vorhergehenden Zeichnung mit dem Heuwagen hat
hier van Goyen einen großen Gegenstand – zur Seite versetzt –
in den Vordergrund seiner Komposition gerückt, um die Räum-
lichkeit zu verstärken.

A river landscape with a windmill

Black chalk
148 × 261 mm
Signed with initials and dated in black chalk, lower right:
'VG 1644'
Bequeathed by Sir Bruce Ingram, 1963. PD. 382–1963
Provenance: Baron L. d'Ivry, his sale, Paris, 7 May 1885, no. 85; with
Lasquin; Mrs Evans; Maurice Ruffer, his sale, London, Sotheby's, 29
April 1931, lot 6; with Larsen; with P. & D. Colnaghi, London, from
whom bought by Ingram (Lugt 1405a)
Literature: J. G. van Gelder, *Prenten en Tekeningen,* Amsterdam, 1958,
p. 96, pl. 99; Beck, I, no. 151
Exhibited: London, 1946/47, no. 11; London, Colnaghi, 1952, no. 47;
Bath, 1952, no. 32; London, 1953, no. 355; Bedford, 1958, no. 22;
Washington and American Tour, 1959/60, no. 14; Leiden, De Laken-
hal, and Arnhem, Gemeentemuseum, 1960, *Jan van Goyen,* no. 78;
Rotterdam / Amsterdam, 1961/62, no. 44; American Tour and Cam-
bridge, 1976/77, no. 73; Cambridge, 1985, handlist, p. 25/26

One of a number of drawings of 1644, of similar size with similar
elements arranged at the water's edge which do not recur, how-
ever, in any known painting. As in the drawing with the hay
waggon van Goyen has used a large object in the foreground of
his composition, set to one side, to emphasise the breadth of the
surrounding environment.

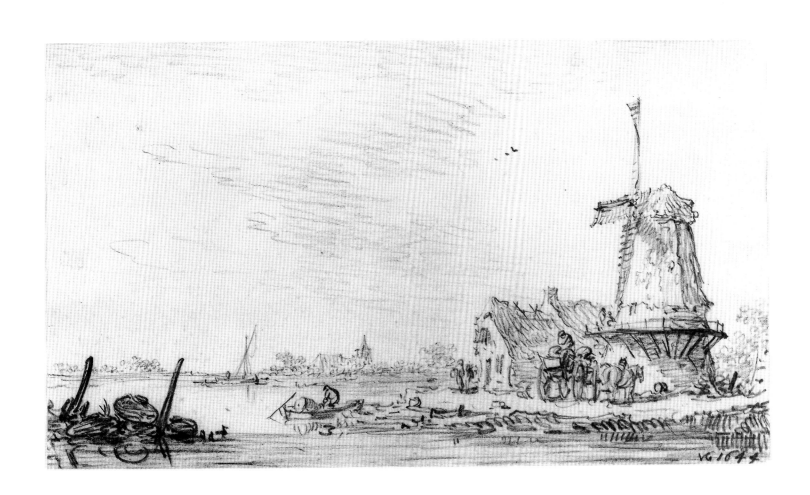

JAN VAN GOYEN
Leiden 1596–1656 Den Haag / The Hague

Ansicht von Dordrecht

Schwarze Kreide und graue Lavierung, allseitig Randlinie mit Pinsel
in Braun
110 x 170 mm
Vermächtnis Sir Bruce Ingram, 1963. PD. 369–1963
Provenienz: Earls of Warwick; Auktion Earls of Warwick, Sotheby's,
London, 17. Juni 1936, wahrscheinlich in Lot 127 oder 127 a; Kunst-
handlung P. & D. Colnaghi, London; hier von Ingram (Lugt 1405 a) im
Juni 1936 erworben
Literatur: Beck I, Nr. 697
Bisher noch nicht öffentlich ausgestellt

Die Ansicht zeigt die Stadtbefestigung (Papenbolwerk) und den
runden Turm der Engelenburg in Dordrecht. Van Goyen be-
suchte Dordrecht um 1648; Ansichten der Stadt finden sich in
seinem Dresdener Skizzenbuch (Kupferstich-Kabinett).

A view in Dordrecht

Black chalk and grey wash, bordered on all sides by a line
in brown wash
110 x 170 mm
Bequeathed by Sir Bruce Ingram, 1963. PD. 369–1963
Provenance: the Earls of Warwick, sale, London, Sotheby's, 17 June
1936, probably part of lot 127 or 127 a; with P. & D. Colnaghi,
London, from whom bought by Ingram (Lugt 1405 a), June 1936
Literature: Beck, I, no. 697
Not previously exhibited

This shows the Papal bulwark and Engelenburg round tower at
Dordrecht. Van Goyen visited Dordrecht c.1648, and there are
drawings of the town in his Dresden sketch-book (Kupferstich-
Kabinett).

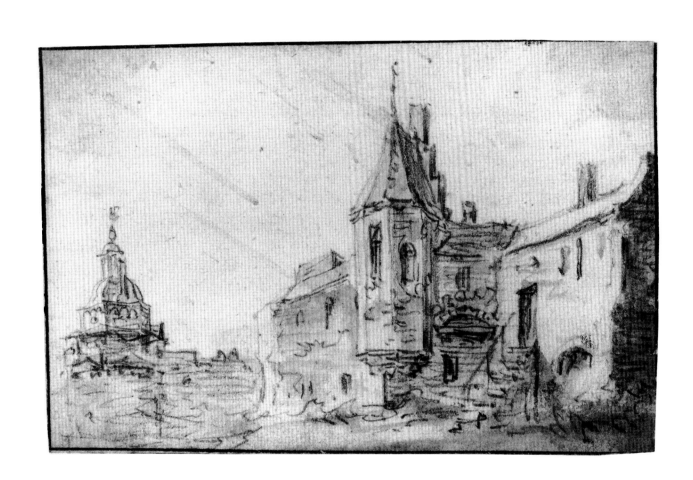

JAN VAN GOYEN
Leiden 1596–1656 Den Haag/The Hague

Kirchenruine

Schwarze Kreide, allseitig Randlinie aus schwarzer Kreide
156 x 203 mm
Verso mit Tinte numeriert ‚No 151'
Vermächtnis Sir Bruce Ingram, 1963. PD. 365–1963
Provenienz: Earls of Warwick; Auktion Earls of Warwick, Sotheby's, London, 17. Juni 1936, wahrscheinlich in Lot 127 oder 127a; Kunsthandlung P. & D. Colnaghi, London; hier von Ingram (Lugt 1405a) im Juni 1936 erworben
Literatur: Beck I, Nr. 819
Bisher noch nicht öffentlich ausgestellt

Ger Luijten erkannte auf diesem Blatt die gleiche Kirche wie in einer anderen Zeichnung aus dem Vermächtnis Ingram (PD. 364–1963), wo sie Beck (a. a. O., Nr. 480) als die Kirche von Noordwijkerhout, landeinwärts bei Lisse und nördlich von Noordwijk aan Zee gelegen, identifizierte. Jenes Blatt ist 1653 datiert, so daß unsere Zeichnung wahrscheinlich im gleichen Jahr entstanden ist. Die Kirche von Noordwijkerhout war vermutlich im Achtzigjährigen Krieg (1568–1648) zerstört worden.

A ruined church

Black chalk, bordered on all sides by a line of black chalk
156 x 203 mm
Numbered, *verso*, in ink: 'No 151'
Bequeathed by Sir Bruce Ingram, 1963. PD. 365–1963
Provenance: the Earls of Warwick, sale, London, Sotheby's, 17 June 1936, probably part of lot 127 or 127a; with P. & D. Colnaghi, London, from whom bought by Ingram (Lugt 1405a), June 1936
Literature: Beck, I, no. 819
Not previously exhibited

Ger Luijten recognised that this is a view of the same church as that in another of Ingram's drawings (PD. 364–1963) which Beck (*op. cit.*, no. 480) has identified as the church at Noordwijkerhout, inland from the sea, near Lisse and north of Noordwijk aan Zee. That example is dated 1653 which is the probable date of this drawing. The church was presumably damaged in the Eighty Years' War (1568–1648).

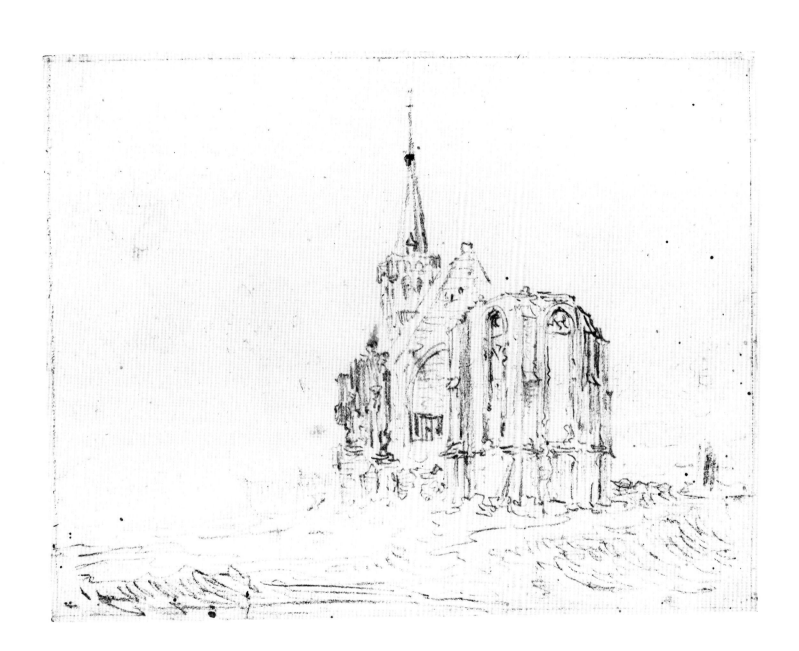

JAN VAN GOYEN
Leiden 1596–1656 Den Haag / The Hague

Gehöfte am Flußufer mit Bootsanlegestelle

Schwarze Kreide, rötlich-braune und graue Lavierung
173 x 275 mm
Vermächtnis Sir Bruce Ingram, 1963. PD. 375–1963
Provenienz: Lord Knutsford; Sir Bruce Ingram (Lugt 1405a)
Literatur: Beck I, Nr. 825
Ausstellungen: Cambridge, Fitzwilliam Museum, 1953/54 (o. Kat.);
Cambridge 1985, handlist, S. 24

Diese besonders sorgfältig ausgeführte Zeichnung ist ein heraus-
ragendes Beispiel für die Art, wie van Goyen Lavierung ein-
setzte; eindrucksvoll sind hier die Spiegelungen im Wasser. Um
so mehr verwundert es bei einer so ausgearbeiteten Zeichnung,
daß sie weder signiert noch datiert ist. Eine Kopie nach unserem
Blatt befand sich 1917 in der Kunsthandlung R. W. P. de Vries in
Amsterdam (Beck, a.a.O.).

Farm buildings by a river with shipping

Black chalk, reddish-brown and grey wash
173 x 275 mm
Bequeathed by Sir Bruce Ingram, 1963. PD. 375–1963
Provenance: Lord Knutsford; Sir Bruce Ingram (Lugt 1405a)
Literature: Beck, I, no. 825
Exhibited: Cambridge, Fitzwilliam Museum, 1953/54 (no handlist);
Cambridge, 1985, handlist, p. 24

The reflections in the water are especially effective in this draw-
ing which is a particularly elaborate example of van Goyen's use
of wash. It is surprising that he did not sign and date so finished
a drawing; Beck (*loc. cit.*) records a copy after it with the dealer
R. W. P. de Vries in Amsterdam in 1917.

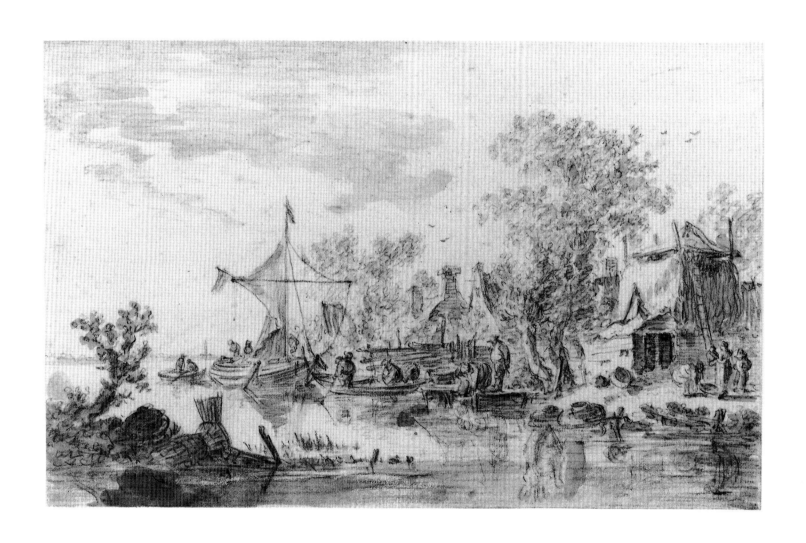

Waldlichtung mit einem Teich

Feder und braune Tusche, allseitig Randlinie mit Pinsel in Braun
263 x 405 mm, wohl beschnitten
Unten links in schwarzer Kreide mit Initialen bezeichnet ‚I.L.‘
Vermächtnis Sir Bruce Ingram, 1963. PD. 452–1963
Provenienz: Unbekannter Sammler, Blindstempel oben links und
rechte Ecken ‚I‘ und ‚V‘ (nicht bei Lugt); Kunsthandlung P. & D. Col-
naghi, London; hier von Ingram (Lugt 1405 a) April 1951 erworben
Literatur: H. Schneider, *Jan Lievens. Sein Leben und seine Werke.*
Supplement. Amsterdam 1973, S. 389, Nr. SZ 427; Sumowski VII, s. v.
Nr. 1679*, 6
Ausstellungen: Cambridge, Fitzwilliam Museum, 1953 (o. Kat.); Bed-
ford 1958, Nr. 26; Cambridge 1966, Nr. 40; Wanderausstellung USA
und Cambridge 1976/77, Nr. 78; Cambridge 1985, handlist, S. 18

Jan Lievens war der Sohn des Stickers Lievens Hendricx. 1615
begann er seine Ausbildung als Maler bei Joris van Schooten
(1587–1651) in Leiden; zwischen 1619 und 1621 war er Schüler
des Pieter Lastman (1583–1633) in Amsterdam. In den Jahren
1625 bis 1631 arbeitete er in engem Werkstattverband mit Rem-
brandt (1606–1669) in Leiden. 1632 bis 1635 bereiste Lievens
England; 1635 bis 1643 war er in Antwerpen tätig, wo er
Suzanna Colyns de Noie heiratete. Mit Ausnahme der Jahre in
Den Haag (1654–1658, 1670–1671) und Leiden (1672) ver-
brachte er den Rest seines Lebens in Amsterdam. Die Sujets sei-
ner Gemälde umfassen biblische und mythologische Historien,
Allegorien, Genre und Portraits sowie einige wenige Landschaf-
ten. Er trat als Holzschneider und Radierer hervor und war ein
begabter Zeichner.

 Keine der Landschaftszeichnungen, die Jan Lievens zuge-
schrieben werden, ist durch eine Signatur oder ein Dokument
gesichert, und Sumowski erkennt weder das Monogramm auf
unserer Zeichnung noch auf der *Waldlandschaft mit Flöte spielen-
dem Hirten* in Amsterdam an (Sumowski VII, S. 3710). Wie er
ausführt, kann der ganze Komplex der Landschaftszeichnungen
– die meisten von ihnen im Atelier ausgeführte idealisierte
Kompositionen – nicht genauer datiert werden. Die Land-
schaftszeichnungen von Lievens bilden eine „ziemlich homo-
gene Masse", wie Schneider anmerkt (a.a.O., S. 75); als Zeich-
ner war er stark von den Italienern beeinflußt, besonders von
Tizian, Campagnola, Agostino und Annibale Carracci. Er hatte
wahrscheinlich auf seiner Englandreise auch die Landschafts-
zeichnungen van Dycks gesehen und sich von dessen grazilem
Federstrich beeinflussen lassen. Im Gegensatz zu Wurzbach und
van Gelder, die einen großen Teil der Landschaftszeichnungen
Jan Lievens' seinem Sohn Jan Andrea (1644–1680) zuweisen,
sieht Sumowski keinen Grund, diese dem Vater abzusprechen.
Er ordnet unsere Zeichnung Waldlandschaften zu, die ihrer-
seits in enger Verwandtschaft stehen mit einer Zeichnung der
Fondation Custodia in Paris (Sumowski VII, Nr. 1670*), die um
1654/58 im Atelier nach einer Naturstudie entstanden ist. Wie
er beobachtet, weisen der kunstvolle Bildaufbau und die kalli-
graphische Linienführung hin auf eine typische Atelierzeichnung.

A wooded landscape with a pond

Pen and brown ink, bordered on all sides by a line of brown wash
263 x 405 mm, appears to be cut down
Inscribed with initials in black chalk, lower left: 'I. L.'
Bequeathed by Sir Bruce Ingram, 1963. PD. 452–1963
Provenance: unknown collector, blind stamp upper left and right
corners: 'I' and 'V' (not in Lugt); with P. & D. Colnaghi, London,
from whom bought by Ingram (Lugt 1405 a), April 1951
Literature: H. Schneider, *Jan Lievens, Sein Leben und seine Werke*,
supplement, Amsterdam, 1973, p. 389, no. SZ 427; Sumowski, VII, *s.v.*
no. 1679*, 6
Exhibited: Cambridge, Fitzwilliam Museum, 1953 (no handlist);
Bedford, 1958, no. 26; Cambridge, 1966, no. 40; American Tour and
Cambridge, 1976/77, no. 78; Cambridge, 1985, handlist, p. 18

Jan Lievens was the son of the embroiderer Lievens Hendricx. In
1615 he began to study with Joris van Schooten (1587–1651) at
Leiden and between 1619–1621 he was a pupil of Pieter Lastman
(1583–1633) in Amsterdam. From 1625–1631 he worked in
close association with Rembrandt (1606–1669) in Leiden. Dur-
ing 1632–1635 he travelled in England and from 1635–1643 he
was active in Antwerp where he married Suzanna Colyns de
Noie. Except for periods in The Hague (1654–58; 1670–71) and
Leiden (1672) he spent the rest of his life in Amsterdam. His
paintings include biblical and mythological history pictures,
allegories, genre and portraits as well as a few landscapes. He
made woodcuts and etchings and was a fine draughtsman.

 None of the landscape drawings attributed to Jan Lievens is
substantiated by a signature or document, and Sumowski disre-
gards the monogram both on this drawing and on the *Wooded
landscape with a shepherd playing the flute* in Amsterdam (Sumow-
ski, VII, p. 3710). As he explains, the whole of the landscape
material, most of it idealised compositions done in the studio,
cannot be dated with any precision. Lievens' landscape drawings
form a 'homogeneous entity' as Schneider noted; as a draughts-
man he was much influenced by the Italians, particularly Titian,
Campagnola and Agostino and Annibale Carracci. It is likely
also that he saw van Dyck's landscape drawings when he visited
England and was influenced by his delicate use of the pen.
Sumowski notes that despite Wurzbach's and van Gelder's
attempt to assign the large part of Lievens' landscape drawings
to his son, Jan Andrea (1644–1680), there is no reason to
ascribe most of the landscapes to him. Sumowski groups this
drawing with several wooded landscapes which he finds stylisti-
cally akin to a drawing in Paris, Fondation Custodia (Sumowski,
VII, no. 1670*), made after a study from nature, *c.*1654/58. As he
observes, the artful construction and calligraphic execution
argue for this type of drawing being a studio composition.

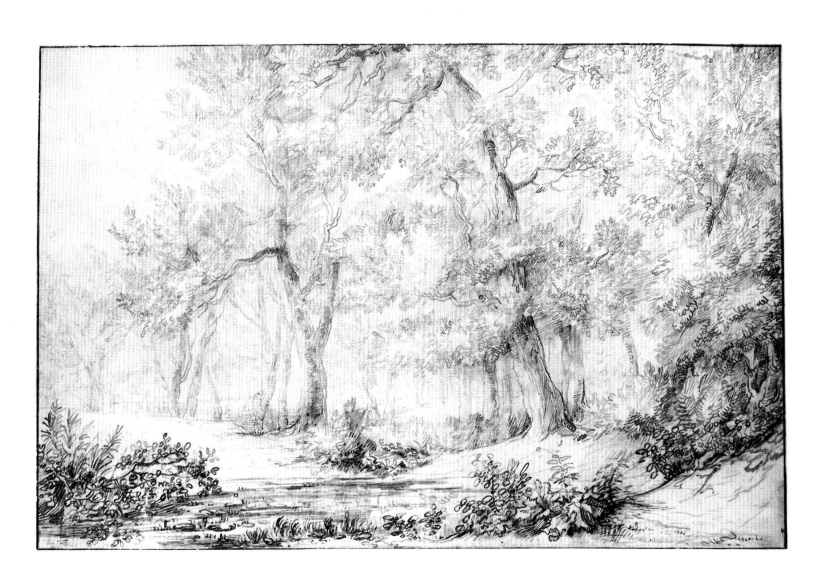

JAN LIEVENS der Ältere/the Elder
Leiden 1607–1674 Amsterdam

Baumgruppe mit Häusern im Hintergrund

Feder und braune Tusche, braune Lavierung
243 x 402 mm, beschnitten
Verso in Bleistift bezeichnet ‚J. Lievens' und numeriert ‚1607'
und ‚714'
Vermächtnis Sir Bruce Ingram, 1963. PD. 448–1963
Provenienz: Sir Robert Witt (Lugt 2228 b); Kunsthandlung P. & D. Colnaghi, London; hier von Ingram (Lugt 1405 a) im Januar 1939 erworben
Literatur: H. Schneider, *Jan Lievens. Sein Leben und seine Werke.* Haarlem 1932, S. 241, Z. 359; Sumowski VII, s. v. Nr. 1704*
Ausstellung: Cambridge 1966, Nr. 37

Das Blatt gehört zu einer Gruppe lavierter Zeichnungen, die Sumowski zur *Straße mit Bäumen und Pferdewagen bei einem Dorf* in Beziehung setzt (Northampton MA, Smith College Museum of Art; Sumowski VII, Nr. 1704*). Allerdings zeigt keine der anderen bei Sumowski abgebildeten Zeichnungen eine so kühn über den Vordergrund gezogene Lavierung, die eine deutliche Grenze setzt zwischen den Bäumen in der Zeichnung und dem Betrachter. Da die Umrisse der Häuser zur Linken nur angedeutet sind, liegt wohl eine unvollendete Arbeit vor.

A group of trees with houses in the background

Pen and brown ink, brown wash
243 x 402 mm, cut down
Inscribed, in pencil, *verso*: 'J. Lievens' and numbered '1607' and '714'
Bequeathed by Sir Bruce Ingram, 1963. PD. 448–1963
Provenance: Sir Robert Witt (Lugt 2228b); with P. & D. Colnaghi, London, from whom bought by Ingram (Lugt 1405 a), January 1939
Literature: H. Schneider, *Jan Lievens. Sein Leben und seine Werke*, Haarlem, 1932, p. 241, Z. 359; Sumowski, VII, *s.v.* no. 1704*
Exhibited: Cambridge, 1966, no. 37

One of a group of drawings with wash which Sumowski relates to a *Road with trees and a horse-drawn waggon near a village* in the Smith College Museum of Art, Northampton, Mass. (Sumowski, VII, no. 1704*). In fact no other drawing reproduced in Sumowski has so bold a sweep of wash across the foreground, effectively establishing a sense of distance between the trees and the viewer. The buildings on the left are barely sketched in, so that the drawing may be considered unfinished.

PIETER MOLIJN
London 1595–1661 Haarlem

Landschaft mit Bauernhaus am Fuß eines bewaldeten Hügels

Schwarze Kreide und graue Lavierung, schwarzer Kreidestrich entlang des rechten Randes der Darstellung; allseitig Randlinie mit Pinsel in Braun
351 x 314 mm
Oben links signiert und datiert ‚P Molyn' (PM ligiert)/ ‚1659'
Verso in Graphit bezeichnet ‚P. Molyn'
Vermächtnis Sir Bruce Ingram, 1963. PD. 473–1963
Provenienz: Henry Scipio Reitlinger; Auktion Reitlinger, Sotheby's, London, 23. Juni 1954, Lot 681; hier für Ingram (Lugt 1405 a) von Kunsthandlung P. & D. Colnaghi, London, erworben
Ausstellungen: Bedford 1958, Nr. 30; Washington u. a. 1959/60, Nr. 56; Rotterdam / Amsterdam 1961/62, Nr. 60; Wanderausstellung USA und Cambridge 1976/77, Nr. 80; Cambridge 1985, handlist, S. 11

Pieter Molijn war Maler, Zeichner und Radierer. 1616 wurde er in die Lukasgilde in Haarlem aufgenommen, wo er bis zu seinem Tode lebte. 1624 heiratete er Mayken Gerards; im gleichen Jahr trat er in die Gilde der Büchsenmacher ein. Zu seinen Schülern zählen Allaert van Everdingen (1621–1675) und Gerard ter Borch (1617–1681). Molijn gehört zu den wenigen holländischen Künstlern, die ihre Zeichnungen fast immer signierten und datierten.

Unser Blatt ist erheblich mehr durchgearbeitet als die meisten Zeichnungen Molijns und steht den Arbeiten van Goyens, dem Molijn meist sehr ähnelt, am wenigsten nahe. Auf Grund des ungewöhnlichen Hochformats vermutete Carlos van Hasselt, daß es sich um eine Vorzeichnung für eine Wanddekoration handelt, möglicherweise für ein Wandbild auf Leinwand, wie es in Holland im 18. Jahrhundert üblich werden sollte.

Landscape with a farm on a wooded hillside

Black chalk and grey wash, a line of black chalk along the right; bordered on all sides by a line of brown wash
351 x 314 mm
Signed and dated, upper left : 'P Molyn' (the PM in monogram)/ '1659'
Inscribed, *verso*, in graphite: 'P.Molyn'
Bequeathed by Sir Bruce Ingram, 1963. PD. 473–1963
Provenance: Henry Scipio Reitlinger, his sale, London, Sotheby's, 23 June 1954, lot 681; bought by P. & D. Colnaghi, London, for Ingram (Lugt 1405 a)
Exhibited: Bedford, 1958, no. 30; Washington and American Tour, 1959/60, no. 56; Rotterdam / Amsterdam, 1961/62, no. 60; American Tour and Cambridge, 1976/77, no. 80; Cambridge, 1985, handlist, p. 11

Pieter Molijn was a painter, draughtsman and etcher. In 1616 he enrolled in the Guild of St Luke at Haarlem, where he lived until his death. He married Mayken Gerards in 1624, the same year that he joined the Gunsmiths' Guild. His pupils include Allaert van Everdingen (1621–1675) and Gerard ter Borch (1617–1681). Molijn was one of the few Dutch artists who almost always signed and dated his drawings.

This is more elaborate than most of Molijn's drawings: its scale is more impressive and it is less like van Goyen's work, whom Molijn often resembles. The unusual vertical format has suggested to Carlos van Hasselt that it may have been designed for a mural decoration – perhaps for a wall-painting done on canvas, which was to become the common practice in Holland in the eighteenth century.

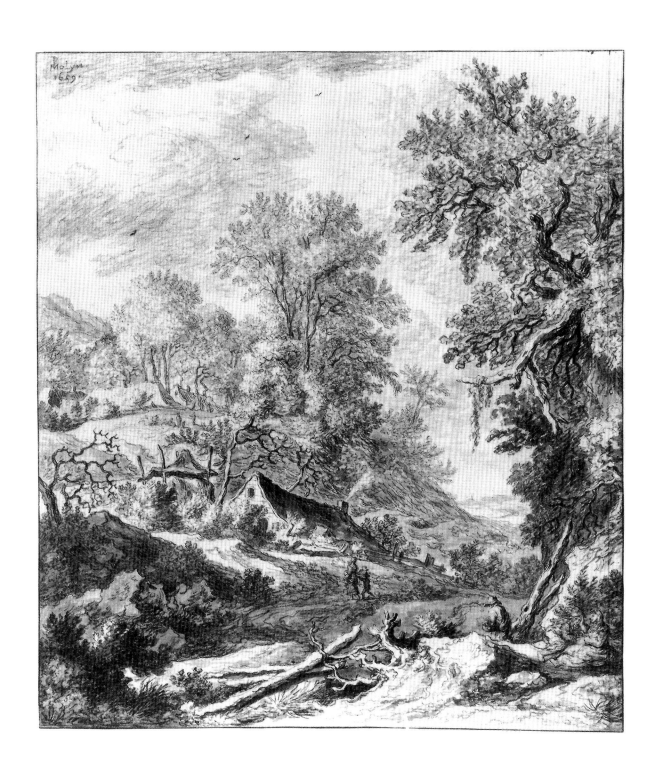

ADAM PIJNACKER
Pijnacker (bei/near Delft) 1622–1673 Amsterdam

Studie von Bäumen im Wald

Dünner Pinsel in Braun und braune Lavierung über Graphit, allseitig
Randlinie mit Pinsel in Braun
338 x 417 mm
Verso in brauner Tusche bezeichnet ‚Jan Bodt'; in Bleistift ‚2‘,7 p‘;
‚Pyna…‘; ‚UG‘; auf der alten Montierung in brauner Tusche ‚Jan
Both‘ (ausradiert); ‚64 S. R.‘
Geschenk Sir Frank Brangwyn R. A., 1943. Nr. 2582
Provenienz: Barthold Suermondt (Lugt 415); nicht lokalisier- und
datierbare französische Auktion, Lot 18, als Jan Both; Sir Frank
Brangwyn
Ausstellung: Cambridge 1985, handlist, S. 3, als Jan Both

Pijnacker begann möglicherweise als Geschäftsmann, als Wein-
händler wie sein Vater. Wahrscheinlich hielt er sich zwischen
1645 und 1648 in Italien auf; sein frühestes datiertes Gemälde
stammt aus dem Jahre 1650. Als er 1658 Eva de Geest aus
Leeuwarden heiratete, trat er zum Katholizismus über. Aus der
Ehe gingen ein Sohn und eine Tochter hervor. Pijnacker ist als
Maler, Zeichner und Radierer bekannt. Er arbeitete hauptsäch-
lich italianisierend unter dem Einfluß von Jan Both (um
1615–1652) und Jan Asselijn (1610/14–1652).

In unsere Sammlung gelangte die Zeichnung mit einer
Zuschreibung an Jan Both; Carlos van Hasselt wies sie dann An-
thonie Waterloo (1609–1690) zu. Wegen der Ähnlichkeiten in
Technik und Art der Zeichnung mit Jan Both hielt J. Rosenberg
die Zuschreibung an ihn für möglich (vgl. die Both-Zeichnun-
gen in Berlin, Kupferstichkabinett [Bock-Rosenberg, Nr. 557]
und München [Wegner, Nrn. 307 und 308]), doch erinnern
Komposition und Feinheit der Lavierungen eher an Pijnacker
(vgl. die Zeichnungen in München [Wegner, Nr. 839] und Paris
[Fondation Custodia, Nr. 6952]). Sowohl Martin Royalton-Kish
als auch Christopher Brown stimmen der Zuschreibung an
Pijnacker zu; obwohl keine direkten Vergleiche mit Gemälden
von seiner Hand greifen, legen Lichtführung und Disposition
der Bäume eine Datierung in die sechziger Jahre nahe.

Study of trees in a wood

Point of the brush and brown wash over graphite, bordered on all sides
by a line of brown wash
338 x 417 mm
Inscribed, *verso*, in brown ink: ‘Jan Bodt’; in pencil : ‘2’ ‘7p’; ‘Pyna..’;
‘UG’; on the old mount in brown ink: ‘Jan Both’(erased); ‘64 S.R.’
Given by Sir Frank Brangwyn R. A., 1943. No. 2582
Provenance: Barthold Suermondt (Lugt 415); sale in France of uncer-
tain date and place, lot 18, as Jan Both; Sir Frank Brangwyn
Exhibited: Cambridge, 1985, handlist, p. 3, as Jan Both

Pijnacker may have begun his career as a businessman, following
in his father's footsteps as a wine merchant. He was probably in
Italy between 1645 and 1648 and the earliest dated painting by
him is from 1650. In 1658 he married Eva de Geest of Leeu-
warden, converting to Catholicism on that occasion; they had a
son and a daughter. Pijnacker was known as a painter, draughts-
man and etcher. He worked mostly in the Italianate manner and
seems to have based his work on Jan Both (c.1615–1652) and
Jan Asselijn (1610/14–1652).

This drawing entered the collections with an attribution to
Jan Both but was attributed subsequently to Anthonie Waterloo
(1609–1690) by Carlos van Hasselt. There is a similarity in
technique and type with drawings by Jan Both and J. Rosenberg
thought an attribution to him possible (compare those at Berlin,
Kupferstichkabinett [Bock-Rosenberg, no. 557] and Munich
[Wegner, nos. 307, 308]), but the *mise-en-page* and subtlety of
the washes is more reminiscent of Pijnacker (compare Munich
[Wegner, no. 839] and Paris [Fondation Custodia, no. 6952]).
Both Martin Royalton-Kish and Christopher Brown concur with
the attribution to Pijnacker, and although no direct comparison
can be made with any of his paintings the handling of light and
disposition of the trees on the paper suggest a date in the 1660s.

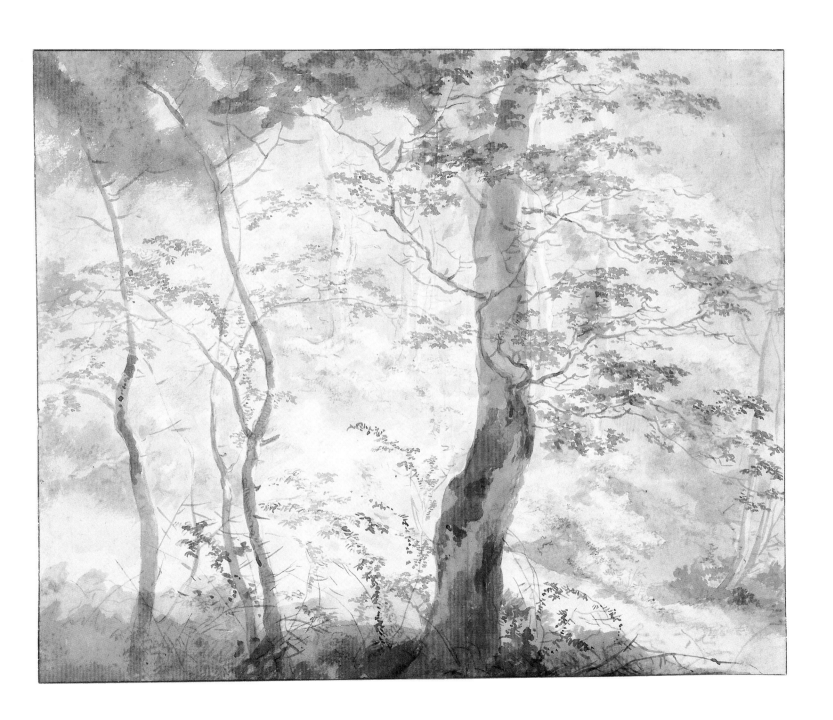

Bauernhaus unter Bäumen mit einem Steg

Rohrfeder und braune Tusche, Spuren von schwarzer Kreide und Weißhöhung, graue Lavierung, auf bräunlichem Papier, allseitig Randlinie mit Graphit
159 x 182 mm, allseitig beschnitten
Unten links in brauner Tusche bezeichnet „... embrant'
Provenienz: Unbekannt, 1946 in die Sammlung aufgenommen.
Nr. 3106
Literatur: Benesch 1947, Nr. 172; Benesch VI, Nr. 1274, Abb. 1503; Cynthia P. Schneider, *Rembrandt's landscapes: drawings and prints.* Ausstellungskatalog Washington 1990, S. 129, Abb. 1
Ausstellungen: Cambridge 1966, Nr. 6; Cambridge 1985, handlist, S. 15; Wanderausstellung USA 1989/90, Nr. 90; Cambridge 1993/94, Nr. 38

Rembrandt war Sohn eines Müllers und schrieb sich 1620 an der Universität Leiden ein. Er lernte bei dem Historienmaler Jacob Isaacsz. Swanenburgh (um 1571–1638), danach in Amsterdam um 1623/24 bei Pieter Lastman (1583–1633) und dann bei Jacob Pynas (um 1585–nach 1656). Nach seiner Rückkehr nach Leiden arbeitete er einige Zeit mit Jan Lievens (1607–1674), um sich dann 1631 endgültig in Amsterdam niederzulassen. 1632 heiratete er Saskia van Uylenburgh, die 1642 starb. 1645 zog Hendrickje Stoffels in seinen Haushalt. Rembrandt erklärte sich 1656 für bankrott und war 1658 gezwungen, seine Kunstsammlungen zu veräußern. Ein Kind, Titus, erreichte das Erwachsenenalter, aber starb vor seinem Vater im Jahre 1668.

Rembrandt war ein herausragender Portraitist, aber er malte auch Landschaften, Stilleben, Historienbilder und religiöse Sujets; er war ein höchst bedeutender Zeichner und in seinem druckgraphischen Werk der innovativste und ausdrucksstärkste Künstler seiner Generation. Unter seinen zahlreichen Schülern sind vor allen zu nennen Ferdinand Bol (1616–1680), Gerrit Dou (1613–1675), Gerbrand van den Eeckhout (1621–1674), Carel Fabritius (1622–1654), Govaert Flinck (1615–1660), Aert de Gelder (1645–1727), Samuel van Hoogstraten (1627–1678), Philips de Koninck (1619–1688) und Nicolaes Maes (1634–1693).

Unsere Zeichnung diente im Gegensinn für die Radierung von 1652, *Das Gehölz* (Hollstein 222). Das Blatt steht der Radierung näher als die Zeichnungen mit dem gleichen Motiv in Rotterdam (Benesch VI, Nr. 1272) und Berlin (wahrscheinlich Rembrandt-Schule, Benesch VI, Nr. 1273).

In den Jahren zwischen 1650 und 1652 schuf Rembrandt eine Reihe von Landschaftszeichnungen in Rohrfeder, von denen die meisten Gehölze und Buschwerkgruppen darstellen. Frits Lugt (*Mit Rembrandt in Amsterdam.* Berlin 1920, S. 121) nahm an, daß er diese Motive am Amstelufer fand. Die Weißhöhung und die grauen Lavierungen sind mit ziemlicher Sicherheit Zutaten einer anderen Hand aus dem 17. Jahrhundert. Dies sah zuerst 1931 Dr. Göpel (Leipzig); Haverkamp-Begemann verwies darüber hinaus auf zwei Landschaftszeichnungen in der Frick Collection, New York (Benesch VI, Nrn. 1313 und 1325), die ähnliche Überarbeitungen aufweisen.

Farmhouse beneath trees, with a footbridge

Reed pen and brown ink, traces of black chalk and white heightening, grey wash, on brownish paper, bordered by a line of graphite on all sides
159 x 182 mm, cut down on all sides
Inscribed, lower left in brown ink: '... embrant'
Provenance: uncertain, accessioned in 1946. No. 3106
Literature: Benesch, 1947, no. 172; Benesch, VI, no. 1274, fig. 1503; Cynthia P. Schneider, *Rembrandt's landscapes: drawings and prints,* Exhib. Cat., Washington, 1990, p. 129, fig. 1
Exhibited: Cambridge, 1966, no. 6; Cambridge, 1985, handlist, p. 15; American Tour, 1989/90, no. 90; Cambridge, 1993/94, no. 38

The son of a miller, Rembrandt was enrolled at University in Leiden in 1620. He studied there with the history painter Jacob Isaacsz. Swanenburgh (c.1571–1638) and at Amsterdam, c.1623/24, with Pieter Lastman (1583–1633) and Jacob Pynas (c.1585–after 1656). He returned to Leiden and worked for a time with Jan Lievens (1607–1674) before returning to Amsterdam for good in 1631. In 1632 he married Saskia van Uylenburgh who died in 1642. In 1645 Hendrickje Stoffels came to live with Rembrandt. In 1656 he was declared bankrupt and was obliged to sell his important art collections in 1658. One child, Titus, survived to maturity, but he pre-deceased his father, dying in 1668.

Rembrandt was an exceptional painter of portraits and also painted landscape, still-life and history and religious paintings. A superb draughtsman he was the most innovative and expressive print-maker of his generation. He had many students, including Ferdinand Bol (1616–1680), Gerrit Dou (1613–1675), Gerbrand van den Eeckhout (1621–1674), Carel Fabritius (1622–1654), Govaert Flinck (1615–1660), Aert de Gelder (1645–1727), Samuel van Hoogstraten (1627–1678), Philips de Koninck (1619–1688), and Nicolaes Maes (1634–1693).

Used in reverse for the etching of 1652 *Clump of trees with a vista* (Hollstein 222). It is closer to the etching than the drawings of the same motif in Rotterdam (Benesch, VI, no. 1272) and Berlin (probably Rembrandt school, Benesch, VI, no. 1273).

Rembrandt made a number of landscape drawings with a reed pen between 1650 and 1652, mostly representing clumps of trees and copses. Frits Lugt (*Mit Rembrandt in Amsterdam*, Berlin, 1920, p. 121) suggested that the site of these drawings was along the Amstel. The white heightening and the grey washes were almost certainly added by another seventeenth-century hand. This was first suggested by Dr Göpel (Leipzig) in 1931, and Haverkamp-Begemann has pointed out that in this respect it is similar to two landscape drawings in the Frick Collection, New York (Benesch, VI, nos. 1313, 1325).

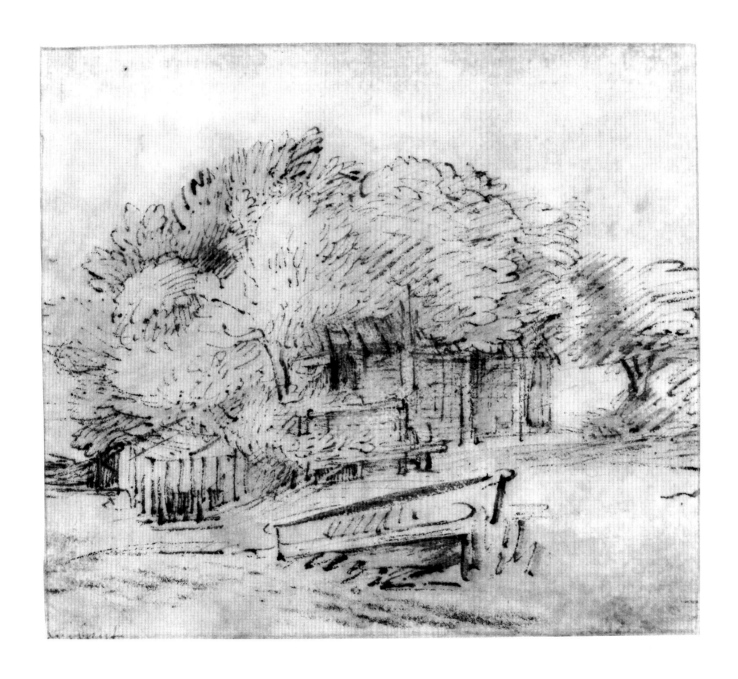

Landschaft mit Wanderer, der auf eine Klippe zuschreitet

Feder und braune Tusche mit farbigen Lavierungen über schwarzer Kreide, allseitig Randlinie mit Pinsel in Braun
161 x 242 mm
Unten links in brauner Tusche signiert ‚Roelant Roghman'
Verso in Graphit bezeichnet ‚PS/PS/-'
Vermächtnis Sir Bruce Ingram, 1963. PD. 648–1963
Provenienz: Kunsthandlung E. Parsons, London, 1934, Nr. 51; entweder hier oder möglicherweise im Dezember 1947 in der Kunsthandlung P. & D. Colnaghi, London, von Ingram (Lugt 1405 a) erworben
Ausstellungen: Cirencester 1951, Nr. 34; London, Colnaghi, 1952, Nr. 37; Bath 1952, Nr. 45; Cambridge, Fitzwilliam Museum, 1953 (o. Kat.); London, Colnaghi, 1956, Nr. 30; Bedford 1958, Nr. 36; Cambridge 1985, handlist, S. 8

Roelant Roghmans Vater, Hendrick Lambertsz. (1600/01–nach 1647), war Kupferstecher von Beruf und seine Mutter Maria die Tochter des Malers Roelandt Savery (1576–1639). Seine erste Ausbildung als Maler erhielt Roghman bei seinem Onkel; später war er mit Gerbrand van den Eeckhout (1621–1674) und mit Rembrandt (1606–1669) bekannt, dessen Stil der vierziger Jahre ihn stark beeinflußte. Sein Werk zeigt auch die Kenntnis der Arbeiten Anthonie Waterloos (1609–1690) und Simon de Vliegers (um 1601–1653). Innerhalb seines Œuvres am wichtigsten ist eine Folge von 241 großformatigen topographischen Zeichnungen mit Kastellen und Landschlössern in Holland, Utrecht und Gelderland, entstanden zwischen 1646 und 1647 (im Fitzwilliam Museum, Cambridge, die Zeichnung des *Kastells von Marquette* [PD. 645–1963]). In den frühen fünfziger Jahren ging er nach Italien. Von seiner Hand stammen etwa fünfzig Radierungen und einige wenige Gemälde; als Zeichner hingegen war er überaus fruchtbar, und er ist einer der wichtigsten Landschaftszeichner des 17. Jahrhunderts in Holland.

Abgesehen von der umfangreichen Gruppe der „kasteeltekeningen", die zwischen 1646 und 1647 ausgeführt wurden, ist es sehr schwierig, Zeichnungen Roghmans zu datieren. Unser Blatt gehört in die Kategorie, die Sumowski (X, S. 5041) „Monumentallandschaften" nennt. Innerhalb dieser Gruppe ist nur eine Zeichnung in Leipzig (Sumowski X, Nr. 2234) mit der Datierung 1655 versehen; Radierungen und Gemälde dieser Kategorie sind nicht datiert. Ungewöhnlich ist unsere Zeichnung wegen ihrer farbigen Lavierungen, doch besteht kein Grund, deren Eigenhändigkeit anzuzweifeln, da sie in ihrer Art sehr gut vergleichbar sind mit denen auf der Amsterdamer Zeichnung *Reisende bei einem Gasthaus im Wald* (Rijksprentenkabinet, Nr. 1880 A. 550).

Landscape with a traveller approaching a cliff

Pen and brown ink and coloured washes over black chalk, bordered on all sides by a line of brown wash
161 x 242 mm
Signed, lower left in brown ink: 'Roelant Roghman'
Inscribed, *verso*, in graphite: 'PS/PS/-'
Bequeathed by Sir Bruce Ingram, 1963. PD. 648–1963
Provenance: with E. Parsons, London, 1934, no. 51; either acquired by Ingram (Lugt 1405 a) at that time or possibly with P. & D. Colnaghi, London, from whom bought by Ingram, December 1947
Exhibited: Cirencester, 1951, no. 34; London, Colnaghi, 1952, no. 37; Bath, 1952, no. 45; Cambridge, Fitzwilliam Museum, 1953 (no handlist); London, Colnaghi, 1956, no. 30; Bedford, 1958, no. 36; Cambridge, 1985, handlist, p. 8

Roghman's father, Hendrick Lambertsz. (1600/01–after 1647) was an engraver and his mother, Maria, was the daughter of Roelandt Savery (1576–1639). Roghman first studied with his uncle and later was acquainted with Gerbrand van den Eeckhout (1621–1674) and with Rembrandt (1606–1669) whose style of the 1640s influenced him greatly. His style is also influenced by Anthonie Waterloo (1609–1690) and Simon de Vlieger (c.1601–1653). Roghman's most important work is a series of 241 large topographical drawings of castles and country-seats in Holland, Utrecht and Gelderland, done between 1646 and 1647 (the Fitzwilliam owns one of *The Castle of Marquette* [PD. 645–1963]). Early in the 1650s he went to Italy. He produced about 50 etchings and his painted output is small, but as a draughtsman he was extremely prolific and is one of the principal landscapists of seventeenth-century Holland.

Apart from the group of castles executed in 1646/47 it is extremely difficult to assign a date to Roghman's drawings. This example belongs to the category classified by Sumowski (X, p. 5041) as 'monumental landscape'. Of this group only the drawing in Leipzig (Sumowski, X, no. 2234) is dated, 1655; the etchings and related paintings are not dated. This drawing is unusual in having coloured washes but there is no reason to doubt their authenticity and they compare well with the similar colours on the *Travellers near an inn in the woods* in the Rijksprentenkabinet, Amsterdam (no. 1880 A. 550).

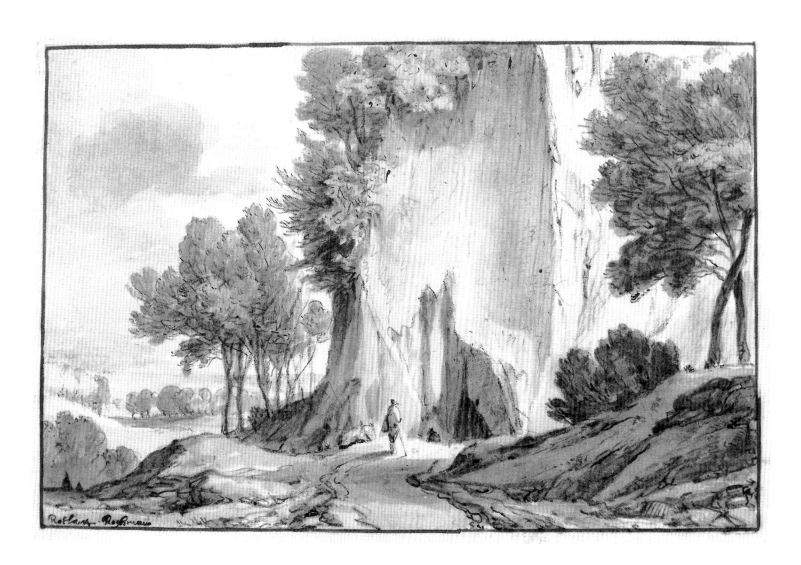

ROELANT ROGHMAN
Amsterdam 1627–1692 Amsterdam

Felsige Landschaft mit Wanderern auf einer Straße zur Linken

Feder und braune Tusche, graue und braune Lavierung über schwarzer Kreide, allseitig Randlinie mit Pinsel in Braun
151 x 232 mm
Unten links in brauner Tusche signiert ‚R. Roghman‘
Verso in Tinte bezeichnet ‚F. Gawet 808‘; eine weitere, ausradierte unleserliche Beschriftung
Vermächtnis Sir Bruce Ingram, 1963. PD. 655–1963
Provenienz: F. Gawet (Lugt 1069); J. D. Böhm (Lugt 271); Kunsthandlung P. & D. Colnaghi, London; hier von Ingram (Lugt 1405 a) im März 1937 erworben
Ausstellungen: London 1946/47, Nr. 15; Cambridge, Fitzwilliam Museum, 1953 (o. Kat.); London, Colnaghi, 1956, Nr. 30; Cambridge 1985, handlist, S. 6

Unser Blatt gehört zu Roghmans Zeichnungen, die Sumowski (X, S. 5041) unter der Kategorie „Monumentallandschaften" zusammenfaßt, und stammt wohl aus den fünfziger Jahren.

A rocky landscape with travellers on a road to the left

Pen and brown ink, grey and brown wash over black chalk, bordered on all sides by a line of brown wash
151 x 232 mm
Signed, lower left, in brown ink: 'R. Roghman'
Inscribed, *verso*, in ink: 'F. Gawet 808'; and another illegible inscription, erased
Bequeathed by Sir Bruce Ingram, 1963. PD. 655–1963
Provenance: F. Gawet (Lugt 1069); J. D. Böhm (Lugt 271); with P. & D. Colnaghi, London, from whom bought by Ingram (Lugt 1405 a) in March 1937
Exhibited: London, 1946/47, no. 15; Cambridge, Fitzwilliam Museum, 1952/53 (no handlist); London, Colnaghi, 1956, no. 30; Cambridge, 1985, handlist, p. 6

One of the group of drawings classified by Sumowski as 'monumental', this may date from the 1650s.

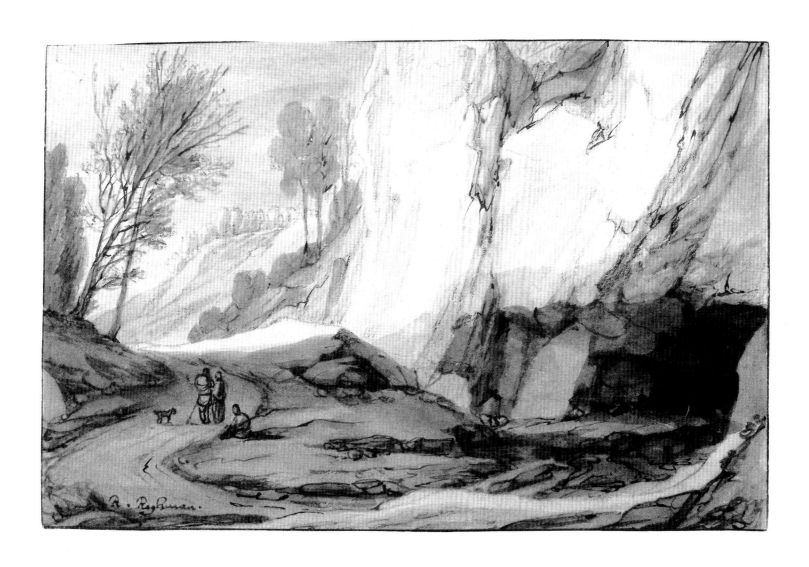

ABRAHAM RUTGERS der Ältere/the Elder
Amsterdam 1632–1699 Amsterdam

Feld mit Garbenbündeln vor einem Dorf

Feder und braune Tusche, allseitig Randlinie mit Pinsel in Braun
98 x 181 mm
Vermächtnis Sir Bruce Ingram, 1963. PD. 662–1963
Provenienz: A. W. M. Mensing; Auktion Mensing, Amsterdam,
27. April 1937, Lot 204 (als Furnerius); Kunsthandlung P. & D. Colnaghi, London; hier von Ingram (Lugt 1405a) im Mai 1937 erworben
Literatur: Christopher White, Drawings in the Ingram Collection.
Apollo Magazine 75, 1962, S. 63 (m. Abb.)
Ausstellung: Rotterdam / Amsterdam 1961/62, Nr. 75

Rutgers war von Beruf Tuchhändler, hatte sich aber auch als Amateur mit seinen Zeichnungen topographischer Ansichten und Landschaften einen Namen gemacht. Man hat angenommen, daß er Schüler des Ludolf Backhuizen (1631–1708) war. Gesichert jedoch ist seine Freundschaft mit Jacob Esselens (1626–1687), durch den er mit Rembrandts Stil in Berührung kam. Rutgers Zeichenstil ist eng verwandt dem des Anthonie van Borssom (1629/30–1677) und des Johannes Leupenius (1643–1693). Die meisten Motive seiner Zeichnungen stammen aus dem südlichen Gebiet an der Vecht, wo seine Familie ein Landhaus besaß. Sein Enkel Anthonie Rutgers der Jüngere war ein bekannter Sammler und *marchand amateur*.

Viele von Rutgers Zeichnungen sind fälschlicherweise anderen Künstlern zugewiesen worden; so nahm man früher an, daß unser Blatt von der Hand des Abraham Furnerius (um 1628–1654) stamme. Eine vergleichbare Zeichnung einer *Straße, die in ein Dorf führt,* in schwarzer Kreide, bewahrt das Rijksprentenkabinet in Amsterdam (A. 3535)

A field with corn stooks at the edge of a village

Pen and brown ink, bordered on all sides by a line of brown wash
98 x 181 mm
Bequeathed by Sir Bruce Ingram, 1963. PD. 662–1963
Provenance: A. W. M. Mensing, his sale, Amsterdam, 27 April 1937, lot 204 (as Furnerius); with P. & D. Colnaghi, London, from whom bought by Ingram (Lugt 1405a), May 1937
Literature: Christopher White, 'Drawings in the Ingram Collection', *Apollo Magazine*, 75, 1962, p. 63, repr.
Exhibited: Rotterdam / Amsterdam, 1961/62, no. 75

Rutgers, by profession a cloth merchant, was an amateur but much esteemed draughtsman of topographical views and landscapes. It has been suggested that he was a pupil of Ludolf Backhuizen (1631–1708). What is certain is that he was a friend of Jacob Esselens (1626–1687), through whom he came into contact with Rembrandt's style. His own technique is close to that of Anthonie van Borssom (1629/30–1677) and Johannes Leupenius (1643–1693). Most of the scenes in his drawings are located in the southern part of the Vecht region where his family owned property. His grandson, Anthonie Rutgers the Younger, was a well-known collector and *marchand amateur*.

Many of Rutgers' drawings have been mis-attributed to other artists. This one was formerly considered to be by Abraham Furnerius (c.1628–1654). A comparable drawing of a *Road leading into a village*, in black chalk, is in the Rijksprentenkabinet, Amsterdam (A.3535).

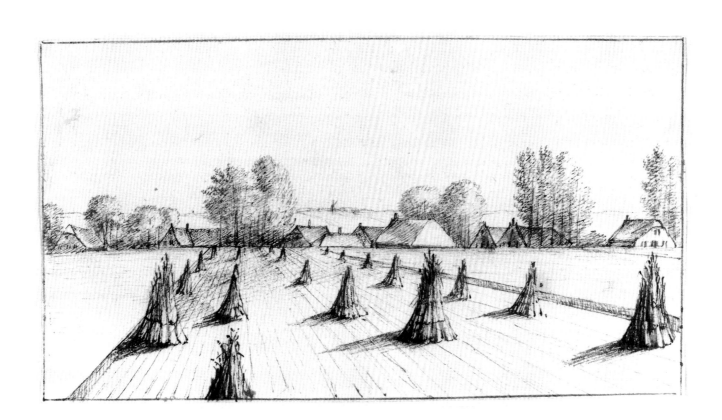

ABRAHAM RUTGERS der Ältere/the Elder
Amsterdam 1632–1699 Amsterdam

Tor zu einem Gehöft mit Graben

Feder und braune Tusche, braune Lavierung und Spuren von Weißhöhung über schwarzer Kreide, allseitig Randlinie mit Pinsel in Braun
112 x 209 mm
Verso unleserlich in Graphit bezeichnet
Vermächtnis Sir Bruce Ingram, 1963. PD. 664–1963
Provenienz: Galton; A. W. M. Mensing; Auktion Mensing, Amsterdam, 29. April 1937, Lot 620; Kunsthandlung P. & D. Colnaghi, London; hier von Ingram (Lugt 1405 a) im Mai 1937 erworben
Ausstellungen: Cambridge, Fitzwilliam Museum, 1953 (o. Kat.); Cambridge 1985, handlist, S. 21

Unser Blatt ist ein besonders charakteristisches Beispiel für Roghmans Zeichenkunst und läßt sich mit zahlreichen der 88 Zeichnungen im Museum Mr. Simon van Gijn in Dordrecht vergleichen, die in einem Album mit 1686/87 datiertem Titelblatt eingeklebt sind. Dieses Album, das wahrscheinlich vom Künstler selbst zusammengestellt wurde, ist in drei Kategorien gegliedert: „Principale" (Zeichnungen unmittelbar nach der Natur), „Inventive" (Phantasieszenerien mit Gebirgslandschaften und Ruinen) und „Copijen" (Kopien nach anderen Meistern). Die Motive etlicher Zeichnungen konnten identifiziert werden und zeigen, daß Rutgers hauptsächlich in der Landschaft zwischen Amsterdam und Utrecht arbeitete.

A gate to a moated farmhouse

Pen and brown ink, brown wash, traces of white heightening, over black chalk, bordered on all sides by a line of brown wash
112 x 209 mm
Inscribed in graphite, illegibly, *verso*
Bequeathed by Sir Bruce Ingram, 1963. PD. 664–1963
Provenance: Galton; A. W. M. Mensing, his sale, Amsterdam, 29 April 1937, lot 620; with P. & D. Colnaghi, London, from whom bought by Ingram (Lugt 1405 a), May 1937
Exhibited: Cambridge, Fitzwilliam Museum, 1953 (no handlist); Cambridge, 1985, handlist, p. 21

A highly characteristic example of Rutgers' draughtsmanship, comparable with many of the 88 drawings in the Museum Mr. Simon van Gijn, Dordrecht, mounted in an album with a title page dated 1686/87. This album, probably put together by the artist himself, is divided into three categories: 'Principale' (*i.e.* original drawings based on the study of nature), 'Inventive' (imaginary scenes with mountains and ruins) and 'Copijen' (copies after other masters). The identification of several of the scenes represented in the drawings show that Rutgers worked primarily in the region between Amsterdam and Utrecht.

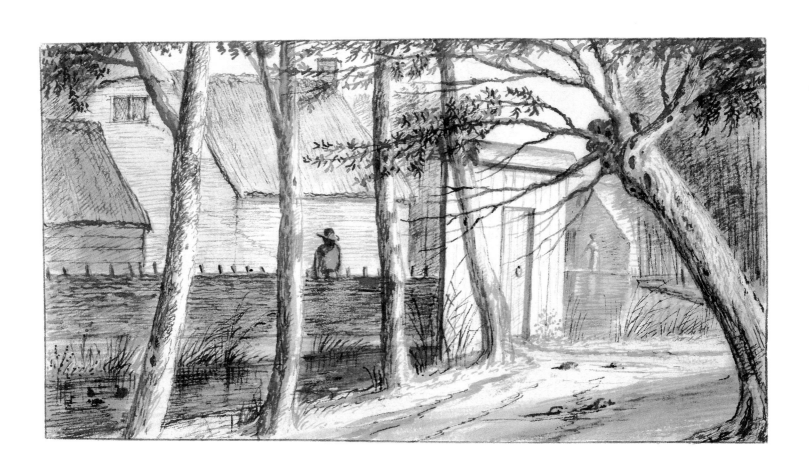

CORNELIS SAFTLEVEN
Gorinchem 1607–1681 Rotterdam

Altes Haus in Hoge Zwaluwe

Graue Lavierung über roter und schwarzer Kreide, an drei Seiten
Randlinie mit Pinsel in Braun
236 x 555 mm (aus sechs Blättern zusammengesetzt)
Alte Ausbesserung oben links
Unten links von der Mitte in Graphit datiert ‚1665‘
Verso in schwarzer Tusche bezeichnet ‚Albert Cuyp/daté à gauche
1665‘
Vermächtnis Sir Bruce Ingram, 1963. PD. 656–1963
Provenienz: Unbekannte französische Sammlung; A. W. M. Mensing;
Auktion Mensing, Amsterdam, 28. April 1937, Lot 602; Kunsthand-
lung P. & D. Colnaghi, London; hier von Ingram (Lugt 1405 a) im Mai
1937 erworben
Bisher noch nicht öffentlich ausgestellt

Cornelis Saftleven, ältester Sohn des Malers und Kunsthändlers
Herman Saftleven d. Ä. (gest. 1627), erhielt seine erste Aus-
bildung wahrscheinlich bei seinem Vater. 1609 ist die Familie
als in Rotterdam ansässig bezeugt, wo seine Brüder Herman
(1609–1685) und Abraham (1612/13–nach 1638) geboren wur-
den. Man nimmt an, daß Cornelis um 1632/34 nach Antwerpen
reiste. Er heiratete zweimal, 1648 Catharina van der Heyden
und 1655 Elisabeth van den Avondt. Von 1648 bis 1674 lebte er
in Rotterdam und war dort 1667 im Vorstand der Gilde. Corne-
lis Saftleven war als Maler – vor allem von Genreszenen –,
Zeichner und Radierer tätig; zu seinen Schülern zählt Ludolf de
Jonghe (1616–1679).

Hoge Zwaluwe liegt auf der Südseite des Flußdeltas südlich
von Dordrecht und nördlich von Breda. Die alte Zuschreibung
an Aelbert Cuyp (1620–1691) wurde schon vor dem Zugang die-
ses Blattes in das Fitzwilliam Museum als unhaltbar erkannt; es
wurde hier als Zeichnung von Roelant Roghman (1627–1692)
aufgenommen. Diese Zuweisung traf auf allgemeine Akzeptanz,
obwohl bemerkt werden muß, daß die Technik der Vorzeichnung
in roter Kreide für Roghman untypisch ist. I. Q. van Regteren
Altena schlug eine versuchsweise Zuschreibung an Herman
Saftleven d. J. (1609–1685) vor; in jüngster Zeit brachte Gre-
gory Rubinstein Cornelis Saftleven ins Gespräch. Eine signierte
und 1666 datierte Zeichnung des Meisters (Wolfgang Schulz,
Cornelis Saftleven 1607–1681. Berlin / New York 1978, Kat. 451)
bestätigt diesen Vorschlag; sehr charakteristisch für Saftleven ist
außerdem die Darstellung der Vögel am Himmel.

Old House at Hoge Zwaluwe

Grey wash over red and black chalk, bordered on three sides by a line
of brown wash
236 x 555 mm on six sheets of paper
An old repair upper left
Dated, lower left of centre, in graphite: ‘1665’
Inscribed, *verso*, in black ink: ‘Albert Cuyp/daté à gauche 1665’
Bequeathed by Sir Bruce Ingram, 1963. PD. 656–1963
Provenance: unknown collection in France; A.W.M. Mensing, his
sale, Amsterdam, 28 April 1937, lot 602; with P. & D. Colnaghi, Lon-
don, from whom bought by Ingram (Lugt 1405 a), May 1937
Not previously exhibited

The eldest son of the artist and dealer, Herman Saftleven, the
Elder (died 1627), Cornelis probably was taught by his father. By
1609 the family had moved to Rotterdam, where his brothers
Herman (1609–1685) and Abraham (1612/13–after 1638) were
born. Cornelis is thought to have travelled to Antwerp
c.1632/34. He married twice, in 1648 Catharina van der Heyden
and in 1655 Elisabeth van den Avondt. He lived in Rotterdam
from 1648–1674 and was head of the Guild there in 1667.
Active as a painter, particularly of genre scenes, draughtsman
and etcher, Cornelis included Ludolf de Jonghe (1616–1679)
among his pupils.

Hoge Zwaluwe is on the south side of the estuary south of Dor-
drecht and to the north of Breda. The old attribution to Aelbert
Cuyp (1620–1691), clearly untenable, was discarded before the
drawing entered the Fitzwilliam, where it was accessioned with
an attribution to Roelant Roghman (1627–1692). This met with
general acceptance although it must be observed that the tech-
nique of red underdrawing is not characteristic of his work. I.Q.
van Regteren Altena proposed a tentative attribution to Her-
man Saftleven (1609–1685) and most recently Gregory Rubin-
stein suggested Cornelis Saftleven. A signed and dated drawing
of 1666 (Wolfgang Schulz, *Cornelis Saftleven 1607–1681*, Berlin,
New York, 1978, no. 451) confirms his proposal and the treat-
ment of the birds in the sky is quite characteristic of him.

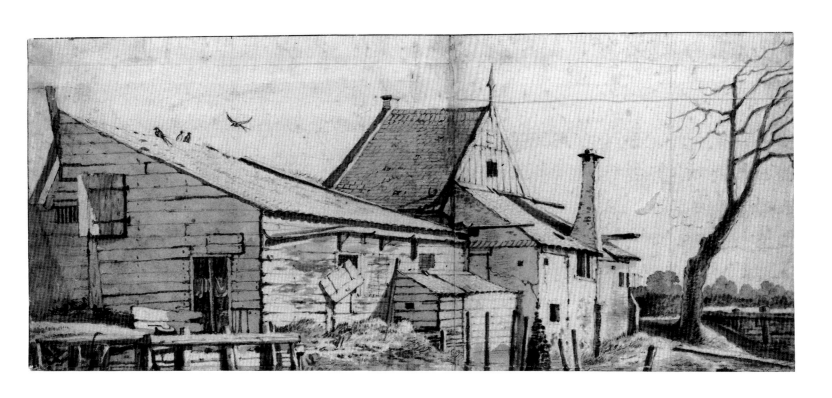

Auenlandschaft mit Wald und Buschwerk

Feder und braune Tusche, allseitig Randlinie mit Pinsel in Braun
116 x 217 mm (Blattgröße unregelmäßig)
Verso in Graphit bezeichnet „J. van de Velde'
Vermächtnis Sir Bruce Ingram, 1963. PD. 692–1963
Provenienz: A. W. M. Mensing; Auktion Mensing, Amsterdam,
29. April 1937, Lot 755 (als Esaias van de Velde); Kunsthandlung
P. & D. Colnaghi, London; hier von Ingram (Lugt 1405 a) im Mai 1937
erworben (als Buytewech)
Literatur: Wolfgang Schulz, *Herman Saftleven.* Berlin / New York
1982, Nr. 355, Taf. 65
Ausstellungen: London, Colnaghi, 1952, Nr. 23; Bath 1952, Nr. 27;
Rotterdam / Amsterdam 1961/62, Nr. 77; Cambridge 1985, handlist,
S. 13

Herman Saftleven d. J. wurde wahrscheinlich zuerst von seinem
Vater Herman d. Ä. (gest. 1627) und dann von seinem älteren
Bruder Cornelis (1607–1681) unterrichtet; vielleicht war er
auch Schüler des Jan van Goyen (1596–1656). 1632 zog er nach
Utrecht, wo er von 1655 bis 1667 in der Malergilde amtierte.
1633 heiratete er Anna van Vliet. Einige ausgedehnte Reisen
führten ihn an Mosel und Rhein, und er scheint 1667 in Elber-
feld ansässig gewesen zu sein. Er zeichnete eine Reihe von topo-
graphischen Ansichten der Stadt Utrecht im Auftrag des Magi-
strates. Etwa 300 Gemälde und 1100 Zeichnungen sind von
seiner Hand erhalten; darüber hinaus war er auch als Radierer
tätig. Zu seinen Schülern zählen Willem van Bemmel (1630–
1708) und Jan Vorstermans (1643–um 1699).

Unser Blatt wurde Herman Saftleven erstmals von J. van Gel-
der zugeschrieben, der es in die Zeit um 1625/30 datierte, als der
junge Künstler stark unter dem Einfluß der Zeichnungen und
Radierungen des Willem Buytewech (1591/92–1624) stand.
Andere Zuschreibungen nennen Buytewech, Esaias van de Velde
(1587–1630), Jan van de Velde II. (1593–1641) und Claes Jansz.
Visscher (1587–1652), doch hat sich van Gelders Zuweisung all-
gemein durchgesetzt. Unser Blatt ist einer anderen Zeichnung
in der gleichen Technik im British Museum in London
(1836–8–11–566) sehr ähnlich, die als Vorzeichnung für eine
frühe Radierung Saftlevens (Hollstein 38) identifiziert werden
kann. Vergleichbar sind auch Zeichnungen im Herzog Anton
Ulrich-Museum in Braunschweig und in Berlin, ebenfalls für
Radierungen (Hollstein 20–24), von denen eine auf 1627
datiert ist.

Erst auf den zweiten Blick erkennt man auf der Zeichnung das
flache Boot zur Linken und das Paar am Flußufer unterhalb des
mittleren Baumes.

A wooded landscape bordering a stream

Pen and brown ink, bordered on all sides by a line of brown wash
116 x 217 mm, irregular
Inscribed, *verso*, in graphite: 'J. van de Velde'
Bequeathed by Sir Bruce Ingram, 1963. PD. 692–1963
Provenance: A. W. M. Mensing, his sale, Amsterdam, 29 April 1937,
lot 755 (as Esaias van de Velde); with P. & D. Colnaghi, London, from
whom bought by Ingram (Lugt 1405 a), May 1937 (as Buytewech)
Literature: Wolfgang Schulz, *Herman Saftleven*, Berlin, New York,
1982, no. 355, pl. 65
Exhibited: London, Colnaghi, 1952, no. 23; Bath, 1952, no. 27; Rot-
terdam / Amsterdam, 1961/62, no. 77; Cambridge, 1985, handlist, p. 13

Herman Saftleven the Younger probably was taught first by his
father, Herman (died 1627) and then by his older brother, Cor-
nelis (1607–1681); he is said to have been a pupil of Jan van
Goyen (1596–1656). He moved to Utrecht in 1632, where later
he held offices in the Painters' Guild between 1655 and 1667. In
1633 he married Anna van Vliet. He made several long trips in
the Moselle and Rhine valleys and appears to have lived at
Elberfeld in 1667. He made several precise topographical draw-
ings of Utrecht as a commission of the municipality. His output
consists of about 300 paintings and 1100 drawings and he was
also active as an etcher. His pupils include Willem van Bemmel
(1630–1708) and Jan Vorstermans (1643–c.1699).

First attributed to Saftleven by Professor van Gelder, who
dated it *c.*1625/30, at a time when the young Saftleven was
strongly influenced by the drawings and etchings of Willem
Buytewech (1591/92–1624). The drawing has been attributed
severally to Buytewech, Esaias van de Velde (1587–1630), Jan
van de Velde II (1593–1641) and Claes Jansz. Visscher
(1587–1652), but van Gelder's attribution is accepted generally.
It compares very well with another drawing in the same tech-
nique in the British Museum (1836–8–11–566) which is prepar-
atory for Saftleven's early etching (Hollstein 38) and with draw-
ings at Braunschweig and Berlin also preparatory to etchings
(Hollstein 20–24), one of which is dated, 1627.

The flat bottomed boat on the left and the couple seated
beneath the central tree are not immediately visible at a casual
glance.

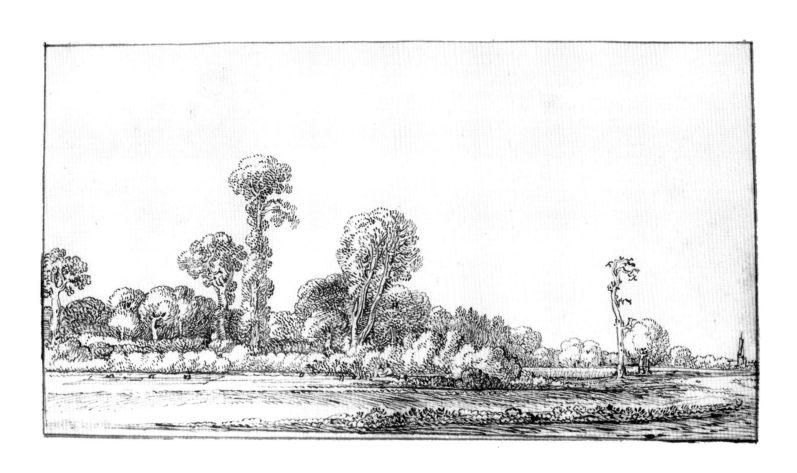

HERMAN SAFTLEVEN der Jüngere/the Younger
Rotterdam 1609–1685 Utrecht

Panoramablick bei Wageningen

Schwarze Kreide, graue und braune Lavierung
226 x 518 mm
Unten links in schwarzer Kreide monogrammiert ‚HS‘
Verso in brauner Tinte beschriftet ‚H. Saftleven/Paysage vues
générales/à la pierre noire, lave de bistre pièce capitale/Vente de
A. G. Visser/8 Mars 1869‘. Verso unten links in brauner Tinte
numeriert ‚No 138‘, ‚15[?3]76‘
Vermächtnis Sir Bruce Ingram, 1963. PD. 690–1963
Provenienz: Auktion A. G. de Visser, Den Haag, 8. März 1869; unbe-
kannte französische Sammlung; Auktion A. G. Visser, Muller, Amster-
dam, 16.–18. Mai 1881, wahrscheinlich Lot 370, erworben von Muller
selbst; A. W. M. Mensing; Auktion Mensing, Amsterdam, 29. April
1937, Lot 642; Kunsthandlung P. & D. Colnaghi, London; hier von
Ingram (Lugt 1405 a) im Mai 1937 erworben
Literatur: Wolfgang Schulz, *Herman Saftleven.* Berlin/New York
1982, Nr. 636
Ausstellungen: London 1946/47, Nr. 17; Washington u. a. 1959/60,
Nr. 72; Rotterdam/Amsterdam 1961/62, Nr. 78; London, The Tate
Gallery, 1971, *The Shock of Recognition,* Nr. 93; Cambridge 1985,
handlist, S. 11

Wolfgang Schulz konnte die dargestellte Landschaft, die bisher
als Blick im Gelderland galt, als Ansicht bei Wageningen west-
lich von Arnhem identifizieren. Die Zeichnung zeigt, wie ausge-
wogen Saftleven die Einflüsse Jan van Goyens (1596–1656) und
Pieter Molijns (1595–1661) verarbeitete, nachdem er sich 1632
in Utrecht niedergelassen hatte. Andere weite Panoramen ähn-
lichen Typus und aus vergleichbarer Zeit befinden sich in der
Albertina in Wien und im Museum Boymans-van Beuningen in
Rotterdam (Nr. 704).

A panoramic view near Wageningen

Black chalk, grey and brown wash
226 x 518 mm
Signed with initials, lower left, in black chalk: 'HS'
Inscribed, *verso,* in brown ink: 'H. Saftleven/Paysage vues générales/
à la pierre noire, lave de bistre pièce capitale/Vente de A. G. Visser/
8 Mars 1869'. Numbered, *verso,* lower left, in brown ink: 'No 138',
'15[?3]76'
Bequeathed by Sir Bruce Ingram, 1963. PD. 690–1963
Provenance: sale, A. G. de Visser, The Hague, 8 March 1869; French
Collection; A. G. de Visser, his sale, Muller, Amsterdam, 16–18 May
1881, probably lot 370, bought by Muller; A. W. M. Mensing, his sale,
Amsterdam, 29 April 1937, lot 642; P. & D. Colnaghi, London, from
whom bought by Ingram (Lugt 1405 a), May 1937
Literature: Wolfgang Schulz, *Herman Saftleven,* Berlin, New York,
1982, no. 636
Exhibited: London, 1946/47, no. 17; Washington and American Tour,
1959/60, no. 72; Rotterdam/Amsterdam, 1961/62, no. 78; London,
The Tate Gallery, 1971, *The Shock of Recognition,* no. 93; Cambridge,
1985, handlist, p. 11

Wolfgang Schulz identified the scene, previously described as a
view in Gelderland, as near Wageningen (to the West of Arn-
hem). The drawing shows how well Saftleven assimilated the
influence of both Jan van Goyen (1596–1656) and Pieter Molijn
(1595–1661) after he moved to Utrecht in 1632. Other broad
panoramas of a similar type and date are in the Albertina,
Vienna, and the Boymans-van Beuningen Museum, Rotterdam
(no. 704).

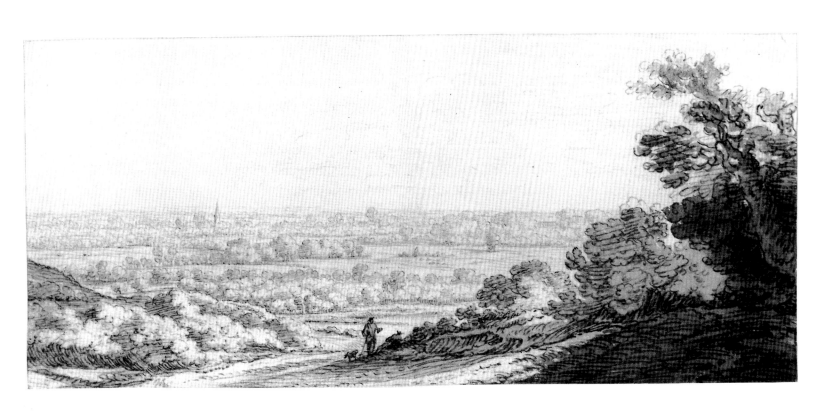

Auf der Wallanlage von Utrecht

Schwarze Kreide, graue und braune Lavierung, allseitig Randlinie mit
schwarzem Kreidestrich, an drei Seiten Randlinie mit Pinsel in Braun
372 x 484 mm (Blattgröße unregelmäßig)
Mittlere Bugfalte und zwei Knicke im Papier
Vermächtnis Sir Bruce Ingram, 1963. PD. 688–1963
Provenienz: Vielleicht Auktion R. Ph. Goldschmidt, Frankfurt a. M.,
4.–15. Oktober 1917, Lot 521; Kunsthandlung P. & D. Colnaghi,
London, 1949; hier erworben von Ingram (Lugt 1405 a) im Januar
1951
Literatur: Wolfgang Schulz, *Herman Saftleven.* Berlin / New York
1982, Nr. 395
Ausstellung: London, Colnaghi, 1949, Nr. 55

Im Auftrag des Magistrats zeichnete Saftleven eine Reihe topo-
graphischer Ansichten der Stadt Utrecht. Einige großformatige
Blätter sind erhalten geblieben, unter ihnen vier, die 1695 der
Sammlung Feitama angehörten: Zwei befinden sich heute im
Gemeente Archief in Utrecht, eines von ihnen 1650 datiert,
und zwei im Rijksprentenkabinet in Amsterdam (s. *Oud Holland*
101, 1987, S. 171 ff.).

On the ramparts of Utrecht

Black chalk, grey and brown wash, bordered on all sides by a line
in black chalk, and on three sides by a line of brown wash
372 x 484 mm, irregular
A central fold and two central creases in the paper
Bequeathed by Sir Bruce Ingram, 1963. PD. 688–1963
Provenance: perhaps R. Ph. Goldschmidt, sale Frankfort, 4–15 Octo-
ber 1917, lot 521; with P. & D. Colnaghi, London, 1949, from whom
bought by Ingram (Lugt 1405 a), January 1951
Literature: Wolfgang Schulz, *Herman Saftleven*, Berlin, New York,
1982, no. 395
Exhibited: London, Colnaghi, 1949, no. 55

Saftleven was commissioned by the municipality of Utrecht to
make topographical drawings of the city. Several large drawings
of this type survive, notably four examples which were part of
the Feitama Collection in 1695 (of these two are now in the
Gemeente Archief in Utrecht, one dated 1650, and two in the
Rijksprentenkabinet, Amsterdam [v. *Oud Holland*, 101, 1987,
pp. 171 ff.]).

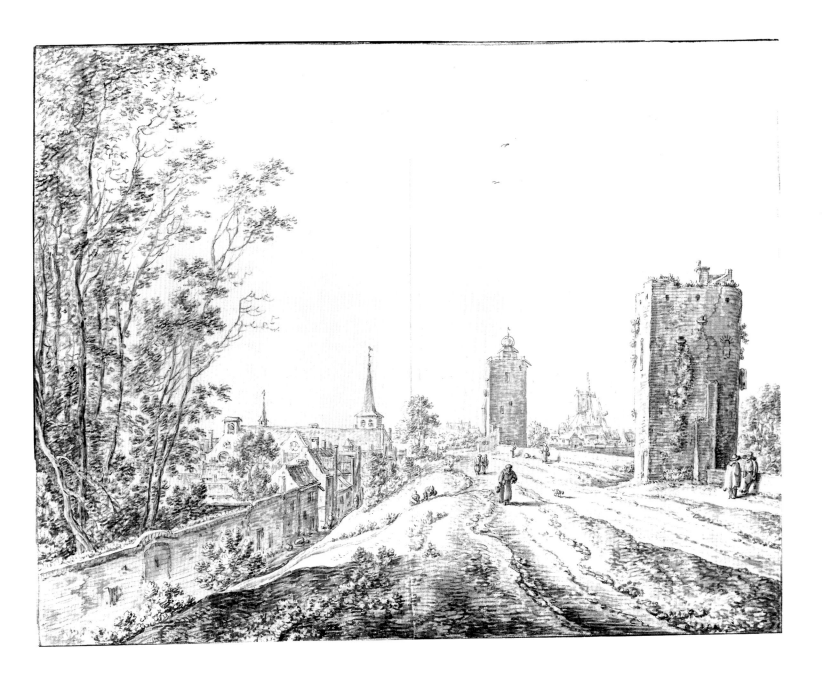

ESAIAS VAN DE VELDE
Amsterdam 1587–1630 Den Haag / The Hague

Dorfstraße mit Kirche zur Linken

Feder, braune Tusche, braune Lavierung
197 x 307 mm
Links wasserrandig; alter vertikaler Knick rechts im Papier;
Ecken oben rechts und unten links abgerieben
Unten rechts in brauner Tusche signiert und datiert
‚E. VANDEN. VELDE 16..3 [?]‘
Vermächtnis Sir Bruce Ingram, 1963. PD. 777–1963
Provenienz: Kunsthandlung E. Parsons, London; hier von Ingram
(Lugt 1405 a) im November 1933 erworben
Literatur: Keyes 1984, D153, S. 262, Abb. 14
Ausstellung: Cambridge 1985, handlist, S. 12

Esaias van de Velde war der Sohn des Antwerpener Malers und
Kunsthändlers Hans van de Velde (1552–1609) und wurde mög-
licherweise von seinem Vater in der Malerei unterwiesen. Man
nimmt an, daß er Schüler von Gillis van Coninxloo
(1544–1607) oder David Vinckboons (1576–1630/33) war.
1609 ließ sich die Familie van de Velde in Haarlem nieder, wo
Esaias 1611 Catelijn Maertens aus Gent heiratete; aus der Ehe
gingen drei Söhne und eine Tochter hervor. 1612 erscheint er in
der Liste der Lukasgilde in Haarlem, 1618 zog er nach Den Haag,
wo er wiederum Mitglied der Lukasgilde wurde. 1620 erhielt er
hier das Bürgerrecht. Er unterrichtete Jan van Goyen
(1596–1656) und übte großen Einfluß auf Pieter Molijn
(1595–1661) aus. Esaias van de Velde war als Maler und Zeich-
ner tätig und hinterließ auch eine Reihe von Radierungen.

Keyes liest die Datierung unserer Zeichnung als 1613 oder
1614, womit sie die früheste erhaltene signierte Zeichnung des
Künstlers wäre, doch läßt die Bereibung an der rechten Ecke
eine solche Lesart nicht mit Sicherheit zu. Stilistisch entspricht
das Blatt zwei Landschaftszeichnungen in der Pierpont Morgan
Library in New York (Keyes, a. a. O., D171, 172), die 1616
datiert sind. Keyes sieht Parallelen in der Art der Schraffierun-
gen mit Radierungen van de Veldes, die 1615 datiert werden
können; darüber hinaus erscheint die Kirche mit der Einfriedung
und dem Torhäuschen seitenverkehrt auf einem Gemälde in
einer deutschen Privatsammlung, das er mit 1619 ansetzt (Keyes
132). Eine Kirche mit einem ähnlich hohen und schlanken
Turm zeigt sich, von vorne gesehen, auf van de Veldes Radierung
mit der Ansicht des Dorfes Spaernwou (Keyes E12).

A village street with a church on the left

Pen, brown ink, brown wash
197 x 307mm
Water stain left; old vertical crease in paper, right; corners abraded
upper right and lower left
Signed and dated in brown ink, lower right:
‘E. VANDEN. VELDE 16..3[?]’
Bequeathed by Sir Bruce Ingram, 1963. PD. 777–1963
Provenance: with E. Parsons, from whom bought by Ingram
(Lugt 1405 a), November 1933
Literature: Keyes, 1984, D 153, p. 262, pl. 14
Exhibited: Cambridge, 1985, handlist, p. 12

The son of the Antwerp painter and artdealer, Hans van de
Velde (1552–1609), Esaias may have studied painting with his
father. He is thought to have been a pupil of Gillis van Coninx-
loo (1544–1607) or David Vinckboons (1576–1630/33). In
1609 van de Velde moved to Haarlem and in 1611 Esaias mar-
ried Catelijn Maertens of Ghent, by whom he had three sons
and a daughter. In 1612 he was inscribed in the Guild of Saint
Luke in Haarlem and in 1618 when he moved to The Hague he
joined the same guild there, becoming a burgher in 1620. He
taught Jan van Goyen (1596–1656) and greatly influenced
Pieter Molijn (1595–1661). In addition to painting and drawing
he made several etchings.

Keyes reads the date as 1613 or 1614 which would make this
van de Velde's earliest surviving signed drawing, but the abra-
sion in the right corner prevents the date from being certain.
Stylistically the drawing is analogous to two landscape drawings
in the Pierpont Morgan Library, New York (Keyes, *op. cit.,*
D 171, 172) which are dated 1616. Keyes points out parallels in
hatching with etchings by van de Velde which can be dated
1615; the church with its close and gatehouse appears in reverse
in a painting in a private collection in Germany, which he dates
1619 (Keyes 132). A church with a similarly tall steeple appears,
seen from the front, in van de Velde's etching of the village of
Spaernwou (Keyes E 12).

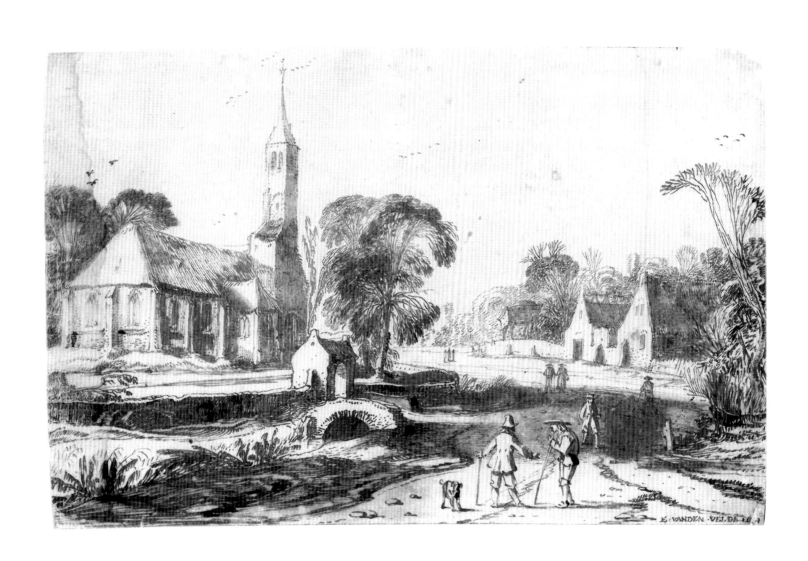

ESAIAS VAN DE VELDE
Amsterdam 1587–1630 Den Haag / The Hague

Freudenfeuer in einem Dorf

Schwarze Kreide und graubraune Lavierung, allseitig Randlinie
mit Pinsel in Braun
187 x 306 mm, beschnitten (?)
Alte Ausbesserung in der oberen Mitte
Unten links in brauner Tusche signiert und datiert ‚E. V. VELDE/1628'
Verso in Graphit beschriftet ‚No 53 Esaias vande Velde'
Vermächtnis Sir Bruce Ingram, 1963. PD. 771–1963
Provenienz: Auktion Amsterdam, 13./14. November 1894, Lot 592;
A. W. M. Mensing; Auktion Mensing, Amsterdam, 29. April 1937,
Lot 754; Kunsthandlung P. & D. Colnaghi, London; hier von Ingram
(Lugt 1405 a) im Mai 1937 erworben
Literatur: Keyes 1984, D 149, S. 261, Abb. 248
Ausstellungen: Cirencester 1951, Nr. 18; Cambridge 1985, handlist, S. 19

Keyes nimmt an, daß Signatur und Datierung die ursprünglichen
Angaben ersetzen, die verlorengingen, als die Zeichnung
beschnitten wurde; die Art und Weise jedoch, in der die Zahl 8
geschrieben ist – wenn auch in Tusche und nicht in Kreide –, ist
identisch mit van de Veldes Handschrift. Unser Blatt ist eines
der schönsten Beispiele für van de Veldes Kunst, Atmosphäri-
sches darzustellen; den Rauch, der von dem Feuer aufsteigt, setzt
er in einen fein durchgearbeiteten Kontrast zum Grau des Him-
mels. Der Zeichenduktus ist charakteristisch für den reifen Stil
des Künstlers und weist voraus auf Jan van Goyen (1596–1656)
und Pieter Molijn (1595–1661).

A village bonfire

Black chalk and grey-brown wash, bordered on all sides by a line
of brown wash
187 x 306 mm, cut down(?)
Old repair top centre
Signed and dated in brown ink, lower left: 'E.V.VELDE/1628'
Inscribed in graphite, *verso*: 'No 53 Esaias vande Velde'
Bequeathed by Sir Bruce Ingram, 1963. PD. 771–1963
Provenance: Amsterdam, sale, 13/14 November 1894, lot 592;
A. W. M. Mensing, his sale, Amsterdam, 29 April 1937, lot 754; with
P. & D. Colnaghi, London, from whom bought by Ingram (Lugt
1405 a), May 1937
Literature: Keyes, 1984, D 149, p. 261, pl. 248
Exhibited: Cirencester, 1951, no. 18; Cambridge, 1985, handlist, p. 19

Keyes considers the signature and date replace another which
was 'removed when the drawing was cut down', but, although it
is in ink rather than chalk, the script and way of forming the fig-
ure '8' are identical with van de Velde's own writing. The Fitz-
william drawing is one of his most sophisticated attempts to
reproduce atmospheric effects, the smoke from the fire in subtle
contrast with the grey sky. The handling is characteristic of his
mature style and looks forward to the work of Jan van Goyen
(1596–1656) and Pieter Molijn (1595–1661).

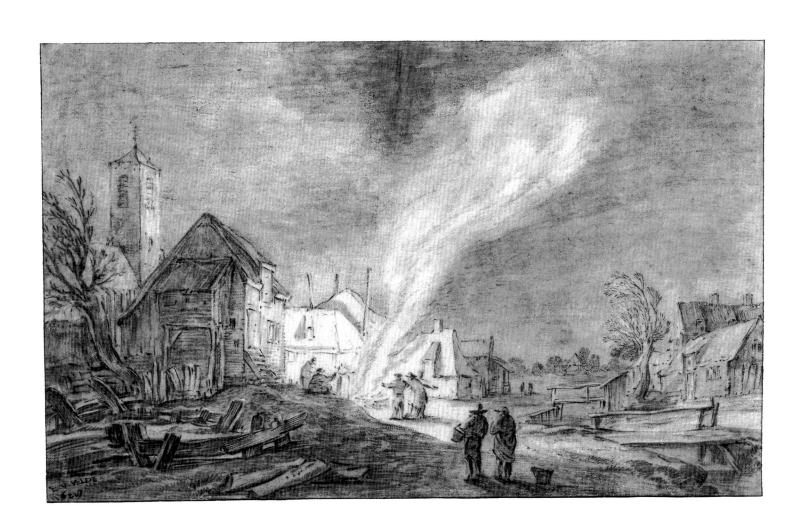

JAN VAN DE VELDE II
Delft (?) 1593–1641 Enkhuizen

Flußufer mit Gebäuden und Figurenstaffage

Feder und braune Tusche, braune Lavierung, allseitig Randlinie
mit Pinsel in Braun; die Rückseite grünlich eingefärbt
123 x 170 mm, beschnitten
Verso in brauner Tusche bezeichnet ‚Jan Van de Velde / Oom van
Adriaen en Willem / van de Velde en broeder Esaias v d Velde';
‚1673'; ‚No. 907'; in Graphit ‚Leyden 1598'
Vermächtnis Sir Bruce Ingram, 1963. PD. 779–1963
Provenienz: Vernon Wethered; Kunsthandlung P. & D. Colnaghi,
London; hier von Ingram (Lugt 1405 a) im März 1937 erworben
Literatur: J. G. van Gelder, *Jan van de Velde*. Den Haag 1933, S. 54
und 88, Nr. 59, Taf. XVIII, Abb. 33; Hollstein s. v. 223
Ausstellungen: London, Royal Academy, 1929, *Dutch Art*, Nr. 540;
Cambridge, Fitzwilliam Museum, 1953/54 (o. Kat.);
Rotterdam / Amsterdam 1961/62, Nr. 96; Cambridge 1985, handlist, S. 20

Am meisten bekannt ist Jan van de Velde II. als Kupferstecher
und Radierer, hauptsächlich von Landschaften und Portraits; er
war der Sohn des aus Antwerpen gebürtigen Jan van de Velde I.
(1568–1623), der als Zeichner und Kalligraph arbeitete. Er
lernte bei Jacob Matham (1571–1631) um 1613 in Haarlem, wo
er 1614 in die Lukasgilde aufgenommen wurde. Angeblich berei-
ste er in den Jahren 1615 und 1616 Frankreich und war viel-
leicht auch in Italien. Nach seiner Rückkehr nach Haarlem stu-
dierte er wahrscheinlich bei seinem Vetter Esaias van de Velde
(1587–1630), bevor er sich in Enkhuizen niederließ, wo er 1618
Styntgen Non heiratete. Aus der Ehe ging ein Sohn hervor,
ebenfalls Jan genannt (1619/20–1662 oder danach), der wie
sein Vater den Künstlerberuf ergriff. Künstlerischen Einfluß auf
Jan van de Velde II. übten Hendrick Goltzius (1558–1617),
Claes Jansz. Visscher (1587–1652) und Willem Buytewech
(1591/92–1624), aber auch sein Vetter Esaias aus.

Van Gelder (a. a. O., S. 54) und Ger Luijten, der Mitverfasser
des entsprechenden Hollstein-Bandes, schlagen vor, daß es sich
bei unserem Blatt um eine Vorzeichnung zu van de Veldes Radie-
rung *Zugefrorener Fluß mit Schlittschuhläufern und Bauern auf der
Straße* (Hollstein 223), Blatt 8 der 1616 veröffentlichten Folge
der *Landschaften und Ruinen*, handelt. Unser Blatt ist jedoch
deutlich kleiner als die Radierung (133 x 203 mm) und darüber
hinaus in der Komposition so völlig anders angelegt, daß kaum
zu glauben ist, es sei in Hinblick auf die Radierung gezeichnet.
Gemeinsam ist beiden lediglich das Bauernhaus am Fluß mit
dem gestelzten Landesteg und dem primitiven Hebekran, Ele-
mente, die immer wieder in der Druckgraphik van de Veldes auf-
tauchen und zu den üblichen Versatzstücken der holländischen
Landschaft dieser Zeit gehören. Eine Datierung um 1616 ist
jedoch einleuchtend.

In seiner Zeichentechnik zeigt unser Blatt bemerkenswerte
Ähnlichkeiten mit Arbeiten von Willem Buytewech und Claes
Jansz. Visscher, besonders mit einer dem letzteren von Haver-
kamp-Begemann zugewiesenen Zeichnung in Kopenhagen (Tu
63–8), die die Bezeichnung Esaias van de Velde und das Datum
1614 aufweist.

River scene with buildings and figures

Pen and brown ink, brown wash, bordered on all sides by a line
of brown wash. The *verso* is tinted slightly green
123 x 170 mm, cut down
Inscribed, *verso*, in brown ink: 'Jan Van de Velde / Oom van Adriaen
en Willem / van de Velde en broeder Esaias v d Velde'; '1673';
'No. 907'; in graphite: 'Leyden 1598'
Bequeathed by Sir Bruce Ingram, 1963. PD. 779–1963
Provenance: Vernon Wethered; with P. & D. Colnaghi, London, from
whom bought by Ingram (Lugt 1405 a), March 1937
Literature: J. G. van Gelder, *Jan van de Velde*, The Hague, 1933,
pp. 54, 88, no. 59, pl. XVIII, fig. 33; Hollstein *s. v.* 223
Exhibited: London, Royal Academy, 1929, *Dutch Art*, no. 540; Cam-
bridge, Fitzwilliam Museum, 1953/54 (no handlist); Rotter-
dam / Amsterdam, 1961/62, no. 96; Cambridge, 1985, handlist, p. 20

Best known as an engraver, primarily of landscapes and portraits,
Jan van de Velde was the son of a draughtsman and calligrapher
of the same name who came from Antwerp (1568–1623). Van de
Velde II studied under Jacob Matham (1571–1631) in Haarlem
c. 1613 and was enrolled in the Guild of St Luke there in 1614.
He is said to have travelled in France during 1615 and 1616 and
may have gone to Italy. Back in Haarlem he probably studied
with his cousin Esaias van de Velde (1587–1630) before settling
in Enkhuizen where he married Styntgen Non in 1618. They had
a son, also called Jan (1619/20–1662 or later), who was likewise
an artist. Jan van de Velde II's style reflects the influence of
Hendrick Goltzius (1558–1617), Claes Jansz. Visscher
(1587–1652) and Willem Buytewech (1591/92–1624) as well as
that of his cousin.

Both van Gelder (*op. cit.*, p. 54) and Ger Luijten, the co-
author of the relevant Hollstein volume, suggest that this is pre-
paratory to van de Velde's etching *Frozen river with skaters and
peasants on a road* (Hollstein 223), published in 1616. Apart
from being notably smaller (the etching measures 133 x 203 mm)
the drawing differs so considerably from the print that it is hard
to conclude that the drawing was made with the etching specif-
ically in mind. The features they have in common, a cottage by
a river with an elevated landing-stage and primitive crane, occur
regularly in prints by van de Velde and are common features of
Dutch landscape at this time. A date of *c*. 1616 is plausible.

Technically the drawing shows striking similarities with the
work of Willem Buytewech and Claes Jansz. Visscher, particu-
larly with a drawing which bears an inscription to Esaias van de
Velde and a date of 1614 now in Copenhagen (Tu 63–8) which
Haverkamp-Begemann has attributed to Visscher.

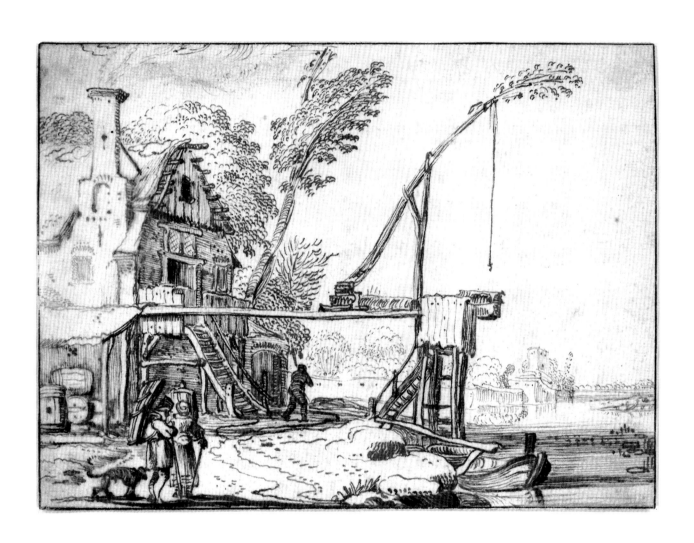

CLAES JANSZ. VISSCHER
Amsterdam 1586/87–1652 Amsterdam

Ausflug auf dem Lande

Feder, schwarzbraune und hellbraune Tusche, graue Lavierung,
allseitig Randlinie mit Pinsel in Braun
120 x 184 mm
Rechtes oberes Eckchen fehlt
Vermächtnis Sir Bruce Ingram, 1963. PD. 783–1963
Provenienz: Kunsthandlung P. & D. Colnaghi, London; hier von
Ingram (Lugt 1405 a) im Februar 1954 erworben
Ausstellungen: Cambridge 1977, Nr. 23; Cambridge 1985, handlist,
S. 20

Visscher war der Sohn eines Schiffszimmermanns und erhielt
seine künstlerische Ausbildung wohl bei David Vinckboons
(1576–1630/33). 1608 wird er in Amsterdam als Stecher von
Werken nach Vinckboons und Pieter Bruegel d. Ä. (um 1525/
30–1569) genannt. Schon bald gehörte er zu den bedeutendsten
Verlegern seiner Zeit für Landschafts- und Portraitstiche sowie
Kartenwerke. Nach seinem Tode übernahm sein Sohn Nicolaes
das florierende Verlagsunternehmen.

Unser Blatt war ursprünglich als Arbeit Jan van de Veldes II.
(1593–1641) eingeordnet; Frits Lugt schlug dann für diese
Zeichnung und eine in seiner eigenen Sammlung (Paris, Fonda-
tion Custodia, Nr. 5934) als Autor Gillis van Scheyndel
(1635–1678) vor. George Keyes hingegen sah in ihr die gleiche
Hand am Werk wie in einer Zeichnung des Louvre (Frits Lugt,
Inventaire général des dessins des Écoles du Nord. École Hollandaise
II. Paris 1931, Nr. 864), die als Art des Claes Jansz. Visscher
katalogisiert ist. Seine Zuschreibung unserer Zeichnung an Vis-
scher wird mittlerweile allgemein akzeptiert. Große Ähnlichkei-
ten bestehen auch mit einer anderen Zeichnung Visschers, *Der
Weg nach Sloten*, in der Sammlung Hans van Leeuwen.

Auf unserem Blatt überquert zur Linken gerade ein Heuwagen
eine Brücke. Martin Royalton-Kish erklärt die Szene folgender-
maßen: „Die Menschen in dem Heuwagen ergötzen sich an
einem ‚speelreisje‘ (Ausflug). Dies war eine wohlbekannte Gele-
genheit, bei der sich Liebespaare treffen konnten, und für
gewöhnlich küßten sie sich beim Überqueren einer Brücke"
(*Adriaen van de Venne's Album*. London 1988, S. 104). Während
van de Venne (1589–1662) und andere Künstler, die dieses
Vergnügen darstellen, häufig Figuren einfügen, die ihre Mißbil-
ligung dieses Brauchs deutlich machen, zeigt Visscher das „speel-
reisje" ohne jeden Kommentar.

Landscape with a cart crossing a bridge

Pen, dark brown and light brown ink, grey wash, bordered on all sides
by a line of brown wash
120 x 184 mm
Loss upper right corner
Bequeathed by Sir Bruce Ingram, 1963. PD. 783–1963
Provenance: with P. & D. Colnaghi, London, from whom bought by
Ingram (Lugt 1405 a), February 1954
Exhibited: Cambridge, 1977, no. 23; Cambridge, 1985, handlist, p. 20

Visscher was the son of a ship's carpenter; he is thought to have
studied with David Vinckboons (1576–1630/33). In 1608 he is
mentioned as a print maker in Amsterdam, etching works by
Vinckboons and Pieter Bruegel the Elder (c.1525/30–1569). He
soon became one of the most important publishers of prints of
landscapes, portraits and maps of his day. After his death, his son
Nicolaes Visscher, took over the prosperous publishing house.

Although Frits Lugt suggested that both this drawing and one
in his own collection (Paris, Fondation Custodia, no. 5934) were
by Gillis van Scheyndel (1635–1678), the drawing was previ-
ously catalogued as the work of Jan van de Velde II
(1593–1641). George Keyes observed that it was by the same
hand as a drawing in the Louvre (Frits Lugt, *Inventaire général des
dessins des Écoles du Nord, École Hollandaise*, II, Paris, 1931,
no. 864) described as in the manner of Claes Jansz. Visscher and
his attribution to Visscher has been accepted generally. The
drawing compares well with another drawing by Visscher, *The
road to Sloten* in the collection of Hans van Leeuwen.

On the left is a haycart crossing a bridge. As Martin Royalton-
Kish explains (*Adriaen van de Venne's Album*, London, 1988,
p. 104): 'The figures in the haycart are enjoying a *speelreisje*
('pleasure journey'). It was a well-known way for lovers to meet,
and the custom was for them to kiss as they crossed the bridge.'
Whereas van de Venne (1589–1662) and other artists often
include figures showing disapprobation of the *speelreisje*, Vis-
scher has drawn it without comment.

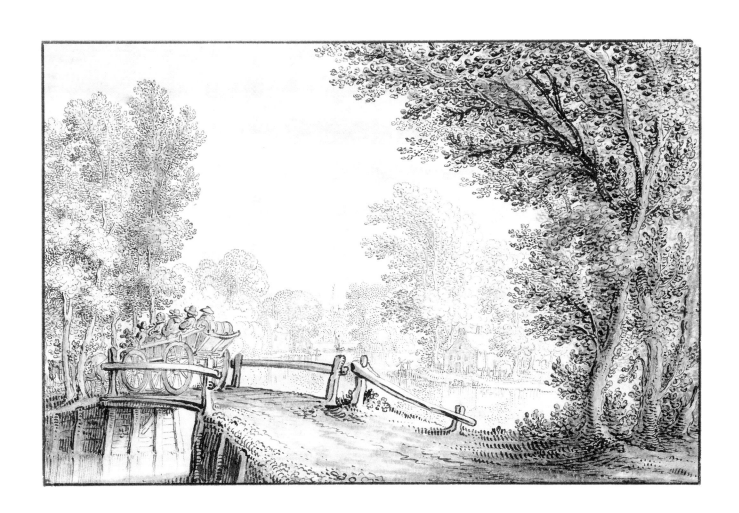

SIMON DE VLIEGER
Rotterdam (?) um/*c.* 1601–1653 Weesp

Studie von Bäumen in einem Wald

Schwarze Kreide, weiß gehöht und graue Lavierung auf blauem Papier,
allseitig Randlinie mit Pinsel in Braun
412 x 272 mm, seitlich beschnitten
Die Ecken oben rund geschnitten und wieder hinterlegt;
in der unteren linken Ecke eine alte Ausbesserung
Auf der alten Montierung unten mit schwarzer Kreide bezeichnet
‚Very good-but a little hard/Waterloo … [?]‘
Vermächtnis Sir Bruce Ingram, 1963. PD. 897–1963
Provenienz: Sir Robert Witt (Lugt 2228 b); Kunsthandlung P. & D.
Colnaghi, London; hier von Ingram (Lugt 1405 a) im November 1939
erworben
Ausstellungen: Oxford 1943 (o. Kat.); Bedford 1958, Nr. 60;
Cambridge 1985, handlist, S. 3

Simon de Vlieger erlernte sein künstlerisches Handwerk wohl
bei Willem van de Velde d. Ä. (1611–1693) und Jan Porcellis
(1584–1632). Er war zuerst in Rotterdam tätig, wo er 1627 Anna
Gerrits van Willige heiratete, und übersiedelte danach nach
Delft, wo er 1634 Mitglied der Lukasgilde wurde. Zwischen 1638
und 1648 war er in Amsterdam ansässig. 1649 kaufte er ein Haus
in Weesp. De Vlieger machte sich als Marinemaler einen
Namen, fertigte aber auch Kartons für Tapisserien und Vorlagen
für bemalte Orgelgehäuse und für Glasgemälde. Darüber hinaus
war er ein geübter Stecher und ein produktiver Zeichner. Zu sei-
nen Schülern zählten vermutlich Willem van de Velde d. J.
(1633–1707) und Hendrick Dubbels (1620/21–1676). Seine
Tochter Cornelia heiratete 1651 den Maler Paulus van Hille-
gaert d. J. (1631–1658).
 Ingram erwarb die Zeichnung als Arbeit des Anthonie Water-
loo (1609–1690), und sie wurde bisher unter diesem Namen
auch ausgestellt. Die neue Zuschreibung an de Vlieger geht auf
Martin Royalton-Kish zurück. Es ist oft schwierig, die Wald-
stücke des de Vlieger, Waterloo und Roelant Roghman
(1627–1692) voneinander abzugrenzen, aber ein Vergleich mit
einer anderen Zeichnung aus dem Ingram-Vermächtnis (PD.
881–1963), die traditionell de Vlieger zugewiesen wird, ist hier
überzeugend. Die weißen Lichter im Blattwerk der Bäume sug-
gerieren eindrucksvoll einen räumlichen Tiefenzug im Verhält-
nis zum kräftig angelegten Vordergrund, während die eher dif-
fuse Strichführung im Mittelgrund zwischen beiden Bildebenen
überleitet.

Study of trees in a forest

Black chalk heightened with white, grey wash on blue paper,
bordered on all sides by a line of brown wash
412 x 272 mm, cut down at the sides
Top with rounded corners, made up left and right; old repair,
lower left corner
Inscribed on the old mount, below, in black chalk:
‘Very good- but a little hard / Waterloo … [?]’
Bequeathed by Sir Bruce Ingram, 1963. PD. 897–1963
Provenance: Sir Robert Witt (Lugt 2228 b); with P. & D. Colnaghi,
London, from whom bought by Ingram (Lugt 1405 a), November 1939
Exhibited: Oxford, 1943 (no handlist); Bedford, 1958, no. 60.;
Cambridge, 1985, handlist, p. 3

De Vlieger may have studied with Willem van de Velde the
Elder (1611–1693) and Jan Porcellis (1584–1632). He first
worked in Rotterdam where he married Anna Gerrits van Wil-
lige in 1627, and then moved to Delft, where he became a mem-
ber of the Guild of St Luke in 1634. De Vlieger lived in Amster-
dam between 1638 and 1648. In 1649 he bought a house in
Weesp. Best known as a marine painter he also made cartoons
for tapestries, organ cases and stained glass. A fine print maker,
he was a prolific draughtsman as well. He is thought to have
taught Willem van de Velde the Younger (1633–1707) and Hen-
drick Dubbels (1620/21–1676). His daughter, Cornelia, married
the artist Paulus van Hillegaert the Younger (1631–1658) in
1651.
 Acquired by Ingram as the work of Anthonie Waterloo
(1609–1690) and exhibited as such until now. The attribution to
de Vlieger was proposed by Martin Royalton-Kish. It is often dif-
ficult to distinguish between the wooded landscapes of de
Vlieger, Waterloo and Roelant Roghman (1627–1692) but com-
parison with another drawing, traditionally attributed to de
Vlieger, also from the Ingram collection and now in the Fitzwil-
liam (PD. 881–1963), is compelling. The white highlights are
particularly subtle in their suggestion of spatial recession
between the foliage of the trees and the use of a more emphatic
outline in the foreground and a more indefinite line in the
middleground likewise contributes to the sense of distance.

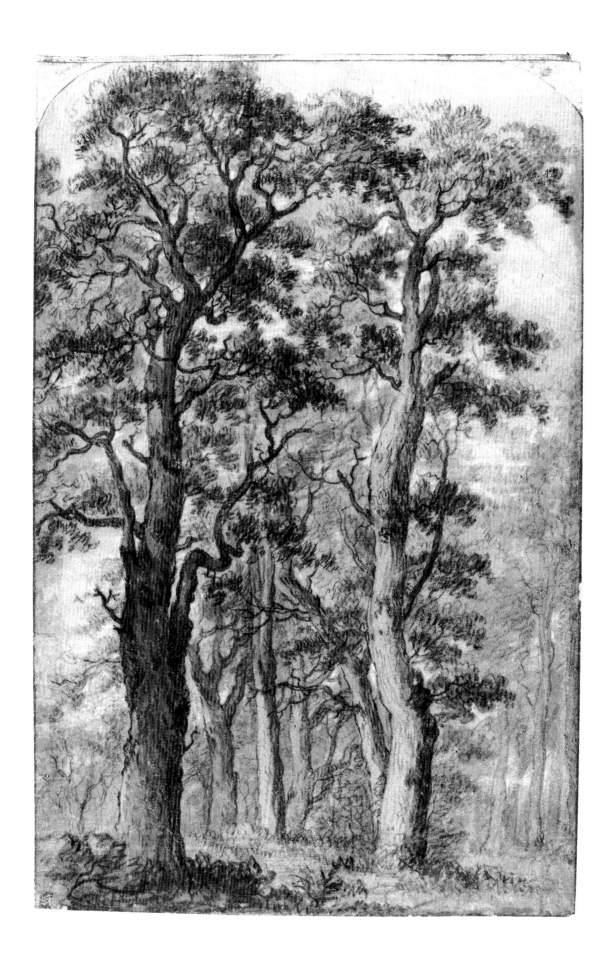

ANTHONIE WATERLOO
Lille 1609–1690 Utrecht

Baum neben einer Brücke mit einem Angler, im Spätherbst

Dünner Pinsel, braune Tusche, Gummi Arabicum, braune, graue und
farbige Lavierung, Deckfarbe, über schwarzer Kreide, Weißhöhungen,
auf blaugrauem Papier, allseitig Randlinie mit Pinsel in Braun
347 x 284 mm
Vermächtnis Sir Bruce Ingram, 1963. PD. 893–1963
Provenienz: Henry Scipio Reitlinger; Kunsthandlung P. & D. Colnaghi,
London; hier von Ingram (Lugt 1405 a) im Oktober 1938 erworben
Literatur: *The Illustrated London News*, 26. Januar 1952, S. 136
Ausstellungen: Cirencester 1951, Nr. 26; Cambridge, Fitzwilliam
Museum, 1951 (o. Kat.); London, Colnaghi, 1952, Nr. 46; Bath 1952,
Nr. 41; Washington u. a. 1959/60, Nr. 97; Rotterdam / Amsterdam
1961/62, Nr. 116; Cambridge 1985, handlist, S. 11

Anthonie Waterloo wurde als Sohn von Caspar Waterloo,
einem Tuch-Zuschneider, und dessen Frau Magdalena, der Tante
des Wallerant Vaillant (1623–1677), geboren. Über seine künst-
lerische Ausbildung ist nichts bekannt. 1630 ist er in Amster-
dam nachweisbar, 1640 in Zevenbergen, wo er die Witwe
Catharyna Stevens van der Dorp ehelichte, eine Gemälde-
händlerin; aus der Ehe gingen sechs Kinder hervor. 1641 kehrte
er nach Amsterdam zurück, wo er bis 1653 blieb, dem Jahr, in
dem er das Bürgerrecht in Leeuwarden erhielt. Sein Aufenthalt
in dieser Stadt war jedoch nur von kurzer Dauer, denn 1654 war
er wieder in Amsterdam ansässig und blieb hier bis mindestens
1663. Nach dem Tod seiner Frau, 1674, lebte Waterloo noch
16 Jahre in Utrecht und starb daselbst. Waterloo ist mehr als
Zeichner und Radierer, weniger als Maler bekannt. Er unter-
nahm ausgedehnte Reisen in Deutschland und hielt sich auch in
den Südlichen Niederlanden auf; obwohl zahlreiche seiner
Radierungen italianisierende Motive zeigen, scheint er doch nie
in Italien gewesen zu sein.

Unser Blatt ist eine verhältnismäßig frühe Zeichnung aus
einer Zeit, in der Waterloo noch unter dem Einfluß Everdingens
(1621–1675) stand. Obwohl sich farbige Lavierungen nur selten
in seinen Arbeiten finden, kann unsere Zeichnung mit zwei
Winterlandschaften verglichen werden, die im Louvre aufbe-
wahrt sind (Frits Lugt, *Inventaire général des dessins des Écoles du
Nord. École Hollandaise* II. Paris 1931, S. 56, Kat. 884 und 885).
Um die Atmosphäre des sich hebenden Herbstnebels einzufan-
gen, verwendete Waterloo in unserem Blatt Weißhöhungen.

Tree beside a bridge with a man fishing in late autumn

Point of the brush, brown ink, gum Arabic, brown, grey and coloured
wash, bodycolour, over black chalk, heightened with white,
on blue-grey paper, bordered on all sides by a line of brown wash
347 x 284 mm
Bequeathed by Sir Bruce Ingram, 1963. PD. 893–1963
Provenance: Henry Scipio Reitlinger; with P. & D. Colnaghi, London,
from whom bought by Ingram (Lugt 1405 a), October 1938
Literature: *The Illustrated London News*, 26 January 1952, p. 136
Exhibited: Cirencester, 1951, no. 26; Cambridge, Fitzwilliam Museum,
1951 (no handlist); London, Colnaghi, 1952, no. 46; Bath, 1952,
no. 41; Washington and American Tour, 1959/60, no. 97; Rotter-
dam / Amsterdam, 1961/62, no. 116; Cambridge, 1985, handlist, p. 11

Waterloo was the son of a cloth-cutter, Caspar Waterloo; his
mother, Magdalena, was the aunt of Wallerant Vaillant
(1623–1677). Nothing is known of his training. He was in
Amsterdam by 1630 and in 1640 he was in Zevenbergen where
he married Catharyna Stevens van der Dorp, a widow who acted
as a picture dealer, by whom he had six children. In 1641 he was
back in Amsterdam where he stayed until he was given citizen-
ship in Leeuwarden in 1653. Back in Amsterdam in 1654 he was
there until at least 1663. His wife died in 1674 and Waterloo
outlived her by sixteen years, dying in Utrecht. His reputation
was rather as a draughtsman and etcher than as a painter. He
travelled extensively in Germany and also visited the Southern
Netherlands; although many of his etchings are Italianate there
is no evidence that he visited Italy.

A comparatively early drawing made when Waterloo was still
influenced by Everdingen (1621–1675). Coloured washes are
unusual in his work, although comparable drawings of winter are
in the Louvre (Frits Lugt, *Inventaire général des dessins des Écoles
du Nord, École Hollandaise*, II, Paris, 1931, p. 56, nos. 884/85).
The use of white heightening to suggest the effect of mist rising
is particularly effective.

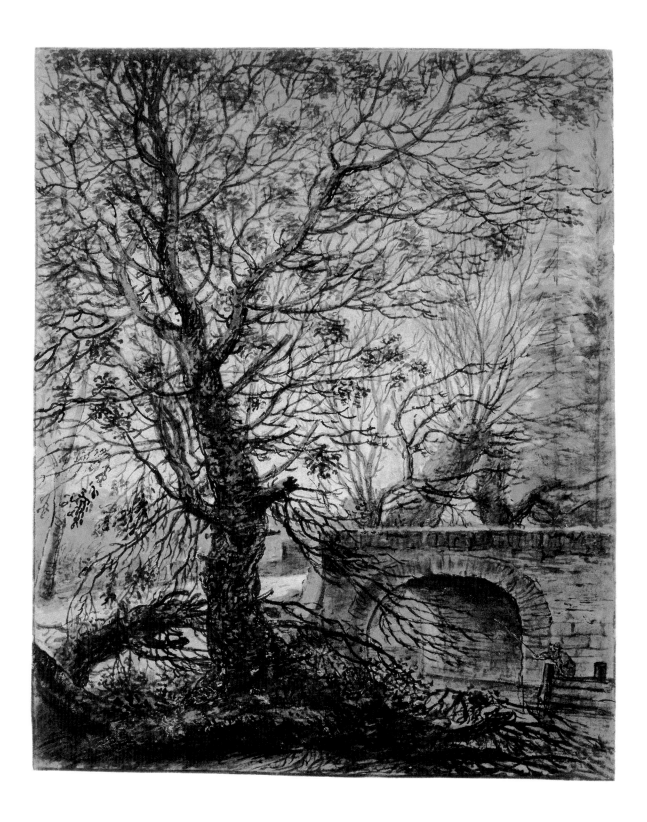

ANTHONIE WATERLOO
Lille 1609–1690 Utrecht

Tor hinter einer Brücke

Schwarze Kreide und graue Lavierung, allseitig Randlinie mit Pinsel in Braun
298 x 439 mm

Verso: Studie eines offenen Fensters
Schwarze Kreide

Verso bezeichnet in der Handschrift des Ploos van Amstel ‚L.N.49 A.Waterlo f.‘
Vermächtnis Sir Bruce Ingram, 1963. PD. 901–1963
Provenienz: Ploos van Amstel (Lugt 2034); J. de Vos (Lugt 1450); A. W. M. Mensing; Auktion Mensing, Amsterdam, 29. April 1937, Lot 810; Kunsthandlung P. & D. Colnaghi, London; hier von Ingram (Lugt 1405 a) im Mai 1937 erworben
Ausstellung: Cambridge 1985, handlist, S. 7

Waterloo zeichnete eine große Anzahl von Stadtansichten – darunter eine ganze Serie von Amsterdam –, die wahrscheinlich in den fünfziger und sechziger Jahren entstanden sind. Dieses alte, von Kletterpflanzen überwucherte Torgebäude konnte nicht identifiziert werden. In der Art der Darstellung zeigt sich des Künstlers Sinn für das Pittoreske, das besonders im 18. Jahrhundert bei Künstlern und Sammlern beliebt war; in dieser Zeit wurden auch Waterloos Arbeiten am höchsten geschätzt. Wahrscheinlich haben wir es bei diesem Blatt mit einer ausgearbeiteten Atelierzeichnung zu tun, die für den Verkauf angefertigt wurde – die Figurenstaffage, ein junges Mädchen mit einem Bündel auf dem Kopf, läßt dies vermuten.

A gate with a bridge in front of it

Black chalk and grey wash, bordered on all sides by a line of brown wash
298 x 439 mm

Verso: Study of an open window
Black chalk

Inscribed, *verso*: 'L.N.49 A.Waterlo f.', in Ploos van Amstel's hand
Bequeathed by Sir Bruce Ingram, 1963. PD. 901–1963
Provenance: Ploos van Amstel (Lugt 2034); J. de Vos (Lugt 1450); A. W. M. Mensing, his sale, Amsterdam, 29 April 1937, lot 810; with P. & D. Colnaghi, London, from whom bought by Ingram (Lugt 1405 a), May 1937
Exhibited: Cambridge, 1985, handlist, p. 7

A large number of drawings of town scenes survive by Waterloo, including a fine series of Amsterdam. They were probably drawn in the 1650s and 1660s. This old gateway, overgrown with climbing plants, has not been identified. It has a sense of the picturesque which appealed particularly to artists and collectors in the eighteenth century, when Waterloo's public reputation was at its height. The addition of the girl with a bundle on her head suggests that this was a finished drawing done in the studio and intended for sale.

ANTHONIE WATERLOO
Lille 1609–1690 Utrecht

Windbruch mit umgestürztem Baum

Kohle und graue Lavierung, weiß gehöht, auf braungelb getünchtem
Papier, allseitig Randlinie mit Pinsel in Braun
285 x 242 mm

Verso: Knorriger Baum im Wald mit umgestürztem Stumpf
Kohle und graue Lavierung, weiß gehöht

Recto unten links in brauner Tusche bezeichnet ‚waterlo‘
Vermächtnis Sir Bruce Ingram, 1963. PD. 903–1963
Provenienz: Sir Robert Witt (Lugt 2228 b); Kunsthandlung P. & D.
Colnaghi, London (als de Vlieger); hier von Ingram (Lugt 1405 a) im
Juli 1937 erworben
Ausstellungen: London 1946/47, Nr. 28; Cambridge, Fitzwilliam
Museum, 1952/53 (o. Kat.); Washington u. a. 1959/60, Nr. 92;
Rotterdam / Amsterdam 1961/62, Nr. 117; Cambridge 1977, Nr. 44;
Cambridge 1985, handlist, S. 10

Trotz seiner alten Bezeichnung „waterlo" wurde unser Blatt von
Ingram als Arbeit des Simon de Vlieger (um 1601–1653) erwor-
ben. In der Tat ist es nicht immer einfach, bei Zeichnungen die-
ser Art zwischen Waterloo und de Vlieger zu unterscheiden; eine
Zuschreibung an Waterloo scheint jedoch eher gerechtfertigt,
vergleicht man unser Blatt mit ähnlichen Studien in der Witt
Collection (Nr. 627), im British Museum (Hind IV, S. 98, Nr. 4,
hier als de Vlieger), in der Kunsthalle, Hamburg (Nr. 22 695),
dem Kröller-Muller Museum in Otterloo und in der Albertina,
Wien (Nr. 9350). Das Thema der Darstellung leitet sich von
Pieter Bruegel d. Ä. (um 1525/30–1569) und Roelandt Savery
(1576–1639) her. Die fast noch manieristisch anmutende
Gestaltung der knorrigen Baumstämme legt eine frühe Datie-
rung der Zeichnung nahe. Unser Blatt kann zwar nicht unmit-
telbar mit Radierungen Waterloos in Verbindung gebracht wer-
den, doch erscheinen ähnliche Baumformen jeweils rechts auf
zwei Radierungen, *Bauer mit Schaufel* (Bartsch 110) und *Aus dem
Fluß saufender Hund* (Bartsch 120). Peter Morse bemerkt in sei-
nem Kommentarband zu Bartsch (TIB 2 Commentary, Part 1,
1992, Appendix A, S. 181), daß die Radierungen Bartsch
107–112 und 113–118 technisch recht schwach ausgeführt und
daher wohl in der Frühzeit des Künstlers anzusetzen sind. Auch
bei unserem Blatt handelt es sich wohl um ein solches Frühwerk.

Study of trees in a wood

Charcoal and grey wash, heightened with white, on buff coloured
paper, bordered on all sides by a line of brown wash
285 x 242 mm

Verso: Study of trees in a wood
Charcoal, grey wash, heightened with white

Inscribed, *recto*, in brown ink, lower left: ‘waterlo’
Bequeathed by Sir Bruce Ingram, 1963. PD. 903–1963
Provenance: Sir Robert Witt (Lugt 2228b); with P. & D. Colnaghi,
London, from whom bought by Ingram (Lugt 1405a), July 1937
(as de Vlieger)
Exhibited: London, 1946/47, no. 28; Cambridge, Fitzwilliam Museum,
1952/53 (no handlist); Washington and American Tour, 1959/60,
no. 92; Rotterdam / Amsterdam, 1961/62, no. 117; Cambridge, 1977,
no. 44; Cambridge, 1985, handlist, p. 10

Despite the old inscription to Waterloo this was bought by
Ingram with an attribution to Simon de Vlieger (c.1601–1653).
It is not always easy to distinguish in this type of drawing
between Waterloo and de Vlieger, but comparison with similar
drawings in the Witt Collection (no. 627), the British Museum
(Hind, IV, p. 98, no. 4 as de Vlieger), the Kunsthalle, Hamburg
(no. 22695), the Kröller-Muller Museum, Otterloo, and the
Albertina, Vienna (no. 9350), make one favour an attribution to
Waterloo. The theme is one developed from the tradition of
Pieter Bruegel the Elder (c.1525/30–1569) and Roelandt Savery
(1576–1639). The heavy, almost Mannerist, forms of the limbs
of the trees suggest a date early in Waterloo's career. Although
not related specifically to any of Waterloo's etchings similarly
bold forms appear to the right of two of them, *Peasant with a
shovel* (Bartsch 110) and *Dog drinking from a stream* (Bartsch
120). In his commentary on Bartsch, Peter Morse (TIB 2 Com-
mentary, Part 1, 1992, Appendix A, p. 181) suggests that Bartsch
110 is an early work, ‘rather weakly etched … the mark of a
beginner, a man still learning the craft of etching’, supporting an
early date for this kind of drawing.

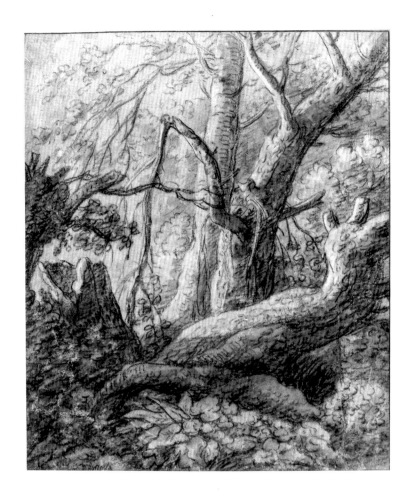

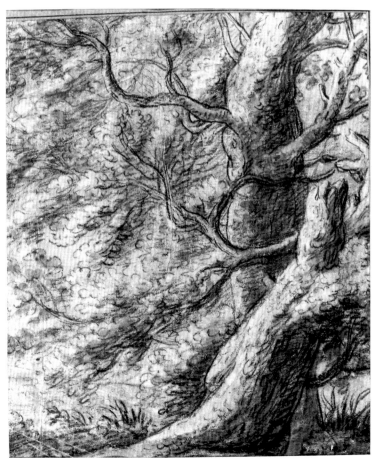

ANTHONIE WATERLOO
Lille 1609–1690 Utrecht

Landschaft zwischen Vreeland und dem Hinderdam in der Provinz Utrecht

Schwarze Kreide, graue Lavierung, Weißhöhungen, auf blauem Papier
382 x 560 mm (Blattgröße unregelmäßig)
Verso bezeichnet ‚Gezigt tusche / Vreeland en den Hinderdam‘
und in anderer Handschrift ‚from the collection of Ploos van
Amstel / Waterloo‘
Vermächtnis Sir Bruce Ingram, 1963. PD. 904–1963
Provenienz: Ploos van Amstel (Lugt 2034); William Mayor (Lugt
2799); Kunsthandlung P. & D. Colnaghi, London; hier von Ingram
(Lugt 1405a) im Dezember 1937 erworben
Literatur: *A Brief Chronological Description of a Collection of Original
Drawings, Formed by the Late Mr William Mayor.* London 1875,
Nr. 716; Malcolm Cormack, *Constable.* Oxford 1986, S. 30, Abb. 21
Ausstellungen: Wanderausstellung USA und Cambridge 1976/77,
Nr. 95; Cambridge 1985, handlist, S. 3

Von der Hand Waterloos stammen zahlreiche ähnliche Zeichnungen auf blauem Papier. Ihre bildmäßige Durchführung mit raffinierten Lichteffekten legt die Vermutung nahe, daß sie für den Verkauf hergestellt wurden. Zeichnungen dieser Art erfreuten sich im 18. Jahrhundert großer Beliebtheit und dienten als Vorbilder für zahlreiche Landschaftsmaler und -zeichner in Deutschland und England. Die Bezeichnung auf der Rückseite des Blattes nennt als Ort die Umgebung des Hinderdams ungefähr acht Kilometer südlich von Weesp und nördlich von Utrecht, wo Waterloo nach dem Tode seiner Frau, 1674, ansässig war. Stilistisch ist die Zeichnung nach 1660 einzuordnen.

A view between Vreeland and the Hinderdam in the Province of Utrecht

Black chalk, grey wash, heightened with white on blue paper
382 x 560 mm, irregular
Inscribed, *verso*: ‘Gezigt tusche / Vreeland en den Hinderdam’ and, in
a different hand, ‘from the collection of Ploos van Amstel / Waterloo’
Bequeathed by Sir Bruce Ingram, 1963. PD. 904–1963
Provenance: Ploos van Amstel (Lugt 2034); William Mayor
(Lugt 2799); with P. & D. Colnaghi, London, from whom bought by
Ingram (Lugt 1405a), December 1937
Literature: *A Brief Chronological Description of a Collection of Original
Drawings, Formed by the Late Mr William Mayor*, London, 1875,
no. 716; Malcolm Cormack, *Constable*, Oxford, 1986, p. 30, pl. 21
Exhibited: American Tour and Cambridge, 1976/77, no. 95;
Cambridge, 1985, handlist, p. 3

A large number of similar drawings on blue paper by Waterloo are known. Their scale and degree of finish, together with their subtle light effects which make them the equivalent of paintings, suggest that they were done for sale as finished objects. As such they achieved high popularity in the eighteenth century, influencing a number of landscape artists from the German and English schools. The inscription on the *verso* reveals that the drawing was made near the Hinderdam about five miles south of Weesp and north of Utrecht, where Waterloo lived after his wife's death in 1674. Stylistically this could date from any time after the 1650s.

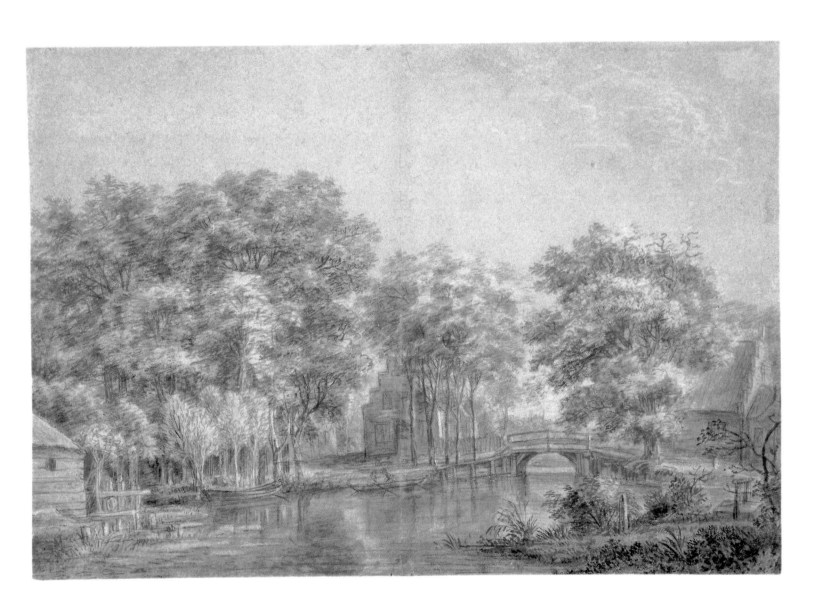

HOLLÄNDISCHE KÜNSTLER
IN DER FREMDE

DUTCH ARTISTS ABROAD

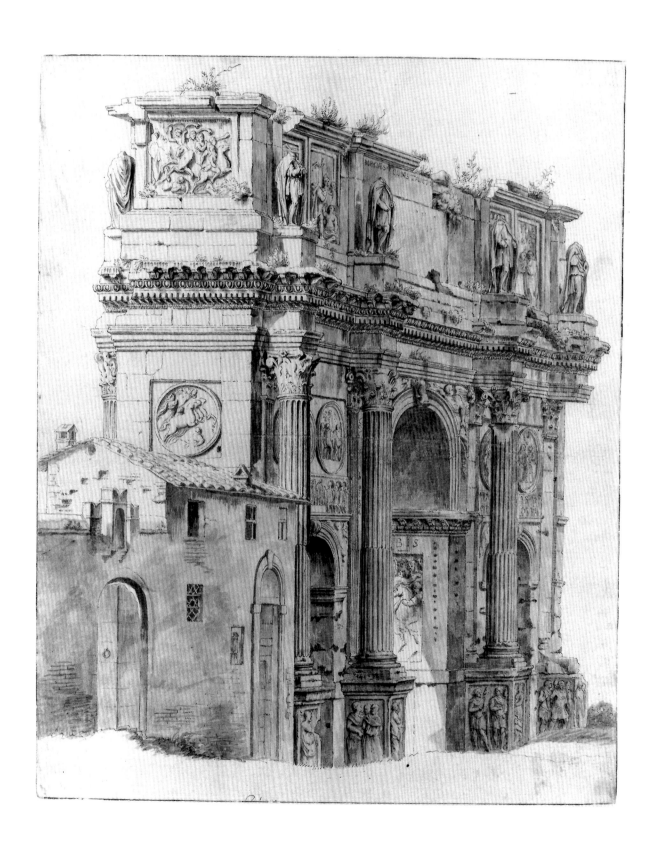

JAN ASSELIJN
zugeschrieben / attributed to
Dieppe 1610/14–1652 Amsterdam

Der Konstantinsbogen

Feder und braune Tusche, graue Lavierung, allseitig Randlinie
mit Pinsel in Braun
389 x 315 mm (Blattgröße unregelmäßig)
Am unteren mittleren Bildrand unleserliche und nur teilweise sicht-
bare Beschriftung
Vermächtnis Sir Bruce Ingram, 1963. PD. 189–1963
Provenienz: Earls of Warwick; Kunsthandlung P. & D. Colnaghi,
London; hier von Ingram (Lugt 1405 a) im Juni 1944 erworben
Ausstellungen: Washington u. a. 1959/60, Nr. 19; Rotterdam / Amster-
dam 1961/62, Nr. 23; Cambridge 1985, handlist, S. 4; Cambridge 1990,
handlist, S. 6

Für das Jahr 1633 ist Asselijns Aufenthalt in Amsterdam belegt,
wo er bei Jan Martszen d. J. (um 1609–nach 1647), dem Schüler
und Neffen des Esaias van de Velde (1587–1630), lernte. Zwi-
schen 1635 und 1646 reiste er für längere Zeit nach Italien und
hielt sich wahrscheinlich dort 1641 zusammen mit Jan Both (um
1615–1652) und dessen Bruder Andries (um 1612–um 1642)
auf; spätestens 1644 war er in Rom. In der Gemeinschaft der
Bentveughels, der niederländischen Maler in Rom, gab man ihm
den Spitznamen *Crabbetje* oder kleine Krabbe (wohl wegen sei-
ner verkrüppelten Hand). Auf der Heimreise unterbrach Asse-
lijn in Lyon (1644), wo er Antonette Huaart (Houwaart) heira-
tete; aus der Ehe ging eine Tochter, Caterina, hervor. 1645/46
hielt er sich in Paris auf, wo er Gabriel Perelle (1603–1677)
Vorzeichnungen für drei druckgraphische Folgen lieferte. 1647
kehrte Asselijn nach Amsterdam zurück, wo er den Rest seines
Lebens verbrachte. Er übte beträchtlichen Einfluß auf Adam
Pijnacker (1622–1673), Karel Dujardin (um 1622–1678) und
Nicolaes Berchem (1620–1683) aus.

Unser Blatt zeigt den Konstantinsbogen in Rom, vom Kolos-
seum aus schräg von vorne gesehen; die Schmalseite ist von
einer Schänke halb zugebaut. Ansichten des Konstantinsbogens
waren bei den holländischen Künstlern in Rom im 17. Jahrhun-
dert sehr beliebt. Als Ingram die Zeichnung erwarb, hatte sie
eine Zuschreibung an Bartholomeus Breenbergh (1598–1657);
bis 1962 wurde sie als dessen Arbeit ausgestellt. 1979 wies Mat-
thias Winner diese Zuschreibung zurück und schlug als Zeichner
Cornelis van Poelenburgh (1594/95–1667) vor; unter dessen
Namen wurde sie 1985 in Cambridge ausgestellt. Die Zuweisung
an Asselijn stammt von Ger Luijten, der sie mit einer vom
Künstler signierten und 1650 datierten Zeichnung des Konstan-
tinsbogens im Louvre verglich (Steland, Nr. 134). Dieser Ver-
gleich hat zwar einiges für sich, ist aber nicht restlos überzeu-
gend. Die feinlinige Durcharbeitung der Architektur- und
Skulpturdetails des Bogens ist nicht unbedingt ein Charakteri-
stikum der gesicherten Zeichnungen Asselijns und eher typisch
für Poelenburgh. Es ist auch möglich, daß die Zeichnung später
im Jahrhundert, um 1670, anzusetzen ist und von einem Künst-
ler stammt, der seinen Zeichenstil retrospektiv orientierte.

The Arch of Constantine

Pen and brown ink, grey wash, bordered on all sides by a line
of brown wash
389 x 315 mm, irregular
Inscribed, in brown ink, lower centre: illegible – cut off
Bequeathed by Sir Bruce Ingram, 1963. PD. 189–1963
Provenance: the Earls of Warwick; with P. & D. Colnaghi, London,
from whom bought by Ingram (Lugt 1405 a), June 1944
Exhibited: Washington and American Tour, 1959/60, no. 19; Rotter-
dam / Amsterdam, 1961/62, no. 23; Cambridge, 1985, handlist, p. 4;
Cambridge, 1990, handlist, p. 6

In 1633 Asselijn is recorded in Amsterdam, where he studied
with Jan Martszen the Younger (c. 1609–after 1647), the pupil
and nephew of Esaias van de Velde (1587–1630). He travelled to
Italy between 1635 and 1646 and was probably there in 1641
with Jan Both (c. 1615–1652) and his brother Andries
(c. 1612–c. 1642), and, at the latest, was in Rome in 1644. His
nickname in the *Bentveughels,* the Netherlandish colony of
painters in Rome, was *Crabbetje* or little crab. On his return he
stopped at Lyons (1644), where he married Antonette Huaart
(Houwaart), by whom he had a daughter, Caterina. He was in
Paris 1645/46, where he made drawings for three series of prints
which were executed by Gabriel Perelle (1603–1677). Asselijn
returned to Amsterdam in 1647 and spent the rest of his life
there. He had a considerable influence on Adam Pijnacker
(1622–1673), Karel Dujardin (c. 1622–1678) and Nicolaes Ber-
chem (1620–1683).

View of a side and part of the front of the Arch of Constan-
tine in Rome, seen from the Colosseum; about half of the side of
the arch is obscured by an 'Osteria' built against it. The subject
was a favourite one with Dutch artists working in Rome in the
seventeenth century. The drawing was attributed to Bartholo-
meus Breenbergh (1598–1657) when Ingram acquired it and was
exhibited as such till 1962. The attribution was rejected by Mat-
thias Winner in 1979, who proposed Cornelis van Poelenburgh
(1594/95–1667) and it was exhibited in Cambridge in 1985
under his name. The attribution to Asselijn was proposed by Ger
Luijten who compared it with a drawing of the same subject in
the Louvre, signed and dated 1650 (Steland, no. 134). This com-
parison is telling but not conclusive. The delicate penmanship
in the architectural and sculptural detailing on the Arch is not
a characteristic feature of Asselijn's secure drawings but rather
more typical of Poelenburgh and it remains possible that the
drawing could be a little later in the century, c. 1670, drawn by
an artist who was aware of the work of his predecessors.

JAN ASSELIJN
zugeschrieben / attributed to
Dieppe 1610/14–1652 Amsterdam

Landschaft mit Kastell und Häusern am Steilufer eines Flusses

Graphit und Spuren von schwarzer Kreide, graue Lavierung
277 x 416 mm (Blattgröße unregelmäßig)

Verso: Landschaftsstudie
Schwarze Kreide

Recto unten links in Graphit bezeichnet ‚du Jardin'
Vermächtnis Sir Bruce Ingram, 1963. PD. 276–1963
Provenienz: Paul Sandby (Lugt 2112); Auktion Sotheby's, London, 9. Juli 1936, Teil von Lot 7, hier für Ingram (Lugt 1405 a) von Kunsthandlung P. & D. Colnaghi, London, erworben
Ausstellung: Cambridge 1985, handlist, S. 4

Die herkömmliche Zuschreibung an Karel Dujardin (um 1622–1678) verwarf Christopher White zugunsten einer Zuweisung an Asselijn, wobei er unser Blatt mit Zeichnungen im British Museum in London (Steland, Nrn. 105, 106, 114 und 117) verglich. Ein ähnliches Motiv zeigt eine Zeichnung des Jan Both (um 1615–1652) in Hamburg. Das Graphit ist wiederum sehr ähnlich verwendet wie in einer *Baumstudie* (Kat. 17) des Adam Pijnacker (1622–1673). Eine Zuschreibung an diesen Künstler vertritt Martin Royalton-Kish. Die Komposition mit dem seitlich einfallenden grellen Licht, das von den Felsen zurückgeworfen wird, ist ein Charakteristikum der Arbeiten zahlreicher holländischer Künstler, die Rom besucht hatten.

Landscape with a castle and buildings on an outcrop beside a river

Graphite and traces of black chalk, grey wash
277 x 416 mm, irregular

Verso: Study of landscape
Black chalk

Inscribed, *recto*, in graphite, below left: 'du Jardin'
Bequeathed by Sir Bruce Ingram, 1963. PD. 276–1963
Provenance: Paul Sandby (Lugt 2112); London, Sotheby's, 9 July 1936, part of lot 7; with P. & D. Colnaghi, London, from whom bought by Ingram (Lugt 1405 a), July 1936
Exhibited: Cambridge, 1985, handlist, p. 4

The traditional attribution to Karel Dujardin (c.1622–1678) was rejected by Christopher White in favour of one to Asselijn, by comparison with drawings in the British Museum (Steland, nos. 105, 106, 114 and 117). A drawing of a similar subject by Jan Both (c.1615–1652) is in Hamburg. The handling of the graphite is very similar to that in the drawing *Study of trees in a wood* (Cat. no. 17) by Adam Pijnacker (1622–1673), an attribution which Martin Royalton-Kish prefers to that of Asselijn. The composition with its emphasis on light reflected off the side of the rock is characteristic of many of the Dutch artists who visited Rome.

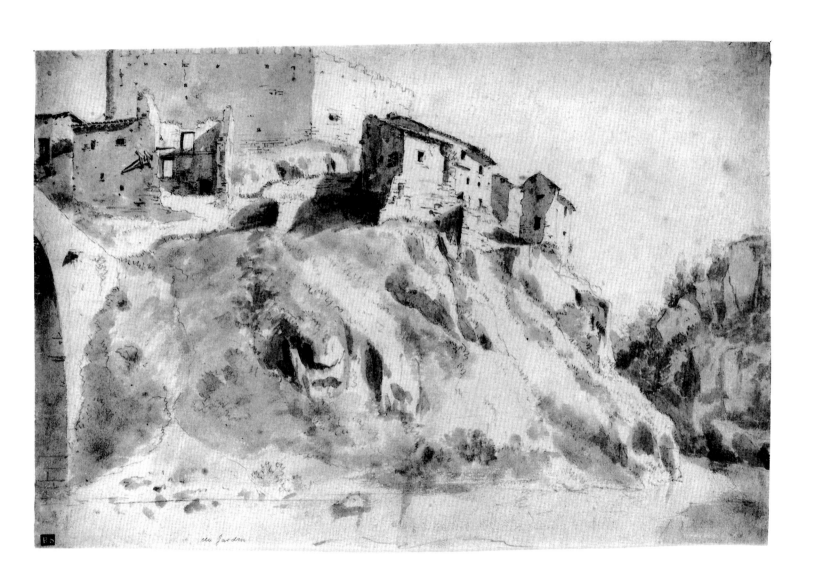

du Jardin

NICOLAES BERCHEM
Haarlem 1620–1683 Amsterdam

Italienische Landschaft – Reisende mit Mauleseln und Schafen auf einer Straße

Rötel
193 x 313 mm
Vermächtnis Sir Bruce Ingram, 1963. PD. 138–1963
Provenienz: Kunsthandlung P. & D. Colnaghi, London; hier von
Ingram (Lugt 1405 a) im Dezember 1942 erworben
Ausstellungen: Cambridge 1977, Nr. 37; Cambridge 1985, handlist, S. 4

Berchem erhielt seine erste Ausbildung bei seinem Vater, dem Stillebenmaler Pieter Claesz. (1596/97–1661), und ging anschließend zu Jan van Goyen (1596–1656), Nicolaes Moeyaert (1590/91–1655), Pieter de Grebber (um 1600–1653) und Jan Wils (um 1600–1666). Er heiratete die Tochter von Jan Wils, mit dem er bei einigen Gemälden zusammenarbeitete. 1642 wurde Berchem Mitglied der Lukasgilde in Haarlem, wo er bis 1677, dem Jahr seines endgültigen Weggangs nach Amsterdam, ansässig blieb. Obwohl ein Italienaufenthalt für ihn nicht nachgewiesen werden konnte, gilt er als der ausgeprägteste italianisierende Maler seiner Generation und ist damit in einer Reihe zu nennen mit Jan Both (um 1615–1652), Jan Asselijn (1610/14–1652), Jan Baptist Weenix (1621–um 1660) und Adam Pijnacker (1622–1673). Zu seinen Schülern zählen Karel Dujardin (um 1622–1678), Pieter de Hooch (1629–nach 1684) und Justus van Huysum (1659–1716). In Frankreich erfreute sich Berchem im 18. Jahrhundert besonderer Wertschätzung.

Unser Blatt ist eine Vorstudie zu einem signierten Gemälde Berchems, ehemals in Rudding Park, Yorkshire, und zeigt, daß der Künstler häufiger als seine Zeitgenossen mit Rötel arbeitete, auch wenn Zeichnungen in diesem Medium nicht allzu oft bei ihm vorkommen. Sowohl die Verwendung der roten Kreide als auch die malerischen Elemente der Komposition und die gefällige Durcharbeitung weisen deutlich auf die Franzosen des 18. Jahrhunderts voraus, die er beeinflußte, in erster Linie auf François Boucher (1703–1770) und Jean-Honoré Fragonard (1732–1806).

An Italian landscape, travellers with mules and sheep on a road

Red chalk
193 x 313 mm
Bequeathed by Sir Bruce Ingram, 1963. PD. 138–1963
Provenance: with P. & D. Colnaghi, London, from whom bought by
Ingram (Lugt 1405 a), December 1942
Exhibited: Cambridge, 1977, no. 37; Cambridge, 1985, handlist, p. 4

Berchem studied with his father, the still-life painter, Pieter Claesz. (1596/97–1661), and then with Jan van Goyen (1596–1656), Nicolaes Moeyaert (1590/91–1655), Pieter de Grebber (c. 1600–1653) and Jan Wils (c. 1600–1666). He married Wils' daughter and the two artists collaborated on several paintings. In 1642 Berchem became a member of the Guild of St Luke in Haarlem and he was based there until 1677 when he moved permanently to Amsterdam. Whether or not he visited Italy has not yet been established, but he was the foremost Italianate painter of his generation, in direct competition with Jan Both (c. 1615–1652), Jan Asselijn (1610/14–1652), Jan Baptist Weenix (1621–c. 1660) and Adam Pijnacker (1622–1673). His pupils include Karel Dujardin (c. 1622–1678), Pieter de Hooch (1629–after 1684) and Justus van Huysum (1659–1716). Berchem was particularly admired in France in the eighteenth century.

A study for the signed painting formerly at Rudding Park, Yorkshire. Berchem used red chalk more regularly than most of his contemporaries, although even in his drawings it is comparatively infrequent. Both the medium, the picturesque elements in the composition and its decorative handling anticipate clearly the French artists of the eighteenth century whom he influenced, notably François Boucher (1703–1770) and Jean-Honoré Fragonard (1732–1806).

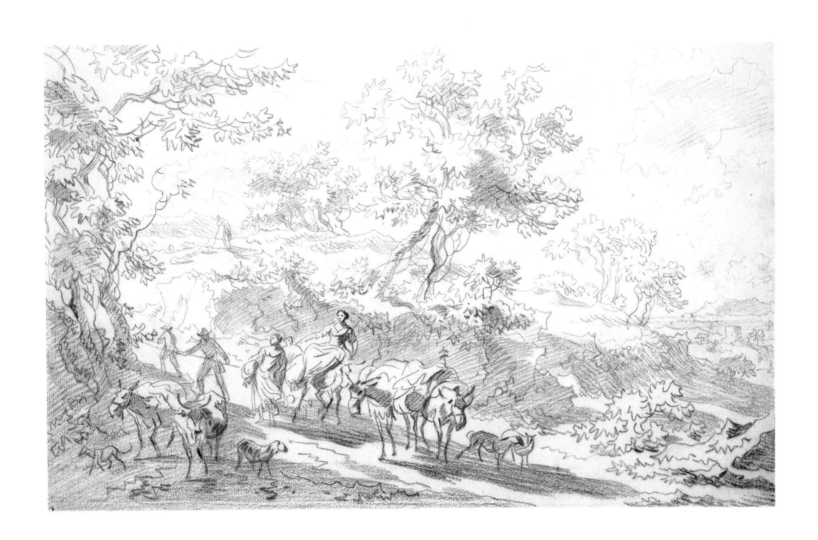

NICOLAES BERCHEM
Haarlem 1620–1683 Amsterdam

Rinderherde an einer Furt

Feder, braune Tusche, braune Lavierung
292 x 384 mm (Blattgröße unregelmäßig)
Unten rechts in brauner Tusche signiert ‚Berchem:f:‘
Verso in Bleistift in der Handschrift des Ploos van Amstel bezeichnet
‚Nos Berchem f / hoog 14¹/2 d. / breed 15 d‘
Vermächtnis Sir Bruce Ingram, 1963. PD. 143–1963
Provenienz: Ploos van Amstel (Lugt 2034); R. S. Holford (Lugt
2243); Auktion Holford, Christie's, London, 11. Juli 1893; Kunsthandlung P. & D. Colnaghi, London; hier von Ingram (Lugt 1405 a) im Juni 1938 erworben
Ausstellungen: Wanderausstellung USA und Cambridge 1976/77, Nr. 59; Cambridge 1985, handlist, S. 5

Unser Blatt ist ein herausragendes Beispiel für Berchems pastorale Landschaften. Zahlreiche solcher Zeichnungen wurden von ihm oder nach ihm gestochen oder radiert und waren im 18. Jahrhundert äußerst beliebt. Das Gegenstück, das Ingram gleichzeitig mit diesem Blatt aus der Sammlung Holford kaufte (Fitzwilliam Museum, PD. 142–1963), stach Jan de Visscher (um 1636–nach 1692) im Gegensinn; die hier ausgestellte Zeichnung scheint jedoch nicht als Vorlage für eine Druckgraphik gedient zu haben. Die Komposition ist sehr beliebt bei den italianisierenden holländischen Malern. In seiner Durchführung und Handschrift steht unser Blatt Zeichnungen im Fogg Art Museum, Cambridge MA., und im Musée Condé in Chantilly (Nr. 360 H) nahe.

Cattle by a ford

Pen, brown ink, brown wash
292 x 384 mm, irregular
Signed, lower right, in brown ink: ‘Berchem:f:’
Inscribed, *verso*, in pencil in Ploos van Amstel's hand:
‘Nos Berchem f / hoog 14¹/2 d. / breed 15d’
Bequeathed by Sir Bruce Ingram, 1963. PD. 143–1963
Provenance: Ploos van Amstel (Lugt 2034); R.S. Holford (Lugt 2243), his sale, London, Christie's, 11 July 1893; with P. & D. Colnaghi, London, from whom bought by Ingram (Lugt 1405 a), June 1938
Exhibited: American Tour and Cambridge, 1976/77, no. 59; Cambridge, 1985, handlist, p. 5

This exemplifies Berchem's highly finished manner of treating pastoral subjects. Many such drawings were engraved or etched and were very popular in the eighteenth century. A companion piece in the Fitzwilliam Museum (PD. 142–1963), bought by Ingram at the same time as this and also from the Holford collection, was engraved in reverse by Jan de Visscher (c.1636–after 1692), but this particular drawing does not seem to have been used for a print. The composition is a favourite one of several of the Italianate painters. In finish and style, the Fitzwilliam drawing can be compared with examples in the Fogg Art Museum, Cambridge MA., and the Musée Condé, Chantilly (no. 360 H).

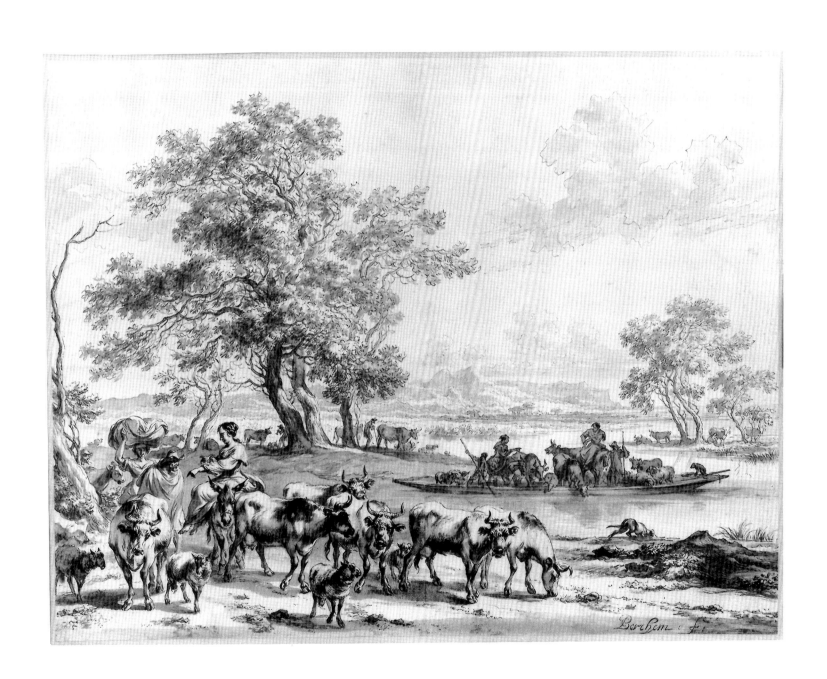

Berchem. f.

LAMBERT DOOMER
Amsterdam 1624–1700 Amsterdam

Die Weinpresse des Monsieur Dittyl bei Nantes

Feder und braune Tusche, braune Lavierung, allseitig Randlinie
mit Pinsel in Braun
240 × 415 mm
Verso in Tusche bezeichnet ‚Een Wijnpers van M. Dittyl / buyte
Nantes‘; in Graphit ‚inv. 620‘, ‚1171‘ und ‚1647‘
Vermächtnis Sir Bruce Ingram, 1963. PD. 268–1963
Provenienz: Jerome Tonneman; Versteigerung Amsterdam, 21. Okto-
ber 1754, Teil von Portefeuille R oder S; Jan Lambers; Versteigerung
Amsterdam, 6. Mai 1788; Pieter Oets; Versteigerung Amsterdam,
31. Januar 1791, Konstboek H, Teil von Nr. 20; Dirk Versteegh; Ver-
steigerung Amsterdam, 3. November 1823, Portefeuille 2, Nr. 38; hier
erworben von de Gruyter; Ludwig Heinrich Storck; Auktion Storck,
Amstel & Ruthardt, Berlin, 25. Januar 1894, Lot 166; P. Langerhuizen
Lzn.; Auktion Langerhuizen, Muller, Amsterdam, 29. April 1919, Lot
227; Dr. C. Hofstede de Groot (Lugt 561); Auktion Hofstede de Groot,
Boerner, Leipzig, 4. November 1931, Lot 75; Kunsthandlung P. & D.
Colnaghi, London; von Ingram (Lugt 1405 a) April 1935 erworben
Literatur: H. M. van den Berg, Willem Schellinks en Lambert Doo-
mer in Frankrijk. *Oudheidkundig Jaarboek* IV, 1942, S. 29, Nr. 60; Wolf-
gang Schulz, *Lambert Doomer, 1624–1700. Leben und Werke.* Berlin
1972, S. 258, Nr. 92; Ders., *Lambert Doomer. Sämtliche Zeichnungen.*
Berlin / New York 1974, S. 26, 54, Nr. 68; Sumowski II, S. 819,
Nr. 383/13
Ausstellungen: Den Haag 1930, *Collection of C. Hofstede de Groot,* III,
Nr. 138; Cirencester 1951, Nr. 30; Cambridge, Fitzwilliam Museum,
1951/52 (o. Kat.); Bedford 1958, Nr. 15; Washington u. a. 1959/60,
Nr. 27; Rotterdam / Amsterdam 1961/62, Nr. 30; Cambridge 1966, Nr. 14

Lambert Doomer war der Sohn des Harmen Doomer, eines Rah-
menmachers und Kunsttischlers aus Anrath bei Krefeld, zu des-
sen Abnehmern Rembrandt (1606–1669) zählte. Man nimmt
auch an, daß Doomer um 1640/45 zum Schülerkreis Rembrandts
gehörte. 1645/46 reiste er durch Frankreich, um seine beiden
Brüder in Nantes zu besuchen; der Rückweg führte ihn – zusam-
men mit dem Maler Willem Schellinks (1623–1678) – durch das
Loiretal und über Paris. Um 1663 besuchte er Deutschland und
reiste rheinaufwärts, über Augsburg und in die Schweiz. 1668
heiratete er Metje Harmens, die 1677 in Alkmaar starb, wo Doo-
mer von 1669 bis 1695 lebte. In zweiter Ehe war er mit Geesje
Esdras verheiratet. Er war fast ausschließlich als Zeichner tätig.

Auf seinen Reisen zeichnete Doomer nach der Natur; viele
dieser Zeichnungen verarbeitete er später in Gestalt großforma-
tiger Repliken. Unser Blatt geht wahrscheinlich auf eine Studie
zurück, die während seines Besuches bei den Brüdern in Nantes
entstand, wo er das Keltern der Trauben auf dem Weingut des
Monsieur Dittyl – dessen Name auf der Rückseite vermerkt ist –
beobachtete. Schulz (1974, S. 26) nimmt an, daß unsere Zeich-
nung in den frühen siebziger Jahren zu Hause in Holland ausge-
arbeitet wurde. Das ursprüngliche Studienblatt ist unbekannt,
aber ein Vergleich mit Zeichnungen, die vor Ort in Frankreich
entstanden, wie das *Bauernhaus bei Nantes* (Fitzwilliam Museum,
PD. 269–1963), zeigt, daß es von deutlich kleinerem Format
gewesen sein muß.

The Winepress of Monsieur Dittyl, outside Nantes

Pen and brown ink, brown wash, bordered on all sides by a line
of brown wash
240 × 415 mm
Inscribed *verso*, in ink: ‘Een Wijnpers van M. Dittyl / buyte Nantes’;
in graphite: ‘inv. 620’, ‘1171’ and ‘1647’
Bequeathed by Sir Bruce Ingram, 1963. PD. 268–1963
Provenance: Jerome Tonneman, his sale, Amsterdam, 21 October
1754, part of portefeuille R or S; Jan Lambers, his sale, Amsterdam,
6 May 1788; Pieter Oets, his sale, Amsterdam, 31 January 1791,
Konstboek H, part of no. 20; Dirk Versteegh, his sale, Amsterdam,
3 November 1823, Portefeuille 2, no. 38, bought by de Gruyter; Lud-
wig Heinrich Storck, his sale, Berlin, Amstel and Ruthardt, 25 Jan-
uary 1894, lot 166; P. Langerhuizen Lzn., his sale, Amsterdam, Muller,
29 April 1919, lot 227; Dr C. Hofstede de Groot (Lugt 561), his sale,
Leipzig, Boerner, 4 November 1931, lot 75; with P. & D. Colnaghi,
London, from whom bought by Ingram (Lugt 1405 a), April 1935
Literature: H. M. van den Berg, ‘Willem Schellinks en Lambert
Doomer in Frankrijk’, *Oudheidkundig Jaarboek,* IV, 1942, p. 29, no. 60;
Wolfgang Schulz, *Lambert Doomer, 1624–1700, Leben und Werke,* Ber-
lin, 1972, p. 258, no. 92; Wolfgang Schulz, *Lambert Doomer. Sämtliche
Zeichnungen,* Berlin, New York, 1974, pp. 26, 54, no. 68; Sumowski, II,
p. 819, no. 383/13
Exhibited: The Hague, 1930, *Collection of C. Hofstede de Groot,* III,
no. 138; Cirencester, 1951, no. 30; Cambridge, Fitzwilliam Museum,
1951/52 (no handlist); Bedford, 1958, no. 15; Washington and Amer-
ican Tour, 1959/60, no. 27; Rotterdam / Amsterdam, 1961/62, no. 30;
Cambridge, 1966, no. 14

The son of Harmen Doomer, a frame and cabinetmaker from
Anrath near Krefeld, one of whose customers was Rembrandt
(1606–1669). Doomer is thought to have studied with Rem-
brandt c.1640/45. In 1645/46 he travelled through France to
visit his two brothers at Nantes, and on his return, with the art-
ist Willem Schellinks (1623–1678), he travelled along the Loire
valley and via Paris. He visited Germany, going up the Rhine, to
Augsburg and Switzerland c.1663. In 1668 he married Metje
Harmens, who died in 1677 in Alkmaar, where Doomer lived
from 1669 till 1695. After her death Doomer married Geesje
Esdras. Doomer made his career almost exclusively as a draughts-
man.

Doomer drew from nature when he was on his travels and later
worked up many of his original drawings into full-scale replicas.
He visited Nantes where his two brothers lived, in 1645/46, and
presumably that was the occasion of his seeing this scene of the
pressing of grapes to make wine on the estate of Monsieur Dit-
tyl, whose name is recorded on the back of this drawing. Schulz
(1974, p. 26) believes this to have been worked up in Holland,
probably in the early 1670s. The original drawing made on the
spot is not known, but by comparison with examples done in
France, one of which is in the Fitzwilliam (PD. 269–1963, *Farm-
house near Nantes*), it is likely that the original was considerably
smaller.

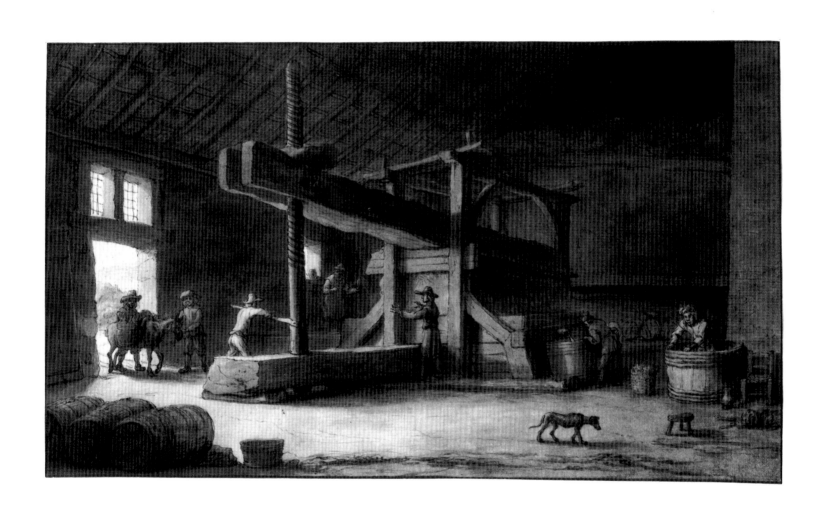

JACOB ESSELENS
Amsterdam 1626–1687 Amsterdam

Blick auf Dover

Feder und braune Tusche, graue, braune und grüne Lavierung über
schwarzer Kreide, allseitig Randlinie mit Pinsel in Braun
231 x 584 mm (Blattgröße unregelmäßig), aus vier Papierstreifen
zusammengesetzt
Durchgehend stockfleckig
Verso in brauner Tusche bezeichnet ‚Krytbergen aan Zee'; in Graphit
‚Een Gedeelte van Doevres / en der Krytbergen'; ‚.. V. Velde'
Vermächtnis Sir Bruce Ingram, 1963. PD. 299–1963
Provenienz: Lord Aylesford (Lugt 58); A. W. M. Mensing; Auktion
Mensing, Amsterdam, 27. April 1937, Lot 189; Kunsthandlung P. & D.
Colnaghi, London; hier im Mai 1937 von Ingram (Lugt 1405 a)
erworben
Literatur: P. H. Hulton, *Drawings of England in the Seventeenth Century
by Willem Schellinks, Jacob Esselens and Lambert Doomer.* London 1959
(Walpole Society 35, 1954 / 56)
Ausstellungen: London, Colnaghi, 1938, Nr. 72; London 1946/47,
Nr. 8; Cambridge, Fitzwilliam Museum, 1951/52 (o. Kat.)

Jacob Esselens war der jüngste der drei Söhne des Pieter Esselens
und von Beruf Samt- und Seidenhändler. Es ist nicht bekannt,
bei wem er seine künstlerische Schulung erhielt. Er vertrieb
seine Stoffe in vielen Ländern Europas, und zahlreiche Zeich-
nungen entstanden teilweise auf Geschäftsreisen in England,
Deutschland, Frankreich und vielleicht Italien. 1662 heiratete
er Janneken Jans. Sein zeichnerischer Stil orientiert sich an
Gerbrand van den Eeckhout (1621–1674), Simon de Vlieger
(um 1601–1653) und Anthonie Waterloo (1609–1690).
Esselens trat hauptsächlich als Zeichner hervor, auch wenn
Landschaftsgemälde und Portraits von seiner Hand bekannt
sind.

Die Bezeichnung auf der Rückseite unseres Blattes benennt
die Ansicht als „Kreideberge am Meer". Die Zeichnung zeigt
Dover von Osten mit Blick auf „Shakespeare's Cliff". Esselens
scheint sich um 1662 in England aufgehalten zu haben; seine
gezeichneten Ansichten von Rye, Greenwich, Chatham, Roche-
ster und London (die alte Kathedrale St. Paul's vor dem Stadt-
brand von 1666) sind in den Atlas van der Hem in der Öster-
reichischen Nationalbibliothek, Wien (vol. XIX/XX) eingefügt.

View of Dover

Pen and brown ink, grey, brown and green wash, over black chalk,
bordered on all sides by a line of brown wash
231 x 584 mm, irregular; on four pieces of paper
Foxed throughout
Inscribed, *verso*, in brown ink: 'Krytbergen aan Zee'; in graphite:
'Een Gedeelte van Doevres / en der Krytbergen'; and: '..V. Velde'
Bequeathed by Sir Bruce Ingram, 1963. PD. 299–1963
Provenance: Lord Aylesford (Lugt 58); A.W.M. Mensing, his sale,
Amsterdam, 27 April 1937, lot 189; with P. & D. Colnaghi, London,
from whom acquired by Ingram (Lugt 1405 a), May 1937
Literature: P.H. Hulton, *Drawings of England in the Seventeenth Cen-
tury by Willem Schellinks, Jacob Esselens and Lambert Doomer*, London,
1959 (Walpole Society, 35, 1954 / 56)
Exhibited: London, Colnaghi, 1938, no. 72; London, 1946/47, no. 8;
Cambridge, Fitzwilliam Museum, 1951/52 (no handlist)

Esselens was the son of Pieter Esselens and the youngest of three
brothers. Active as a velvet and silk merchant, we do not know
with whom he trained. He traded his fabrics in many parts of
Europe and his numerous drawings were partly made on his busi-
ness trips to England, Germany, France and perhaps Italy. In
1662 he married Janneken Jans. His style of drawing depends on
the examples of Gerbrand van den Eeckhout (1621–1674),
Simon de Vlieger (c.1601–1653) and Anthonie Waterloo
(1609–1690). Although paintings of landscape and portraits are
known by him, the bulk of his artistic output was drawn.

The inscription of the *verso* identifies the view as 'Chalk
mountains on Sea'. The view is taken from the East, looking
towards 'Shakespeare's Cliff'. Esselens appears to have been in
England c.1662; drawings by him of Rye, Greenwich, Chatham,
Rochester and London (showing old St Paul's, and therefore
drawn before the Great Fire of 1666) are in the van der Hem
Atlas in Vienna, National Library (vol. XIX/XX).

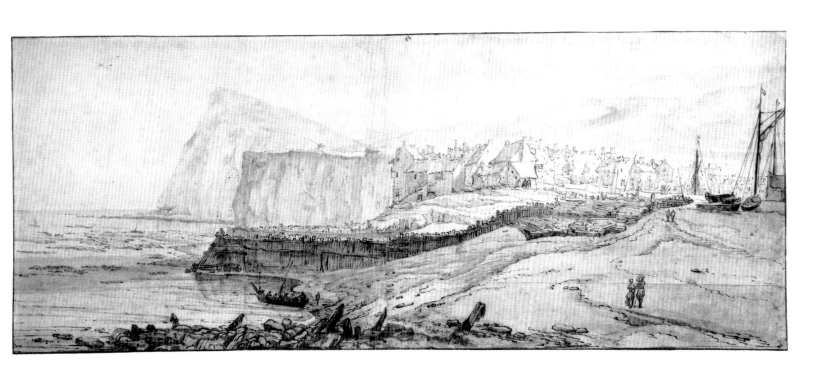

JACOB ESSELENS
Amsterdam 1626–1687 Amsterdam

Rye, von Point Hill aus gesehen

Feder und braune Tusche, graue Lavierung über schwarzer Kreide, allseitig Randlinie mit Pinsel in Braun
249 x 370 mm
Unten rechts in brauner Tusche signiert ‚J. Esselens‘
Vermächtnis Sir Bruce Ingram, 1963. PD. 298–1963
Provenienz: Kunsthandlung P. & D. Colnaghi, London; hier von Ingram (Lugt 1405 a) im Juli 1936 erworben
Literatur: P. H. Hulton, *Drawings of England in the Seventeenth Century by Willem Schellinks, Jacob Esselens und Lambert Doomer.* London 1959 (Walpole Society 35, 1954/56), s. v. Nr. 38, S. 35; J. Foster, *Rye and District.* Rye 1964; K. M. Clark, Rye, 150 years of Town Guides. *Rye Museum Publication* 7, Rye 1965, Abb. 4
Ausstellungen: London, Colnaghi, 1937, Nr. 4; Cambridge, Fitzwilliam Museum, 1952 (o. Kat.); Washington u. a. 1959/60, Nr. 33; Cambridge 1985, handlist, S. 19

Fast identisch mit dieser Ansicht ist eine Zeichnung im Hochformat im van der Hem Atlas der Österreichischen Nationalbibliothek in Wien. Hulton (a. a. O.) lokalisiert den Standpunkt des Zeichners unterhalb des Playden Cliff (im Vordergrund rechts). Im Hintergrund erhebt sich auf dem Hügel im Zentrum der Stadt die Pfarrkirche St. Mary. Zur Linken ist der Ypres Tower zu erkennen und weiter links am Horizont Schloß Winchelsea. In der Mitte des Mittelgrundes die Toranlage Land Gate und von hier nach rechts ausgehend Teile der Stadtummauerung mit einer kleinen Ausfallpforte; zur Linken der Althafen und die Trichtermündung des Rother. Das Versanden des Hafens von Rye begann im 16. Jahrhundert und war 1618 so fortgeschritten, daß Bürgermeister und Rat der Stadt Rye beklagten, „daß nun unser Hafen so verfallen ist, daß aller Handel uns verließ" (British Museum, Add. MS. 5705, f. 82 v).

Rye from Point Hill

Pen and brown ink, grey wash, over black chalk, bordered on all sides by a line of brown wash
249 x 370 mm
Signed, lower right, in brown ink: ‘J. Esselens’
Bequeathed by Sir Bruce Ingram, 1963. PD. 298–1963
Provenance: with P. & D. Colnaghi, London, from whom bought by Ingram (Lugt 1405 a), July 1936
Literature: P. H. Hulton, *Drawings of England in the Seventeenth Century by Willem Schellinks, Jacob Esselens and Lambert Doomer*, London, 1959 (Walpole Society, 35, 1954/56), *s. v.* no. 38, p. 35; J. Foster, *Rye and District*, Rye, 1964; K. M. Clark, ‘Rye, 150 years of Town Guides’, *Rye Museum Publication*, no. 7, Rye, 1965, pl. 4
Exhibited: London, Colnaghi, 1937, no. 4; Cambridge, Fitzwilliam Museum, 1952 (no handlist); Washington and American Tour, 1959/60, no. 33; Cambridge, 1985, handlist, p. 19

An almost identical version in a vertical format is in the van der Hem Atlas in Vienna (National Library). Hulton (*loc. cit.*) identifies the view from below Playden Cliff (in the foreground on the right). In the distance, crowning the hill in the centre of the town, the parish church of St Mary. To the left the Ypres tower, and still further to the left in the far distance, Winchelsea Castle. In the middle distance, centre, the Land Gate and to the right, part of the town walls with a small postern gate. On the left, the Old Harbour and estuary of the Rother. The silting up of Rye harbour began in the sixteenth century and by 1618 the mayor and jurats of Rye were complaining that ‘now is our Harbour so decaied, that all Trade has forsaken us’ (B. M., Add. MS. 5705, f. 82 v).

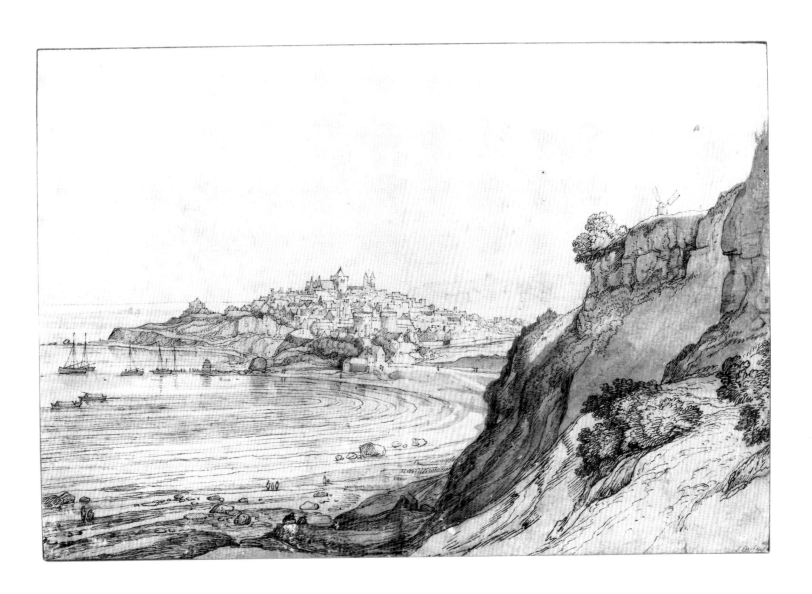

ALLAERT VAN EVERDINGEN
Alkmaar 1621–1675 Amsterdam

Felsige Landschaft mit zwei Brücken

Dünner Pinsel, braune Tusche, braune Lavierung über Spuren von schwarzer Kreide oder Graphit, allseitig Randlinie mit Pinsel in Braun
162 x 237 mm
Auf dem mittleren Felsbrocken monogrammiert ‚AVE‘
Vermächtnis Sir Bruce Ingram, 1963. PD. 317–1963
Provenienz: Kunsthandlung P. & D. Colnaghi, London; hier von Ingram (Lugt 1405 a) im Januar 1939 erworben
Bisher noch nicht öffentlich ausgestellt

Unser Blatt zeigt einen deutlichen Nachhall von Everdingens Reisen nach Schweden und Norwegen zwischen 1640 und 1644. Einige Zeichnungen von seiner Hand haben sich erhalten, die mit Sicherheit vor Ort in Schweden und Norwegen entstanden sind, doch besitzt dieses Blatt keine Bezeichnung, die es jenen zuordnen würde: Wahrscheinlich ist es erst nach seiner Rückkehr nach Haarlem 1645 entstanden. Die Figurenstaffage im Vordergrund ist ausgeprägt italianisierend und erinnert an Nicolaes Berchem (1620–1683) und den „Bamboccio" Pieter van Laer (1599–1642); der Esel ist ganz auf italienische Art mit einer Schabracke herausgeputzt (vgl. Pieter van Bloemens [1657–1720] Gemälde *Rastende Maulesel am Wegesrand* im Fitzwilliam Museum [Nr. 257]), und die warmtonige braune Lavierung suggeriert südliches Licht. Dies macht es wahrscheinlich, daß unsere Zeichnung nach Everdingens Rückkehr nach Holland zu datieren ist.

Rocky landscape with two bridges

Point of the brush, brown wash, over traces of black chalk or graphite, bordered on all sides by a line of brown wash
162 x 237 mm
Signed with initials on the rock in the centre: 'AVE'
Bequeathed by Sir Bruce Ingram, 1963. PD. 317–1963
Provenance: with P. & D. Colnaghi, London, from whom bought by Ingram (Lugt 1405 a), January 1939
Not previously exhibited

This drawing shows the clear inspiration on Everdingen's work of his journey to Sweden and Norway between 1640 and 1644. Although several drawings survive which were definitely drawn in Scandinavia there is no inscription on this example to prove it and it seems likely that this was executed after his return to Haarlem in 1645. The staffage of figures in the foreground has a distinctly Italianate look, reminiscent of Berchem (1620–1683) and the Bamboccianti artist Pieter van Laer (1599–1642); indeed the donkey is caparisoned in a wholly Italian manner (compare the painting by Pieter van Bloemen [1657–1720] in the Fitzwilliam Museum of *Mules halting by the wayside* [no. 257]), and the use of a warm brown wash suggests a southern light, both of which facts reinforce the probability that the drawing was done after Everdingen's return to Holland.

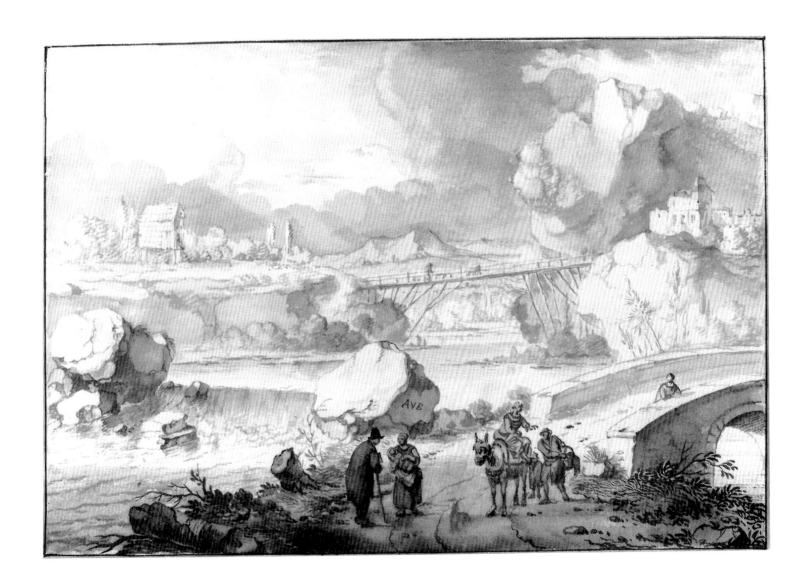

JAN WILLEMSZ. LAPP

zugeschrieben/attributed to
tätig in Den Haag/active in The Hague 1625–1670

Gebirgslandschaft in italienischer Manier

Feder und braune Tusche, braune Lavierung über Graphit
270 x 379 mm
Unten links bezeichnet ‚H'
Vermächtnis Sir Bruce Ingram, 1963. PD. 393–1963
Provenienz: Wahrscheinlich Kunsthandlung P. & D. Colnaghi, London; hier erworben von Ingram (Lugt 1405a) im November 1938 (eine andere Zeichnung, die, wie dieses Blatt, Hackaert zugeschrieben wurde, erwarb Ingram im Mai 1933 in der Kunsthandlung E. Parsons & Sons in London. Beide trugen den gleichen Titel, so daß es nicht klar ist, welches Blatt von welcher Kunsthandlung kam, jedoch war die Colnaghi-Zeichnung beträchtlich teurer als die von Parsons. Man kann also annehmen, daß unser großformatiges Blatt dasjenige ist, das Ingram bei Colnaghi erwarb. Da das Ingram-Vermächtnis nur diese eine sog. Hackaert-Zeichnung enthält, wird Ingram das zweite Blatt vor seinem Tode veräußert haben)
Ausstellung: Cambridge, Fitzwilliam Museum, 1952/53 (o. Kat.)

Jan Lapp, in Italien Giovanni Lap genannt, wird 1625 als Mitglied der Lukasgilde in Den Haag archivalisch bezeugt. Er soll bis 1670 tätig gewesen sein. Überraschend wenig ist über sein Leben bekannt, man nimmt aber einen Italienaufenthalt an. Seine wenigen erhaltenen Gemälde zeigen einen starken italianisierenden Einfluß; es sind zumeist Landschaften mit Ruinen und vielen Figuren in der Manier von Jan Both (um 1615–1652), Nicolaes Berchem (1620–1683) und Karel Dujardin (um 1622–1678). Einige dieser Bilder bewahren das Mauritshuis in Den Haag und die Dulwich Picture Gallery in London. Am meisten bekannt ist Lapp jedoch als Zeichner.

Unsere Zeichnung wurde lange Zeit Jan Hackaert (1628–nach 1685) zugeschrieben, und sie weist in der Tat eine Reihe von Übereinstimmungen mit signierten Zeichnungen im van der Hem Atlas der Österreichischen Nationalbibliothek in Wien auf. Dennoch schließen sich weder Carlos van Hasselt noch Martin Royalton-Kish der herkömmlichen Zuweisung an. Gerade Vergleiche mit gesicherten Hackaert-Zeichnungen (zwei Kopien Hackaerts nach Landschaften von Jan Both im Fitzwilliam Museum [PD. 181–1963 und 182–1963] eingeschlossen) bestätigen ihre Vermutung, daß es sich bei unserem Blatt nicht um eine Arbeit Hackaerts handelt. Vor allem dessen Abbreviaturen für das Laubwerk der Bäume und für bewachsenen Grund sind dichter und genauer als beim Zeichner unseres Blattes. Martin Royalton-Kish schlug eine Zuschreibung an Lapp vor im Vergleich mit einer Zeichnung dieses Künstlers im British Museum in London (Gg. 2–308; Abb. Hind III, S. 133, Taf. LXX).

Die Szenerie konnte nicht lokalisiert werden, aber sie scheint aus Schweizer und italienischen Landschaftselementen versatzstückhaft zusammengestellt zu sein. Auffallend sind die drei waagerechten Linien, die der Künstler im unteren Teil der Darstellung über das Blatt gezogen hat; sie dienen der perspektivischen Verkürzung des Vordergrundes.

Mountainous Italianate Landscape

Pen and brown ink, brown wash, over graphite
270 x 379 mm
Inscribed, lower left: 'H'
Bequeathed by Sir Bruce Ingram, 1963. PD. 393–1963
Provenance: probably with P. & D. Colnaghi, London, from whom bought by Ingram (Lugt 1405a), November 1938 (another drawing which, like this, was attributed to Hackaert, was bought by Ingram from E. Parsons & Sons in May 1933; it is not possible to be sure which one this drawing is, as they were given the same title; but the Colnaghi drawing was considerably more expensive than the Parsons one, so it is likely that this large drawing is the one bought from Colnaghi. The Ingram bequest included only one drawing then attributed to Hackaert, so it is assumed that Sir Bruce disposed of one before his death)
Exhibited: Cambridge, Fitzwilliam Museum, 1952/53 (no handlist)

Jan Lapp, known in Italy as Giovanni Lap, is documented as a member of the painter's Guild in The Hague in 1625. He is said to have been active until 1670. Surprisingly little is known about him. He is thought to have travelled to Italy. His paintings, which are rare, show a strong Italianate influence, largely depicting landscapes with ruins and numerous figures in the manner of Jan Both (c.1615–1652), Nicolaes Berchem (1620–1683) and Karel Dujardin (c.1622–1678). There are examples at the Mauritshuis, The Hague, and the Dulwich Picture Gallery, London. He is best known as a draughtsman.

This drawing was previously attributed to Jan Hackaert (1628–after 1685) and there is much in common with it and with signed drawings by him in the Atlas van der Hem (Vienna, National Library). However neither Carlos van Hasselt nor Martin Royalton-Kish accept the traditional attribution and comparison with drawings which are certainly by Hackaert (including two copies after landscapes by Jan Both in the Fitzwilliam [PD. 181 & 182–1963]) reinforces their opinion. Above all Hackaert's shorthand for the foliage of trees and for grasses is tighter and better realised than that of the artist responsible for this drawing. The attribution to Lapp was suggested by Martin Royalton-Kish by comparison with a drawing in the British Museum (Gg. 2–308, repr. Hind, III, p. 133, pl. LXX).

The scene has not been identified but appears to be an amalgam of Swiss and Italian scenery. Of particular interest is the artist's use of three lines drawn across the lower section of the drawing as a guide to the perspective of the foreground.

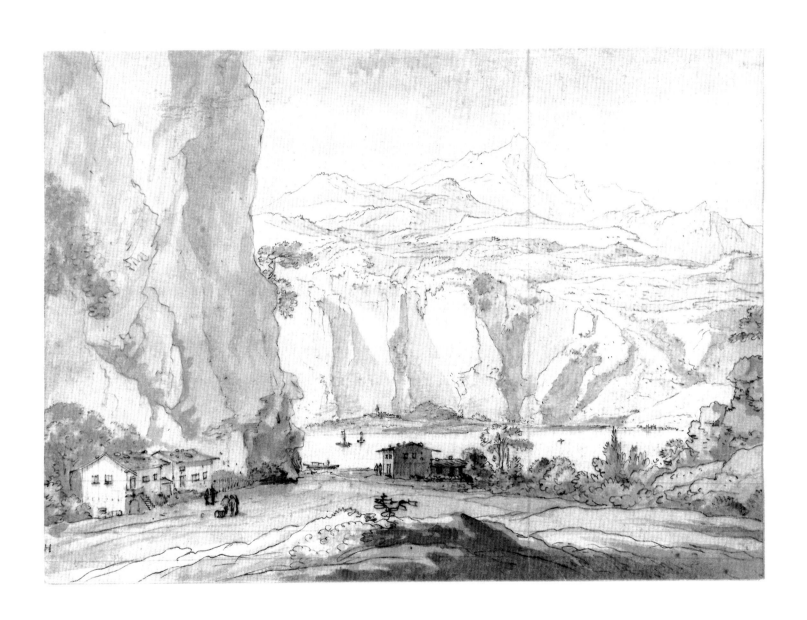

ABRAHAM STORCK
Amsterdam 1644–um/c. 1710 Amsterdam

Venezianisches Architekturcapriccio

Feder und braune Tusche, graue Lavierung auf verfärbtem,
bräunlichem Papier, allseitig Randlinie mit Pinsel in Braun
147 x 196 mm
Durchgehend stockfleckig und fleckig
Unten links in brauner Tusche signiert und datiert
‚A:Storck fecit ao 1678'
Vermächtnis Sir Bruce Ingram, 1963. PD. 724–1963
Provenienz: Französische Privatsammlung; Kunsthandlung P. & D.
Colnaghi, London; hier von Ingram (Lugt 1405 a) im November 1935
erworben
Bisher noch nicht öffentlich ausgestellt

Abraham Storck war als Maler von Architekturveduten, See-
stücken und Hafenszenen, als Zeichner und als Radierer tätig.
Über seine künstlerische Ausbildung ist nichts bekannt, doch
zeigen seine Arbeiten deutliche Einflüsse des Ludolf Backhuizen
(1631–1708). Er malte auch Figurenstaffagen in den Landschaf-
ten des Frederick de Moucheron (1633–1686) und des Meindert
Hobbema (1638–1709).

In diesem venezianischen Architekturcapriccio hat sich
Storck die künstlerische Freiheit genommen, den Campanile
und die Markusbasilika direkt ans Wasser neben den Dogen-
palast zu versetzen.

A Venetian Capriccio

Pen and brown ink, grey wash on discoloured brownish paper,
bordered on all sides by a line of brown wash
147 x 196 mm
Generally foxed and stained
Signed and dated, lower left, in brown ink:
‘A:Storck fecit ao 1678’
Bequeathed by Sir Bruce Ingram, 1963. PD. 724–1963
Provenance: private collection in France; with P. & D. Colnaghi,
London, from whom bought by Ingram (Lugt 1405 a), November 1935
Not previously exhibited

Abraham Storck was a painter of architectural vistas, seascapes
and port scenes, a draughtsman and an etcher. We do not know
with whom he studied but he was clearly influenced by Ludolf
Backhuizen (1631–1708). He also painted figures for Frederick
de Moucheron (1633–1686) and Meindert Hobbema (1638–
1709).

In this capriccio of Venice, Storck has used artistic licence to
move the Campanile and the Church of St Mark to the water's
edge, next to the Doge's palace.

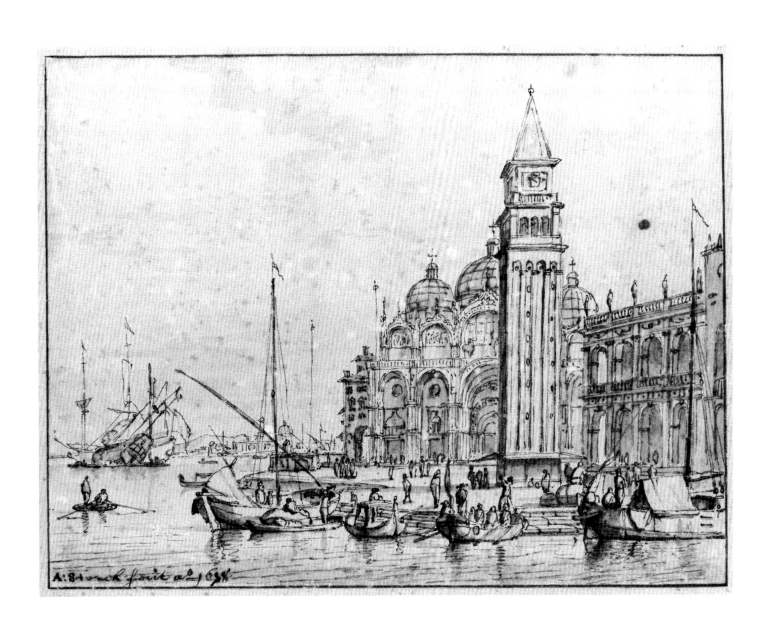

JACOB VAN DER ULFT
Gorinchem 1621–1689 Noordwijk

Italianisierende Ruinenlandschaft

Feder und braune Tusche, braune Lavierung, allseitig Randlinie
mit Pinsel in Braun
227 x 365 mm
Oben rechts in brauner Tusche datiert ‚Fecit 1671'; unten links in
brauner Tusche bezeichnet ‚Jacob van der Ulft / No. 68'
Vermächtnis Sir Bruce Ingram, 1963. PD. 750–1963
Provenienz: Kunsthandlung P. & D. Colnaghi, London; hier von
Ingram (Lugt 1405 a) im Juli 1938 erworben
Ausstellungen: Rotterdam / Amsterdam 1961/62, Nr. 89; Cambridge
1985, handlist, S. 27; Cambridge 1990, handlist, S. 7

Über eine künstlerische Ausbildung van der Ulfts ist nichts
bekannt, und man nimmt an, daß er Autodidakt war. Er amtierte
als Bürgermeister von Gorinchem. Wahrscheinlich hielt er sich
mehrfach in Italien auf, wenn auch Zeichnungen von seiner
Hand mit bestimmbaren italienischen Motiven, die in die Jahre
1663 bis 1674 datieren, möglicherweise Arbeiten anderer Künst-
ler reflektieren. In seinem Zeichenstil ist er deutlich Jan de Bis-
schop (1628–1671) verpflichtet. Van der Ulft war als Maler,
Radierer und Zeichner tätig.

Zeichnungen dieser Art sind nicht ungewöhnlich im Werk
van der Ulfts. Sie schildern hauptsächlich italienische Land-
schaften mit phantastischen klassisch-antiken Bauten; ein sehr
ähnliches Blatt bewahrt die Albertina in Wien (Nr. 9884). Eine
andere Gruppe von Zeichnungen mit realistischen italienischen
Ansichten, auf die oben bereits hingewiesen wurde, hat die Ver-
mutung entstehen lassen, daß sich van der Ulft in Italien auf-
hielt, auch wenn eine solche Reise nicht belegt werden konnte.
Unser Blatt ist eine Detailstudie zu van der Ulfts Gemälde
Die Erbauung Karthagos, ehemals Sammlung Rt. Hon. Lewis Fry,
versteigert bei Christie's, London, 25. Juli 1924, als Lot 90.

An Italianate landscape with ruined buildings

Pen and brown ink, brown wash, bordered on all sides by a line
of brown wash
227 x 365 mm
Dated, upper right in brown ink: 'Fecit 1671'; inscribed, lower left in
brown ink: 'Jacob van der Ulft / No. 68'
Bequeathed by Sir Bruce Ingram, 1963. PD. 750–1963
Provenance: with P. & D. Colnaghi, London, from whom bought by
Ingram (Lugt 1405 a), July 1938
Exhibited: Rotterdam / Amsterdam, 1961/62, no. 89; Cambridge, 1985,
handlist, p. 27; Cambridge, 1990, handlist, p. 7

Nothing is known about van der Ulft's training, but he is
thought to have been self-taught. He was burgomaster of Gorin-
chem and probably visited Italy on more than one occasion
(drawings of specific Italian sites exist by him dated between
1663 and 1674, but these could be based on other artists' work).
His style of drawing owes much to Jan de Bisschop (1628–1671).
He was active as a painter, etcher and draughtsman.

Drawings of this type are not uncommon in van der Ulft's
œuvre. They chiefly depict Italian landscapes with imaginary
classical buildings and a very similar example is in the Albertina,
Vienna (no. 9884). There is also a group, referred to above,
which shows specific sites in Italy, from which it has been argued
that van der Ulft visited Italy, although this has not been
proved. The Fitzwilliam drawing is preparatory to van der Ulft's
painting of *The building of Carthage* formerly in the collection of
the Rt. Hon. Lewis Fry, sold at Christie's, London, 25 July 1924,
lot 90.

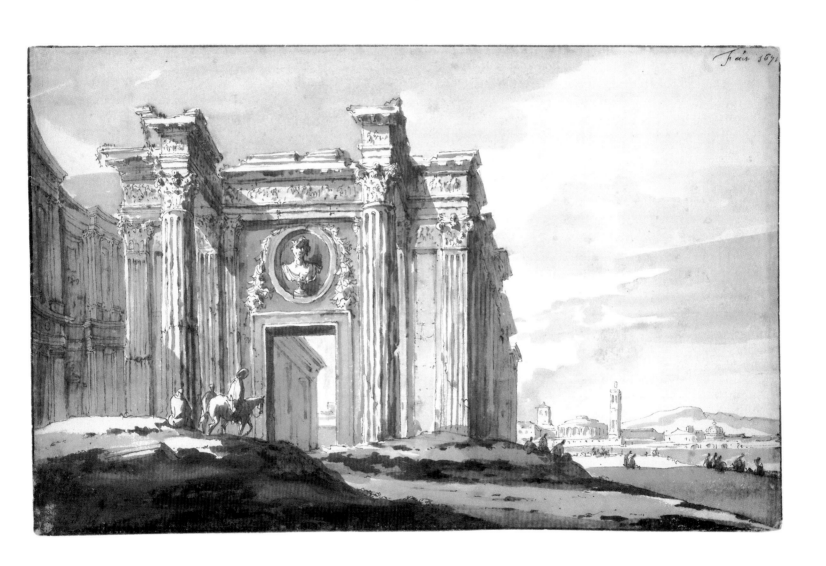

ANTHONIE WATERLOO
Lille 1609–1690 Utrecht

Gebirgslandschaft mit Fichtenbruch

Dünner Pinsel mit schwarzer und brauner Tusche, Feder und schwarze
Tusche, schwarze Kreide, graue und braune Lavierung,
am linken Bildrand grau lavierter Strich und Graphit
412 x 426 mm (Blattgröße unregelmäßig)
An einigen Stellen beschnitten, die linken und rechten unteren
Ecken stark abgegriffen
Vermächtnis Sir Bruce Ingram, 1963. PD. 697–1963
Provenienz: Kunsthandlung P. & D. Colnaghi, London; hier von
Ingram (Lugt 1405 a) im Februar 1950 erworben
Literatur: Wolfgang Schulz, *Herman Saftleven.* Berlin / New York 1982,
S. 378, s. v. Nr. 985
Ausstellungen: Cambridge, Fitzwilliam Museum, 1951 (o. Kat.); Lon-
don, Colnaghi, 1952, Nr. 42 m. Abb.; Bath 1952, Nr. 12; Gent, Musée
des Beaux-Arts, *Roelandt Savery,* 1954, Nr. 169 m. Abb. (alle als
Roelandt Savery); Rotterdam / Amsterdam 1961/62, Nr. 80, Abb. 17
(als Paulus van Vianen); Wanderausstellung USA und Cambridge
1976/77, Nr. 90 (als Roelandt Savery); Cambridge 1985, handlist, S. 2
(Waterloo zugeschrieben)

Dieses Blatt wurde lange Zeit für ein herausragendes Beispiel der
Tiroler Ansichten gehalten, die Roelandt Savery (1576–1639)
für Kaiser Rudolf II. zwischen 1606 und 1612 angefertigt hatte.
Vergleicht man die Zeichnung jedoch mit einem dieser farbig
lavierten Blätter (z. B. Fitzwilliam Museum, PD. 696–1963) oder
mit der berühmten Folge, die einst Rembrandt (1606–1669) und
dann Lambert Doomer (1624–1700) gehörte und heute Teil des
Atlas van der Hem in der Österreichischen Nationalbibliothek
in Wien ist, so zeigt sich, daß die zeichnerische Durcharbeitung
unseres Blattes spröder und weniger spontan ist als bei Savery.
1961 wurde die Zuschreibung an Savery zum ersten Mal ange-
zweifelt und die Zeichnung versuchsweise Paulus van Vianen
(um 1570–1613) zugeordnet; 1976, auf der Wanderausstellung
in den Vereinigten Staaten, setzte sich wiederum die Zuweisung
an Savery durch.

Eine Reihe von Künstlern kopierte nach Saverys Tiroler
Ansichten; von Lambert Doomer stammen sechs Blätter in Ber-
lin, Paris (Fondation Custodia) und Cleveland (Cleveland
Museum of Art); eines von Pieter Molijn (1595–1661) bewahrt
die Albertina in Wien, eines mit einem wohl falschen Allaert-
van-Everdingen-Monogramm (1621–1675) das J. Paul Getty
Museum in Malibu. Ein weiteres Blatt in Besançon (D. 740) wird
Everdingen zugewiesen, ist aber „A. W", wohl für Anthonie
Waterloo, monogrammiert. Martin Royalton-Kish schlug als
erster vor, daß auch unser Blatt eine Kopie nach einer Zeich-
nung Saverys ist und dem jungen Anthonie Waterloo zugewie-
sen werden kann. Zum Vergleich zog er die oben erwähnte
Zeichnung in Besançon heran sowie ein Blatt im Boymans-van
Beuningen Museum in Rotterdam (Nr. 15), dessen kontrastrei-
che Staffelung von Vorder- und Hintergrund ähnlich angelegt
ist. Joaneath Spicer, die in ihrer Dissertation über Savery (1979)
dessen Autorschaft für unsere Zeichnung ebenfalls bezweifelte,
schreibt sie, wie Royalton-Kish, Waterloo zu.

A rocky landscape with pine trees

Point of the brush with black and brown ink, pen and black ink,
black chalk, grey and brown wash, a line of grey wash and graphite
on the left
412 x 426 mm, irregular
Cut in several places, the corners bottom left and right much abraded
Bequeathed by Sir Bruce Ingram, 1963. PD. 697–1963
Provenance: with P. & D. Colnaghi, London, from whom bought by
Ingram (Lugt 1405 a), February 1950
Literature: Wolfgang Schulz, *Herman Saftleven,* Berlin, New York,
1982, p. 378, *s.v.* no. 985
Exhibited: Cambridge, Fitzwilliam Museum, 1951 (no handlist); Lon-
don, Colnaghi, 1952, no. 42, repr.; Bath, 1952, no. 12; Ghent, Musée
des Beaux-Arts, *Roelandt Savery,* 1954, no. 169, repr. (always as Roe-
landt Savery); Rotterdam / Amsterdam, 1961/62, no. 80, fig. 17 (as
Paulus van Vianen); American Tour and Cambridge, 1976/77, no. 90
(as Roelandt Savery); Cambridge, 1985, handlist, p. 2 (attributed to
Waterloo)

Previously considered a masterly example of the drawings done
between 1606 and 1612 by Roelandt Savery (1576–1639) of
views in the Tyrol for Emperor Rudolf II. From a comparison
with a drawing of that type, with coloured washes, also in the
Fitzwilliam (PD. 696–1963), and with the famous group which
was once owned by both Rembrandt (1606–1669) and Lambert
Doomer (1624–1700), now in the Atlas van der Hem (Vienna,
National Library), it is clear that the handling of this drawing is
both harder and less spontaneous than in Savery's own work. In
1961 the attribution to Savery was doubted for the first time and
the drawing was tentatively attributed to Paulus van Vianen
(c. 1570–1613) but the Savery idea was reinstated when the
drawing was exhibited in America (1976).

Several artists made copies after Savery's Tyrolean drawings:
there are six by Lambert Doomer in Berlin, Paris (Fondation
Custodia) and the Cleveland Museum of Art; one by Pieter
Molijn (1595–1661) in the Albertina, Vienna; one with a
monogram (?false) of Allaert van Everdingen (1621–1675)
(J. Paul Getty Museum, Malibu); another at Besançon (D. 740)
attributed to Everdingen but monogrammed 'A.W', which is
presumably by Anthonie Waterloo. Martin Royalton-Kish was
the first to suggest the Fitzwilliam drawing was a copy of a Sav-
ery drawing done early in his career by Anthonie Waterloo and
he compared it both with the Besançon drawing cited above and
with a drawing in the Boymans-van Beuningen Museum, Rotter-
dam (no. 15), which has a similar contrast of handling between
the foreground and the background. Joaneath Spicer, who
doubted the attribution to Savery in her dissertation on the art-
ist (1979), concurs with Royalton-Kish in attributing it to
Waterloo.

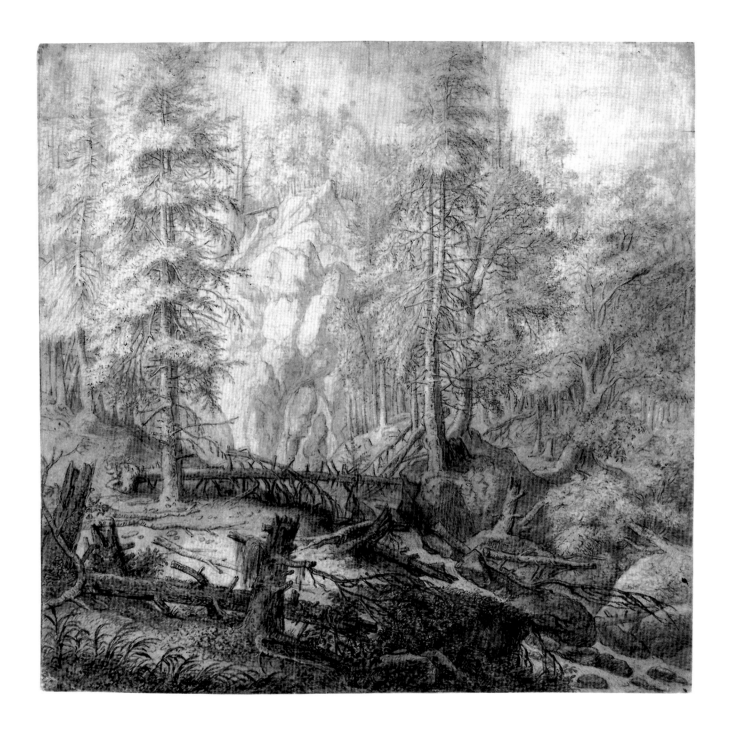

JAN WORST
zugeschrieben / attributed to
1625–1680

Die Ruinen des Kolosseums

Schwarze Kreide und farbige Lavierungen über Spuren von
eingedrückten Strichen, allseitig Randlinie mit Pinsel in Braun,
auf zwei Papierstücken
387 x 258 mm (beschnitten)

Verso: Baumstudien
Dünner Pinsel und braune Lavierung

Vermächtnis Sir Bruce Ingram, 1963. PD. 25–1963
Provenienz: Paul Sandby (Lugt 2112); Kunsthandlung P. & D. Col-
naghi, London; hier von Ingram (Lugt 1405 a) als Teil des ,Sandby
Album' im Juli 1936 erworben
Ausstellungen: Cambridge 1985, handlist, S. 5; Cambridge 1990,
handlist, S. 7

Nur wenig ist über Jan Worst bekannt; sein künstlerischer Wer-
degang, sein Geburts- und Sterbeort sind nicht überliefert,
obwohl er angeblich in Holland gestorben sein soll. Einzig gesi-
chert ist ein Romaufenthalt mit Johan Lingelbach (1622–1674),
der dort zwischen 1644 und 1650 archivalisch belegt ist.

Unser Blatt wurde lange für flämisch gehalten und dann ver-
suchsweise Paul Bril (1554–1626) zugeschrieben. Christopher
White zog als erster einen holländischen Ursprung in Betracht
und schlug als Autor Thomas Wyck (1616–1677) vor. Die
Zuschreibung an Worst stammt schließlich von Carlos van Has-
selt. Stilistisch steht die Zeichnung einem anderen Blatt von
Worst mit der Darstellung des Kolosseum im Rijksprentenkabi-
net in Amsterdam und einigen Zeichnungen von ihm im
Museum Boymans-van Beuningen in Rotterdam nahe. Es soll
jedoch erwähnt werden, daß Martin Royalton-Kish der
Zuschreibung an Worst nicht zustimmt und das Blatt für älter
hält. Die Spuren von eingedrückten Strichen im hinteren rech-
ten Bogen lassen vermuten, daß die Zeichnung möglicherweise
zur druckgraphischen Vervielfältigung bestimmt war. Die Dar-
stellung auf der Rückseite ist deutlich beschnitten; ihr Zeichen-
duktus ist dem der Vorderseite ähnlich, aber zeigt einen zöger-
licheren Umgang mit der Lavierung.

The ruins of the Colosseum

Black chalk and coloured washes over traces of incision, bordered
on all sides by a line of brown wash, on two sheets of paper
387 x 258 mm, cut down

Verso: Study of trees
Point of the brush and brown wash

Bequeathed by Sir Bruce Ingram, 1963. PD. 25–1963
Provenance: Paul Sandby (Lugt 2112); with P. & D. Colnaghi, Lon-
don, from whom bought by Ingram (Lugt 1405 a), probably as part of
the 'Sandby album', July 1936
Exhibited: Cambridge, 1985, handlist, p. 5; Cambridge, 1990, hand-
list, p. 7

Very little is known of Jan Worst. With whom he trained, where
he studied, his place of birth and of death are all uncertain,
although he is said to have died in Holland. The only certain
fact about his life is that he was in Rome with Johan Lingelbach
(1622–1674), who is documented there between 1644 and 1650.

Previously thought to be Flemish and then attributed tenta-
tively to Paul Bril (1554–1626); Christopher White was first to
consider it Dutch and he suggested Thomas Wyck (1616–1677).
The attribution to Worst was proposed by Carlos van Hasselt.
Stylistically the drawing is fairly compatible with another draw-
ing of the Colosseum by him which is in Amsterdam, Rijkspren-
tenkabinet, and with a group in Rotterdam, Museum Boymans-
van Beuningen. It should however be noted that Martin
Royalton-Kish disagrees with the attribution to Worst and con-
siders the drawing to be earlier. The traces of incised line in the
background visible through the arch on the right suggest that
the drawing might have been intended to be engraved or etched.
The drawing on the *verso*, clearly cut down, shows a handling
similar to that on the *recto*, but is a little less free in the applica-
tion of washes.

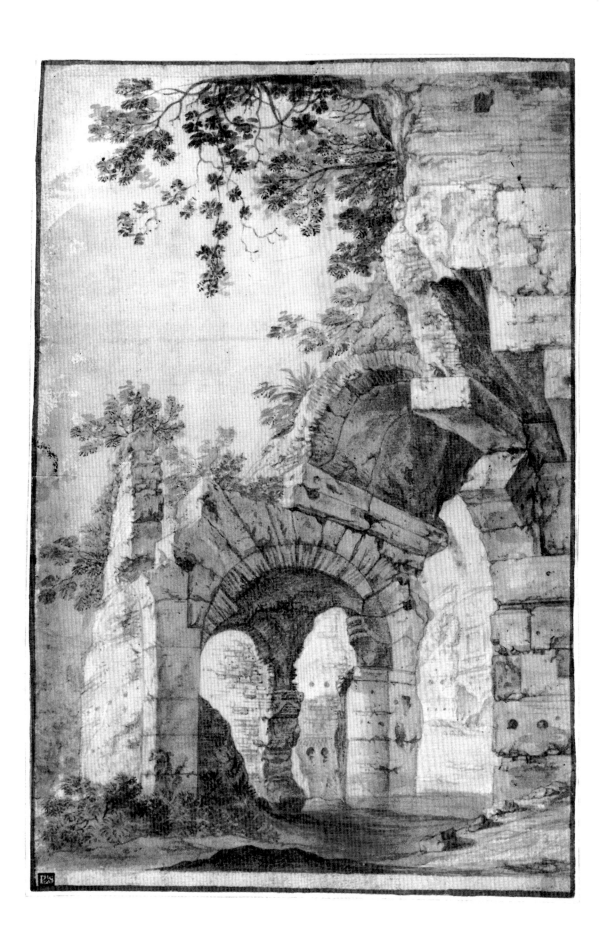

THOMAS WYCK
Beverwijk um/*c.* 1616–1677 Haarlem

Gebirgslandschaft mit einer Stadt in der Ferne

Dünner Pinsel und graue Lavierung über Graphit
214 x 293 mm
Oben links mit Monogramm signiert ‚TW fecitt'
Verso in Graphit bezeichnet ‚Berchem' und in brauner Tinte numeriert ‚No 771'
Vermächtnis Sir Bruce Ingram, 1963. PD. 938–1963
Provenienz: Kunsthandlung P. & D. Colnaghi, London; hier von Ingram (Lugt 1405 a) im Dezember 1936 erworben, zusammen mit PD. 935–1963, *Blick auf Westminster vom anderen Themseufer*
Ausstellung: Cambridge 1985, handlist, S. 10

Thomas Wyck erhielt seine künstlerische Ausbildung wohl bei seinem Vater. Er besuchte Italien und hielt sich in Neapel auf, wo er eine Reihe von Zeichnungen anfertigte und sich einen Ruf als Maler von Seestücken und Stadtveduten erwarb. Nach seiner Rückkehr nach Holland lebte er als angesehener Maler in Haarlem, wurde 1642 Mitglied der Lukasgilde und 1669 deren Vorsteher. Nach der Wiedereinsetzung von Charles II. ging er nach England und schuf eine Anzahl bemerkenswerter Ansichten von London, vor und nach dem großen Stadtbrand von 1666. Seine dortigen Reisen führten ihn weit in den Norden hinauf, bis nach Stirling in Schottland (eine Ansicht des Schlosses Stirling unter PD. 939–1963 im Fitzwilliam Museum); danach kehrte er nach Holland zurück und starb in Haarlem. Neben 21 Radierungen sind vor allem seine Gemälde und Zeichnungen bekannt. Sein Sohn Jan (um 1640–1702) begleitete ihn nach England und nahm dort seinen Wohnsitz; er starb in Mortlake.

Die alte Bezeichnung „Berchem" (1620–1683) auf der Rückseite unseres Blattes ist irreführend, während das Monogramm auf der Vorderseite authentisch erscheint. Die Binnenstruktur des Blattwerkes im Vordergrund und die zarten atmosphärischen Lavierungen, die sich in der Ferne verlieren, finden wir auch in den Zeichnungen Thomas Wycks im British Museum in London (*Blick auf London von Blackheath aus*, Nr. 1897.8.31.1) und in Windsor Castle (*Landschaft mit Angler*, Nr. 12 874).

Die Landschaft konnte bisher nicht lokalisiert werden, aber die scharfen Hell-Dunkel-Kontraste sind kennzeichnend für das südliche Licht. Zusammen mit den charakteristischen Bergformationen läßt sich durchaus an die Gegend südlich von Rom bei Monte Cassino denken. Martin Royalton-Kish ist von der Zuschreibung an Wyck nicht restlos überzeugt; seiner Meinung nach könnte unser Blatt auch von Theodoor Wilkens (um 1690–um 1748) stammen, in Anlehnung vielleicht an Herman Naiwyncx (um 1624–1651 oder nach 1654). Für Wycks Autorschaft sprechen allerdings die oben erwähnten stilistischen Vergleiche und das Papier mit Straßburger Wasserzeichen (Lilie), dessen Verwendung für die erste Hälfte des 17. Jahrhunderts kennzeichnend ist.

Mountainous landscape, with a distant view of a town

Point of the brush and grey wash over graphite
214 x 293 mm
Signed with initials in monogram, upper left: 'TW fecitt'
Inscribed, *verso*, in graphite: 'Berchem'; numbered in brown ink: 'No 771'
Bequeathed by Sir Bruce Ingram, 1963. PD. 938–1963
Provenance: with P. & D. Colnaghi, London, from whom bought by Ingram (Lugt 1405 a), December 1936 (with PD. 935–1963, A *view of Westminster from across the River*)
Exhibited: Cambridge, 1985, handlist, p. 10

Thomas Wyck is said to have been taught by his father. He visited Italy and stayed in Naples, where he made a number of drawings and became well known as a painter of seascapes and townscapes. On his return to Holland he lived in Haarlem where he continued to maintain his reputation as a painter, becoming a member of the Guild of St Luke in 1642, Dean in 1669. After the Restoration of Charles II he came to Britain and produced some notable views of London before and after the Great Fire of 1666. He ventured as far North as Stirling in Scotland (a drawing of Stirling Castle [PD. 939–1963] is in the Fitzwilliam), but returned to Holland and died in Haarlem. He made 21 etchings but is known best as a painter and draughtsman. His son Jan (*c.*1640–1702) came to England with his father and stayed on, dying in Mortlake.

The suggested attribution on the *verso* to Berchem (1620–1683) is wholly unrealistic and the monogram on the *recto* looks authentic. The handling of foliage in the foreground and the soft use of atmospheric washes fading into the distance are also found on drawings by Thomas Wyck in the British Museum (*View of London from Blackheath*, no. 1897.8.31.1) and at Windsor (*Landscape with a fisherman*, no. 12874).

The view has not been identified but the strong contrasts of tone suggest the full light of the Italian campagna. Martin Royalton-Kish is not entirely happy with the attribution to Wyck and has suggested that it might be a drawing by Theodoor Wilkens (*c.*1690–*c.*1748), based on someone else's work, perhaps Herman Naiwyncx (*c.*1624–1651 or after 1654). In favour of the Wyck attribution are the stylistic comparisons referred to above and the fact that the paper is typical of the first half of the seventeenth century (watermark: Strasbourg lily).

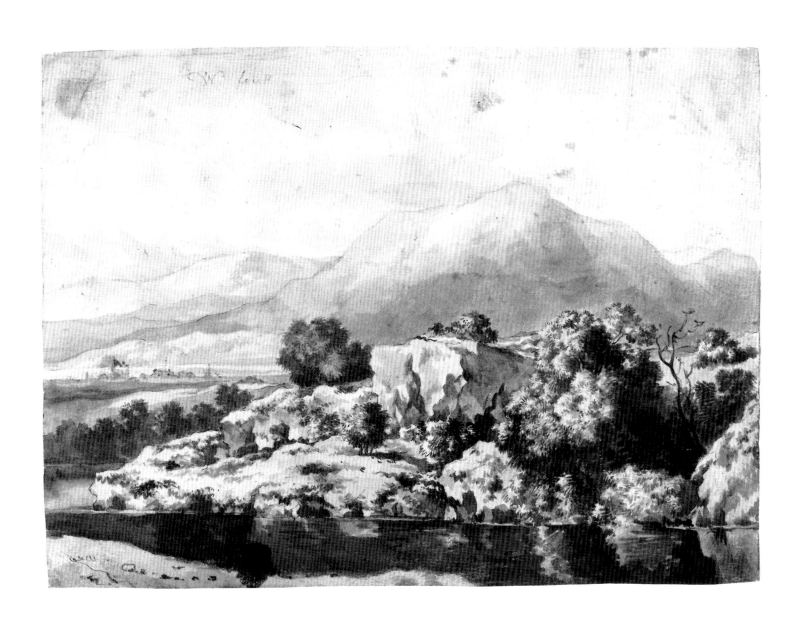

SEESTÜCKE

SEASCAPES

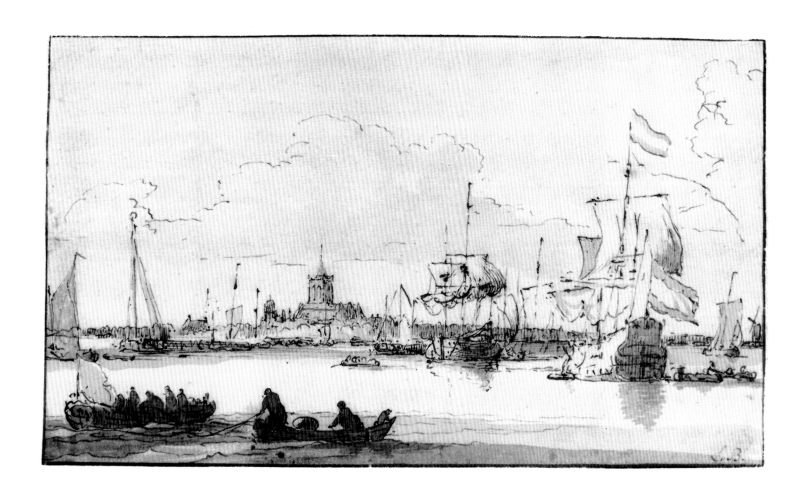

LUDOLF BACKHUIZEN
Emden 1631–1708 Amsterdam

Hafen mit Blick auf Vlaardingen

Feder und braune Tusche, graue Lavierung, allseitig Randlinie
mit Pinsel in Braun
129 x 226 mm
Unten rechts mit brauner Tusche monogrammiert ‚L.B.'
Vermächtnis Sir Bruce Ingram, 1963. PD. 90–1963
Provenienz: Unbekannter Sammler (nicht bei Lugt); unbekannter
holländischer Sammler (Lugt 1481 b); wohl Kunsthandlung P. & D.
Colnaghi, London; hier von Ingram (Lugt 1405 a) 1937 oder 1938
erworben
Ausstellungen: London, Colnaghi, 1937, Nr. 24; London 1946/47,
Nr. 5; Cambridge, Fitzwilliam Museum, 1951 (o. Kat.); Bedford 1958,
Nr. 3; Washington u. a. 1959/60, Nr. 11; Rotterdam / Amsterdam
1961/62, Nr. 12; Cambridge 1982 (o. Kat.)

Backhuizen war gebürtig aus Emden in Ostfriesland. 1649 wan-
derte er nach Amsterdam aus, wo er bis an sein Lebensende
blieb. Eigentlich war er Kalligraph und als solcher nach seiner
Ankunft in Amsterdam für einen Emdener Landsmann, den
Kaufmann Guillielmo Bartoletti, tätig. Im Holland des 17. Jahr-
hunderts erfreute sich die Kunst der Kalligraphie hoher Wert-
schätzung und zählte zu den Schönen Künsten. Noch 1656 wird
Backhuizen als Schreibmeister erwähnt; im folgenden Jahr nen-
nen ihn die Quellen einen Zeichner, im Jahre seiner dritten
Eheschließung, 1664, einen Maler. Unterricht erhielt er bei
Allaert van Everdingen (1621–1675) und Hendrick Dubbels
(1620/21–1676); seine frühen Arbeiten umfassen Zeichnungen
und Gemälde von Landschaften und Seestücke. Sein eigentli-
ches Ansehen aber erlangte er durch seine Marinedarstellungen
in Zeichnung, Radierung und Malerei und löste darin Willem
van de Velde d. J. (1633–1707) ab, der 1672/73 nach London
übersiedelte. Backhuizen gilt als der bekannteste holländische
Maler von Seestücken.

Rechts von der Mitte liegt ein großes holländisches Schiff von
Backbord achtern aus gesehen vor Anker, die oberen Segel
gelöst, am Hauptmast eine Flagge. Vor ihm ein Handelsschiff,
zur Linken eine Barkasse und zwei Männer in einem Fischer-
boot, die auf die Schiffe zuhalten. Im Hintergrund erscheint das
Städtchen Vlaardingen, westlich von Rotterdam gelegen, mit
dem charakteristischen Umriß des kubischen Turmes seiner
Hauptkirche. Eine sehr ähnliche, allerdings detaillierter durch-
gearbeitete Ansicht befand sich ehemals in der Sammlung R. Ph.
Goldschmidt (Auktion Prestel, Frankfurt am Main, 4./5. Okto-
ber 1917, Lot 13) und eine Version als Gemälde (Hofstede de
Groot, VII, Nr. 437) in der Sammlung A. E. van Marenzeller
(Auktion A. Kende, Wien, 11. März 1908, Lot 3).

A view of Vlaardingen with shipping in the foreground

Pen and brown ink, grey wash, bordered on all sides by a line
of brown wash
129 x 226 mm
Signed with initials, lower right, in brown ink: 'L. B.'
Bequeathed by Sir Bruce Ingram, 1963. PD. 90–1963
Provenance: anonymous Collector, not in Lugt; anonymous Collector,
Holland (Lugt 1481b); (?) with P.& D.Colnaghi, London, from whom
bought by Ingram (Lugt 1405 a) in 1937 or 1938
Exhibited: London, Colnaghi, 1937, no. 24; London, 1946/47, no. 5;
Cambridge, Fitzwilliam Museum, 1951 (no handlist); Bedford, 1958,
no. 3; Washington and American Tour, 1959/60, no. 11; Rotter-
dam / Amsterdam, 1961/62, no. 12; Cambridge, 1982 (no handlist)

Backhuizen was born at Emden in Germany. He emigrated to
Amsterdam in 1649 and stayed there for the rest of his life. He
was a calligrapher and was employed on his arrival in Amster-
dam by another native of Emden, the merchant Guillielmo Bar-
toletti. In seventeenth-century Holland the art of calligraphy
was very highly esteemed and was considered one of the fine
arts. Backhuizen is mentioned as a writing master as late as 1656.
The following year he was described as a drauhgtsman and by the
time of his third marriage in 1664 he is called a painter. He was
taught by Allaert van Everdingen (1621–1675) and Hendrick
Dubbels (1620/21–1676) and initially drew and painted land-
scapes as well as seascapes. However it is as a draughtsman,
etcher and painter of marines that he won his reputation and,
after the departure from Amsterdam of Willem van de Velde the
Younger (1633–1707) for London in 1672/73, Backhuizen
became the most renowned sea-painter in Holland.

To the right is a port-quarter view of a large Dutch ship at
anchor, her top sails loosed, a flag at the main; there is a mer-
chant ship at anchor ahead of her. On the left a barge and two
men in a small fishing boat are pulling towards the ships. The
background shows the small town of Vlaardingen, to the west of
Rotterdam, dominated by the square tower of its church. A very
similar view, more worked up and somewhat laboured, but
authentic, was in the R.Ph. Goldschmidt collection (Sale,
Frankfurt, Prestel, 4/5 October 1917, lot 13), and a painted ver-
sion of this subject (Hofstede de Groot, VII, no. 437) was in the
collection of A. E. van Marenzeller (Sale, Vienna, A. Kende, 11
March, 1908, lot 3).

LUDOLF BACKHUIZEN
Emden 1631–1708 Amsterdam

Gekrängtes Schiff im Hafen von Amsterdam bei Sonnenuntergang

Feder und braune Tusche, braune und graue Lavierung über Spuren von Graphit, allseitig Randlinie mit Pinsel in Braun
154 x 270 mm
An der linken Seite und der unteren linken Ecke kleiner Blattverlust; zwei Bugfalten oben links nach Mitte rechts und Mitte links entlang der Ecke
Verso in der Handschrift des Jacob de Vos bezeichnet ‚No. 602'
Vermächtnis Sir Bruce Ingram, 1963. PD. 127–1963
Provenienz: Jacob de Vos (Lugt 1450); Auktion de Vos, 1883, Lot 14; von Beckerath; Berlin, Kupferstichkabinett (Lugt 1609), veräußert (Lugt 2482); Kunsthandlung P. & D. Colnaghi, London; hier von Ingram (Lugt 1405 a) im September 1936 erworben
Literatur: Bock-Rosenberg, S. 74, KdZ 12366; Henri Nannen, *Ludolf Backhuysen*. Emden 1985, S. 146 f. m. Abb.
Ausstellungen: London, Colnaghi, 1936, Nr. 25; Bedford 1958, Nr. 4

Das Handelsschiff in der Mitte des Blattes wird von zwei Einmastern hinter dem Schiff gekrängt, d.h. an den Masten in eine Schräglage gebracht; Männer auf einem Ponton sind dabei, das Unterwasserschiff zu kalfatern, also es mit Werg und Teer zu verfugen. Rechts davon liegt eine holländische Fluyt (Fleute) vor Anker; unter den Schiffen zur Linken eine Galiot und eine Barkasse, die von dem gekrängten Schiff weg gerudert werden. Am rechten Bildrand erscheint die Silhouette von Amsterdam.

Backhuizen hatte 1690 eine kleinere Variante dieser Darstellung gezeichnet (Amsterdam, Historisch Museum), die er als Vorlage für eine seiner Radierungen der Folge *D'Y Stroom en Zeegezichten* von 1701 verwendete.

A careened ship in Amsterdam harbour at sunset

Pen and brown ink, brown and grey wash, over traces of graphite bordered on all sides by a line of brown wash
154 x 270 mm
A small loss on the left hand side and lower left corner; two creases, top left to middle right and middle left along the corner
Inscribed, *verso*, in de Vos' hand: 'No. 602'
Bequeathed by Sir Bruce Ingram, 1963. PD. 127–1963
Provenance: Jacob de Vos (Lugt 1450), his sale, 1883, lot 14; von Beckerath; Berlin, Kupferstichkabinett (Lugt 1609); sold by the Berlin Museum (Lugt 2482); with P. & D. Colnaghi, London, from whom bought by Ingram (Lugt 1405 a), September 1936
Literature: Bock-Rosenberg, p. 74, KdZ 12366; Henri Nannen, *Ludolf Backhuysen*, Emden, 1985, p. 146 f., repr.
Exhibited: London, Colnaghi, 1936, no. 25; Bedford, 1958, no. 4

The merchant ship in the centre is being careened by two single-masted ships, i.e. the ship is being set at an angle by the masts. Men can be seen on a pontoon, caulking the hull – i.e., sealing it with tow and pitch. To the right a Dutch fluteship is at anchor; to the left amongst other shipping is a galjoot and a barge pulling away from the ship being careened. In the background, on the right, can be seen the city of Amsterdam. This is a characteristic example of the finished drawings for which Backhuizen was famous before his reputation as a sea-painter was fully established.

As early as 1690, Backhuizen had drawn a small variation of the same depiction (Amsterdam, Historisch Museum), which he used as a source for one of his etchings from the series *D'Y Stroom en Zeegezichten* of 1701.

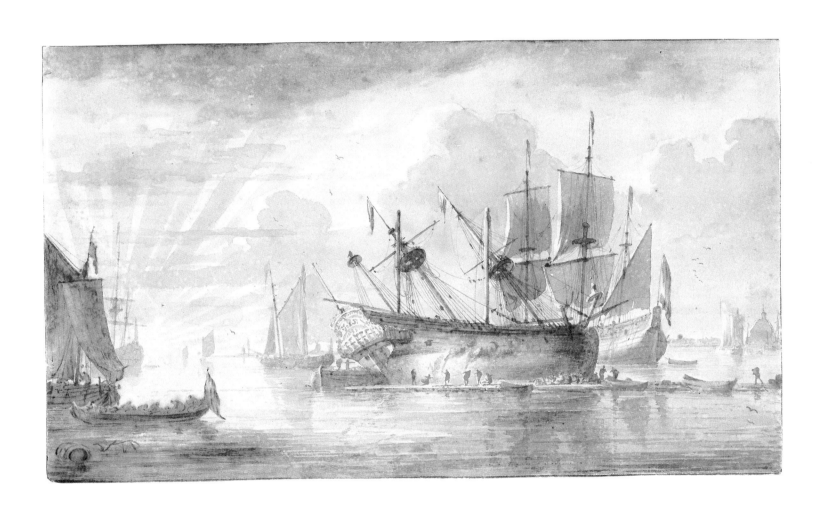

ABRAHAM CASEMBROOT
zugeschrieben/attributed to
Holland vor?/before or in 1593–1658 Messina

Studienblatt mit sieben Schiffen

Graphit und Graphitlavierung (Speichel?)
138 x 195 mm

Verso: Studie eines Galeerenhecks
Graphit

Auf der alten Montierung oben rechts mit Tinte bezeichnet ‚6391'; unten Mitte ‚3'; in Bleistift unten links ‚KdZ 12574'
Vermächtnis Sir Bruce Ingram, 1963. PD. 231–1963
Provenienz: Pacetti (Lugt 2057); Berlin, Kupferstichkabinett (Lugt 1632), veräußert (Lugt 2482); Kunsthandlung P.&D. Colnaghi, London; hier von Ingram (Lugt 1405a) im September 1936 erworben
Literatur: Bock-Rosenberg, S.105, KdZ 12574; Annemarie Beunen, Abraham Casembroot, een Nederlandse schilder in het Sicilie van de zeventiende eeuw. *Oud Holland* 109, 1995, S.54, A 25
Ausstellung: Cambridge 1982 (o.Kat.)

Man nimmt im allgemeinen an, daß Casembroot in Holland geboren ist. Nach Annemarie Beunen (a.a.O.) könnte er auch aus Flandern stammen und im Jahr 1593 (oder davor) in Brügge geboren sein. Er starb 1658 in Messina. Casembroot verbrachte einen Großteil seines Lebens in Sizilien, wo das gesamte von ihm erhaltene Werk entstand. Er wohnte in Messina und war dort ab 1649 bis zu seinem Tode für die Vereinigten Provinzen als Konsul tätig. Er trat hauptsächlich als Maler von Hafenansichten und Marinen hervor. Es sind von ihm Gemälde, Zeichnungen und Radierungen erhalten. Don Antonio Ruffo, für den Rembrandt das Bild *Aristoteles* malte (New York, Metropolitan Museum of Art), gehörte zu seinen Auftraggebern. In Messina, wo Casembroot mindestens fünf Schüler ausbildete, stand er in hohem Ansehen.

Unser Blatt gehörte zu einem Skizzenbuch, das aus der Sammlung Pacetti als Adriaen van der Cabel (1631–1705) in das Berliner Kupferstichkabinett überging und von diesem später veräußert wurde. Ingram erwarb das vollständige Skizzenbuch bei Colnaghi, gab aber dann einige Zeichnungen daraus weg, bevor er den Rest dem Fitzwilliam Museum vermachte. Heute umfaßt die Gruppe im Fitzwilliam Museum zwanzig Blätter; andere Zeichnungen aus dem sogenannten van der Cabel-Skizzenbuch kamen am 27.Juni 1974 als Lot 194 und 201 bei Sotheby's in London zur Auktion. Die alte Zuschreibung an van der Cabel beruht wahrscheinlich darauf, daß zwei seiner Radierungen (Bartsch 14 und 55) ähnliche Schiffe darstellen, und ist daher nur oberflächlich.

Das Blatt zeigt Heck- und Bugstudien einiger mit Anker vertäuter Galeonen; die Lateinsegel sind gerefft.

Studies of seven vessels and boats

Graphite and graphite wash (? spittle)
138x195 mm

Verso: Study of the stern of a galley
Graphite

Inscribed in ink on old mount, upper right: '6391'; lower centre: '3'; in pencil, lower left 'KdZ 12574'
Bequeathed by Sir Bruce Ingram 1963. PD. 231–1963
Provenance: Pacetti (Lugt 2057); Berlin, Kupferstichkabinett (Lugt 1632); sold by the Berlin Museum (Lugt 2482); with P. & D. Colnaghi, London, from whom bought by Ingram (Lugt 1405a), September 1936
Literature: Bock-Rosenberg, p.105, KdZ 12574; Annemarie Beunen, Abraham Casembroot, een Nederlandse schilder in het Sicilie van de zeventiende eeuw, *Oud Holland*, 109, 1995, p.54, A 25
Exhibited: Cambridge, 1982 (no handlist)

Casembroot is traditionally said to have been born in Holland, although Annemarie Beunen (*op.cit.*) suggests he may have been Flemish, born in (?) Bruges before or in 1593 and died in Messina 1658. He spent the latter half of his life in Sicily and his entire extant œuvre was produced there. He lived in the eastcoast port of Messina, where he was consul for the Republic of the United Netherlands from 1649 until his death. He specialised in harbour and marine views and tempests. He was active as a painter, engraver and draughtsman and was patronised by Don Antonio Ruffo who commissioned Rembrandt's *Aristotle* (Metropolitan Museum, New York). He was held in considerable esteem in Messina where he had at least five pupils.

Part of a sketch-book formerly in the Pacetti Collection, then in the Kupferstichkabinett in Berlin (as Adriaen van der Cabel), and sold by the Berlin Museum. Ingram bought the complete book from Colnaghi but gave several sheets away before bequeathing the remainder to the Fitzwilliam. There are now 20 drawings from this group in the Fitzwilliam, others were sold at Sotheby's, London (27 June 1974, lots 194, 201). The old attribution to Adriaen van der Cabel (1631–1705) probably depends on the inclusion of similar vessels in two prints by him (Bartsch 14 and 55) but this is purely superficial.

The drawing shows studies of the bow and the stern of several galleons moored at anchor, with lateen sail furled.

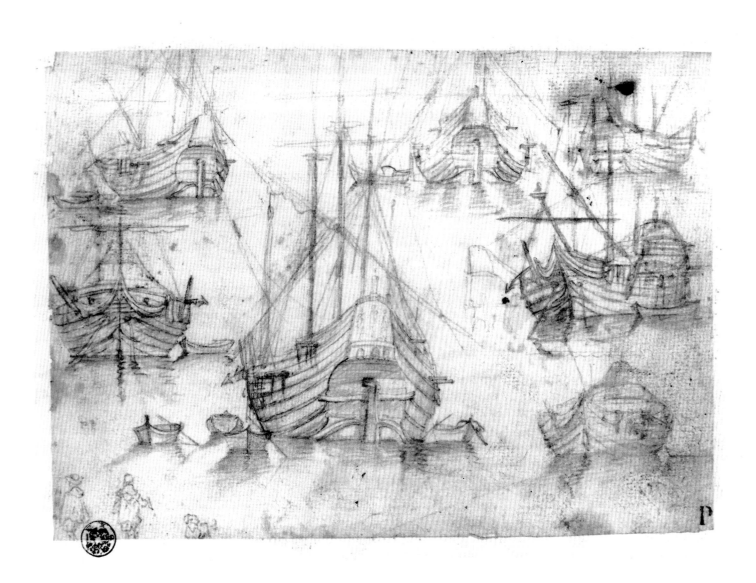

ABRAHAM CASEMBROOT
zugeschrieben / attributed to
Holland vor? / before or in 1593–1658 Messina

Schiffe in einer Lagune

Feder und braune Tusche, graue Lavierung
209 x 256 mm (Blattgröße unregelmäßig)
Auf der alten Montierung in brauner Tusche bezeichnet ‚4‘;
‚Vander Cabel‘; in Bleistift ‚KdZ 12628‘
Vermächtnis Sir Bruce Ingram 1963. PD. 222–1963
Provenienz: Pacetti (Lugt 2057); Berlin, Kupferstichkabinett (Lugt 1632), veräußert (Lugt 2482); Kunsthandlung P. & D. Colnaghi, London; hier von Ingram (Lugt 1405a) im September 1936 erworben
Literatur: Bock-Rosenberg, S. 106, KdZ 12628; Annemarie Beunen, Abraham Casembroot, een Nederlandse schilder in het Sicilie van de zeventiende eeuw. *Oud Holland* 109, 1995, S. 59, D 14 (abgeschrieben)
Ausstellung: Cambridge, Fitzwilliam Museum, 1954/55 (o. Kat.)

Das Blatt gehörte zu einem Skizzenbuch, das aus der Sammlung Pacetti als Adriaen van der Cabel (1631–1705) in das Berliner Kupferstichkabinett überging und von diesem später veräußert wurde. Annemarie Beunen zweifelt die Zuschreibung an Casembroot an und schlägt als Künstler Bonaventura Peeters (1614–1652) vor. Im Zeichenduktus ist es jedoch mit den anderen Casembroot-Blättern im Fitzwilliam Museum durchaus vergleichbar, auch wenn der hier ausgestellten Zeichnung ein größerer Maßstab zugrunde liegt und die Lavierung breitflächiger aufgetragen ist. Bei dem Boot im Vordergrund handelt es sich wohl um eine Schmacke mit einem Lateinsegel.

Shipping in a lagoon

Pen and brown ink, grey wash
209 x 256 mm, irregular
Inscribed on the old mount, in brown ink: '4'; 'Vander Cabel';
in pencil: 'KdZ 12628'
Bequeathed by Sir Bruce Ingram, 1963. PD. 222–1963
Provenance: Pacetti (Lugt 2057); Berlin, Kupferstichkabinett (Lugt 1632); sold by the Berlin Museum (Lugt 2482); with P. & D. Colnaghi, London, from whom bought by Ingram (Lugt 1405a), September 1936
Literature: Bock-Rosenberg, p. 106, KdZ 12628; Annemarie Beunen, 'Abraham Casembroot, een Nederlandse schilder in het Sicilie van de zeventiende eeuw', *Oud Holland*, 109, 1995, p. 59, D 14 (not Casembroot)
Exhibited: Cambridge, Fitzwilliam Museum, 1954/55 (no handlist)

Part of a sketch-book formerly in the Pacetti Collection, then in the Kupferstichkabinett in Berlin (as Adriaen van der Cabel), and sold by the Berlin Museum. Annemarie Beunen is uncertain of the attribution to Casembroot and suggests that this might have been drawn by Bonaventura Peeters (1614–1652). However the drawing is not incompatible with the other Casembroots in the Fitzwilliam, although it is on a larger scale than them and the wash is handled with greater breadth. The ship in the foreground next to the two small rowing boats appears to be a type of smack with a lateen sail.

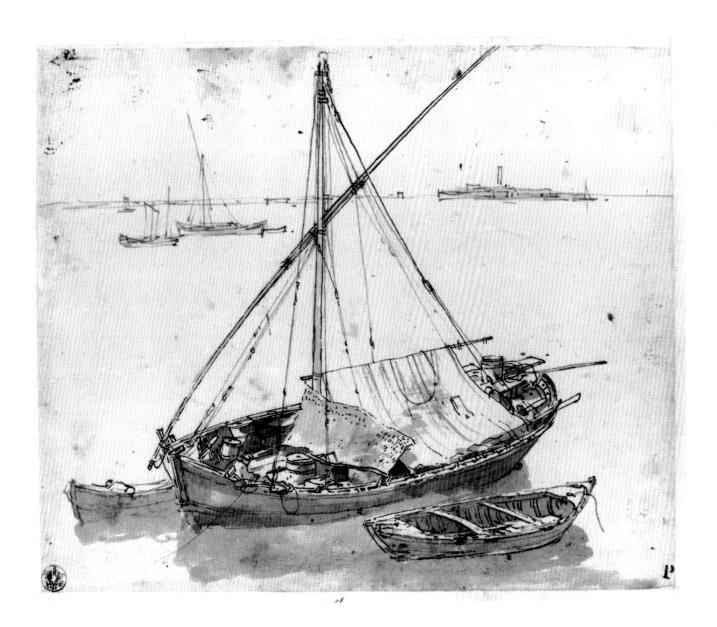

Studie der ‚Eendracht'
(Steuerbordseite)

Graphit, dünner Pinsel und graue Lavierung auf vier Papierstücken
411 x 650 mm (Höchstmaße)
In Graphit unten links bezeichnet ‚Endract bij Ad[miraa]le Opdam
gevoert 1665'; verso in Graphit ‚ed van achter', in Tinte, in der Hand-
schrift Lord Milfords ‚Wm Vandeveld Jnr / No / 462'
Vermächtnis Sir Bruce Ingram, 1963. PD. 787–1963
Provenienz: Erasmus Phillips (?); Lord Milford (Lugt 2687); in Erb-
folge an Sir John Phillips; Kunsthandlung Hans Calmann, London;
Kunsthandlung P. & D. Colnaghi, London; hier von Ingram (Lugt
1405 a) nach 1943 erworben
Literatur: M. S. Robinson, *Van de Velde Drawings*. Cambridge 1958,
c. f. Nr. 236, Taf. 51
Ausstellungen: Cambridge 1982 (o. Kat.); Pennsylvania State Uni-
versity 1982, *The England of William Penn*, Nr. 35

Man nimmt an, daß Willem van de Velde d. Ä. 1622 den ersten
Zeichenunterricht von Cornelis Liefrinck (1581–1640) erhielt.
1631 heiratete er Judith Adrienne van Leeuwen; aus der Ehe
gingen zwei Söhne hervor, Willem d. J. (1633–1707) und
Adriaen (1636–1672), die beide Maler wurden. Vor 1636 sie-
delte die Familie von Leiden nach Amsterdam über. Willem van
de Velde d. Ä. trat als Zeichner und Maler von Marinen, beson-
ders von Seegefechten, hervor, für deren Ausführung ihm die
niederländischen Generalstaaten ein Boot zur Verfügung stell-
ten. Aus Anlaß der Feierlichkeiten zur Wiedereinsetzung
Charles' II. besuchte er 1660 England. 1662 trennte er sich von
seiner Frau. Nach dem Ausbruch des Dritten Englisch-
Niederländischen Krieges 1672 wanderte van de Velde Ende
desselben Jahres oder Anfang Januar 1673 nach England aus, wo
er im Dienst der englischen Regierung tätig wurde und in Lon-
don starb.

Die „Eendracht" (Eintracht) war in Rotterdam 1653 vom Sta-
pel gelaufen und verfügte über 72 Kanonen. Im Zweiten Eng-
lisch-Niederländischen Krieg stand sie unter dem Kommando
des Admirals Jacob Opdam. 1665 sprengten die Verbände des
Herzogs von York, des späteren Königs James II., das Schiff in
Lowestoft, wobei der Admiral und Baron van Wassenaer den
Tod fanden. Auf dem Heckspiegel erkennt man den Löwen der
Vereinigten Provinzen und unterhalb der Galerie auf einem
gewundenen Band den Schiffsnamen „Eendracht". Eine weitere
Ansicht des Kriegsschiffes von Steuerbord, ebenfalls von van de
Velde d. Ä., bewahrt das National Maritime Museum in Green-
wich (Robinson, Nr. 236).

Study of the Dutch ship 'De Eendracht',
seen from starboard quarter

Graphite, point of the brush and grey wash on four pieces of paper
411 x 650 mm (maximum)
Inscribed in graphite, lower left: 'Endract bij Ad[miraa]le Opdam
gevoert 1665'; *verso*, in graphite: 'ed van achter'; in ink, in Milford's
hand: 'Wm Vandeveld Jnr / No / 462'
Bequeathed by Sir Bruce Ingram, 1963. PD. 787–1963
Provenance: Erasmus Phillips (?); Lord Milford (Lugt 2687), by
descent to Sir John Phillips; with Hans Calmann, London; with
P. & D. Colnaghi, London, from whom bought by Ingram (Lugt
1405 a), after 1943
Literature: M.S. Robinson, *Van De Velde Drawings*, Cambridge, 1958,
c.f. no. 236, pl. 51
Exhibited: Cambridge, 1982 (no handlist); Pennsylvania State Uni-
versity, 1982, *The England of William Penn*, no. 35

Willem van de Velde the Elder may have received preliminary
instruction in drawing from Cornelis Liefrinck (1581–1640) in
1622. In 1631 he married Judith Adrienne van Leeuwen by
whom he had two sons, both of whom became painters, Willem
the Younger (1633–1707) and Adriaen (1636–1672). The fam-
ily moved from Leiden to Amsterdam before 1636. Van de Velde
drew and painted marine subjects, especially sea-fights, being
provided with a boat for the purpose by the States-General. In
1660 he was in England for the Restoration of Charles II. In
1662 he separated from his wife. After the beginning of the
Third Anglo-Dutch War in 1672, and towards the end of that
year, or very early in January 1673, van de Velde emigrated to
England where he worked for the English Government and lived
until he died.

The 'Eendracht' (The Concord or The Union) was built at
Rotterdam in 1653; she had seventy-two guns. She was com-
manded by Admiral Jacob Opdam during the Second Anglo-
Dutch War. The ship was blown up in 1665 by the forces of the
Duke of York (later James II) at Lowestoft and amongst the dead
were the Admiral and Baron van Wassenaer. On the tafferel is
the Lion, blazon of the United Provinces, and on a ribbon on the
counter 'Eendracht'. Another view of the starboard quarter is
in the National Maritime Museum, Greenwich (Robinson,
no. 236).

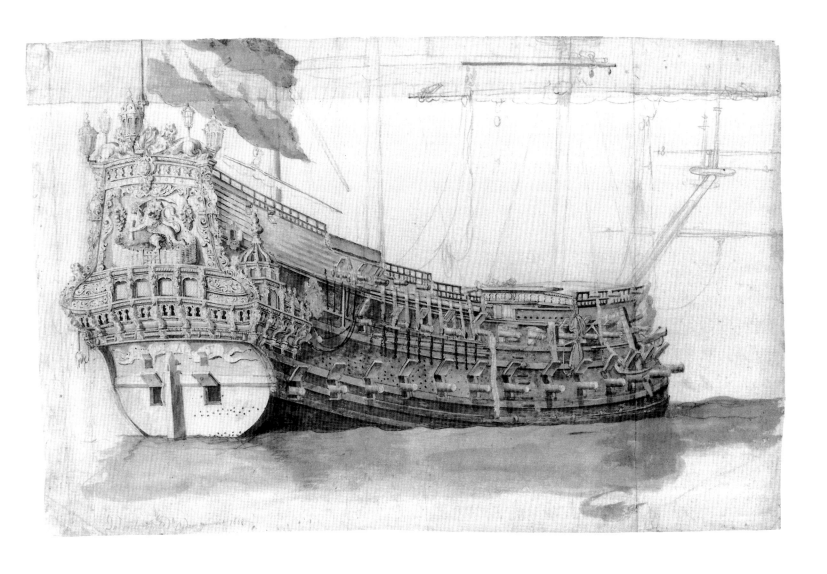

Studie der ‚Eendracht‘ (Backbordseite)

Graphit, dünner Pinsel und graue Lavierung
437 × 675 mm (Blattgröße unregelmäßig), auf drei Papierstücken
Verso in Graphit bezeichnet ‚adr van vooren‘; in Tinte, von der
Hand Lord Milfords ‚Wm vanderveld/Junr/No/460‘
Vermächtnis Sir Bruce Ingram, 1963. PD. 788–1963
Provenienz: Erasmus Phillips (?); Lord Milford (Lugt 2687); in Erb-
folge an Sir John Phillips; Kunsthandlung Hans Calmann, London;
Kunsthandlung P. & D. Colnaghi, London; hier von Ingram (Lugt
1405 a) nach 1943 erworben
Literatur: M. S. Robinson, *Van de Velde Drawings*. Cambridge 1958,
c. f. Nrn. 41, 166, 167, 226
Ausstellungen: Rotterdam, Prins Hendrik Museum 1958 (?) (o. Kat.);
Cambridge 1982 (o. Kat.)

Die Zeichnung steht im Zusammenhang mit einer Grisaille im
Prins Hendrik Museum in Rotterdam. Sieben weitere Portraits
der „Eendracht" sind bekannt: das Gegenstück dieses Blattes im
Fitzwilliam Museum (Kat. 54), eines im Museum Boymans-van
Beuningen in Rotterdam (Nr. 310–1185) und fünf im National
Maritime Museum in Greenwich. Zeichnungen von van de
Velde mit zwei weiteren Schiffen des gleichen Namens befinden
sich ebenfalls in Rotterdam und in Greenwich: Eines dieser
Schiffe lief 1639 vom Stapel, verfügte über 48 Kanonen und ver-
brannte 1673 im Krieg; das andere, 1666 wahrscheinlich als
Ersatz für unsere „Eendracht" gebaut, besaß 80 Kanonen und
ging 1690 unter. Bei der Zuschreibung dieser Zeichnungen an
Willem van de Velde d. Ä. besteht gewisse Unsicherheit; viel-
leicht sind sie auch von der Hand seines Sohnes Willem d. J.
(1633–1707).

Die Männer am Schiffsrumpf sind damit beschäftigt, den
Anker zu lichten.

Study of the Dutch ship 'De Eendracht', seen from the port bow

Graphite, point of the brush and grey wash
437 × 675 mm, irregular, three pieces of paper
Inscribed, *verso*, in graphite: 'adr van vooren'; in ink, in Milford's
hand: 'Wm vanderveld/Junr/No/460'
Bequeathed by Sir Bruce Ingram, 1963. PD. 788–1963
Provenance: Erasmus Phillips(?); Lord Milford (Lugt 2687), by
descent to Sir John Phillips; with Hans Calmann, London; with
P. & D. Colnaghi, London, from whom bought by Ingram (Lugt
1405 a), after 1943
Literature: M. S. Robinson, *Van de Velde Drawings*, Cambridge, 1958,
c. f. nos. 41, 166, 167, 226
Exhibited: Rotterdam, Prins Hendrik Museum, 1958 (?) (no handlist);
Cambridge, 1982 (no handlist)

The drawing relates to a grisaille now in the Prins Hendrik
Museum, Rotterdam. Seven other drawings of the 'Eendracht'
are known, the pair to it in the Fitzwilliam Museum, one in the
Boymans-van Beuningen Museum, Rotterdam (no. 310–1185)
and five in the National Maritime Museum, Greenwich. Draw-
ings of two other ships of the same name by van de Velde are also
at Greenwich and Rotterdam, one of forty-eight guns, built in
1639 and burnt in enemy action in 1673, the other of eighty
guns, built in 1666, presumably to replace the ship in the Fitz-
william drawing, and wrecked in 1690. Some difficulty remains
in attributing these drawings to Willem van de Velde, the Elder
or to his son, Willem, the Younger (1633–1707).

The figures on the side of the ship are concluding the weigh-
ing of the anchor.

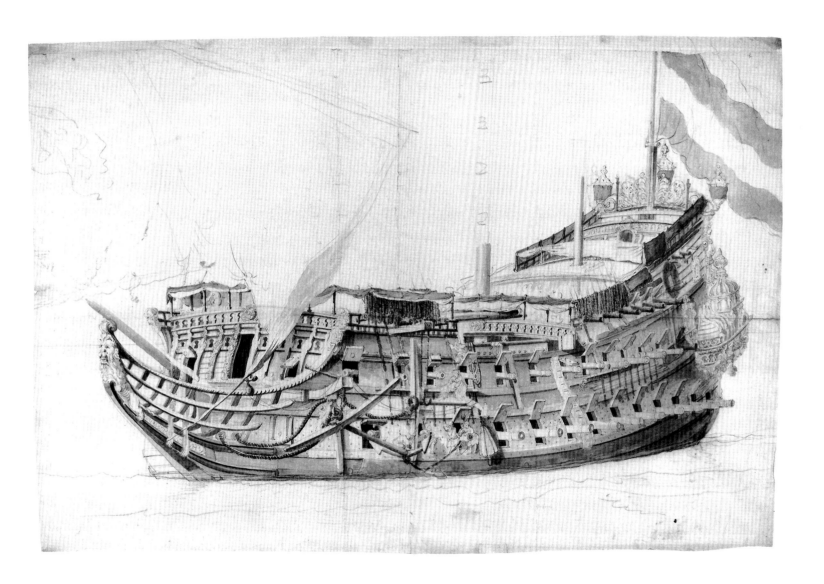

Die Einschiffung der Prinzessin Maria von Modena in Gravesend

Feder und schwarze Tusche, graue Lavierung über Graphit
360 x 1048 mm (Höchstmaße), auf sechs aneinandergeklebten Papierstücken
Obere rechte Ecke ausgebessert; alte Einrisse oben links
Oben links in brauner Tusche eigenhändig beschriftet „... andren van zijn... den heere ducke de Jorck/met de ducsesse tot grevesent smorgens omtrent 8 urren.../veele groote heere & graven op den... november oude stijl 1673'. Diese Bezeichnung stark ausgeblichen und abgegriffen
Vermächtnis Sir Bruce Ingram, 1963. PD. 809–1963
Provenienz: Unbekannt, erworben von Ingram (Lugt 1405 a) vor März 1936
Ausstellungen: London, Colnaghi, 1936, Nr. 46; London 1938, Nr. 569; Bedford 1958, Nr. 54; London, Royal Academy, 1961, *The Age of Charles II*, Nr. 513; Rotterdam/Amsterdam 1961/62, Nr. 98

Van de Velde skizzierte regelmäßig nautische Szenen, Seeschlachten oder Festlichkeiten auf See, wie die hier dargestellte. Üblicherweise stach er mit einer Galiot zur See, im Gepäck aneinandergeklebte Papierstreifen in Rollen, auf die er seine Panoramaansichten zeichnen konnte. Unser Blatt gehört zu einer Serie von elf Zeichnungen, die mit der Anreise der Maria von Modena in Verbindung stehen. Prinzessin Maria von Modena war am 30. September 1673 in Stellvertretung mit James Herzog von York, dem späteren König James II., vermählt worden. Auf dem Landweg reiste sie durch Frankreich und bestieg in Calais die Yacht nach England. Am 21. November traf sie in Dover ein, wo sie vom Herzog empfangen wurde. Gemeinsam nahmen sie die Straße von Dover nach Gravesend, wo sie König Charles II. erwartete, um das Paar auf dem Schiff die Themse aufwärts nach Whitehall eskortieren zu lassen.

Die *London Gazette* notiert unter dem 26. November 1673 (Nr. 837): „Whitehall, 26. Nov. Am heutigen Morgen begab sich Seine Majestät, begleitet vom Vornehmsten des Adels und weiteren Personen von Stand, auf seinen Barkassen flußabwärts, um Ihre Königlichen Hoheiten zu treffen, die hier zur Mittagsstunde erwartet wurden; Ihre Königliche Hoheit wurde, nachdem sie Seine Majestät begrüßt hatte..., in ihre Gemächer in St. James's geleitet."

Van de Veldes Blick richtet sich die Themse abwärts. Zur Rechten erhebt sich das Fort von Gravesend, auf dem der Union Jack gehißt ist. Vor der Mole am Fort sticht die königliche Gesellschaft auf ihrer Reise nach London ins Wasser, begleitet von zahlreichen Barkassen, dazu schießen die Kanonen des Forts Salut. Zur Linken liegt die Flotte vor Anker, mit der der König früher am Morgen gelandet ist. Van de Veldes Beschriftung gibt als Zeit acht Uhr morgens an, und es scheint Niedrigwasser zu herrschen. Da anzunehmen ist, daß die Darstellung auf der genauen Beobachtung van de Veldes beruht, kann man erkennen, daß die Gezeit gerade zur beginnenden Flut umschlägt, die

Mary of Modena embarking at Gravesend

Pen and black ink, grey wash, over graphite
360 x 1048 mm (maximum), six pieces of paper, joined together
Corner repaired, upper right; old tears upper left
Inscribed upper left in brown ink, in van de Velde's hand: '...andren van zijn... den heere ducke de Jorck/met de ducsesse tot grevesent smorgens omtrent 8 urren.../veele groote heere & graven op den... november oude stijl 1673'. This is much faded and abraded
Bequeathed by Sir Bruce Ingram, 1963. PD. 809–1963
Provenance: unknown, bought by Ingram (Lugt 1405 a) before March 1936
Exhibited: London, Colnaghi, 1936, no. 46; London, 1938, no. 569; Bedford, 1958, no. 54; London, Royal Academy, 1961, *The Age of Charles II*, no. 513; Rotterdam/Amsterdam, 1961/62, no. 98

Van de Velde regularly went to sea to make sketches from nature of shipping, battles or ceremonial occasions like this. He usually travelled in a galjoot and seems to have gone prepared with pieces of paper already joined into scrolls on which he could draw panoramic views. This is one of a series of eleven drawings connected with the journey of Mary of Modena. Princess Mary of Modena was married by proxy to James, Duke of York (later James II), on September 30th 1673. She travelled overland through France and embarked for England at Calais and arrived at Dover on November 21st where she was met by the Duke. Together they came by road from Dover to Gravesend, where they were received by Charles II and so proceeded with him by barge up the Thames to Whitehall.

The *London Gazette* 1673 (no. 837) describes the occasion: 'Whitehall Nov 26. This morning His Majesty, attended by the principal of the Nobility, and other persons of Quality went in his Barges down the River, to meet their Royal Highnesses, who arrived here about noon; and Her Royal Highness having been to salute His Majesty... was conducted to her apartment at St James's.'

Van de Velde has drawn the scene looking down the Thames, the fort of Gravesend on the right flying the Union flag; on the right, numerous barges off the jetty in front of the fort from which the Royal party is seen embarking for their journey to London, the cannon of the fort are firing salutes. On the left at anchor, the fleet with which Charles II had arrived earlier that day. Van de Velde's description gives the time as 8 o'clock in the morning and it appears to be low water. If van de Velde has drawn the scene accurately and he appears to have done so, the tide is just about to turn with the young flood making on the South shore, below Gravesend while it still runs down in midstream. If the barges in which the Duke and Duchess are seen embarking left Gravesend with low water at 8 o'clock they would reach Whitehall 'about noon' or probably a little later.

von der Südküste unterhalb von Gravesend herankommt, während sich das Niedrigwasser noch in der Strommitte hält. Wenn die Barkassen, in die sich Herzog und Herzogin gerade eingeschifft haben, Gravesend um acht Uhr morgens bei Niedrigwasser verlassen haben, hätten sie tatsächlich Whitehall „zur Mittagsstunde" oder wenig später erreicht.

Die anderen Zeichnungen der Serie in ihrer chronologischen Abfolge sind: *An der französischen Kanalküste* (London, British Museum, Nr. 34); *Die Eskorte der Maria von Modena vor Calais*, *Die Überfahrt der Maria von Modena* und *Die Landung der Maria von Modena in Dover* (zwei Zeichnungen dieses Themas; Greenwich, National Maritime Museum, Nrn. 411–414); *Das Kastell von Dover von Westen* (London, Victoria & Albert Museum); *Die Landung von Lady Peterborough* (ehemals Sammlung Sir Bruce Ingram); *Die Ankunft Charles' II. in Gravesend* und *Das Treffen Charles' II. mit Maria von Modena* (London, British Museum, Nrn. 35–36); die vorliegende Zeichnung; *Die königliche Gesellschaft bei der Vorbeifahrt an Deptford an der Themse* (London, British Museum, Nr. 37).

The other drawings in the series, in their probable order are: *On the coast of France* (London, British Museum, no. 34); *The Escort for Mary of Modena near Calais, her crossing of the Channel* and *The Landing at Dover* (two drawings, National Maritime Museum, Greenwich, nos. 411–414); *Dover Castle from the West* (London, Victoria & Albert Museum); *The Landing of Lady Peterborough* (formerly Sir Bruce Ingram); *The arrival of Charles II at Gravesend* and *The King meeting the Duchess* (British Museum, nos. 35–36); the present drawing; *The Royal party passing Deptford on the Thames* (British Museum, no. 37).

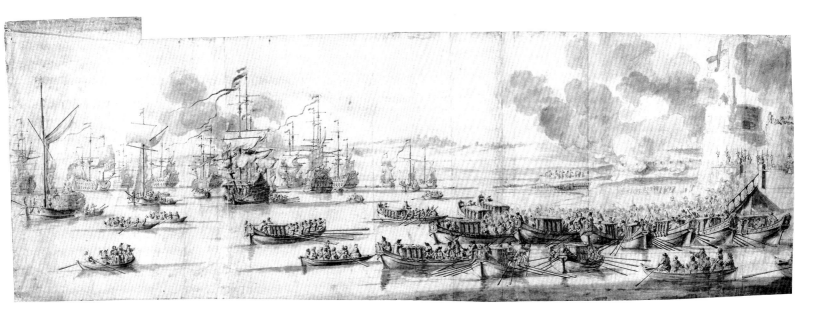

WILLEM VAN DE VELDE der Jüngere/the Younger
Leiden 1633–1707 London

Schiffe vor Anker auf einem Fluß in England

Schwarze Kreide und graue Lavierung auf zwei Papierstücken,
allseitig Randlinie mit Graphit
298 x 741 mm
Vermächtnis Sir Bruce Ingram, 1963. PD. 793–1963
Provenienz: Die rechte Hälfte William Mayor (Lugt 2799); beide
Teile von Ingram (Lugt 1405 a) in Frankreich erworben
Bisher noch nicht öffentlich ausgestellt

Willem van de Velde d. J. war Schüler seines Vaters und folgte
ihm als Marinemaler. Außerdem erhielt er eine Ausbildung bei
Simon de Vlieger (um 1601–1653). 1652 heiratete er Petronella
le Maire aus Weesp. 1672/73 wanderte er nach England aus, wo
er bis zu seinem Lebensende blieb.

Der Fluß ist möglicherweise der Medway, es kann aber auch
die Themse gezeigt sein. Unter den Schiffen befinden sich Fregatten und Ruderboote.

Ships and vessels at anchor in an English river

Black chalk and grey wash on two pieces of paper, bordered on all
sides by a line of graphite
298 x 741 mm
Bequeathed by Sir Bruce Ingram, 1963. PD. 793–1963
Provenance: the right half, William Mayor (Lugt 2799); both sections
bought by Ingram (Lugt 1405 a) in France
Not previously exhibited

Willem van de Velde the Younger was taught by his father and
followed him as a marine painter. He also studied with Simon de
Vlieger (c.1601–1653). In 1652 he married Petronella le Maire
of Weesp. He emigrated to England in 1672/73, where he lived
until he died.

The river is probably the Medway, but could be the Thames.
The ships include frigates and rowing boats.

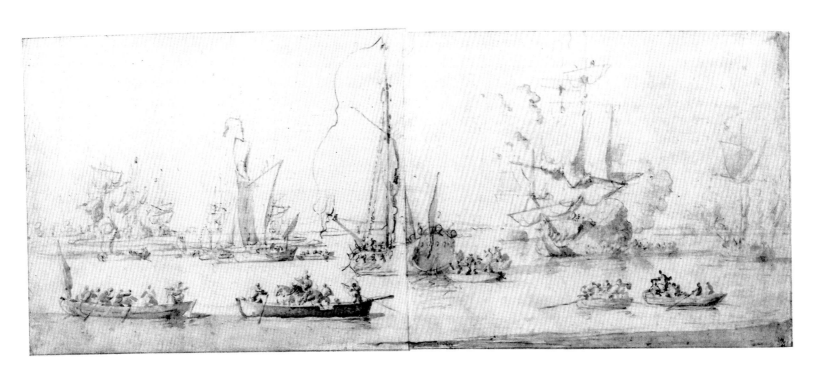

Die Segelwagen des Prinzen Moritz von Nassau am
Strand von Scheveningen

Feder, braune Tusche, graue Lavierung, allseitig Randlinie mit Pinsel
in Braun
220 x 355 mm
Verso in der Hand des J. Goll van Franckenstein in Tusche bezeich-
net ,N 430'; ebenso ,IJ20'; ,965'; in Graphit, teilweise ausradiert,
,Esaias v velde'
Vermächtnis Sir Bruce Ingram, 1963. PD. 851–1963
Provenienz: P. Testas de Jonge; dessen Versteigerung, Amsterdam,
29. März 1757, Boek (letter) I, Nr. 506; Abraham de Haas; dessen Ver-
steigerung, Amsterdam, 8. November 1824, Kunstboek I (letter I),
S. 33, Nr. 28; erworben von Endthoven oder Brondgeest; Jhr. J. Goll
van Franckenstein (Lugt 2987); Ingram (Lugt 1405 a), erworben 1936
Literatur: Maria Simon, *Claes Jansz. Visscher*. Freiburg i. Br. 1958,
S. 99–100 und Nr. 32; I. Q. van Regteren Altena, *Jacques de Gheyn.
Three Generations*. Den Haag / Boston / London 1983, II, S. 43, s. v.
Nr. 152
Ausstellungen: London, Colnaghi, 1936, Nr. 78; London 1946/47,
Nr. 10; Cambridge, Fitzwilliam Museum, 1952/53 (o. Kat.); Washing-
ton u. a. 1959/60, Nr. 91; Rotterdam / Amsterdam 1961/62, Nr. 111;
Cambridge 1982 (o. Kat.)

Unsere Zeichnung, die bisher als Arbeit des Jacques de Gheyn II.
(1565–1629) galt, ist eine freie Kopie nach dem berühmten
Kupferstich nach de Gheyn, die Christoffel van Sichem und
Hendrick Haestens 1603 verlegten. Vier Zustände des Stiches
erschienen insgesamt, der letzte 1652 durch Claes Jansz. Vis-
scher als Verleger. Unser Blatt wird allgemein um 1610 datiert,
wenn auch Simon (a. a. O.) es 1615/16 ansetzt. Dargestellt ist
der berühmte, über 14 holländische Meilen sich erstreckende
Ausflug des Prinzen Moritz von Nassau (1567–1625), des Statt-
halters der Vereinigten Provinzen, am Strand von Scheveningen
nach Petten in einem vom Wind getriebenen Segelwagen. Die-
ser war eine Erfindung des Mathematikers und Ingenieurs Simon
Stevin (1548–1620) und wurde zuerst 1597 erwähnt. Die Aus-
fahrt fand wahrscheinlich im Frühling des Jahres 1602 statt und
dauerte weniger als zwei Stunden. Visscher stellt zwei Segel-
wagen dar, den größeren mit dem Prinzen Moritz, seinem Bruder
Prinz Friedrich Heinrich und dem kriegsgefangenen spanischen
Granden Francis de Mendoza an Bord, so wie sie auch im Stich
nach de Gheyn erscheinen. Die Staffage im Vordergrund und der
Großteil der Marinevedute sind jedoch Visschers eigene Erfin-
dung, auch wenn die beiden Reiter zur Linken ebenfalls im Stich
vertreten sind. Eine Variante der Darstellung in kleinerem For-
mat und mit unterschiedlich arrangierter Staffage von der Hand
Visschers bewahrt gleichfalls das Fitzwilliam Museum (PD.
850–1963). Der kleinere der beiden Segelwagen überdauerte bis
in das späte 18. Jahrhundert. Statthalter Wilhelm V. verwendete
ihn auf dem Hochzeitsfest seiner Tochter, Prinzessin Louise,
doch wurden dabei die Räder gefährlich heiß und mußten im
Meer abgekühlt werden.

The Landyachts of Prince Maurice of Nassau on the beach
at Scheveningen

Pen, brown ink, grey wash, bordered on all sides by a line
of brown wash
220 x 355 mm
Inscribed, *verso*, in the hand of J. Goll van Franckenstein, in ink:
'N 430'; also 'IJ20'; '965'; in graphite, partly erased: 'Esaias v velde'
Bequeathed by Sir Bruce Ingram, 1963. PD. 851–1963
Provenance: P. Testas de Jonge, his sale, Amsterdam, 29 March 1757,
Boek (letter) I, no. 506; Abraham de Haas, his sale, Amsterdam,
8 November 1824, Kunstboek I (letter I), p. 33, no. 28; bought Endt-
hoven or Brondgeest; Jhr. J. Goll van Franckenstein (Lugt 2987);
Ingram (Lugt 1405 a) by 1936
Literature: Maria Simon, *Claes Jansz. Visscher*, Freiburg i. Br., 1958,
pp. 99/100 and no. 32; I. Q. van Regteren Altena, *Jacques de Gheyn.
Three Generations*, The Hague, Boston, London, 1983, II, p. 43, *s.v.*
no. 152
Exhibited: London, Colnaghi, 1936, no. 78; London, 1946/47, no. 10;
Cambridge, Fitzwilliam Museum, 1952/53 (no handlist); Washington
and American Tour, 1959/60, no. 91; Rotterdam / Amsterdam, 1961/62,
no. 111; Cambridge, 1982 (no handlist)

The drawing, previously attributed to Jacques de Gheyn II
(1565–1629), is a free copy after the famous print based on a
design by de Gheyn and published by Christoffel van Sichem
and Hendrick Haestens in 1603. Four states were published, the
last in 1652 when the publisher was Claes Jansz. Visscher. The
Fitzwilliam drawing is generally dated *c.*1610 (although Simon
[*loc.cit.*] proposes 1615/16). The scene records the famous occa-
sion on which Prince Maurice of Nassau (1567–1625), the stadt-
holder (chief executive) of the United Provinces, made a jour-
ney of 14 Dutch miles from Scheveningen to Petten by
landyacht (wind-chariot). The landyacht was the invention of
the mathematician and engineer Simon Stevin (1548–1620)
and is first mentioned in 1597. This journey probably took place
in the spring of 1602: it took under two hours. Visscher shows
the two landyachts, the bigger one containing Prince Maurice,
his brother Frederick Henry and the captive Spanish grandee,
Mendoza, as they appear in the print after de Gheyn, but the
staffage in the foreground and most of the shipping is Visscher's
own invention although the two horsemen on the left also fea-
ture in the print. Another, smaller, version of the subject, with
a different arrangement, by Visscher is also in the Fitzwilliam
(PD. 850–1963). Of the two coaches the smaller survived until
the end of the 18th century. William V used it once for his
daughter's, Princess Louise's wedding feast, but the wheels
became dangerously overheated and had to be cooled in the sea.

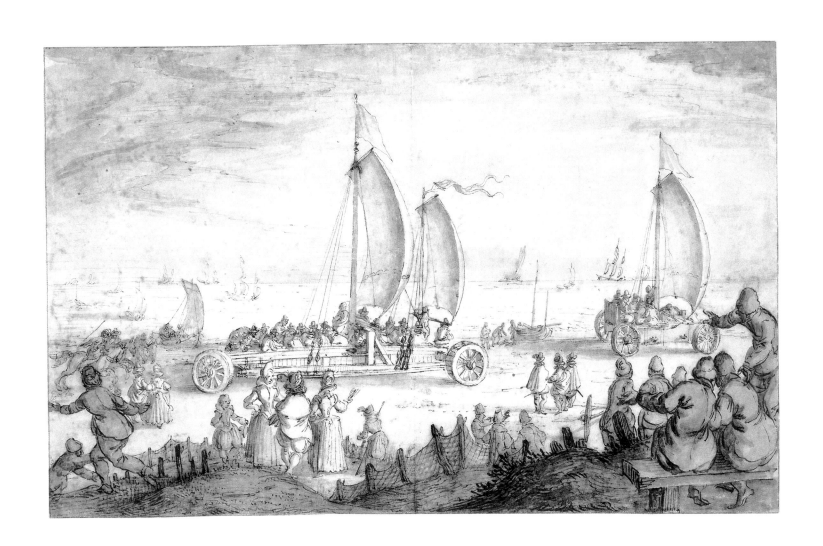

SIMON DE VLIEGER
Rotterdam (?) um/*c.* 1601–1653 Weesp

Drei Segelboote in stürmischer See

Graphit, allseitig Randlinie mit Pinsel in Braun
187 x 300 mm, am rechten und linken Bildrand beschnitten
Leicht stockfleckig
Unten rechts in Graphit bezeichnet ‚D VLIGER‘
Verso in brauner Tusche bezeichnet ‚Ex coll. Henrici Hamal Leod‘;
in Graphit ‚S. de Vlieger / 1642 / master of V. Velde‘
Vermächtnis Sir Bruce Ingram, 1963. PD. 878–1963
Provenienz: H. Hamal (Lugt 1231); dessen Versteigerung, Paris,
21.–23. Januar 1805; Kunsthandlung P. & D. Colnaghi, London; hier
von Ingram (Lugt 1405 a) im November 1944 erworben
Bisher noch nicht öffentlich ausgestellt

Die Bezeichnung „D VLIGER“ ist eine spätere Zutat. Meister-
haft hat der Künstler das Anschwellen der Wogen in rauher See
mit wenigen Strichen charakterisiert.

Three ships in a rough sea

Graphite, bordered on all sides by a line of brown wash
187 x 300 mm, cut down, left and right
Slight foxing
Inscribed, lower right, in graphite: ‘D VLIGER’
Inscribed *verso*, in brown ink: ‘Ex coll. Henrici Hamal Leod’;
in graphite: ‘S. de Vlieger / 1642 / master of V. Velde’
Bequeathed by Sir Bruce Ingram, 1963. PD. 878–1963
Provenance: H. Hamal (Lugt 1231); his sale, Paris, 21–23 January
1805; with P. & D. Colnaghi, London, from whom bought by Ingram
(Lugt 1405 a), November 1944
Not previously exhibited

The inscription with de Vlieger’s name is a later addition. The
artist has drawn the swell of waves in a rough sea to splendid
effect.

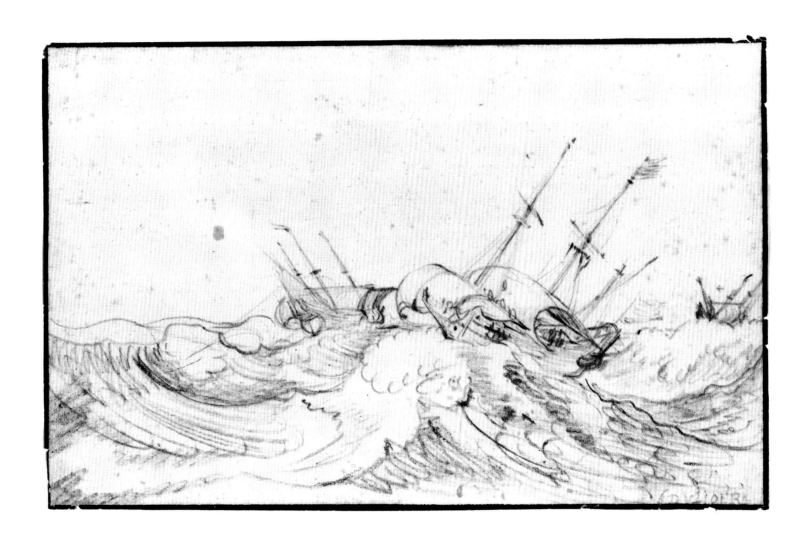

HENDRICK CORNELISZ. VROOM
Haarlem 1566–1640 Haarlem

Blick auf Elsinore und Schloß Kronborg vom Sund aus

Feder und braune Tusche auf blauem Papier
120 x 379 mm

Verso: Schiffstudien
Feder und braune Tusche

Auf der Vorderseite am oberen Bildrand von des Künstlers Hand in brauner Tusche beschriftet ‚d sondt' und ‚cronenburgh'
Vermächtnis Sir Bruce Ingram, 1963. PD. 885–1963
Provenienz: Kunsthandlung P. & D. Colnaghi, London; hier von Ingram (Lugt 1405 a) im Februar 1934 erworben
Literatur: George Keyes, *Cornelis Vroom*. Alphen aan de Rijn 1975, I, Taf. XXIII
Ausstellungen: London, Colnaghi, 1936, Nr. 81; London 1946/47, Nr. 27; Bedford 1958, Nr. 56; Washington u. a. 1959/60, Nr. 95; Rotterdam / Amsterdam 1961/62, Nr. 114

Hendrick Vroom war der Sohn eines Bildhauers und Keramikkünstlers; seine erste künstlerische Ausbildung hat er vielleicht in Delft erhalten. Er reiste nach Spanien und Italien, um dort die Kunst der Keramikbemalung zu lernen. In Rom schloß er sich Paul Bril (1554–1626) an; später ging er nach Venedig, wo er sich ebenfalls mit der Auszier von Majolika beschäftigte. Auf seiner Rückreise nach Haarlem besuchte er Mailand, Genua, Turin und Lyon. 1590 heiratete er. Um 1596 war er in England tätig, wo er in Zusammenarbeit mit dem Delfter Teppichwirker François Spierincx (1551–1630) zehn große Kartons für die *Armada*-Tapisserien anfertigte, die der englische Admiral Lord Howard of Effingham in Auftrag gegeben hatte. 1603 stand er in den Diensten der Stadt Leiden und 1611 und 1614 in denen des Erzherzogpaares Albert und Isabella in Brüssel. 1616 ist er in den Listen der Antwerpener Lukasgilde aufgeführt. Vroom starb 1640 in Haarlem. Er hatte drei Kinder; zwei Söhne, Cornelis (1591/92–1661) und Frederick (1600–1667), waren ebenfalls als Maler tätig.

Der Standpunkt des Zeichners ist im Sund. An der Küstenlinie erscheinen als Silhouette die Stadt Elsinore (heute Helsingør) mit den beiden Kirchen St. Olaf und St. Marien und zur Rechten das alte Zollhaus sowie Schloß Kronborg. Dieses zeigt sich in der Gestalt, die es in seiner Bauphase unter Frederick II. zwischen 1574 und 1585 erhielt. Der mächtige Turm zur Linken wird von einem hohen spitzen Helm bekrönt, der noch nicht in der gestochenen Ansicht von G. Braun und F. Hogenberg (*Civitates Orbis Terrarum*. Köln 1575, II, Nr. 33) erscheint: Der Helm und der größere Teil des Schlosses wurden in einem Brand 1629 zerstört, der Helm nie wieder aufgerichtet. Derselbe Stich zeigt die beiden Kirchen von Elsinore mit getreppten Giebeln an Stelle der spitzen Türme unserer Zeichnung. Der Turm von St. Marien wurde 1589 verändert, der von St. Olaf 1615. Man kann aus diesen Baudaten schließen, daß unser Blatt zwischen 1615 und 1629 entstand.

View of Elsinore and Kronborg Castle

Pen and brown ink on blue paper
120 x 379 mm

Verso: Studies of ships
Pen and brown ink

Inscribed, *recto*, in brown ink, in the artist's hand:
'd sondt' and 'cronenburgh'
Bequeathed by Sir Bruce Ingram, 1963. PD. 885–1963
Provenance: with P. & D. Colnaghi, London, from whom bought by Ingram (Lugt 1405 a), February 1934
Literature: George Keyes, *Cornelis Vroom*, Alphen aan de Rijn, 1975, I, pl. XXIII
Exhibited: London, Colnaghi, 1936, no. 81; London, 1946/47, no. 27; Bedford, 1958, no. 56; Washington and American Tour, 1959/60, no. 95; Rotterdam / Amsterdam, 1961/62, no. 114

Hendrick Vroom was the son of a sculptor and ceramicist; he may have had his preliminary training in Delft. He travelled to Spain and Italy to study the art of pottery decoration. In Rome he was befriended by Paul Bril (1554–1626); later he went to Venice where he continued to practice majolica decoration. On his return to Haarlem he visited Milan, Genoa, Turin and Lyons. He was married by 1590. He collaborated with the Delft weaver, François Spierincx (1551–1630), providing ten large cartoons for the *Armada* tapestries, commissioned by the British Admiral, Lord Howard of Effingham, when he visited England c.1596. He worked for the city of Leiden in 1603 and for the Archdukes Albert and Isabella in Brussels in 1611 and 1614, he was made a member of the Guild at Antwerp in 1616 and died in Haarlem. He had three children; two sons, Cornelis (1591/92–1661) and Frederick (1600–1667), were also painters.

The view is taken from the Sondt. Across the background can be seen the profile of the town of Elsinore (Helsingør) with its two churches, St Olav and St Mary, and, to the right, the old 'Tolhuis' (customs-house) and Kronborg Castle. Kronborg Castle as it appears in this drawing was built largely by Frederick II between 1574 and 1585. The large tower on the left is crowned with a tall spire not yet shown in the engraving in G. Braun and F. Hogenberg's *Civitates Orbis Terrarum*, II, Cologne, 1575, no. 33. This spire and with it the greater part of the castle were destroyed by fire in 1629; the spire was never rebuilt. The same engraving presents the two church towers of Elsinore with stepped gables instead of the tall spires shown in this drawing. The tower of St Mary was altered in 1589 and that of St Olav in 1615. The drawing must have been executed between 1615 and 1629.

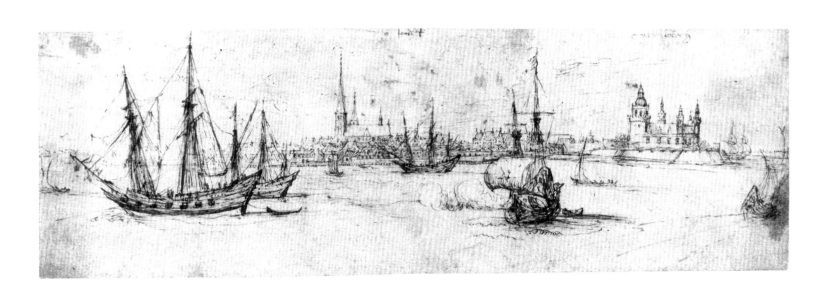

CORNELIS CLAESZ. VAN WIERINGEN
zugeschrieben/attributed to
Haarlem um/c. 1580–1633 Haarlem

Schiffe in schwerer See

Schwarze Kreide, Feder und braune Tusche, weiß gehöht,
auf graubraunem Papier
192 x 310 mm
Die Ecken angesetzt, mit Ausnahme von rechts oben
Oben rechts in brauner Tusche bezeichnet ‚Van Wiringe.fe.'
Vermächtnis Sir Bruce Ingram, 1963. PD. 914–1963
Provenienz: Kunsthandlung P. & D. Colnaghi, London; hier von
Ingram (Lugt 1405a) im März 1952 erworben
Literatur: vgl. George S. Keyes, Cornelis Claesz. van Wieringen.
Oud Holland 93, 1979, S. 1–46
Ausstellung: Cambridge 1982 (o. Kat.)

Van Wieringen war wahrscheinlich Schüler des Hendrick Cor-
nelisz. Vroom (1566–1640) und in seiner Zeit ebenso hoch
geschätzt wie dieser. Es gibt nur wenige Gemälde und Radierun-
gen von ihm, doch hat sich ein umfangreicherer Corpus von
Zeichnungen erhalten, die meist sehr penibel durchgearbeitet
sind. Von seiner Hand stammt auch der Entwurf für die Tapis-
serie der *Eroberung von Damiette* im Magistratszimmer des Haar-
lemer Rathauses.

Keine der Zeichnungen, die Keyes in seinem Artikel in *Oud
Holland* aufführt, sind in der Technik unseres Blattes gearbeitet.
Die meisten (vier Blätter in Cambridge eingeschlossen) sind in
Feder und Tusche, mit grauen oder farbigen Lavierungen und
mit besonderer Akkuratesse in der Binnenzeichnung ausgeführt.
Unser Blatt ist im Vergleich freier angelegt; doch zeigen sich
durchaus Gemeinsamkeiten in der Art, wie die Linien, die die
Komposition bestimmen, mit dickeren Federstrichen hervorge-
hoben werden. Die Zeichnungen, in denen kurze, heftige Wellen
dargestellt werden (vgl. *Segelboot vor einem Pier*, Fitzwilliam
Museum, PD. 566–1963), zeigen eine ähnliche Rhythmik in der
Strichführung, die trotz der anderen Technik eine Zuschreibung
des hier vorgestellten Blattes an van Wieringen erwägenswert
erscheinen läßt. Dennoch sollte man im Auge behalten, daß
Zeichnungen van Wieringens mit Arbeiten des Jan Porcellis
(1584–1632) und des Simon de Vlieger (um 1601–1653) ver-
wechselt werden können.

Shipping in a heavy sea

Black chalk, pen and brown ink, heightened with white
on grey-brown paper
192 x 310 mm
Corners made up except for top right
Inscribed in brown ink, upper right: 'Van Wiringe.fe.'
Bequeathed by Sir Bruce Ingram, 1963. PD. 914–1963
Provenance: with P. & D. Colnaghi, London, from whom bought by
Ingram (Lugt 1405a), March 1952
Literature: *cf.* George S. Keyes, 'Cornelis Claesz. van Wieringen',
Oud Holland, 93, 1979, pp. 1–46
Exhibited: Cambridge, 1982 (no handlist)

Van Wieringen was probably taught by Hendrick Cornelisz.
Vroom (1566–1640) and in his day was as highly esteemed. His
paintings and etchings are rare but a *corpus* of his drawings is
known, mostly drawn in a meticulous technique. He designed
the tapestry of the *Capture of Damiate* which hangs in the
magistrates' chamber in the Haarlem Town Hall.

None of the drawings included by Keyes in his article in *Oud
Holland* are in the technique of this drawing. Most of them
(including four in Cambridge) are in pen and ink with grey or
coloured washes, and they are handled with a particular delicacy.
What they have in common with this drawing, which is much
more loosely handled, is a habit of reinforcing the outline of
prominent features with thicker strokes of the pen. The draw-
ings with choppy seas (one of which, *Sailboat before a pier*, [PD.
566–1963], is in the Fitzwilliam) show a rhythm in the handling
of water which, taking into consideration the different medium,
is sufficiently similar to make the attribution to van Wieringen
worth considering, but it must be born in mind that his drawings
are often confused with those of both Jan Porcellis (1584–1632)
and Simon de Vlieger (c.1601–1653).

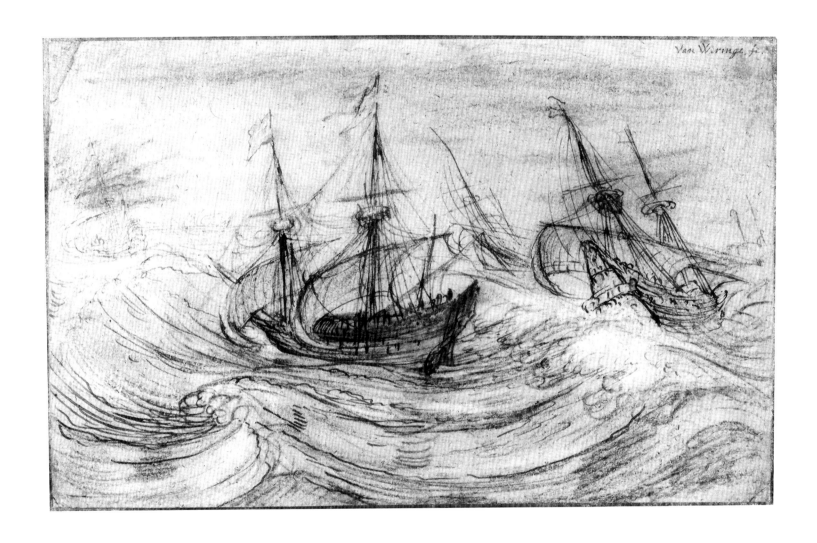

TIERE UND PFLANZEN

ANIMALS AND FLOWERS

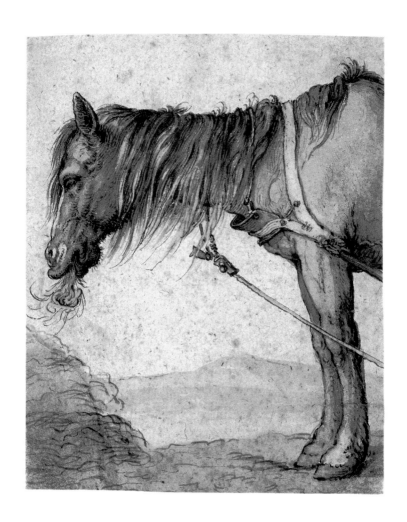

ABRAHAM BLOEMAERT
Gorinchem 1566–1651 Utrecht

Heu raufendes Pferd

Feder und braune Tusche, braune und blaugrüne Lavierung
über Graphit
122 x 97 mm (allseitig beschnitten)

Verso: Rückenansicht eines Mannes im Mantel
Feder und braune Tusche

An der unteren linken Ecke alte Ausbesserung; Riß durch die Hufe
des Pferdes
Verso bezeichnet ‚D. Schellinks'
Vermächtnis Sir Bruce Ingram, 1963. PD. 159–1963
Provenienz: Auktion Sotheby's, London, 7. Dezember 1938, Teil von
Lot 1 (unbekannte Sammlung); Kunsthandlung P. & D. Colnaghi,
London; hier von Ingram (Lugt 1405 a) im Dezember 1938 erworben
Ausstellungen: Cambridge, Fitzwilliam Museum, 1951 (o. Kat.);
London, Colnaghi, 1952, Nr. 66; Bath 1952, Nr. 9; London, Colnaghi,
1953, Nr. 15; Birmingham 1953 und Cirencester 1953, Nr. 15;
Cambridge, Fitzwilliam Museum, 1955/56 (o. Kat.); Bedford 1958,
Nr. 7; Rotterdam / Amsterdam 1961/62, Nr. 15; London, The Park Lane
Hotel, 1993, *The World of Watercolours: A Draughtsman's Menagerie*
(o. Kat.)

Dieses Blatt, das bisher Jacques de Gheyn II. (1565–1629) zuge-
schrieben wurde, zeigt deutliche Ähnlichkeiten mit Bloemaerts
Tierstudien und geht letztendlich auf Dürers „vermenschlichte"
Tierstudien zurück. Eine ganze Reihe Tierzeichnungen sind von
Bloemaert bekannt, meist Studien nach Tieren auf Bauernhöfen.
Eine Gruppe solcher Blätter enthält das sogenannte *Tekenboek*
(Fitzwilliam Museum, PD. 166–1963, siehe Kat. 83) mit zwei
Zeichnungen, die Pferdeköpfe mit Zaumzeug darstellen (folios
122 und 123). Unsere Studie entstand wahrscheinlich um
1600–1610.

A horse eating

Pen and brown ink, brown and blue-green wash over graphite
122 x 97 mm, irregular, cut on all sides

Verso: Part of a man, wearing a cloak, seen from behind
Pen and brown ink

Old repair, lower left corner; tear across the horse's hooves
Inscribed, *verso*: 'D.Schellinks'
Bequeathed by Sir Bruce Ingram, 1963. PD. 159–1963
Provenance: anonymous Collector; London, Sotheby's, 7 December
1938, part of lot 1; P. & D. Colnaghi, London, from whom bought by
Ingram (Lugt 1405 a), December 1938
Exhibited: Cambridge, Fitzwilliam Museum, 1951 (no handlist); Lon-
don, Colnaghi, 1952, no. 66; Bath, 1952, no. 9; London, Colnaghi,
1953, no. 15; Birmingham, 1953, and Cirencester, 1953, no. 15; Cam-
bridge, Fitzwilliam Museum, 1955/ 56 (no handlist); Bedford, 1958,
no. 7; Rotterdam / Amsterdam, 1961/62, no. 15; London, The Park Lane
Hotel, 1993, *The World of Watercolours: A Draughtsman's Menagerie*
(no handlist)

Previously attributed to Jacques de Gheyn II (1565–1629), the
drawing has a close affinity with Bloemaert's animal studies and
stems ultimately from the 'human' animal studies of Albrecht
Dürer. Quite a number of animal drawings by Bloemaert are
known, most of them depicting farm animals. A group of them
are in the *Drawing Book* (now in the Fitzwilliam Museum,
PD. 166–1963, s. Cat. no. 83) of which two show horses' heads
with bridles (folios 122,123). This study was probably drawn
*c.*1600–1610.

AELBERT CUYP
Dordrecht 1620–1691 Dordrecht

Studie eines Pferdes

Dünner Pinsel, schwarze Tusche über Graphit
87 x 96 mm
Vermächtnis Sir Bruce Ingram, 1963. PD. 256–1963
Provenienz: Sir Bruce Ingram (Lugt 1405 a)
Bisher noch nicht öffentlich ausgestellt

Studie eines Pferdes mit Stallknecht

Dünner Pinsel, schwarze Tusche über Graphit
67 x 98 mm
Unten links in schwarzer Tusche bezeichnet (Signatur?) ‚A Kuijp'
Vermächtnis Sir Bruce Ingram, 1963. PD. 257–1963
Provenienz: Sir Bruce Ingram (Lugt 1405 a)
Bisher noch nicht öffentlich ausgestellt

Beide Pferdestudien, die eindeutig nach der Natur gezeichnet sind, werden von Egbert Haverkamp-Begemann als Arbeiten von Aelbert Cuyp angesehen. Martin Royalton-Kish sah in dem Studienblatt mit dem Stallknecht (Kat. 64) Ähnlichkeiten mit Werken des Pieter Verbeeck (um 1610–1654), der durch seine Pferdebilder bekannt wurde.

A study of a horse

Point of the brush, black ink, over graphite
87 x 96 mm
Bequeathed by Sir Bruce Ingram, 1963. PD. 256–1963
Provenance: uncertain before its acquisition by Ingram (Lugt 1405 a)
Not previously exhibited

Study of a horse with a groom

Point of the brush, black ink, over graphite
67 x 98 mm
Inscribed (signed?) in black ink, lower left: 'A Kuijp'
Bequeathed by Sir Bruce Ingram, 1963. PD. 257–1963
Provenance: uncertain before its acquisition by Ingram (Lugt 1405 a)
Not previously exhibited

Clearly drawn from the life, both these studies are accepted as works by Cuyp by Egbert Haverkamp-Begemann. The one without the groom reminded Martin Royalton-Kish of Pieter Verbeeck (c. 1610–1654), who is renowned for his painting of horses.

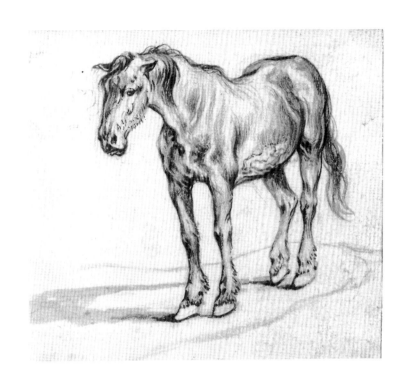

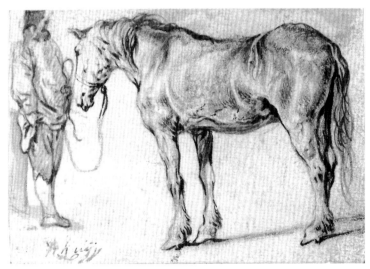

CORNELIS SAFTLEVEN
Gorinchem 1607–1681 Rotterdam

Trompetender Elefant

Schwarze Kreide
262 x 383 mm
Vermächtnis Sir Bruce Ingram, 1963. PD. 678–1963
Provenienz: Kunsthandlung P. & D. Colnaghi, London; hier von
Ingram (Lugt 1405 a) im Dezember 1954 erworben
Ausstellung: London, The Park Lane Hotel, 1993, *The World of
Watercolours: A Draughtsman's Menagerie* (o. Kat.)

Der Elefant auf diesem Blatt zeigt bemerkenswerte Ähnlichkei-
ten mit dem hinteren seiner beiden Artgenossen in Herman
Saftlevens Radierung *Zwei Elefanten* (Hollstein 40) von 1646.
Während von Herman Saftleven kaum Tierzeichnungen
bekannt sind, ist von Cornelis Saftleven eine beträchtliche
Anzahl vorhanden, darunter auch zwei Studien im Fitzwilliam
Museum, *Esel* (PD. 676–1963) und *Rehbock* (PD. 677–1963).
Unser Blatt wurde zwar von Wolfgang Schulz nicht in seine
Monographie über Cornelis Saftleven (Berlin / New York 1978)
aufgenommen, er wird es aber (laut Brief an das Museum vom
4. August 1983) in seinem revidierten Katalog unter Nummer
299–B verzeichnen. Wenn er auch bezüglich der Autorschaft
zwischen Herman und Cornelis Saftleven geschwankt hat, ten-
diert er eher zu Cornelis. Eine andere Zeichnung von Cornelis
Saftleven, auf der ein Elefant nach rechts schreitet und Nahrung
im Rüssel trägt, befand sich in der Kunsthandlung F. A. Drey in
London, ein weiteres Blatt mit einem Elefanten ist im Katalog
einer Versteigerung in Amsterdam vom 30. Oktober 1780 als Lot
426 verzeichnet. Von der Hand Rembrandts haben sich drei
Zeichnungen mit Elefanten erhalten, eine davon mit der Jahres-
zahl 1637 (Wien, Albertina): Sie zeigt Hanske, eine indische
Elefantenkuh, die 1630 in Ceylon geboren wurde, in Europa in
Wandermenagerien vorgeführt wurde und 1655 starb.

An elephant, trumpeting

Black chalk
262 x 383 mm
Bequeathed by Sir Bruce Ingram, 1963. PD. 678–1963
Provenance: with P. & D. Colnaghi, London, from whom bought by
Ingram (Lugt 1405 a), December 1954
Exhibited: London, The Park Lane Hotel, 1993, *The World of Water-
colours: A Draughtsman's Menagerie* (no handlist)

The drawing bears considerable similarities to the elephant in
the background of the etching of *Two Elephants* by Herman Saft-
leven (Hollstein 40) made in 1646. However Herman is not well
known for drawings of animals, a good group of which survives
from Cornelis' hand (in the Fitzwilliam a *Study of a donkey* [PD.
676–1963] and a *Study of a roebuck* [PD. 677–1963]). The
present drawing was not included in Wolfgang Schulz's mono-
graph (*Cornelis Saftleven*, Berlin, New York, 1978), but, in a let-
ter to the Museum (4 August 1983), Schulz states that he has
given this drawing the number 299–B in his revised catalogue
and that although he had hesitated between an attribution to
Herman Saftleven or to Cornelis he thinks the drawing rather to
be by Cornelis than Herman Saftleven. Another drawing by
Cornelis of an elephant walking to right with food in his trunk
was with F.A. Drey in London and one was recorded in a sale in
Amsterdam (30 October 1780, lot 426). Three drawings of an
elephant by Rembrandt survive, one dated 1637 (Vienna, Alber-
tina); identified as a female Asiatic elephant, called Hanske,
which was born in Ceylon in 1630 and was widely exhibited
throughout Europe before she died in 1655.

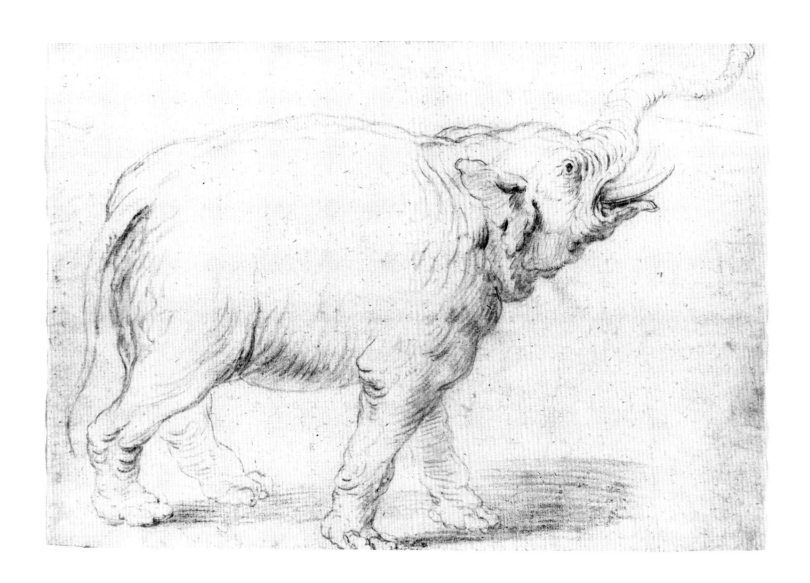

AERT SCHOUMAN
Dordrecht 1710–1792 Den Haag / The Hague

Fliegende Stockente über einer Flußmündung

Aquarell über Spuren von Graphit, allseitig Randlinie mit Pinsel in Braun
262 x 363 mm
Vermächtnis Sir Bruce Ingram, 1963. PD. 714–1963
Provenienz: Kunsthandlung P. & D. Colnaghi, London; hier von Ingram (Lugt 1405 a) im April 1938 erworben
Ausstellungen: Cambridge, Fitzwilliam Museum, 1952 (o. Kat.); London, Colnaghi, 1956, Nr. 16

Schouman lernte acht Jahre lang im Atelier des Adriaen van der Burg (1693–1733) in Dordrecht. 1748 wurde er in die Lukas-gilde in Den Haag aufgenommen; er hielt sich teils in Dordrecht, teils in Den Haag auf, wo er schließlich 1753 seinen endgültigen Wohnsitz nahm. Zu seinem Schülerkreis gehörte auch sein Neffe Martinus (1770–1848). Schouman spezialisierte sich auf Vogelbilder in der Art des Melchior d'Hondecoeter (1636–1695) und Jan Weenix (1640–1719), aber er malte auch klein-formatige Historienbilder, Portraits, Landschaften und Blumen.

Das Fitzwilliam Museum besitzt zwei weitere Vogelzeichnungen von Schouman, *Großer Kakadu mit weißer Haube* (PD. 41–1954) und *Distelfink mit einer Distel* (PD. 127–1973, fol. 26). Letztere befindet sich in einem Album mit 63 Blumenbildern, von denen 62 von Schouman stammen. Darüber hinaus bewahrt das Museum auch zwei Portraitzeichnungen von seiner Hand. Seine Blumenbilder sind größtenteils kompositorisch ähnlich wie die Tierzeichnungen angelegt: Die Pflanze nimmt den dominanten Platz im Vordergrund ein und wird oft mit einer Landschaft hinterlegt, die disproportional wirkt. Tier- und Pflanzendarstellungen stimmen in der Aquarelltechnik überein, die souverän eingesetzt ist.

A Mallard duck flying over an estuary with shipping

Watercolour over traces of graphite, bordered on all sides by a line of brown wash
262 x 363 mm
Bequeathed by Sir Bruce Ingram, 1963. PD. 714–1963
Provenance: with P. & D. Colnaghi, London, from whom bought by Ingram (Lugt 1405 a), April 1938
Exhibited: Cambridge, Fitzwilliam Museum, 1952 (no handlist); London, Colnaghi, 1956, no. 16

Schouman studied with Adriaen van der Burg (1693–1733) in Dordrecht for eight years. He was admitted to the Guild in The Hague in 1748 and lived between Dordrecht and The Hague, where he finally settled in 1753. Amongst his pupils was his nephew, Martinus (1770–1848). Schouman specialised in bird painting in the manner of Melchior d'Hondecoeter (1636–1695) and Jan Weenix (1640–1719). He also painted small history pictures, portraits, landscapes and flowers.

The Fitzwilliam has two other drawings of birds by Schouman, a *Great White-Crested Cockatoo* (PD. 41–1954) and a *Goldfinch with a thistle* (PD. 127–1973, folio 26) in an album of 63 flower drawings, of which 62 are by Schouman. There are also two portrait drawings by him in the collection. The flower drawings, for the most part, have a similar design, in that the plant occupies a prominent place in the foreground and there is often a landscape background which looks disproportionate to the whole. They are executed in an identical technique, with extreme dexterity in the handling of the medium.

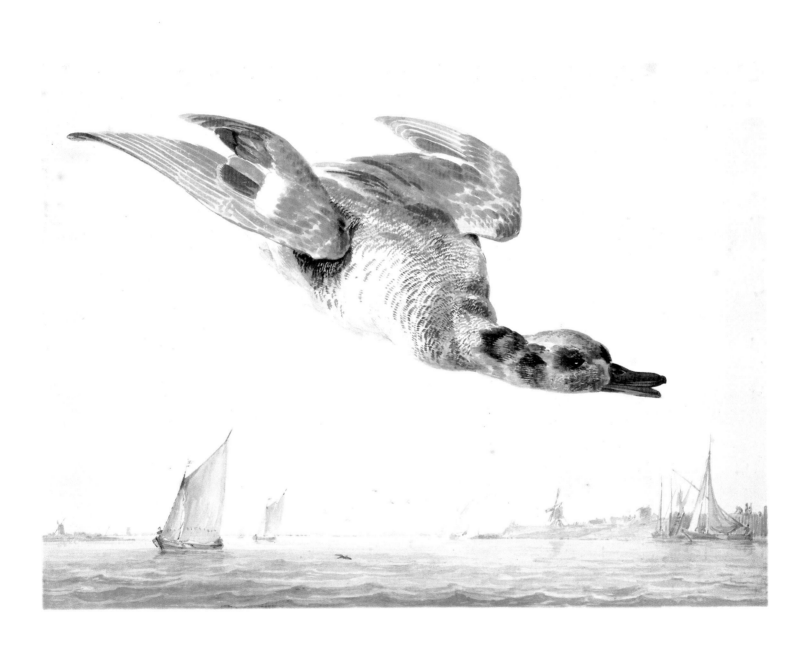

JAN VAN HUYSUM
Amsterdam 1682–1749 Amsterdam

Blumenvase mit Früchten auf einem Sockel, vor einer Vorhangdraperie

Feder und schwarze Tusche, Aquarell, über Graphit
201 x 156 mm
In schwarzer Tusche signiert ,Jan van Huysum fecit'
Vermächtnis Sir Bruce Ingram, 1963. PD. 420–1963
Provenienz: Miss Daisy Haycroft; Kunsthandlung P. & D. Colnaghi, London; hier von Ingram (Lugt 1405a) im Juni 1936 erworben
Literatur: Christopher White, *The Flower Drawings of Jan van Huysum*. Leigh-on-Sea 1964, Nr. 19, Taf. 11
Ausstellungen: Cirencester 1951, Nr. 40; Cambridge, Fitzwilliam Museum, 1951/52 (o. Kat.); Montreal, Museum of Fine Arts, 1953, *Five Centuries of Drawing*, Nr. 144a; London, Colnaghi, 1956, Nr. 27

Jan van Huysum war der älteste Sohn des Justus van Huysum (1659–1716), eines erfolgreichen Blumenmalers, der auch drei weitere Söhne im Familienbetrieb beschäftigte. Sein Atelier muß über eine Ausstattung wie bei einem modernen Innenarchitekten verfügt haben. Jans Frühwerk erinnert an das von Willem van Aelst (1625/26–nach 1683), doch ließ van Huysum in seinen reifen Werken die dunklen Farben und den düsteren Hintergrund, die für die Aelst-Schule charakteristisch sind, hinter sich und wandte sich einer üppigen barocken Kompositionsweise zu, in der die Lichtführung und die Farbgebung des Rokoko vorausgenommen werden.

Van Huysum verbrachte jeden Sommer in Haarlem, um dort Blumen zu studieren, und die meisten seiner Zeichnungen entstanden auf Grund dieser Beobachtungen an den Abenden oder in den Wintermonaten. Er zeichnete sich durch eine geradezu besessene Geheimniskrämerei aus, und niemand durfte sein Atelier betreten, aus Angst, er könne die Methoden und Techniken des Künstlers abschauen. 1704 heiratete er Margrieta Schouten. Zu seinen Gönnern gehörten die Könige von Polen und Preußen, der Kurfürst von Sachsen, Prinz Wilhelm von Hessen, die Herzöge von Orléans und Mecklenburg, der Comte de Murville und Sir Robert Walpole. Sein einziger Schüler war eine Frau, Margaretha Haverman ((1720–1795), die, nachdem sie sein Atelier verlassen hatte, hauptsächlich in Paris tätig wurde.

Eine nahezu identische Studie in Feder und Lavierung, mit der möglicherweise diese Zeichnung vorbereitet wurde, befand sich 1967 in der Kunsthandlung Julius Böhler in München. Unter den Blumen und Früchten erkennt man Klatschmohn, Nelken, Pfirsiche, Trauben, Pflaumen, eine Melone und Aprikosen.

A vase of flowers with fruit on a plinth in front of a draped curtain

Pen and black ink, watercolour, over graphite
201 x 156 mm
Signed in black ink: 'Jan van Huysum fecit'
Bequeathed by Sir Bruce Ingram, 1963. PD. 420–1963
Provenance: Miss Daisy Haycroft; with P. & D. Colnaghi, London, from whom bought by Ingram (Lugt 1405a), June 1936
Literature: Christopher White, *The Flower Drawings of Jan van Huysum*, Leigh-on-Sea, 1964, no. 19, pl. 11
Exhibited: Cirencester, 1951, no. 40; Cambridge, Fitzwilliam Museum, 1951/52 (no handlist); Montreal, Museum of Fine Arts, 1953, *Five Centuries of Drawing*, no. 144a; London, Colnaghi, 1956, no. 27

Jan van Huysum was the eldest son of Justus van Huysum (1659–1716), a successful flower painter who also employed three other sons in the family workshop, which appears to have had the trappings of the modern interior-decorator. Jan's early work is reminiscent of Willem van Aelst (1625/26–after 1683), but van Huysum was to reject the sombre colours and backgrounds characteristic of van Aelst's followers in his mature work for a flamboyant baroque composition with a sense of light and colour anticipating the rococo.

Van Huysum used to go to Haarlem each summer to study flowers and most of his drawings were done in the evenings and during the winter months. He had an obsessional secrecy about his work and no one was allowed inside his studio from fear that he might learn the artist's methods and techniques. He married Margrieta Schouten in 1704. Among his patrons were the Kings of Poland and Prussia, the Elector of Saxony, Prince Wilhelm of Hesse, the Dukes of Orleans and Mecklenburg, the Comte de Murville and Sir Robert Walpole. He had only one pupil, Margaretha Haverman (1720–1795), who worked mainly in Paris after leaving his studio.

A nearly identical study in pen and wash, probably preparatory to this, was with Julius Böhler, Munich, in 1967. Amongst the flowers and fruit the following can be identified: Poppies, carnations, peaches, grapes, plums, melon and apricots.

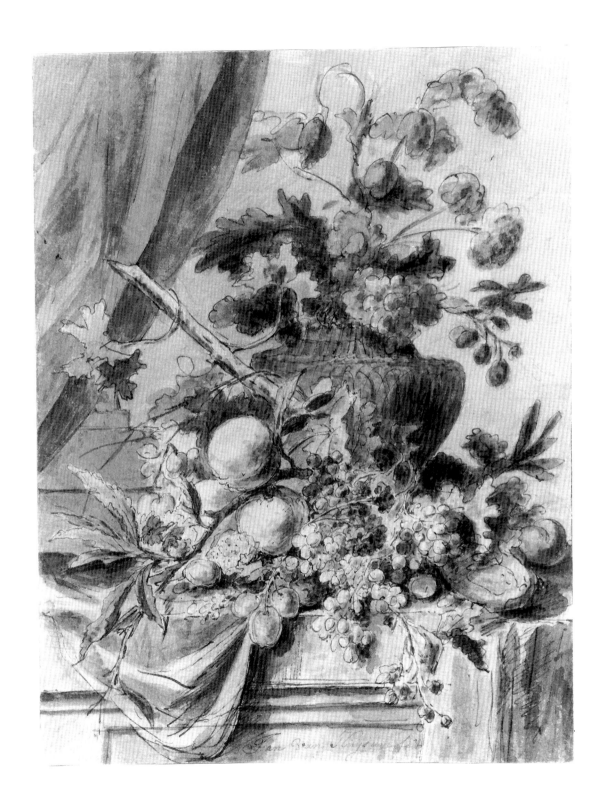

JAN VAN HUYSUM
Amsterdam 1682–1749 Amsterdam

Prunkvase und Korb mit Früchten und Blumen auf einem Sims, mit Blick in einen Garten

Feder und schwarze Tusche, Aquarell, über Graphit
200 x 158 mm
Unten links in schwarzer Tusche signiert ‚Jan van Huysum'
(beschnitten)
Vermächtnis Sir Bruce Ingram, 1963. PD. 421–1963
Provenienz: Miss Daisy Haycroft; Kunsthandlung P. & D. Colnaghi,
London; hier von Ingram (Lugt 1405 a) im Juni 1936 erworben
Literatur: Christopher White, *The Flower Drawings of Jan van Huysum.* Leigh-on-Sea 1964, Nr. 18, Taf. 10
Ausstellungen: London, Colnaghi, 1952, Nr. 25; Bath 1952, Nr. 64;
Montreal, Museum of Fine Arts, 1953, *Five Centuries of Drawing,*
Nr. 144b; London, Colnaghi, 1956, Nr. 31; Rotterdam / Amsterdam
1961/62, Nr. 53

Unser Blatt ist ein charakteristisches Beispiel für van Huysums
Zeichenkunst. Sein früher Biograph, Christian Josi, bemerkte,
daß van Huysum „nicht interessiert am Zeichnen [war] und sich
nur in den Abendstunden und während der Wintermonate
damit beschäftigte, Skizzen für Gemälde anzufertigen, welches
er mit großer Geschicklichkeit tat". Er fügte hinzu, daß Jan
van Huysum ein „natürliches Gespür für das Arrangieren
der Blumen [besaß] und daß zu dieser Zeit die halbe Kunst des
Blumenstillebens bereits darin [lag], die Blumen entsprechend
zu arrangieren".

Christopher White (a. a. O.) führt weiter aus: „Seine Zeich-
nungen stellen in weiten Teilen eine endlose Variation über zwei
Themen dar. Das gleichbleibende kompositorische Element ist
die Prunkvase oder Urne, gewöhnlich auf einen Sockel gestellt,
die entweder mit Blumen oder mit einigen wenigen Blättern und
Zweigen gefüllt ist und neben einem üppigen Arrangement aus
Früchten steht… Aber wenn auch die Ingredienzen die gleichen
blieben, so bemühte sich doch der Künstler in großem Maße, sie
unterschiedlich zu kombinieren, und man kann durchaus anneh-
men, daß diese Kombinationen nicht real, sondern imaginativ
waren… Es gibt keinen Zweifel, daß der Künstler das Medium
der Zeichnung dafür benutzte, sein Gespür für Arrangements zu
schärfen, und sich nur selten damit abgab, die botanischen
Details in der Genauigkeit auszuarbeiten, die seine Gemälde
auszeichnet." Unter den Blumen und Früchten erkennt man
Klatschmohn, Stockrose, Aprikosen, Pflaumen, Pfirsiche,
Walnüsse, Trauben und Melone.

An urn and a basket with fruit and flowers on a stone ledge with a vista to a garden

Pen and black ink, watercolour, over graphite
200 x 158 mm
Signed in black ink, lower left: 'Jan van Huysum', cut
Bequeathed by Sir Bruce Ingram, 1963. PD. 421–1963
Provenance: Miss Daisy Haycroft; with P. & D. Colnaghi, London,
from whom bought by Ingram (Lugt 1405 a), June 1936
Literature: Christopher White, *The Flower Drawings of Jan van
Huysum,* Leigh-on-Sea, 1964, no. 18, pl. 10
Exhibited: London, Colnaghi, 1952, no. 25; Bath, 1952, no. 64;
Montreal, Museum of Fine Arts, 1953, *Five Centuries of Drawing,*
no. 144b; London, Colnaghi, 1956, no. 31; Rotterdam / Amsterdam,
1961/62, no. 53

A characteristic example of van Huysum's draughtsmanship. His
early biographer, Christian Josi, stated that van Huysum 'was
not interested in drawing, and only occupied himself in the
evenings and during the winter months making sketches for
compositions, an occupation which he did with great facility.'
He adds that van Huysum 'had a natural flair for arranging
flowers, and by this date in the history of flower painting half
the art lay in the arrangement.'

Christopher White (*op. cit.*) comments: 'For the most part his
drawings are an endless variation on two themes. The constant
element is an urn, usually on a plinth, either filled with flowers,
or with a few leaves and branches beside a rich assembly of
fruit… But if the ingredients remained the same, the artist took
great care to mix them with a difference, and it is not hard to
believe that he did this from his imagination… No doubt the
artist used drawing as a method of stimulating his sense of
design, rarely bothering to work up the sheet with the botanical
detail that he so rigorously included in his paintings.' Amongst
the flowers and fruit the following can be identified: Poppies,
hollyhock, apricots, plums, peaches, walnuts, grapes and melon.

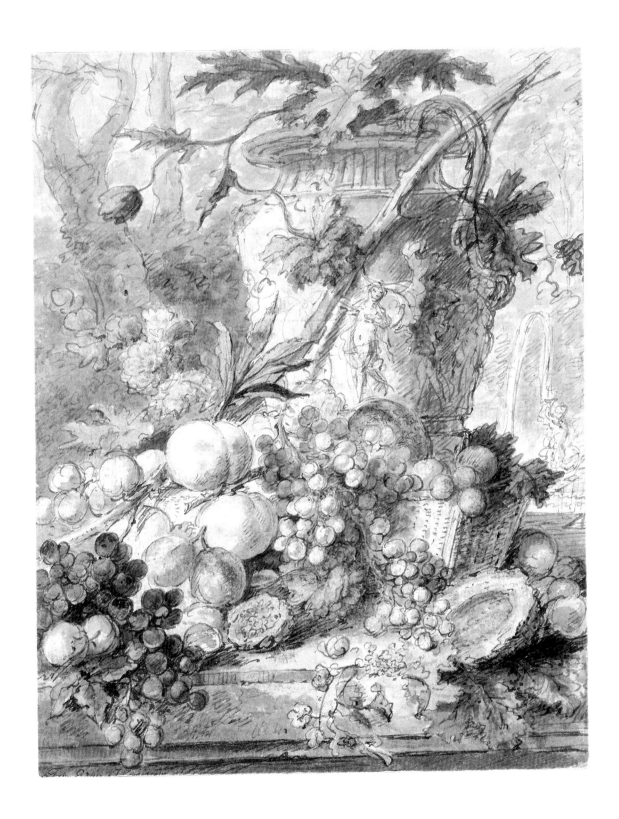

JAN VAN HUYSUM

zugeschrieben / attributed to
Amsterdam 1682–1749 Amsterdam

Vase mit Blumenarrangement auf einem Sockel

Schwarze Kreide und Aquarell
731 x 530 mm
Untere linke Ecke ergänzt
Vermächtnis Major Henry Rogers Broughton, 2nd Lord Fairhaven,
1973; erhalten 1975. PD. 79–1975
Provenienz: Kunsthandlung Levine and Mosley, London; hier von
Major Broughton erworben
Literatur: Christopher White, *The Flower Drawings of Jan van Huy-
sum.* Leigh-on-Sea 1964, Nr. 97
Ausstellungen: Cambridge, Fitzwilliam Museum, 1978, *The Pick of
the Bunch*, Nr. 3; Cambridge, Fitzwilliam Museum, 1978/79, *Principal
Acquisitions of the Last Five Years* (o. Kat.); Cambridge, Fitzwilliam
Museum, 1980, *Dutch and Flemish Artists: Flower drawings*, Nr. 2; Wan-
derausstellung USA 1983/84, Nr. 48

Das Blumenarrangement enthält Purpurwinde, gefüllte Hya-
zinthe, Päonie, gefiederte Tulpen, Schneeball, Rittersporn,
Tuberose, Nelke, Passionsblume, Aurikel, Rosa centifolia und
Schlafmohn. Unser Blatt ist die bei weitem großformatigste
Zeichnung, die White (a. a. O.) bekannt wurde, aber er ist sich
der Zuweisung an van Huysum nicht mehr sicher. Auf der feh-
lenden Ecke hat sich vielleicht eine Bezeichnung oder Signatur
befunden, die entfernt wurde, um einem Händler oder Sammler
die Zuschreibung an van Huysum zu ermöglichen. Wenn auch
die Komposition deutlich von van Huysum beeinflußt ist, so
zeigt sich doch im Umgang mit Kreide und Wasserfarben eine
verschwenderische Handschrift, die gesicherten Zeichnungen
des Künstlers nicht eigen ist. Vielleicht stammt unser Blatt von
einem Maler der nächsten Generation, wie z. B. von Wybrand
Hendriks (1744–1831).

Vase of mixed flowers on a plinth

Black chalk and watercolour
731 x 530 mm
Lower left corner replaced
Bequeathed by Major Henry Rogers Broughton, 2nd Lord Fairhaven,
1973, received 1975. PD. 79–1975
Provenance: with Levine and Mosley, London, from whom bought by
Major Broughton
Literature: Christopher White, *The Flower Drawings of Jan van
Huysum*, Leigh-on-Sea, 1964, no. 97
Exhibited: Cambridge, Fitzwilliam Museum, 1978, *The Pick of the
Bunch*, no. 3; Cambridge, Fitzwilliam Museum, 1978/79, *Principal
Acquisitions of the Last Five Years* (no handlist); Cambridge, Fitzwilliam
Museum, 1980, *Dutch and Flemish Artists: Flower drawings*, no. 2;
American Tour, 1983/84, no. 48

The flowers include morning glory, double hyacinth, peony,
broken tulips, guelder-rose, larkspur, tuberose, carnation, love-
in-a-mist, auricula, *rosa centifolia* and opium poppy. This is much
the largest drawing recorded by White (*op. cit.*) but he no longer
feels confident in the attribution to van Huysum. The missing
corner may have borne an inscription or signature which might
have been removed to enable a dealer or collector to promote
the attribution to van Huysum. Although clearly inspired by van
Huysum's compositions the handling of the chalk and the water-
colour has an overt opulence which is not found in drawings
which are secure in their attributions to him. The drawing may
be by an artist a generation later than van Huysum, Wybrand
Hendriks (1744–1831), for example.

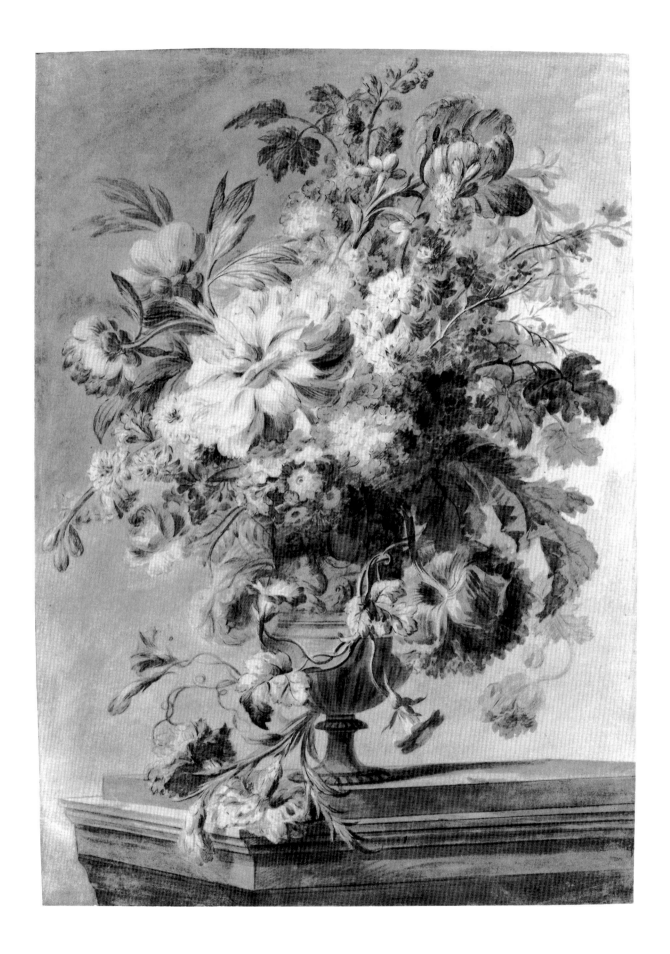

MARIA SYBILLA MERIAN
Frankfurt a.M. 1647–1717 Amsterdam

Hypericum Baxiferum mit Schnecken und Käfer

Dünner Pinsel, rote Tusche, Aquarell und Gummi Arabicum,
weiß gehöht (berieben und oxydiert), auf Pergament
375 x 306 mm (Blattgröße unregelmäßig)
Unten rechts in roter Tusche signiert ‚M:Sybilla Merian'
Verso in Tusche bezeichnet ‚f:-'; ‚Hypericum Baxiferum / Seu Androse-
mum.1695 / nevens obsarbatie van de voortelinge der groote Wyngaert
Slacken / met haer eyjeren als byleggende bescgryving, en der andere
slacken' (… wie auch Beobachtung der Fortpflanzung der Großen
Weinbergschnecke / mit ihren Eiern laut beiliegender Beschreibung,
und die der anderen Schnecken); dazu in späterer Hand: ‚Androsiana
of / Man S(?)loet'; in der Handschrift Esdailes ‚Lord Bute's colln 1794
WE P 66 N 841'
Gestiftet von A.J.Griffith durch den National Art Collections Fund,
1925. Nr.1146D
Provenienz: Lord Bute 1794; W.Esdaile (Lugt 2617); Versteigerung
Esdaile, 24.Juni 1840, wohl Teil von Lot 1224; Gunnery; A.J.Griffith
Ausstellung: Nottingham 1982, Nr.15

Maria Sybilla war die Tochter des Schweizer Kupferstechers
Matthäus Merian (1593–1650). Nach dessen Tod heiratete ihre
Mutter 1651 den deutschen Blumenmaler Jacob Marrel
(1614–1681); bei ihrem Stiefvater erhielt Maria Sybilla ihre
erste Unterweisung. Marrel verließ Frankfurt 1659 und lebte
zeitweise in Utrecht, das er von seinen Lehrjahren bei Jan
Davidsz. de Heem (1606–1683) kannte. 1668 heiratete Maria
Sybilla Merian einen Schüler ihres Stiefvaters, den Nürnberger
Maler Johann Graff (1637–1701). Sie malte Blumen, Früchte
und Vögel, sowohl in Öl wie auch in Wasserfarben, doch ihr
Hauptinteresse galt der Entomologie. 1679 veröffentlichte sie
den ersten von drei Bänden über die europäischen Insekten, *Der
Raupen wunderbare Verwandelung und sonderbare Blumennahrung*,
illustriert mit ihren eigenen Kupferstichen, deren Kolorierung
sie und ihre älteste Tochter Dorothea ausführten. Der zweite und
der dritte Band erschienen 1683 bzw. 1717. 1685 trennte sie sich
von ihrem Ehemann und schloß sich mit ihrer Mutter und zwei
Töchtern einem holländischen Labadistenkonvent in Westfries-
land an. 1691 ließ sie sich in Amsterdam nieder. Im Besitz des
Konventes befand sich eine Sammlung südamerikanischer
Insekten, die Merian so faszinierte, daß sie beschloß, selbst nach
Südamerika zu reisen. 1699 schiffte sie sich mit ihrer Tochter
Dorothea nach Surinam ein (später Niederländisch, Französisch
bzw. Britisch Guayana). Mit Unterstützung der Stadt Amster-
dam verbrachte sie dort zwei Jahre, sammelte auf Expeditionen
Insekten und Pflanzen und zeichnete sie. Ein Werk über die
südamerikanischen Insekten *(Metamorphosis insectorum Surina-
mensium)* erschien 1705. Vor Abschluß dieses Werkes besuchte
sie Südamerika mit ihrer Tochter Johanna, die sich dort nieder-
ließ. Maria Sybilla kehrte nach Holland zurück.

Hypericum oder Johanniskraut gehört zur Gattung der Hart-
heugewächse, von denen etwa 300 Arten bekannt sind. Ihre
Heimat ist Südosteuropa und Kleinasien. Die Beschriftung auf
der Rückseite erklärt, wie die Weinbergschnecke ihre Eier in
einem Erdloch ablegt.

Hypericum Baxiferum, with several snails and a beetle

Point of the brush, red ink, watercolour and gum Arabic,
heightened with white (reduced and blackened), on vellum
375 x 306 mm, irregular
Signed in ink, lower right: 'M:Sybilla Merian'
Inscribed in ink, *verso*: 'f:-'; 'Hypericum Baxiferum / Seu Androse-
mum.1695 / nevens obsarbatie van de voortelinge der groote Wyn-
gaert Slacken / met haer eyjeren als byleggende bescgryving, en der
andere slacken' ('as well as [an] observation of the reproduction of
the Great Vineyard Snail / with her eggs according to the additional
description and of the other snails'); also, in a later hand: 'Andro-
siana of / Man S(?)loet'; in Esdaile's hand: 'Lord Bute's colln 1794
WE P 66 N 841'
Given by A.J.Griffith through the National Art Collections Fund,
1925. No.1146D
Provenance: Lord Bute, 1794; W.Esdaile (Lugt 2617); his sale, 24
June 1840, probably part of lot 1224; Gunnery; A.J.Griffith
Exhibited: Nottingham, 1982, no.15

Daughter of the Swiss engraver, Matthäus Merian (1593–1650).
After Matthäus' death Maria Sybilla's mother married the Ger-
man flower painter Jacob Marrel (1614–1681) in 1651, and it
was from him that she received her first training. Marrel left
Frankfurt in 1659 and partly lived in Utrecht, where earlier he
had studied with Jan Davidsz. de Heem (1606–1683). In 1668
Maria Sybilla married one of her step-father's pupils, the Nurem-
berg painter Johann Graff (1637–1701). She worked in both oils
and watercolours, painting flowers, fruit and birds, but her par-
ticular interest was entomology. In 1679 she published the first
of three volumes on European insects, *The Wonderful Transfor-
mation of Caterpillars (Der Raupen wunderbare Verwandelung und
sonderbare Blumennahrung)*, illustrated with her own engravings,
hand-coloured with the help of her elder daughter, Dorothea.
The second and third volumes were published in 1683 and 1717.
She separated from her husband in 1685 and, with her mother
and two daughters, joined a Dutch Labadist convent in Western
Frisia. She settled in Amsterdam in 1691. In the Convent she
had become fascinated by a collection of South American
insects in its possession and resolved to go there herself. She vis-
ited Surinam (that part of South America later known as the
Dutch, French and British Guianas) with Dorothea in 1699 and,
financed by the City of Amsterdam, spent two years collecting
specimens and drawing insect and plant life. Another work on
the insects she had seen in South America *(Metamorphosis insec-
torum Surinamensium)* was published in 1705. She revisited
South America before completing it, this time with her other
daughter, Johanna, who settled there. Merian returned to Hol-
land, where she died.

Hypericum is commonly known as St John's wort. It is one of
a genus of 300 species of herbaceous perennials and deciduous
and evergreen shrubs, native to South-East Europe and Asia
Minor. The inscription on the *verso* explains the inclusion of the
eggs of the Great Vineyard Snail in a hole on the ground,
beneath her. The drawing exemplifies Merian's obsession with
insects.

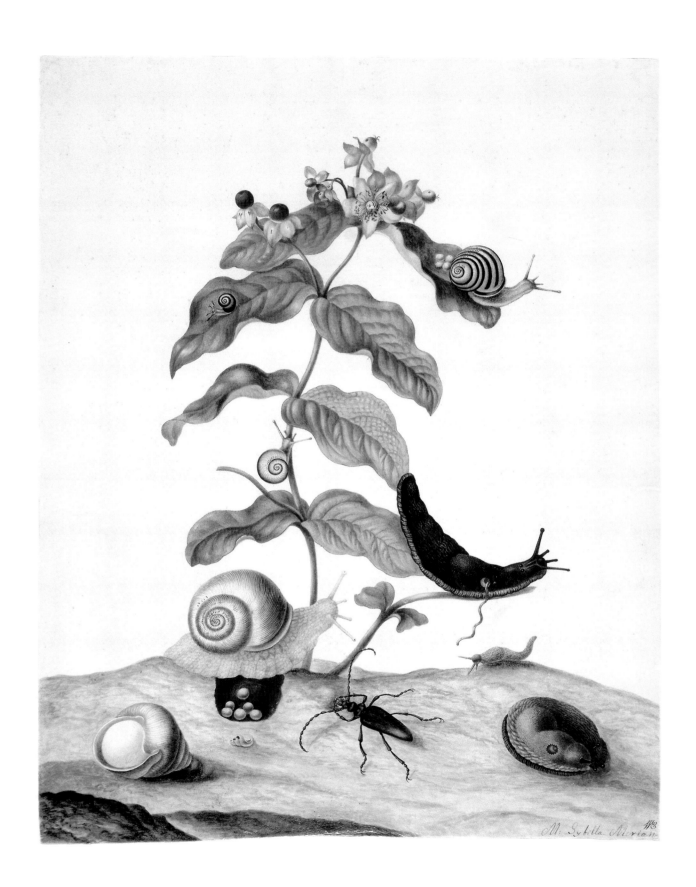

M. Sybilla Merian

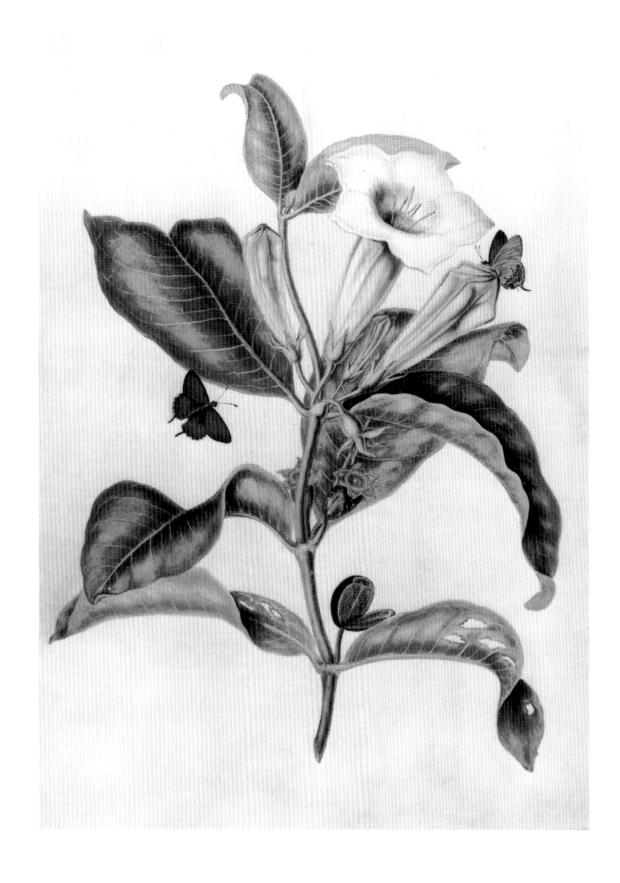

Iris susiana

MARIA SYBILLA MERIAN
Frankfurt a.M. 1647–1717 Amsterdam

‚Datura Wrightii'

Deckfarben über Graphit auf präpariertem Pergament
388 x 278 mm
Einige Farbverluste an den Samenkapseln in der Mitte
Gestiftet von A.A. VanSittart, 1862. Nr. 3055 C
Provenienz: A.A. VanSittart (aus unbekannter Sammlung)
Literatur: Margaretha Pfister-Burkhalter, Maria Sybilla Merian.
Ciba Blätter, Basel, Mai / Juni 1958, S. 18
Bisher noch nicht öffentlich ausgestellt

Männliche Bläulinge dekorieren diese Pflanzenzeichnung. Die Datura Wrightii, heute als Brugmansia klassifiziert, ist in Mittel- und Südamerika heimisch, und ihre Verbreitung reicht von Texas und Colorado bis Mexiko, Ecuador und Südost-Brasilien. Sie gehört zur Gattung Stechapfel und wird bisweilen auch Engelsposaune genannt.

Iris Susiana

Feder, dünner Pinsel, Aquarell und Deckfarben auf Pergament
371 x 280 mm
In Tusche signiert ‚M.S.Merian.fe'; in Graphit bezeichnet ‚Iris susiana'
Gestiftet von A.A. VanSittart, 1862. Nr. 3055 A
Provenienz: A.A. VanSittart (aus unbekannter Sammlung)
Ausstellungen: Nottingham 1982, Nr.17; Cambridge, Fitzwilliam Museum, 1991, *The Joy of Observation* (o. Kat.)

Die Iris Susiana ist eine Bartiris aus dem Libanon. Sie erreicht eine Höhe von etwa 40 cm und wird in Europa seit 1573 kultiviert. Ihr gemeiner Name ist Traueriris, ihre Blütezeit Mai oder Juni.

Blauer Zuckervogel auf einer Distel

Dünner Pinsel, Aquarell und Deckfarben, Weißhöhung (berieben), auf Pergament; allseitig Randlinie mit Pinsel in Schwarz
368 x 282 mm
Einige Bereibungen und Farbverluste unten links und Mitte unten
Verso mit den Initialen ‚MSM' monogrammiert
Vermächtnis Sir Bruce Ingram, 1963. PD. 467–1963
Provenienz: Marquis de Lagoy (Lugt 1710); Kunsthandlung P.& D. Colnaghi, London; hier von Ingram (Lugt 1405 a) im November 1936 erworben
Literatur: Ann Sutherland Harris und Linda Nochlin, *Women Artists 1550–1950*. Ausstellungskatalog Los Angeles, County Museum, 1976/77, S. 43, Taf. 23
Ausstellungen: London, Colnaghi, 1953, Nr. 19; Birmingham 1953, Nr. 19; Cirencester 1953, Nr. 19; Bedford 1958, Nr. 28; Paris, Institut Néerlandais, 1960, *Le Bestiaire Hollandais*, Nr. 143; Nottingham 1982, Nr. 18

Ein blauer Zuckervogel hockt ganz oben auf einer Distel und reckt seinen Schnabel nach einem Schmetterling aus der Familie der Bläulinge. Am unteren Bildrand kopulieren Schnecken auf einem Distelblatt. Eine ähnliche Zeichnung einer Distel von der Hand der Maria Sybilla Merian bewahrt die Royal Collection in Windsor Castle.

‘Datura Wrightii'

Bodycolour over graphite on prepared vellum
388 x 278 mm
Some loss of pigment to the seed-pods in the middle
Given by A.A. VanSittart, 1862. No. 3055 C
Provenance: uncertain before VanSittart
Literature: Margaretha Pfister-Burkhalter, ‘Maria Sybilla Merian', *Ciba Blätter*, Basel, May-June 1958, p. 18
Not previously exhibited

Male hairstreak butterflies ornament the drawing. The ‘Datura Wrightii', now classified as a Brugmansia, is native to Central and South America, ranging from Texas and Colorado to Mexico, Equador and South East Brazil. It is a type of thorn apple, sometimes called ‘angel's trumpet'.

Iris Susiana

Pen, point of the brush, watercolour and body colour on vellum
371 x 280 mm
Signed in ink: ‘M.S.Merian.fe' and inscribed in graphite: ‘Iris susiana'
Given by A.A. VanSittart, 1862. No. 3055 A
Provenance: uncertain before the donor
Exhibited: Nottingham, 1982, no.17; Cambridge, Fitzwilliam Museum, 1991, *The Joy of Observation* (no handlist)

The Iris Susiana is a bearded oncocyclus from the Lebanon. It grows to a height of 15 inches and has been in cultivation in Europe since 1573. Its common name is the ‘mourning Iris' and it flowers in May or June.

A blue honey creeper on a thistle

Point of the brush, watercolour and bodycolour heightened with white (reduced) on vellum. A line of black wash borders it on all sides
368 x 282 mm
Some abrasion and loss of pigment lower left and centre bottom
Inscribed, *verso*, with initials: ‘MSM'
Bequeathed by Sir Bruce Ingram, 1963. PD. 467–1963
Provenance: Marquis de Lagoy (Lugt 1710); with P.& D. Colnaghi, London, from whom bought by Ingram (Lugt 1405 a), November 1936
Literature: Ann Sutherland Harris and Linda Nochlin, *Women Artists 1550–1950*, Exhib. Cat., Los Angeles, County Museum, 1976/77, p. 43, pl. 23
Exhibited: London, Colnaghi, 1953, no. 19; Birmingham, 1953, no. 19; Cirencester, 1953, no. 19; Bedford, 1958, no. 28; Paris, Institut Néerlandais, 1960, *Le Bestiaire Hollandais*, no. 143; Nottingham, 1982, no. 18

The honey creeper is perched on the top of the thistle, its beak advancing towards a Lycaenid butterfly of uncertain species. At the bottom, snails copulate on the thistle's leaf. A similar drawing of a thistle by Merian is in the Royal Collection at Windsor.

PIETER WITHOOS
Amersfoort 1654–1693 Amsterdam

Ackermohn, von der Rückseite gesehen

Dünner Pinsel, Deckfarben und Gummi Arabicum auf Pergament
240 x 193 mm
Auf der Rückseite der Montierung in Graphit bezeichnet
‚Pavot des Jardins / Papaver rheas'
Vermächtnis Major Henry Rogers Broughton, 2nd Lord Fairhaven,
1973. PD. 101–1973 f. 13
Provenienz: Unbekannte französische (?) Sammlung; H. R. Broughton
Bisher noch nicht öffentlich ausgestellt

Pieter Withoos war Sohn und Schüler des Matthias Withoos
(1621–1703), seinerseits der bedeutendste Nachfolger des Otto
Marseus van Schriek (1619/20–1678). Vier der Kinder des Mat-
thias Withoos gingen wie der Vater der Blumenmalerei nach,
am bekanntesten sind Pieter und seine Schwester Alida
(1659/60–1715); der älteste Sohn, Jan (1648–1685), machte
sich auch als Landschaftsmaler einen Namen. Im Garten des
Louis de Marle in Haarlem fertigte Pieter Withoos eine Reihe von
Studien nach Fritillarien (Schachbrettblumen) und Insekten.

Dieses Blatt gehört zu einem Album mit 55 Zeichnungen. Der
rote Einband trägt den Titel *Fleurs*, die einzelnen Blätter sind
auf der Rückseite ihrer Montierung mit den botanischen Namen
der Blumen in Französisch und Latein beschriftet. Daraus kön-
nen wir schließen, daß sich das Album ursprünglich in französi-
schem Besitz befand. Eine der Zeichnungen (PD. 101–1973
f. 14), die eine Aloë abbildet, trägt die Signatur „pwithoos: fe".
Da die anderen Blätter deutlich von derselben Hand stammen,
kann man die gesamte Folge Withoos zuweisen. Die Pflanzen-
darstellungen sind von durchgehend hervorragender Qualität.
Meist wird die Pflanze als Solitär gezeigt, nur folio 11 bringt drei
Nelkenarten (Dianthus) auf einem Blatt. Zwei weitere Darstel-
lungen von Mohn erscheinen auf folio 35 (s. Kat. 75) und 42.

Field poppy, seen from behind

Point of the brush, bodycolour and gum Arabic on vellum
240 x 193 mm
Inscribed in graphite, *verso* of mount:
'Pavot des Jardins / Papaver rheas'
Bequeathed by Major Henry Rogers Broughton, 2nd Lord Fairhaven,
1973. PD. 101–1973 f. 13
Provenance: (?)French collection; of uncertain origin before the
donor
Not previously exhibited

Pieter Withoos was the son and pupil of Matthias Withoos
(1621–1703), the principal follower of Otto Marseus van
Schriek (1619/20–1678). Withoos and his sister Alida (1659/60–
1715) are the best known of Matthias' children, four of whom
followed the family profession of flower-painting; the eldest,
Jan (1648–1685), was also an accomplished landscape painter.
Pieter made a series of studies of fritillaries in the garden
of Louis de Marle at Haarlem and a set of insect studies.

From an album of 55 drawings, bound in red covers with the
inscription *Fleurs* upon it, each of which is described on the back
of its individual mount with the name of the flower in French
and Latin. From this we deduce that the group was once in a
French collection. One of the drawings (PD. 101–1973 f.14, an
aloe) is signed 'pwithoos: fe'; clearly by the same hand as the
others, it is on the basis of this signature that the whole group
has been assigned to Withoos. All of them are painted in the
same manner and they are all of uniformly high quality. Usually
a single flower is shown, but there are three specimens of dian-
thus on folio 11.

Two other drawings of poppies are included in the group, on
folio 35 and folio 42.

PIETER WITHOOS
Amersfoort 1654–1693 Amsterdam

Ackermohn

Dünner Pinsel, Deckfarben und Gummi Arabicum, weiß gehöht,
auf Pergament
242 x 193 mm
Auf der Rückseite der Montierung in Graphit bezeichnet
‚Pavot des jardins / Papaver rheas‘
Vermächtnis Major Henry Rogers Broughton, 2nd Lord Fairhaven,
1973. PD. 101–1973 f. 35
Provenienz: Unbekannte französische (?) Sammlung; H. R. Broughton
Bisher noch nicht öffentlich ausgestellt

Eine von drei Zeichnungen mit Mohnblumen aus einem Album,
in dem 55 Blätter mit Pflanzendarstellungen enthalten sind.
Eines dieser Blätter trägt die Signatur des Künstlers (s. Kat. 74).

Field poppy

Point of the brush, bodycolour and gum Arabic, heightened with
white on vellum
242 x 193 mm
Inscribed in graphite, *verso* of mount:
‘Pavot des jardins / Papaver rheas’
Bequeathed by Major Henry Rogers Broughton, 2nd Lord Fairhaven,
1973. PD. 101–1973 f.35
Provenance: (?)French collection; of uncertain origin before the
donor
Not previously exhibited

One of three drawings of poppies from a group of 55 drawings,
one of which is signed by the artist (s. Cat. no. 74).

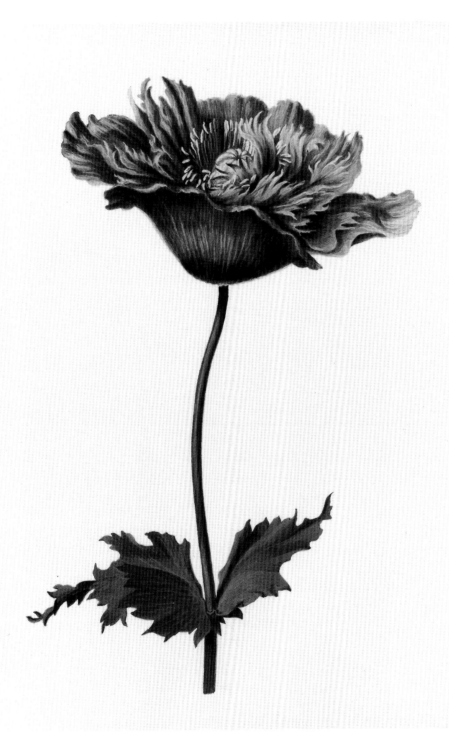

FIGUREN UND GENRE

FIGURE AND GENRE DRAWINGS

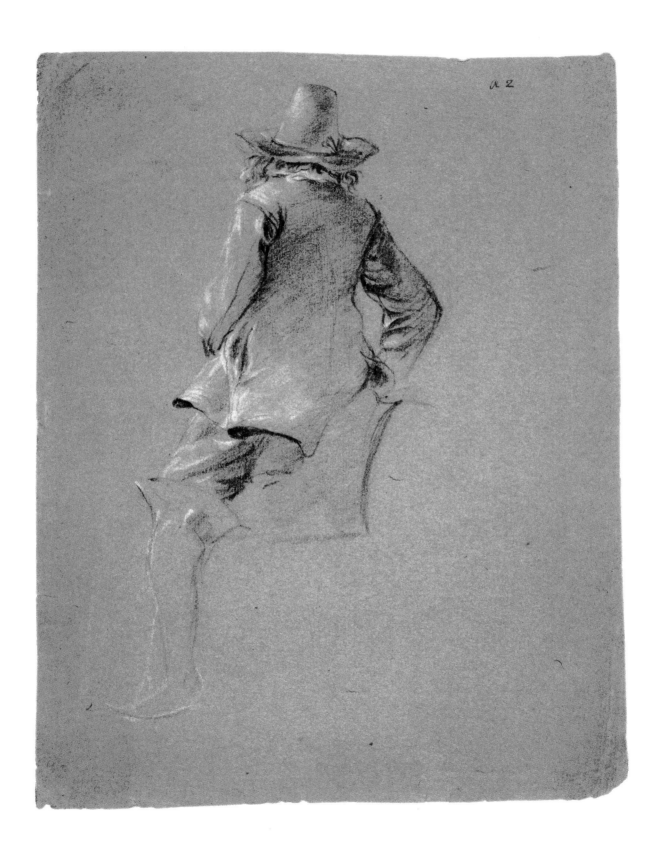

JAN ASSELIJN
Dieppe 1610/14–1652 Amsterdam

Rückenansicht eines Reiters

Schwarze Kreide, weiß gehöht, auf graublauem Papier
287 x 232 mm
Oben rechts in Tusche bezeichnet ‚a 2'; verso in Graphit ‚A 115'
Vermächtnis Sir Bruce Ingram, 1963. PD. 70–1963
Provenienz: Kunsthandlung P. & D. Colnaghi, London; hier von
Ingram (Lugt 1405 a) im November 1939 erworben
Literatur: Steland, Nr. 48 b
Ausstellungen: Oxford 1943 (o. Kat.); Washington u. a. 1959/60,
Nr. 5; Rotterdam / Amsterdam 1961/62, Nr. 5

Unser Blatt gehört zu einer Gruppe von drei Zeichnungen im
Besitz des Fitzwilliam Museums, die alle in der gleichen Technik
auf Papier der gleichen Farbe ausgeführt sind.

Es sind Studien von Reitern, deren Pferd jeweils nur angedeu-
tet wird. Möglicherweise gehörten sie ursprünglich zu einem
Skizzenbuch oder waren Bestandteil eines Albums, da eines der
anderen zwei Blätter (PD. 69–1963) ebenfalls eine Numerie-
rung, nämlich „a 6", in der oberen rechten Ecke aufweist. Die
Zuschreibung dieser Zeichnungen und ähnlicher Blätter im Ber-
liner Kupferstichkabinett und in der Albertina in Wien an Asse-
lijn ist nicht umstritten und wird auch von Anne Charlotte Ste-
land (a. a. O.) akzeptiert; dennoch sollte darauf hingewiesen
werden, daß Reiterstudien dieser Art auch mit Nicolaes Ber-
chem (1620–1683), Willem Romeyn (um 1624–1694) und
Abraham Begeyn (1637–1697) in Verbindung gebracht werden.

Horseman, seen from behind

Black chalk, heightened with white on blue-grey paper
287 x 232 mm
Inscribed in ink, upper right: 'a 2'; *verso*, in graphite: 'A 115'
Bequeathed by Sir Bruce Ingram, 1963. PD. 70–1963
Provenance: with P. & D. Colnaghi, London, from whom bought by
Ingram (Lugt 1405 a), November 1939
Literature: Steland, no. 48 b
Exhibited: Oxford, 1943 (no handlist); Washington and American
Tour, 1959/60, no. 5; Rotterdam / Amsterdam, 1961/62, no. 5

One of three drawings of this kind in the Fitzwilliam, each
drawn in the same technique on the same colour paper. They all
represent riders with only slight indication of their horses. They
may have formed part of a sketch-book or album as one of the
other drawings is likewise marked in the top right hand corner
'a 6' (PD. 69–1963). The traditional attribution of these drawings
and of others, similar, in Berlin, Kupferstichkabinett, and
Vienna, Albertina, to Asselijn and Anne Charlotte Steland
(*loc. cit.*) confirms this, but it should be pointed out that there
are studies of horsemen of this type which are attributed sever-
ally to Nicolaes Berchem (1620–1683), Willem Romeyn
(c. 1624–1694) and Abraham Begeyn (1637–1697).

HENDRICK AVERCAMP
Amsterdam 1585–1635 Kampen

Wintervergnügen auf dem Eis mit Pferdeschlitten

Feder und braune Tusche, rosa aquarelliert und braun laviert
über Graphit, allseitig Randlinie mit Pinsel in Braun
94 x 143 mm (beschnitten)

Verso: Gebäude(?)-Studie und Sims eines Kamins
Graphit

Vermächtnis Sir Bruce Ingram, 1963. PD. 77–1963
Provenienz: Kunsthandlung P. & D. Colnaghi, London; hier von
Ingram (Lugt 1405 a) im März 1938 erworben
Literatur: Clara J. Welcker, *Hendrick Avercamp 1585–1634*. Doorn-
spijk 1979, S. 267, T. 92.1
Ausstellungen: London 1946/47, Nr. 4; London, Colnaghi, 1952,
Nr. 9; Bath 1952, Nr. 15

Hendrick Avercamp, wohl wegen seines körperlichen Gebre-
chens „De Stomme van Kampen" genannt, war Sohn des Stadt-
apothekers in Kampen (gest. 1602), wohin seine Eltern 1586 von
Amsterdam übersiedelt waren. Seine künstlerische Ausbildung
erhielt er möglicherweise entweder bei Pieter Isaacsz. (um
1560–1625), bei dem er 1607 in Amsterdam wohnte, oder bei
einem der Nachfolger Pieter Bruegels d. Ä. (um 1525/30–1569),
vielleicht David Vinckboons (1576–1630/33), der sich auf
Grund der religiösen Verfolgungen in Flandern in Amsterdam
niedergelassen hatte. 1614 kehrte Avercamp nach Kampen
zurück. Seine engsten Schüler waren Arent Arentsz., gen. van
der Cabel (1585/86–1636), und sein Neffe Barent Avercamp
(1612/13–1679).
Die Zeichnungen Avercamps ragen heraus durch ihre tref-
fende Beobachtung und ihren Witz. Auch wenn unser Blatt –
wie übrigens die meisten seiner Zeichnungen – allseitig
beschnitten ist, so vermittelt es doch das Unverwechselbare sei-
ner Handschrift in der freien und flüssigen Unterzeichnung in
Graphit und der Raffinesse, mit der der Künstler gleichzeitig die
Festigkeit und die Brüchigkeit der Eisfläche, auf der seine Perso-
nen agieren, charakterisiert, indem er mit zarten tonigen Abstu-
fungen und Schattierungen arbeitet. Von besonders scharfer
Beobachtungsgabe zeugen die nur in Umrissen skizzierten drei
Schlittschuhläufer im Hintergrund. Eine Barent Avercamp zuge-
schriebene Kopie unseres Blattes kam am 17. November 1980
bei Sotheby's Mak van Waay in Amsterdam zur Auktion.

Horsedrawn sledge on the ice

Pen and brown ink, pink and brown wash over graphite, bordered on
all sides by a line of brown wash
94 x 143 mm, cut down

Verso: Part of a building (?), a chimney piece
Graphite

Bequeathed by Sir Bruce Ingram, 1963. PD. 77–1963
Provenance: with P. & D. Colnaghi, London, from whom bought by
Ingram (Lugt 1405 a), March 1938
Literature: Clara J. Welcker, *Hendrick Avercamp 1585–1634*, Doorn-
spijk, 1979, p. 267, T. 92.1
Exhibited: London, 1946/47, no. 4; London, Colnaghi, 1952, no. 9;
Bath, 1952, no. 15

Nicknamed 'De Stomme van Kampen' (the dumb man from
Kampen). Avercamp's parents moved from Amsterdam to
Kampen in 1586 where his father was Town Apothecary until his
death in 1602. He may have studied with Pieter Isaacsz.
(c.1560–1625), with whom in 1607 he is recorded as living in
Amsterdam, in 1614 he was back in Kampen. If he did not study
with Isaacsz., it has been suggested that he may have worked
with one of the followers of Pieter Bruegel the Elder
(c.1525/30–1569), like David Vinckboons (1576–1630/33),
who had settled in Amsterdam because of religious persecution in
Flanders. His two close followers were Arent Arentsz. called van
der Cabel (1585/86–1636) and his nephew Barent Avercamp
(1612/13–1679).
Avercamp's drawings are famous for their excellent observa-
tion and wit. This, despite having been cut on all sides (as
Avercamp's drawings often are), is characteristic in the liveli-
ness of the handling of the graphite underdrawing, and in the
brilliant way with which the artist has created the sense of the
solidity but transitory nature of the ice on which the figures are
standing by means of soft gradation of tone and cast shadow to
give a sense of reflection. Particularly witty are the three skaters
in the background. A copy attributed to Barent Avercamp was
sold at Sotheby's, Mak van Waay, Amsterdam, 17 November
1980.

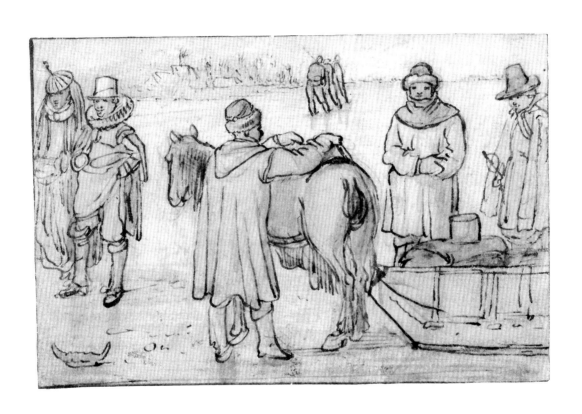

HENDRICK AVERCAMP
Amsterdam 1585–1635 Kampen

Fischer mit Pferdeschlitten am Strand von Scheveningen

Feder und braune Tusche, rosa aquarelliert und braun laviert, über Graphit, allseitig Randlinie mit Pinsel in Braun
121 x 179 mm (beschnitten)
Unten links in brauner Tusche bezeichnet ‚Stom'
Vermächtnis Sir Bruce Ingram, 1963. PD. 79–1963
Provenienz: Sir Thomas Lawrence (Lugt 2445); Colonel Gould Weston; Auktion Weston, Christie's, London, 15. Juli 1958, Lot 126; hier von Kunsthandlung P. & D. Colnaghi, London, für Ingram (Lugt 1405a) erworben
Literatur: Clara J. Welcker, *Hendrick Avercamp 1585–1634.* Doornspijk 1979, S. 267, T. 92.3
Bisher noch nicht öffentlich ausgestellt

Der Mann links im Bild kauft vermutlich gerade Fisch von dem Alten mit der Pelzmütze, der sich über den Tagesfang im Schlitten beugt, während der Pferdeführer geduldig zur Rechten wartet. Die zart skizzierte Dünenlandschaft im Hintergrund ist charakteristisch für Avercamps frische Beobachtungsgabe und kontrastiert bewußt mit den sorgfältiger durchgearbeiteten Figuren und dem Pferdeschlitten im Vordergrund. Diese hat der Künstler erst in Graphit angelegt und dann mit Feder, Tusche, Aquarell und Lavierung überarbeitet.

Fishermen with a horse-drawn sledge on the beach at Scheveningen

Pen and brown ink, pink and brown wash, over graphite, bordered on all sides by a line of brown wash
121 x 179 mm, cut down
Inscribed in brown ink, lower left: 'Stom'
Bequeathed by Sir Bruce Ingram, 1963. PD. 79–1963
Provenance: Sir Thomas Lawrence (Lugt 2445); Colonel Gould Weston, his sale, London, Christie's, 15 July 1958, lot 126, bought by P. & D. Colnaghi, London, for Ingram (Lugt 1405a)
Literature: Clara J. Welcker, *Hendrick Avercamp 1585–1634,* Doornspijk, 1979, p. 267, T. 92.3
Not previously exhibited

The man on the left may be buying fish from the man bending over the catch in the sledge, whilst the driver waits patiently to the right. The finely drawn lines which sketch in the background landscape are typical of Avercamp's freehand observation, contrasting with the more careful delineation of the figures and the horse-drawn sledge in the foreground, which have been drawn first in graphite and then worked up with pen, ink and coloured wash.

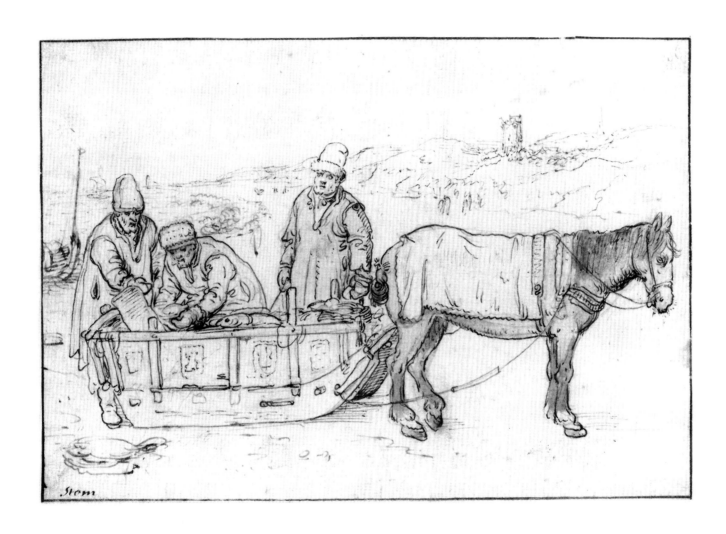

HENDRICK AVERCAMP
Amsterdam 1585–1635 Kampen

Pfeife rauchender Barbier

Feder und braune Tusche, rot und blau aquarelliert, braun laviert, über Graphit, allseitig Randlinie mit Pinsel in Braun
100 x 72 mm (beschnitten)
Unten rechts mit brauner Tinte in einer Handschrift des 18. Jahrhunderts bezeichnet ‚S. van kamp' (= Stomme van Kampen)
Verso: Die Darstellung der Vorderseite durchgedrückt und in Feder, brauner Tusche und brauner Lavierung nachgezogen
Vermächtnis Sir Bruce Ingram, 1963. PD. 87–1963
Provenienz: Kunsthandlung P. & D. Colnaghi, London; hier von Ingram (Lugt 1405 a) im März 1938 erworben
Literatur: Clara J. Welcker, *Hendrick Avercamp 1585–1634*. Doornspijk 1979, S. 268, T. 92.4 und Taf. XIVA; Peter C. Sutton, *Dutch and Flemish Seventeenth-Century Paintings: the Harold Samuel Collection.* Ausstellungskatalog Jackson, Mississippi Museum of Art u. a., 1992, Nr. 3, Abb. 1
Ausstellungen: London 1946/47, Nr. 2; London, Colnaghi, 1952, Nr. 12; Bath 1952, Nr. 18; Washington u. a. 1959/60, Nr. 8

Der Pfeifenraucher wird durch den geringelten Stock unter seinem Arm, dem Kennzeichen seines Berufsstandes, als Barbier identifiziert. Der halb abgeschnittene Knabe zur Linken ist flüchtig in Graphit angelegt. Eine solche Zusammenstellung von detailliert durchgearbeiteten und nur skizzierten Figuren ist typisch für eine Reihe von Zeichnungen Avercamps, nicht nur für die Gruppe von 12 Blättern im Fitzwilliam Museum, sondern auch für eine Folge von 46 Zeichnungen in den Königlichen Sammlungen in Schloß Windsor. Peter Sutton (a. a. O.) verbindet die Studie mit einer Männergestalt auf der linken Hälfte von Avercamps *Winterlandschaft bei Kampen an der IJssel*, die von ihm um 1615 datiert wird.

A barber, smoking a pipe

Pen and brown ink, brown, red and blue wash, over graphite, bordered on all sides by a line of brown wash
100 x 72 mm, cut down
Inscribed in brown ink, in an eighteenth century hand, lower right: 'S. van kamp' (i.e. 'Stomme van Kampen')
Verso: The figure of the man smoking a pipe has been traced through to the back in pen, brown ink and brown wash
Bequeathed by Sir Bruce Ingram, 1963. PD. 87–1963
Provenance: with P. & D. Colnaghi, London, from whom bought by Ingram (Lugt 1405a), March 1938
Literature: Clara J. Welcker, *Hendrick Avercamp 1585–1634*, Doornspijk, 1979, p. 268, T. 92.4, pl. XIVA; Peter C. Sutton, *Dutch and Flemish Seventeenth-Century Paintings; the Harold Samuel Collection*, Exhib. Cat., Jackson, Mississippi Museum of Art e. a., 1992, no. 3, fig. 1
Exhibited: London, 1946/47, no. 2; London, Colnaghi, 1952, no. 12; Bath, 1952, no. 18; Washington and American Tour, 1959/60, no. 8

The man smoking a pipe can be identified as a barber by the coloured pole he is carrying, the symbol of his trade. The figure of a small boy, cut off on the left, is drawn in graphite only. This juxtaposition of figures brought to a high degree of finish alongside others sketched in graphite or pen and ink is a feature of several of Avercamp's drawings, not just of the twelve examples attributed to him in the Fitzwilliam, but also of the fine series of forty-six drawings by him at Windsor. Peter Sutton in the catalogue of the Samuel Collection (*op.cit.*, no. 3) relates this figure to one on the left in Avercamp's *Winter landscape on the River IJssel near Kampen* which he dates *c*. 1615.

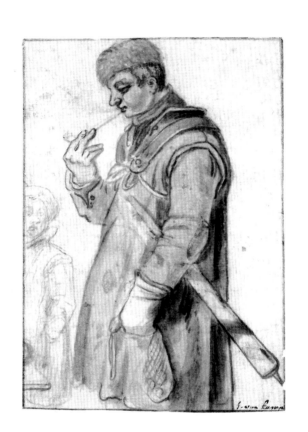

CORNELIS BEGA
Haarlem 1631/32–1664 Haarlem

Stehende Frau im Profil, nach links gewandt

Schwarze Kreide
285 x 176 mm
Obere rechte Ecke fehlt
Verso: Zarte Umrißskizze derselben Figur
Graphit
Vermächtnis Sir Bruce Ingram, 1963. PD. 133–1963
Provenienz: Henry Oppenheimer; Auktion Oppenheimer, Christie's, London, 13. Juli 1936, Teil von Lot 259; Kunsthandlung P. & D. Colnaghi, London; hier von Ingram (Lugt 1405 a) im Juli 1936 erworben
Ausstellungen: Oxford 1943 (o. Kat.); Cambridge, Fitzwilliam Museum, 1951 (o. Kat.); Bedford 1958, Nr. 5; Washington u. a. 1959/60, Nr. 12; Rotterdam / Amsterdam 1961/62, Nr. 13; Wanderausstellung USA und Cambridge 1976/77, Nr. 58; London, Arts Council, 1980/81, *Cross-References* (o. Kat.)

Cornelis Bega war der Sohn des Gold- und Silberschmiedes Pieter Jansz. Begijn (oder Begga) und von Maria Cornelisdr., der Tochter des Haarlemer Malers Cornelis Cornelisz. (1562–1638). Nur wenig ist über sein Leben bekannt; angeblich wurde er von Adriaen van Ostade (1610–1685) unterwiesen, und vielleicht war er in Italien. Anfang des Jahres 1653 bereiste er gemeinsam mit Vincent Laurensz. van der Vinne (1628/29–1702), Theodoor Helmbreecker (1633–1696) und Guillam Du Bois (1623/25–1680) Deutschland und die Schweiz. Im Juni desselben Jahres ist Bega wieder in Haarlem bezeugt, wo er 1654 in die Lukasgilde aufgenommen wurde. Er starb 1664 wahrscheinlich an der Pest und liegt in St. Bavo in Haarlem begraben.

Eine Reihe ähnlich realistischer Studienblätter Begas haben sich erhalten, alle mit naturgetreuen Darstellungen von Bauern und Bäuerinnen in schwarzer oder roter Kreide. Beispiele finden sich in den Kupferstichkabinetten von Berlin, Paris (Louvre) und London (British Museum). Im Zeichenduktus sehr ähnlich ist ein Studienblatt in der Fondation Custodia in Paris (K. G. Boon und P. Schatborn, *Dutch Genre Drawings of the Seventeenth Century*, Washington 1972, Nr. 6). Der in unserem Blatt zu beobachtende Realismus tritt in Begas Druckgraphik und in seinen Gemälden ebenfalls zutage, ist aber ein Kennzeichen auch anderer Haarlemer Künstler, wie des Leendert van der Cooghen (um 1610–1681) und des Gerrit Berckheyde (1638–1698). Bislang konnte kein Gemälde von Bega mit unserer Zeichnung in Verbindung gebracht werden.

Figure of a woman, standing in profile to left

Black chalk
285 x 176 mm
Upper right corner missing
Verso: slight outline sketch of the same figure
Graphite
Bequeathed by Sir Bruce Ingram, 1963. PD. 133–1963
Provenance: Henry Oppenheimer, his sale, London, Christie's, 13 July 1936, part of lot 259; P. & D. Colnaghi, London, from whom bought by Ingram (Lugt 1405 a), July 1936
Exhibited: Oxford, 1943 (no handlist); Cambridge, Fitzwilliam Museum, 1951 (no handlist); Bedford, 1958, no. 5; Washington and American Tour, 1959/60, no. 12; Rotterdam / Amsterdam, 1961/62, no. 13; American Tour and Cambridge, 1976/77, no. 58; London, Arts Council, 1980/81, *Cross-References* (no handlist)

Bega was the son of the gold- and silversmith, Pieter Jansz. Begijn (or Begga) and Maria Cornelisdr., daughter of the Haarlem painter, Cornelis Cornelisz. (1562–1638). Little is known of Bega's life. He is said to have studied with Adriaen van Ostade (1610–1685) and he may have visited Italy. Early in 1653 he travelled in Germany and Switzerland, travelling with Vincent Laurensz. van der Vinne (1628/29–1702), Theodoor Helmbreecker (1633–1696) and Guillam Du Bois (1623/25–1680). By June 1653 Bega was back in Haarlem, where he entered the St Luke Guild in 1654. He died, probably from the plague, in 1664 and was buried in St Bavo's church, Haarlem.

Several comparable studies of similar realism by Bega survive: shrewdly observed studies of peasants, both men and women, in black or red chalk. Examples are in Berlin (Kupferstichkabinett), in Paris (Louvre) and London (British Museum). A particularly fine drawing, which makes good comparison with this, is in the Fondation Custodia, Paris (K. G. Boon and P. Schatborn, *Dutch Genre Drawings of the Seventeenth Century*, Washington, 1972, no. 6). Such figures which occur in Bega's prints and paintings can also be found in the work of other Haarlem artists, Leendert van der Cooghen (c. 1610–1681) and Gerrit Berckheyde (1638–1698) for example. It has not proved possible to connect this characterful study with any painting.

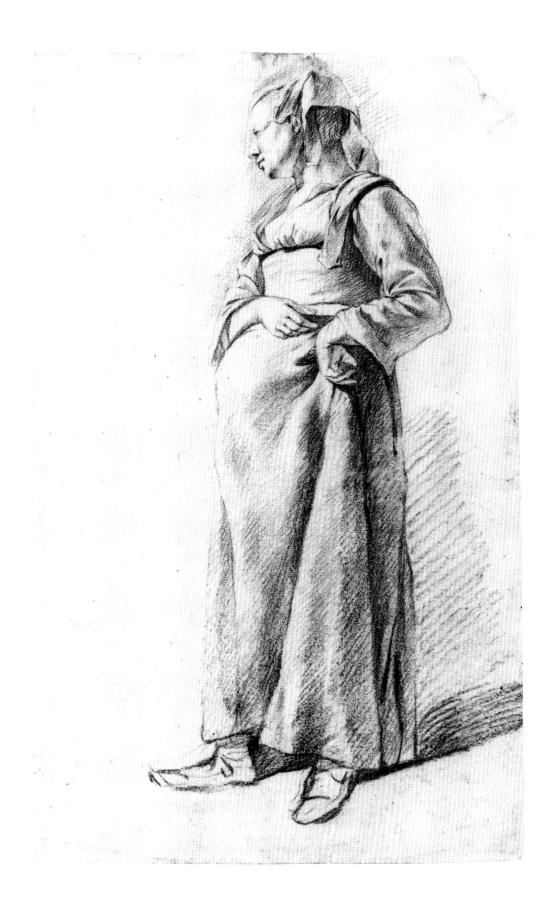

Studienblatt mit sitzender Frau

Feder und braune Tusche, braune Lavierung, allseitig Randlinie
mit Pinsel in Braun
94 x 71 mm
Unten links in brauner Tusche signiert ‚J:de Bisschop.Fecit.'
Gestiftet auf Grund der letztwilligen Verfügung des W. Barclay Squire,
M. A., Pembroke College, Cambridge, durch seine Schwester und
Testamentsvollstreckerin, Mrs. Fuller Maitland, 1927. Nr. 1195 C
Provenienz: W. Barclay Squire (aus unbekannter Sammlung)
Bisher noch nicht öffentlich ausgestellt

Jan de Bisschop, bekannt unter seinem latinisierten Namen
Johannes Episcopius, studierte die Rechte in Leiden und ließ
sich dann als Advokat in Den Haag nieder. 1653 heiratete er
eine Tochter des bekannten Gelehrten Caspar van Baerle. Zu
seinem Freundeskreis gehörten der Dichter und Staatsmann
Constantijn Huyghens (1596–1687) und dessen Sohn, Con-
stantijn d. J. (1628–1697), der wie de Bisschop künstlerischer
Autodidakt war. Mit seinen Zeichnungen und Radierungen
überragt de Bisschop alle anderen Amateure und kann sich sehr
wohl gegenüber seinen in den Künsten ausgebildeten Zeitgenos-
sen behaupten. Er war wahrscheinlich niemals in Italien, auch
wenn die Motive einer Reihe seiner Arbeiten – Landschaften,
Kopien nach antiken Statuen, Gemälden und Wandmalereien
Alter Meister – Italienisches evozieren. Die rostbraune Tusche,
die er für seine Pinselzeichnungen verwandte, hat er selbst ent-
wickelt; sie ist nach ihm benannt.

Unser Blatt, eine Studie nach der Natur, zeigt eine Unmittel-
barkeit der Beobachtung, die eher für seine Landschaften cha-
rakteristisch ist – wie *Flußlandschaft mit Booten und Figuren
(?Amsterdam)* im Fitzwilliam Museum (PD. 146–1963) – als für
seine Kopien nach Alten Meistern.

Studienblatt mit sich zurücklehnender Bäuerin, einen Fuß auf ein Kissenpodest gelegt

Feder und braune Tusche, braune Lavierung, allseitig Randlinie
mit Pinsel in Braun
122 x 90 mm
Gestiftet auf Grund der letztwilligen Verfügung des W. Barclay Squire,
M. A., Pembroke College, Cambridge, durch seine Schwester und
Testamentsvollstreckerin, Mrs. Fuller Maitland, 1927. Nr. 1195 B
Provenienz: W. Barclay Squire (aus unbekannter Sammlung)
Bisher noch nicht öffentlich ausgestellt

Auch wenn die dargestellte Frau zu schlafen scheint, ist ihre
Positur ausgeklügelt. Sie erweckt den Eindruck, nach dem Leben
gezeichnet zu sein; dennoch ist unser Blatt wohl eher eine
Zeichnung nach einem Gemälde, möglicherweise von Jan Steen
(1626–1679) oder Frans van Mieris (1635–1681). Neben die-
sem und dem vorhergehenden Studienblatt (Kat. 81) besitzt das
Fitzwilliam Museum noch eine dritte Zeichnung de Bisschops
mit einer sitzenden Frau im Profil nach links (Nr. 1195 A).

Study of a seated woman

Pen and brown ink, brown wash, bordered on all sides by a line
of dark brown wash
94 x 71 mm
Signed in brown ink, lower left: 'J:de Bisschop.Fecit.'
Given in accordance with the wishes of the late W. Barclay Squire,
M. A., Pembroke College, Cambridge, by his sister and executor, Mrs
Fuller Maitland, 1927. No. 1195 C
Provenance: unknown before W. Barclay Squire
Not previously exhibited

De Bisschop, who was known as Johannes Episcopius, studied
law at Leiden and set up practice as a lawyer in The Hague. In
1653 he married a daughter of Caspar van Baerle, a well known
scholar, and was a friend of the poet and statesman Constantijn
Huyghens (1596–1687) and his son, Constantijn the Younger
(1628–1697), who, like de Bisschop, was an amateur artist. Prob-
ably self-taught as both draughtsman and etcher, no other ama-
teur stands out amongst his professional contemporaries to the
same extent. He probably never visited Italy although several
motifs in his œuvre – landscapes, copies of statues, paintings, and
frescoes – refer to this country. He used the brush with a rusty-
brown ink which he devised and which bears his name.

Drawn from life, this has an immediacy which is more charac-
teristic of de Bisschop's subtle landscapes (one of which, a *River
scene with boats and figures [?Amsterdam]*, PD. 146–1963, is also
in the Fitzwilliam) than of his copies after Old Masters.

Study of a reclining peasant woman, one foot raised, resting on a cushion

Pen and brown ink, brown wash, bordered on all sides by a line
of brown wash
122 x 90 mm
Given in accordance with the wishes of the late W. Barclay Squire,
M. A., Pembroke College, Cambridge, by his sister and executor,
Mrs Fuller Maitland, 1927. No. 1195 B
Provenance: uncertain before W. Barclay Squire
Not previously exhibited

The pose is calculated, although the woman could be asleep.
The drawing may be after the life, but is more likely to be based
on a figure in a painting, perhaps by Jan Steen (1626–1679) or
Frans van Mieris (1635–1681). A third drawing by de Bisschop
of a seated woman, in profile to left, is also in the Fitzwilliam
Museum (no.1195 A).

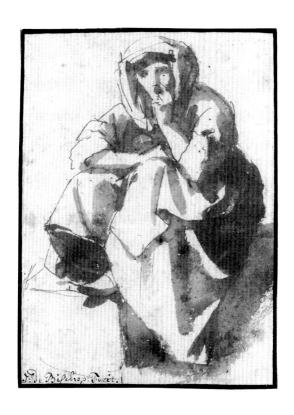

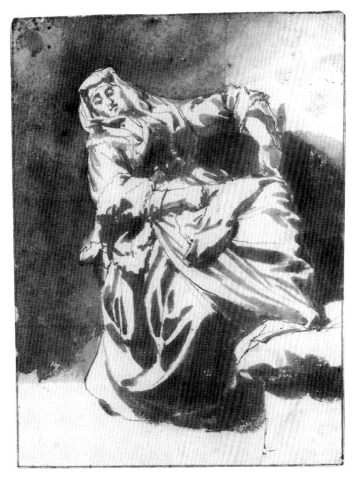

ABRAHAM BLOEMAERT
Gorinchem 1566–1651 Utrecht

Studien von Bauern und eines auf dem Bauch liegenden Mannes

Graphit, weiß gehöht, Feder und braune Tusche, braune Lavierung
155 x 190 mm
Oben links in brauner Tusche numeriert ‚48'

Verso: Studien von Bäuerinnen, einem Bauern und einem sitzenden alten Hirten

Graphit, weiß gehöht, Feder und braune Tusche, braune Lavierung, allseitig Randlinie mit Pinsel in Braun

Vermächtnis Sir Bruce Ingram, 1963. PD. 156–1963
Provenienz: Kunsthandlung P. & D. Colnaghi, London; hier von Ingram (Lugt 1405 a) im April 1950 erworben
Literatur: Marcel G. Roethlisberger, *Abraham Bloemaert and his Sons.* Gent 1993, I, s. v. Nr. 297, S. 232
Bisher noch nicht öffentlich ausgestellt

Unser Blatt ist ein charakteristisches Beispiel für Bloemaerts flüssigen Zeichenstil und seinen Umgang mit Graphit und Lavierung; es ist wohl in die Jahre 1620–1625 zu datieren.

Recto: Der Kopf des Flöte spielenden Bauern erscheint auch im *Tekenboek* des Künstlers auf Blatt 84 (das *Tekenboek* im Fitzwilliam Museum, PD. 166–1963, ist ein Album mit 160 Zeichnungen Abraham Bloemaerts, die als unmittelbare Vorlage für die gestochenen Editionen von 1650/56 und 1740 dienten; der Flöte spielende Bauer in der 2. Auflage, Amsterdam 1740, Nr. 36, im Gegensinn). Der liegende Mann im unteren Drittel unseres Blattes ist eine Vorstudie zu dem im Gegensinn gestochenen Titelblatt von Bloemaerts Folge der *Otia* (Muße), die Cornelis Bloemaert (um 1603–1692) nach 1625 ausführte (Roethlisberger, a. a. O., Nr. 297). Lateinische Verse unter den Darstellungen der *Otia* geben Hinweise zu deren Verständnis: „Die Muße erfreut und macht bereit für die Arbeit / sie stärkt die müden Glieder mit neuer Kraft / Aber die faule Ruhe schwächt den Körper durch Trägheit / und sie lähmt den Geist und verhindert die Redlichkeit /…" Der liegende Mann in der Mitte unserer Zeichnung erscheint im Gegensinn auf dem Blatt des Monats *Juli* aus der Kupferstichfolge der *Zwölf Monate*, die Nicolaes Visscher nach 1635 herausgab (Roethlisberger, a. a. O., Nr. 415); die liegende Figur ganz oben wird – mit erhobenem Kopf – in Blatt 12 der nach 1635 gestochenen Folge der *Großen Landschaften* (Roethlisberger, a. a. O., Nr. 474) verwendet.

Verso: Der sitzende Schäfer in der Mitte erscheint – mit Hut – im Gegensinn gestochen auf dem *März*-Blatt in der nach 1635 von Nicolaes Visscher verlegten Kupferstichfolge der *Zwölf Monate* (Roethlisberger, a. a. O., Nr. 411), und die Rückenfigur des Hirten zur Rechten wird im gleichen Sinn verwendet auf Blatt 4 der *Vier Genreszenen*, die Cornelis Bloemaert stach und Claes Claesz. Visscher I. nach 1652 verlegte (Roethlisberger, a. a. O., Nr. 406). Der Stich trägt in der Mariette-Edition die französische Legende: „Den Himmel als Decke und die Erde als Matratze / kann man Schlaf finden / wie diese ermüdeten Hirten." Roethlisberger datiert die Zeichnungen in die 1620er Jahre.

Studies of peasants, including a man, lying prone

Graphite, heightened with white, pen and brown ink, brown wash
155 x 190 mm
Numbered in brown ink, upper left: '48'

Verso: Studies of peasants, including a seated old man

Graphite, heightened with white, pen and brown ink, brown wash, bordered on all sides by a line of brown wash

Bequeathed by Sir Bruce Ingram, 1963. PD. 156–1963
Provenance: with P. & D. Colnaghi, London, from whom bought by Ingram (Lugt 1405 a), April 1950
Literature: Marcel G. Roethlisberger, *Abraham Bloemaert and his Sons*, Ghent, 1993, I. s.v. no. 297, p. 232
Not previously exhibited

A characteristic example of Bloemaert's fluent draughtsmanship, showing well his facility with both graphite and wash, probably dating from 1620–25.

Recto: The head of the peasant playing the flute recurs in pen and brown ink, with brown wash, in the artist's *Tekenboek* (Fitzwilliam Museum, PD. 166–1963, in the bottom right corner of page 84 [printed edition, 2nd ed., pl. 36]).

The sleeping man at the foot of the page is preparatory (in reverse) to the *Frontispiece* of Bloemaert's *Leisure series* engraved by Cornelis Bloemaert (c. 1603–1692) after 1625 (Roethlisberger, *op. cit.*, no. 297). This was the first of the artist's popular genre sets and the Latin inscription at the foot of the plate describes the point of the set : 'Leisure which restores the tired limbs with new strength provides delight and makes us fit for work. But lazy rest weakens the body with sluggishness and dulls the mind, not allowing it to be virtuous…' The recumbent figure in the centre is preparatory (in reverse) for the print published by Nicolaes Visscher after 1635 of *July* (Roethlisberger, no. 415) and the recumbent figure at the top recurs, but with the head upraised, in the *Large Landscape*, no. 12 (Roethlisberger, no. 474), engraved after 1635.

Verso: The central figure of the seated man, with the addition of a hat, is preparatory (in reverse) for *March* (Roethlisberger, no. 411), published after 1635 by Nicolaes Visscher and the figure on the right hand side is preparatory (in the same direction) for *Herdsmen*, number four of the *4 genre scenes* engraved by Cornelis Bloemaert and published by Claes Claesz. Visscher I after 1652 (Roethlisberger, no. 406), with the inscription : 'With heaven as cover and earth as mattress one can venture to sleep like these tired herdsmen'. The juxtaposition of drawings for figures which occur in so many different prints after Bloemaert confirms Roethlisberger's dating of the composition of each of these series to some time in the 1620s.

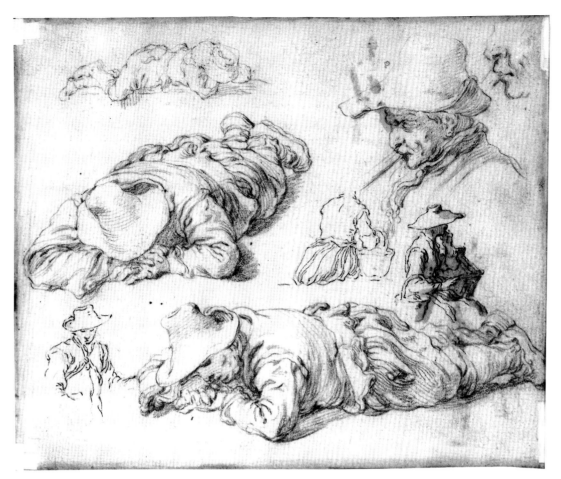

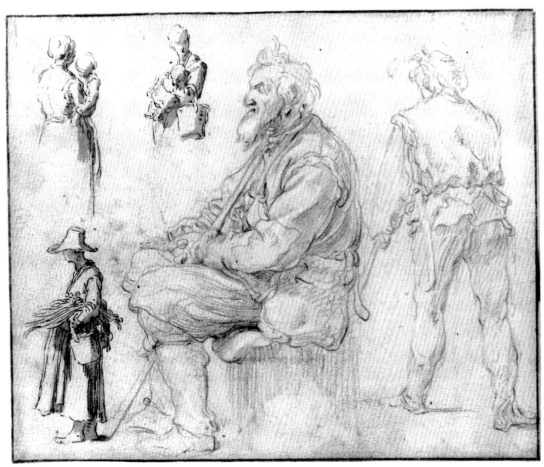

JAN DE BRAY
Haarlem um/c. 1627–1697 Haarlem

Portrait eines jungen Mannes

Schwarze Kreide
152 x 199 mm
Rechts in der Mitte in schwarzer Kreide signiert und datiert
‚JBray 1655 3/3‘, ‚JB‘ ligiert
Aus der University Library übertragen, 1876. Nr. 2891
Provenienz: University Library, Cambridge (unbekannter Herkunft)
Literatur: Joachim Wolfgang von Moltke, Jan de Bray. *Marburger Jahrbuch für Kunstwissenschaft* XI/XII, 1938/39, S. 505, Nr. 103
Bisher noch nicht öffentlich ausgestellt

Jan de Bray war wahrscheinlich Schüler seines Vaters, des Malers und Architekten Salomon de Bray (1597–1664). Mit Ausnahme der Jahre 1686 bis 1688, die er in Amsterdam verbrachte, war er sein ganzes Leben in Haarlem ansässig. Obwohl er in erster Linie als Portraitmaler tätig war (das Fitzwilliam Museum besitzt ein herausragendes Portrait einer Unbekannten, das 1660 datiert ist, PD. 14–1959), stammen von seiner Hand auch religiöse, mythologische und Genrebilder. Zu Lebzeiten war er vor allem als Zeichner berühmt, doch radierte er auch und war als Architekt tätig.

Die Gesichtszüge des jungen Mannes begegnen uns wieder bei der Figur im Halbschatten rechts der Mitte in de Brays *Gastmahl der Kleopatra* in Hampton Court (Nr. 59) und in einer Version davon in der Currier Gallery of Art in Manchester, N.H. (Nr. 1969.8; s. Ausstellungskatalog Den Haag, Mauritshuis, und San Francisco, The Fine Arts Museum, 1990/91, *Hollandse Meesters uit Amerika*, Nr. 13). Die Eltern des Künstlers, Salomon de Bray und Anna Westerbaen, agieren hier als Antonius und Kleopatra, umgeben von ihren Kindern, unter denen Jan zur Linken erscheint. Die Figur des Gemäldes, deren Gesichtszüge denen unseres Portraits so ähnlich sind, wurde als des Künstlers jüngerer Bruder Dirck identifiziert, der 1694 starb. Dirck amtierte zeitweise als Schriftführer der Haarlemer Lukasgilde und wurde von Jan ein weiteres Mal in einem Gruppenbild von 1675 (Amsterdam, Rijksmuseum) portraitiert. Die ungewöhnliche, liebevolle Wärme, die unser Blatt auszeichnet, spricht für ein Bildnis des Bruders; üblicherweise zeigen Jan de Brays Portraits – trotz aller technischer Meisterschaft – eine eher klassizistische Distanziertheit.

Portrait of a young man

Black chalk
152 x 199 mm
Signed and dated in black chalk, centre right: ‘JBray 1655 3/3’
(‘J B’ in monogram)
Transferred from the University Library, 1876. No. 2891
Provenance: uncertain before Cambridge, University Library
Literature: Joachim Wolfgang von Moltke, Jan de Bray, *Marburger Jahrbuch für Kunstwissenschaft*, XI/XII, 1938/39, p. 505, no. 103
Not previously exhibited

Jan de Bray was probably a pupil of his father, the painter and architect, Salomon de Bray (1597–1664). Apart from two years spent in Amsterdam (1686–1688), he lived in Haarlem. Primarily a portraitist (the Fitzwilliam owns a splendid painting of an anonymous woman dated 1660 [PD. 14–1959]),he also painted a number of religious, mythological and genre subjects. He was famous in his lifetime as a draughtsman and also made etchings and practised as an architect.

The physiognomy of the sitter suggests he is the same as the figure in half shadow in the middle right of de Bray's *The Banquet of Cleopatra* at Hampton Court (no. 59) and in Manchester, N.H. (The Currier Gallery of Art, no. 1969.8. *v.* Exhib. Cat. The Hague, Mauritshuis, and San Francisco, The Fine Arts Museum, 1990/91, *Hollandse Meesters uit Amerika*, no. 13). The painting depicts the artist's parents, Salomon and his wife, Anna Westerbaen, as Anthony and Cleopatra, surrounded by their children, with the artist on the left. The figure to whom the drawing in the Fitzwilliam bears so strong a likeness has been identified as the artist's younger brother, Dirck, who died in 1694. Dirck was for a time Secretary of the Guild of St Luke in Haarlem and was portrayed again by Jan in the group portrait of 1675 (Amsterdam, Rijksmuseum). The hypothesis that this shows the artist's brother would account for the unusually sympathetic warmth of de Bray's portrayal. His drawn portraits, whilst showing great technical mastery, normally are cold and classical in tone.

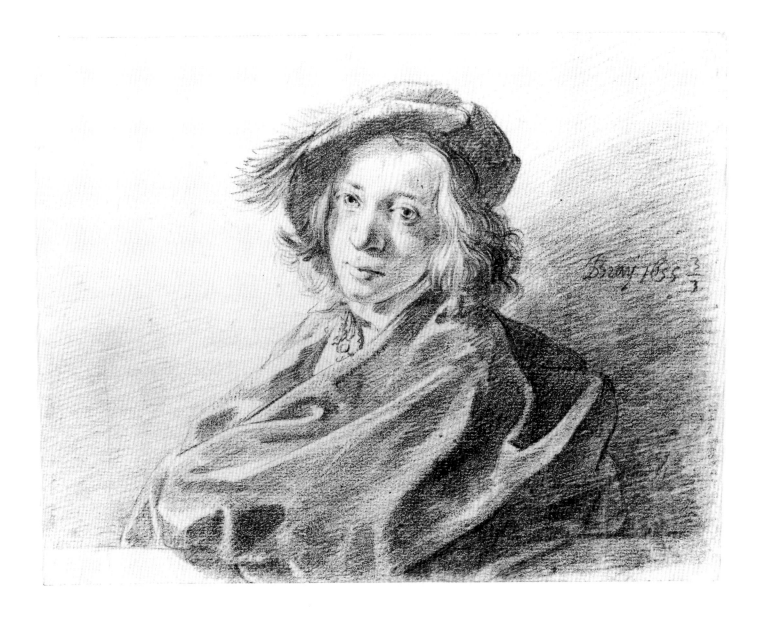

JACQUES DE GHEYN II.
Antwerpen/Antwerp 1565–1629 Den Haag/The Hague

Ein Musketier bläst die Lunte im Hahn an und deckt die Pfanne mit der Hand ab

Feder und braune Tusche, graue Lavierung, allseitig Randlinie mit Pinsel in Braun
281 x 199 mm
Unten rechts in brauner Tusche numeriert ‚10' und in Graphit bezeichnet ‚J de Gheyn'; verso in Graphit numeriert ‚631'; ‚16'; bezeichnet ‚19 2 stuks'
Vermächtnis Sir Bruce Ingram, 1963. PD. 351–1963
Provenienz: J. P. Zoomer; W. Coningham (Lugt 476); von diesem 1876 an Kunsthandlung P. & D. Colnaghi, London; Charles Fairfax-Murray; Auktion Comte de Robiano u. a., Amsterdam, 15.-16. Juni 1926, Teil von Lot 373; A. W. M. Mensing; Auktion Mensing, Amsterdam, 27. April 1937, Teil von Lot 208; Kunsthandlung P. & D. Colnaghi, London; hier von Ingram (Lugt 1405 a) im Mai 1937 erworben
Literatur: I. Q. van Regteren Altena, *Jacques de Gheyn. Three Generations.* Den Haag 1984, II, S. 72, Nr. 397; III, S. 80, Abb. 115 (mit vollständiger Bibliographie)
Ausstellung: Wanderausstellung USA und Cambridge 1976/77, Nr. 70

Jacques de Gheyn II. war der Sohn des Glas- und Miniaturmalers Jacques de Gheyn I. (1537/38–1581). Um 1585 wurde er in die Werkstatt des Hendrick Goltzius (1558–1617) in Haarlem aufgenommen, wo er das Stechen in Kupfer lernte. Nach zwei Jahren Lehrzeit eröffnete er ein eigenes Geschäft in Haarlem, das er nach seiner Übersiedelung 1591 nach Amsterdam von dort aus weiterführte. 1595 heiratete er Eva Stalpaert van der Wielen; der einzige Sohn, Jacques (III.), kam wahrscheinlich 1596 zur Welt. 1597 ist de Gheyn in Leiden bezeugt; 1598 ließ er sich in Den Haag nieder, wo er in die Lukasgilde eintrat. Er erhielt zahlreiche Aufträge von den Generalstaaten, von Prinz Moritz und später von Prinz Friedrich Heinrich von Nassau. Für Constantijn Huyghens d. Ä. (1596–1687), den Sekretär des Prinzen Friedrich Heinrich, war er als Zeichenmeister tätig. Die Bücher der Lukasgilde erwähnen de Gheyn in erster Linie als Maler; heute ist er vor allem als herausragender Stecher und als Zeichner bekannt. Von ihm stammen auch Miniaturen sowie Garten- und Architekturentwürfe.

Im Jahre 1598 besuchte der Vetter des Prinzen Moritz von Nassau, Graf Johann II., die Niederlande. Sein besonderes Interesse galt den theoretischen Aspekten der Militärwissenschaften, Belagerungsmethoden und Verbesserungen des Exerzierens, über die er mit seinem Bruder Wilhelm Ludwig und Prinz Moritz konferieren wollte. Um diese Zeit faßte er den Plan, ein Werk über die Kavallerie und die Infanterie der niederländischen Generalstaaten herauszubringen, und beauftragte damit Jacques de Gheyn. Die Folge der Kavallerie erschien 1599; kurz danach war das Buch über die drei Korps der Infanterie, Musketiere, Scharfschützen mit Handfeuerwaffen und Lasquenets (Piköre), fertiggestellt. Die Publikation erfolgte aber erst 1607, um dem Feind nicht Informationen über die eigenen Exerziermethoden in die Hände zu spielen, da das Buch als Exerzierhandbuch angelegt war und sämtliche Positionen und Handgriffe enthielt. De

A soldier blowing the match, while covering the pan

Pen and brown ink, grey wash, bordered on all sides with a line of brown wash
281 x 199 mm
Numbered in brown ink, lower right: '10'; inscribed in graphite, lower right: 'J de Gheyn'; *verso*: numbered in graphite: '631'; '16'; inscribed: '19 2 stuks'
Bequeathed by Sir Bruce Ingram, 1963. PD. 351–1963
Provenance: J. P. Zoomer; W. Coningham (Lugt 476) in 1876 to P. & D. Colnaghi, London; Charles Fairfax-Murray; Comte de Robiano and others, sold Amsterdam, 15–16 June 1926, part of lot 373; A. W. M. Mensing, his sale, Amsterdam, 27 April 1937, part of lot 208; P. & D. Colnaghi, London, from whom bought by Ingram (Lugt 1405a), May 1937
Literature: I. Q. van Regteren Altena, *Jacques de Gheyn. Three Generations*, The Hague, 1984, II, p. 72, no. 397; III, p. 80, pl. 115, with full bibliography
Exhibited: American Tour and Cambridge, 1976/77, no. 70

Jacques de Gheyn II was the son of the glass-painter and miniaturist Jacques de Gheyn I (1537/38–1581). About 1585 de Gheyn was admitted to the workshop of Hendrick Goltzius (1558–1617) in Haarlem where he learned engraving. After two years with Goltzius he set up an independent shop of his own in Haarlem which he continued to run even after he had moved to Amsterdam in 1591. In 1595 he married Eva Stalpaert van der Wielen; their only son, Jacques (III), was probably born in 1596. Living in Leiden in 1597 de Gheyn moved to The Hague by 1598 where he was admitted to the Guild of St Luke and where he settled. He received many commissions from the States General, Prince Maurice and later Prince Frederick Henry of Nassau. He was the drawing master to Constantijn Huyghens the Elder (1596–1687), secretary to Prince Frederick Henry. Although mentioned primarily as a painter in the Guild of St Luke, de Gheyn is best known as an outstanding engraver and draughtsman. He also painted miniatures and designed gardens and buildings.

In 1598 Count John II of Nassau, cousin to Prince Maurice, who was particularly interested in theoretical aspects of military science, siege methods and improvements in drill, visited the Netherlands for discussions about such matters with his brother William Louis and Prince Maurice. About that time he conceived the idea of publishing a book devoted to the cavalry and infantry of the States' army and Jacques de Gheyn was commissioned to produce it. The cavalry series was published in 1599 and although the book on the three corps of foot-soldiers, consisting of musketeers, marksmen armed with hand-guns and lasquenets was completed shortly after this, its publication was delayed for several years until 1607 to prevent the enemy from taking advantage of the information it contained, as it showed all positions and manual holds in drilling to provide a complete drilling manual. De Gheyn must have completed the drawings

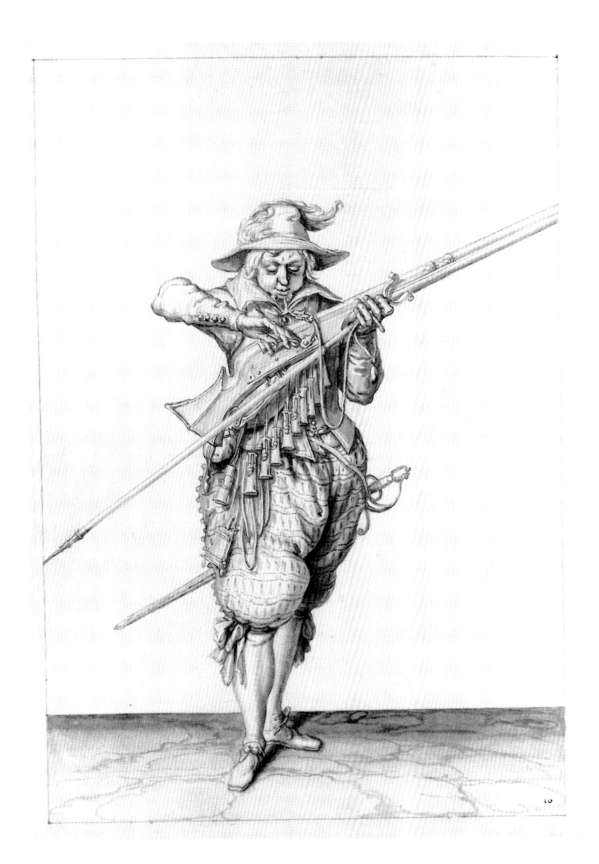

18

Gheyn muß die Vorzeichnungen um 1599 abgeschlossen haben; er überwachte selbst das Stechen. Das Buch über die Infanterie ist nach wie vor sein bekanntestes Werk.

Unser Blatt ist die Vorzeichnung zum zehnten Musketier des genannten dreibändigen *Wapenhandelinghe van Roers-Musquetten ende Spiessen Achtervolgende de ordre van Sijn Excellentie Maurits Prince van Orangie Grave van Nassau*, Amsterdam 1607. In Den Haag erschienen 1608 die englische Ausgabe, *The Exercise of Arms for Calivres, Musketts and Pikes*, und die deutsche, *Waffenhandlung von der Rüren, Musquetten undt Spiessen*. Das Werk enthält 117 Kupferstiche nach Zeichnungen de Gheyns, von denen 73 bekannt sind (darunter fünf weitere im Besitz des Fitzwilliam Museums). Die Vorzeichnungen sind im gleichen Sinn wie die Kupferstiche angelegt. Eine mögliche Werkstattbeteiligung lehnte van Regteren Altena entschieden ab: „Die von Haverkamp-Begemann aufgeworfene Frage, ob Jacques de Gheyn für die zahlreichen Vorzeichnungen der *Wapenhandelinghe* einen Mitarbeiter beschäftigt hat, sollte verneint werden. Alle Zeichnungen zeigen seinen ureigenen, sorgfältigen und treffsicheren Zeichenstil" (a. a. O., II, S. 69).

The design for the tenth musketeer for the *Wapenhandelinghe van Roers-Musquetten ende Spiessen Achtervolgende de ordre van Sijn Excellentie Maurits Prince van Orangie Grave van Nassau* published in Amsterdam in 3 volumes in 1607 of which an English edition *The Exercise of Arms for Calivres, Musketts and Pikes* appeared, published at The Hague, in 1608. The volumes consisted of 117 illustrations, all provided by de Gheyn, of which 73 drawings are now known, five others of which are also in the Fitzwilliam. The drawings are in the same direction as the engravings after them; any question that they might have been produced with studio help was rejected by van Regteren Altena who observed (*op. cit.* II, p. 69): 'The question raised by Haverkamp-Begemann as to whether Jacques de Gheyn employed an assistant for the numerous drawings for the *Exercise of Arms* should be answered in the negative. All of them show his indisputable, careful and effective style of drawing.'

Allegorie des Gesichts

Schwarze Kreide und Wischer, Kohle, graue Lavierung, mit Weiß und Ocker gehöht, allseitig Randlinie mit Pinsel in Braun
318 x 210 mm (Höchstmaße)
Unten links in schwarzer Kreide monogrammiert ‚HG‘
Verso in Bleistift bezeichnet ‚Hendrick Goltzius‘
Vermächtnis Sir Bruce Ingram, 1963. PD. 355–1963
Provenienz: Julian G. Lousada; Auktion Lousada, Sotheby's, London, 7. März 1947, Lot 24; Kunsthandlung P. & D. Colnaghi, London; hier von Ingram (Lugt 1405a) im Juni 1947 erworben
Literatur: E. K. J. Reznicek, *Die Zeichnungen von Hendrick Goltzius.* Utrecht 1961, I, S. 309, K. 173; II, Taf. A. 346; Ders., *Hendrick Goltzius. Drawings Rediscovered 1962–1992.* New York 1993, S. 58, s. v. K. 173a
Ausstellungen: Cambridge, Fitzwilliam Museum, 1952/53 (o. Kat.); Washington u. a. 1959/60, Nr. 38; Rotterdam / Amsterdam 1961/62, Nr. 41; Wanderausstellung USA und Cambridge 1976/77, Nr. 71

Seine erste künstlerische Ausbildung erhielt Goltzius in der Werkstatt seines Vaters, des Glasmalers Jan Goltz (um 1534–nach 1609), der 1562 nach Duisburg ausgewandert war. 1576 trat er in die Lehre des Kupferstechers Dirck Volkertsz. Coornhert (1519/22–1590), mit dem er 1577 nach Haarlem übersiedelte. 1582 eröffnete er ein eigenes Geschäft als Kupferstichverleger und bildete ab 1585 seinerseits Schüler und Mitarbeiter aus, unter ihnen Jacques de Gheyn II. (1565–1629) und Jan Muller (1571–1628). Die Jahre 1590/91 führten ihn nach Rom, Florenz und Venedig. 1579 heiratete er Margaretha Jansdr., die Witwe des Adriaen Matham und Mutter des Jacob Matham (1571–1631), der bei seinem Stiefvater Unterricht im Kupferstechen erhielt. 1600 gab Goltzius das Stechen auf und widmete sich der Malerei.

Unser Blatt gehört zu einer Folge der *Fünf Sinne*, die Goltzius kurz vor 1600 gezeichnet hat. Zwei weitere Blätter dieser Folge sind in öffentlichen Sammlungen, die *Allegorie des Tastsinns (Lukretia)* in der Pierpont Morgan Library in New York (Reznicek, a. a. O., K. 173a) und die *Allegorie des Geschmacks (Pomona?)* im Metropolitan Museum of Art, New York (Reznicek, a. a. O., K. 173b); zwei Blätter befinden sich in Privatbesitz: die *Allegorie des Geruchs* (Mr. und Mrs. Eugene Thaw, New York) und die *Allegorie des Gehörs* (Belgien, Privatsammlung), abgebildet in Felice Stampfle, *Netherlandish drawings of the fifteenth and sixteenth centuries and Flemish drawings of the seventeenth and eighteenth centuries in the Pierpont Morgan Library*, New York, 1991, Abb. 51, 52. Wie unsere Zeichnung, so zeigt auch das Blatt des Metropolitan Museums ein verblaßtes Monogramm.

Allegory of Sight

Black chalk and stump, charcoal, grey wash, heightened with white and ochre, bordered on all sides by a line of brown wash
318 x 210 mm, maximum
Signed in black chalk with initials in a monogram, lower left: 'HG'
Inscribed in pencil, *verso*: 'Hendrick Goltzius'
Bequeathed by Sir Bruce Ingram, 1963. PD. 355–1963
Provenance: Julian G. Lousada, his sale, London, Sotheby's, 7 March 1947, lot 24; P. & D. Colnaghi, London, from whom bought by Ingram (Lugt 1405a), June 1947
Literature: E. K. J. Reznicek, *Die Zeichnungen von Hendrick Goltzius,* Utrecht, 1961, I, p. 309, K. 173; II, pl. A.346; E. K. J. Reznicek, *Hendrick Goltzius, Drawings Rediscovered 1962–1992,* New York, 1993, p. 58, *s.v.* K. 173a
Exhibited: Cambridge, Fitzwilliam Museum, 1952/53 (no handlist); Washington and American Tour, 1959/60, no. 38; Rotterdam / Amsterdam, 1961/62, no. 41; American Tour and Cambridge, 1976/77, no. 71

Goltzius worked initially in the studio of his father, Jan Goltz (*c.*1534–after 1609), a glass-painter who moved in 1562 to Duisburg in Germany. By 1576 he was apprenticed to the engraver Dirck Volkertsz. Coornhert (1519/22–1590) with whom he went to Haarlem in 1577. In 1582 he set up on his own, publishing prints and in 1585 he began employing pupils and assistants, including Jacques de Gheyn II (1565–1629) and Jan Muller (1571–1628). He visited Rome, Florence and Venice in 1590/91. In 1579 he married Margaretha Jansdr., widow of Adriaen Matham and mother of Jacob Matham (1571–1631), whom Goltzius trained as an engraver. In 1600 Goltzius gave up engraving and from then on concentrated on painting.

This is one of a group of the *Five Senses* which Goltzius drew shortly before 1600. Two others in the series are in public collections: *Allegory of Touch: Lucretia* in the Pierpont Morgan Library, New York (Reznicek, *op. cit.*, 1993, K. 173a) and an *Allegorical figure (Pomona?) as Taste* in the Metropolitan Museum, New York (Reznicek, *op. cit.*, 1993, K. 173b). Two others are owned privately: *Allegory of Smell* (Mr. and Mrs. Eugene Thaw, New York) and *Allegory of Hearing* (private collection, Belgium), repr. in Felice Stampfle, *Netherlandish drawings of the fifteenth and sixteenth centuries and Flemish drawings of the seventeenth and eighteenth centuries in the Pierpont Morgan Library*, New York, 1991, figs. 51, 52. The Metropolitan drawing, like that in the Fitzwilliam, has a faint monogram.

Bereits in seiner frühesten Folge der *Fünf Sinne*, die um 1585 entstand, hatte Goltzius die Personifikationen halb entblößt gezeigt – ein deutlicher Bruch mit der Tradition, sie als bekleidete Figuren darzustellen –, hatte aber in seiner Sinnenfolge aus den neunziger Jahren (von der die meisten Blätter heute in Rotterdam aufbewahrt werden) noch einmal auf die herkömmliche Ikonographie zurückgegriffen. Der Adler, der als Symboltier des Gesichts in der Renaissance beliebt war, begleitet bereits in der ersten Folge (Berlin) die weibliche Personifikation; in der entsprechenden Zeichnung der zweiten Folge (Rotterdam) greift Goltzius hingegen auf die Katze, das mittelalterliche Symboltier, zurück. Die weibliche Figur unserer Zeichnung hat man unterschiedlich als Diana oder als Juno interpretiert. Geht man aber davon aus, daß der Adler gleichzeitig auch Symboltier Jupiters ist, so kann man in ihr auch Venus sehen und vermuten, daß, entsprechend der Identifizierung der weiblichen Figuren in den Blättern in New York als Lukretia bzw. Pomona (?), Goltzius hier die Fünf Sinne durch Frauengestalten der Antike personifizieren wollte. Daß die Zusammenstellung von Venus und Jupiter in der Gestalt des Adlers bereits in der Antike bekannt war, zeigt ein in Saphir geschnittener Cameo des Fitzwilliam Museums (CM 19–1967). Der Blick der Frau in den Spiegel hingegen gehört zum üblichen Repertoire einer Allegorie des Gesichts.

In his earliest series of c.1585 Goltzius had already shown the senses half-naked, breaking with the tradition of showing them clothed, although he reverted to tradition in the series from the 1590s most of which are now at Rotterdam. In the first series, too, he shows *Sight* (now in Berlin) with an eagle, the symbol generally adopted in the Renaissance for this sense, although in the drawing in Rotterdam he reverts to the cat of the Mediaeval tradition. The figure in the Fitzwilliam drawing has been variously identified as Diana or Juno, but the appearance of Jupiter in the form of an eagle suggests that if in this series Goltzius planned a group of women from Antiquity to represent the Senses (as with the *Lucretia*) her identity might be Venus. The coupling of Venus with Jupiter as an eagle is attested in Antiquity by a fine sapphire cameo in the Fitzwilliam Museum (CM 19–1967). Otherwise a woman looking at herself in a mirror is a conventional treatment of the symbol of Sight.

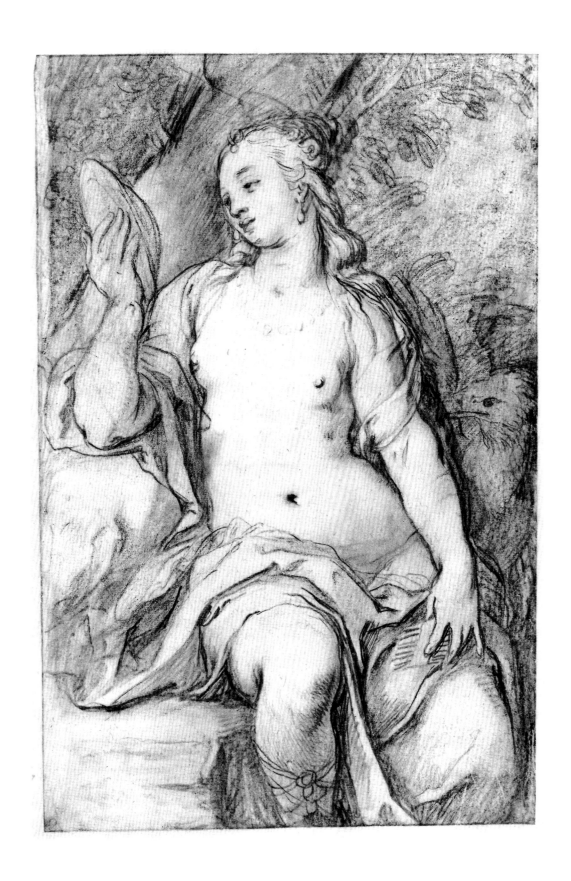

DIRCK HALS
Haarlem 1591–1656 Haarlem

Sitzender Geigenspieler

Öl auf Papier, in Grisaille, linke obere Ecke restauriert
213 x 165 mm (Blattgröße unregelmäßig)
Unten rechts von der Mitte monogrammiert und datiert
‚DH/162[?]9'
Verso in brauner Tusche bezeichnet ‚de jonge Hals feci:';
‚A:ruitgood'; ‚1609 [oder1619]'; in Bleistift ‚d jonge Hals'
Vermächtnis Sir Bruce Ingram, 1963. PD. 401–1963
Provenienz: Kunsthandlung P. & D. Colnaghi, London; hier von
Ingram (Lugt 1405a) im April 1949 erworben
Literatur: P. Schatborn, De Olieverfschetsen van Dirck Hals. *Bulletin
van het Rijksmuseum* 21, 1973, S. 107 ff., Abb. 10; C. van Hasselt,
Rembrandt and his century. Ausstellungskatalog Paris / New York
1977/78, S. 83, Anm. 5
Ausstellungen: London, Colnaghi, 1949, Nr. 37; London, Colnaghi,
1952, Nr. 50; Bath 1952, Nr. 24; Washington u. a. 1959/60, Nr. 44

Vermutlich lernte Dirck Hals bei seinem fast zehn Jahre älteren
Bruder Frans Hals (1581/85–1666) in Haarlem. 1620/21 heiratete er Agneta Jansdr.; aus der Ehe gingen sieben Kinder hervor,
deren ältestes, Anthonie, ebenfalls den Beruf des Malers ergriff.
In den Jahren 1618–1624 diente Dirck Hals als Musketier in der
Bürgerwehr seiner Heimatstadt. 1627 wird er erstmals als Maler
in den Meisterverzeichnissen der Lukasgilde geführt, doch tragen einige seiner Gemälde frühere Datierungen. 1641/42 und
1648/49 ist sein Aufenthalt in Leiden archivalisch bezeugt.
Dirck Hals starb in Haarlem. Am bekanntesten wurde er als
Maler von Interieurszenen und Parklandschaften, in denen die
figürliche Staffage dominiert und die den Arbeiten des Willem
Buytewech (1591/92–1624) ähneln. Höchst ungewöhnlich für
die holländische Malerei seiner Zeit ist seine Technik der Ölskizze auf Papier.

Schatborn (a. a. O.) führt zwölf Ölskizzen auf Papier auf, von
denen sich noch eine weitere in den Sammlungen des Fitzwilliam Museums befindet, *Zwei Damen an einem Tisch sitzend* (PD.
402–1963); van Hasselt konnte dieser Aufstellung ein weiteres
Blatt hinzufügen (a. a. O.), *Sitzender Zecher*, im Victoria & Albert
Museum in London. Die Ölskizzen stellen offensichtlich Vorstudien zu Gemälden dar, ein ungewöhnliches Phänomen für Hals,
da seine Skizzen kaum direkt mit Gemälden in Verbindung
gebracht werden können. Der *Sitzende Geigenspieler* jedenfalls
erscheint in dieser Form in keinem seiner Bilder, lediglich das
Modell begegnet uns, in anderer Haltung, in dem *Interieur mit
fröhlicher Gesellschaft* (Auktion Sotheby's, Parke-Bernet, New
York, 8. Juli 1981, Lot 29) sowie als Figur zur Linken in einem
Gemälde, das die Galerie Internationale in Den Haag 1930
zeigte (Photographie in der Witt Library, Courtauld Institute,
London).

A seated man, playing the violin

Oils on paper, en grisaille, corner made up, upper left
213 x 165 mm, irregular
Signed with initials in monogram and dated, lower right of centre:
'DH/162[?]9'
Inscribed, *verso*, in brown ink: 'de jonge Hals feci:'; 'A:ruitgood';
'1609 [or 1619]'; in pencil: 'd jonge Hals'
Bequeathed by Sir Bruce Ingram, 1963. PD. 401–1963
Provenance: with P. & D. Colnaghi, London, from whom bought by
Ingram (Lugt 1405a), April 1949
Literature: P. Schatborn, 'De Olieverfschetsen van Dirck Hals', *Bulletin van het Rijksmuseum*, 21, 1973, p. 107 ff., fig. 10; C. van Hasselt,
Rembrandt and his century, Exhib. Cat., Paris / New York, 1977/78,
p. 83, note 5
Exhibited: London, Colnaghi, 1949, no. 37; London, Colnaghi,
1952, no. 50; Bath, 1952, no. 24; Washington and American Tour,
1959/60, no. 44

Dirck Hals probably trained as an artist with his brother, Frans
(1581/85–1666), who was almost ten years older than him. In
1620/21 he married Agneta Jansdr. who bore him seven children, of whom the eldest, Anthonie, also became a painter. From
1618–1624 Hals served as a musketeer in the second company of
the third corporalship of the St George Civic Guard. He is first
mentioned as a master painter in the rolls of the Guild of St
Luke in 1627, but some of his paintings have earlier dates. In
1641/42 and 1648/49 he is documented in Leiden. He died in
Haarlem. Best known as a painter of interiors and park landscapes in which figures play a prominent role, in the manner of
Willem Buytewech (1591/92–1624), his oil sketches on paper
are exceptional in Dutch art of this period.

Schatborn (*loc.cit.*) lists twelve oil sketches on paper, another
one of which is in the Fitzwilliam (*Two ladies seated at a table*,
PD. 402–1963), to which van Hasselt (*loc.cit.*) has added
another (*Man seated, drinking*, in the Victoria & Albert Museum,
London). These studies were obviously intended to be used in
finished pictures. However in the surviving output of Dirck Hals
very few correspondances between the oil sketches and the finished paintings can be made. The *Man playing the violin* is not
known to reappear in exactly the same form in one of his paintings, although the same model recurs in a different position in
an *Interior with merry company* (sold New York, Sotheby's, Parke-Bernet, 8 July 1981, lot 29) and it is also the basis for the figure
on the left of a painting shown at the Galerie Internationale,
The Hague in 1930 (photograph in the Witt Library).

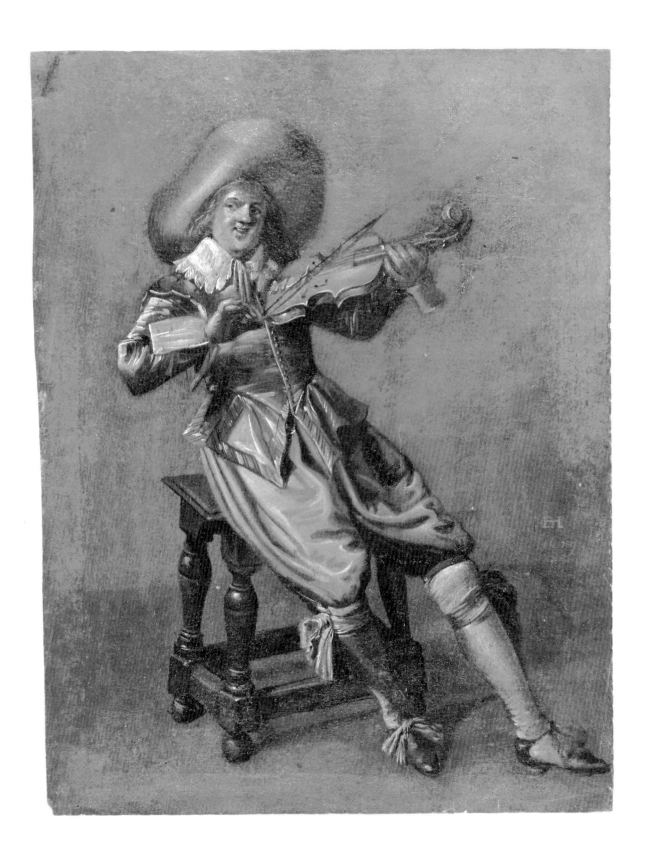

**Studie einer Mutter, die ihrer Tochter vorliest;
Studie der gleichen Figur, nach unten blickend**

Schwarze Kreide
230 x 336 mm
Unleserliche Beschriftung in schwarzer Kreide unterhalb der
Kopfstudie

Verso: Studie eines Mädchenkopfes
Rote Kreide

In Graphit bezeichnet ‚Jacob Jordaens'
Vermächtnis Sir Bruce Ingram, 1963. PD. 407–1963
Provenienz: Seit 1943 Sammlung Ingram (Lugt 1405 a)
Ausstellungen: Oxford 1943 (o. Kat.)

Helmbreecker war Sohn eines Musikers. Künstlerische Unter-
weisung erhielt er in der Werkstatt des Pieter de Grebber (um
1600–1653). 1652 wurde er in die Haarlemer Lukasgilde auf-
genommen, und im folgenden Jahr brach er zusammen mit Cor-
nelis Bega (1631/32–1664), Vincent Laurensz. van der Vinne
(1628/29–1702) und Guillam Du Bois (1623/25–1680) zu einer
Reise nach Deutschland und in die Schweiz auf. 1654 finden wir
ihn in Venedig und in Rom; auf der Heimreise nach Holland
machte er für zwei Jahre in Lyon Station. 1659 war er wieder in
Rom und 1668 nachweislich in Neapel, in dem Jahr, in dem er
als Laienbruder der Gesellschaft Jesu beitrat. 1675 ist er in
Holland bezeugt, im Jahr darauf aber bereits wieder in Rom und
zwar als Mitglied der Accademia di San Luca. Mit Frederick de
Moucheron (1633–1686) unternahm er 1678 eine Reise nach
Frankreich; 1681 ließ er sich endgültig in Rom nieder, wo er
hauptsächlich Aufträge des Jesuitenordens ausführte.

Die alte Zuschreibung unserer Zeichnung an Jacob Jordaens
(1593–1678) ist mit Sicherheit nicht haltbar. Frits Lugt hielt als
erster Helmbreecker für den Autor, eine Hypothese, die sich
vollauf bestätigen läßt im Vergleich mit dessen möglichem
Selbstbildnis aus der Oppenheimer-Auktion (Christie's, London,
10.–14. Juli 1936, Lot 251), dessen spezifischer Rötelstrich und
Anlage der Zeichnung auf unser Blatt verweisen. Wenn auch die
Beschriftung unterhalb der nach unten blickenden Mutter unle-
serlich ist, so könnte man das letzte Wort als „Portret" entziffern.
In der holländischen Malerei der Zeit finden sich zwar intime
Familienszenen dieser Art öfter, in der Zeichnung aber ist ein
solches Thema eher ungewöhnlich.

**Study of a mother reading to her daughter;
study of the same figure, looking down**

Black chalk
230 x 336 mm
Inscribed in black chalk, below the head of the figure looking down:
illegible

Verso: Study of a girl's head
Red chalk

Inscribed in graphite: 'Jacob Jordaens'
Bequeathed by Sir Bruce Ingram, 1963. PD. 407–1963
Provenance: with Ingram (Lugt 1405 a) by 1943
Exhibited: Oxford, 1943 (no handlist)

Helmbreecker was the son of a musician. He trained with Pieter
de Grebber (c.1600–1653). In 1652 he enrolled at the Guild of
St Luke in Haarlem and the following year set off with Cornelis
Bega (1631/32–1664), Vincent Laurensz. van der Vinne
(1628/29–1702) and Guillam Du Bois (1623/25–1680) to Ger-
many and Switzerland. In 1654 he was in Venice and Rome and
on his way back to Holland he spent two years in France at
Lyons. In 1659 he returned to Rome. He is recorded in Naples in
1668, the year in which he became a lay-brother for the Jesuits.
Back in Holland in 1675 he must have returned to Rome by
1676 when he was made a member of the Accademia di San
Luca. In 1678 he was in France with Frederick de Moucheron
(1633–1686) and was back in Rome in 1681, where he lived
until he died, working primarily for the Jesuits.

The old attribution to Jacob Jordaens (1593–1678) is clearly
untenable. Frits Lugt first proposed the authorship of Helm-
breecker and both the handling of the chalk and the general
style of drawing compare well with the possible *Self-portrait* from
the Oppenheimer Sale (London, Christie's, 10–14 July 1936, lot
251), fully supporting Lugt's hypothesis. The inscription below
the head of the mother, looking down, inset into a frame on the
left hand side is indecipherable, but the last word may read: 'Por-
tret'. Although many compositions in oil of this intimate a type
survive in Dutch painting, it is relatively uncommon to find
drawings like this.

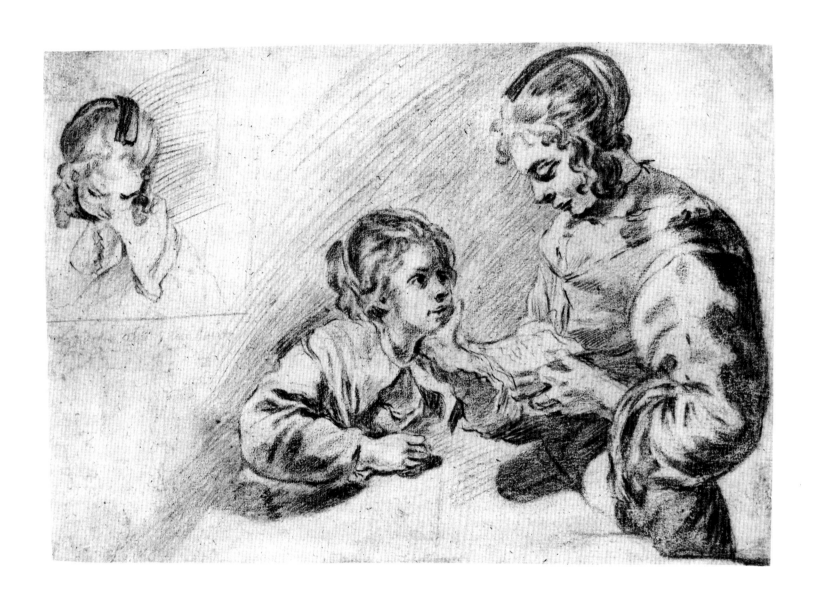

NICOLAES MAES
Dordrecht 1634–1693 Amsterdam

Milchverkäuferin an einer Haustür

Rote Kreide, Pinsel und braune Lavierung, weiß gehöht,
allseitig Randlinie mit Pinsel in Braun
153 x 187 mm
Gestiftet von A. A. VanSittart, 1876. Nr. 3045 B
Provenienz: A. A. VanSittart (aus unbekannter Sammlung)
Literatur: Catalogue of VanSittart and Kerrich Collections (Ms.):
„ob[long] 7⁴/10 x 6 Rembrandt? 8559"; A. M. Hind, Vasari Society,
2nd Series, V, S. II, Nr. 12 m. Abb.; Wilhelm R. Valentiner, Nicolaes
Maes. Berlin/Leipzig 1924, S. 55–56, Abb. 67, S. 60; Sumowski VIII,
S. 4022, Nr. 1788; William W. Robinson, Nicolaes Maes as a Draughts-
man. Master Drawings 27, 1989, S. 146 ff., Abb. 7
Ausstellungen: Cambridge 1966, Nr. 44; Wanderausstellung USA und
Cambridge 1976/77, Nr. 79; London, Southbank Centre und Wander-
ausstellung Arts Council 1991/92, The Primacy of Drawing, Nr. 85

Der Vater des Nicolaes Maes war ein Dordrechter Kaufmann, der
1619 geheiratet hatte. Nach erstem Unterricht bei einem Dord-
rechter Maler kam Maes um 1650 nach Amsterdam in die Werk-
statt Rembrandts (1606–1669), die er aber 1653 wieder verließ,
um nach Dordrecht zurückzukehren. 1654 heiratete er Adriana
Brouwers, die Witwe des Predigers Dr. Arnoldus Gelder. Angeb-
lich hielt er sich in Antwerpen auf, um die Arbeiten von Rubens
(1577–1640) und van Dyck (1599–1641) zu studieren und um
einige Künstler zu besuchen, unter ihnen Jacob Jordaens
(1593–1678). Diese Reise ist wahrscheinlich zwischen 1660 und
1665 anzusetzen. 1673 siedelte er von Dordrecht nach Amster-
dam über, wo er 1693 starb. In seinem Frühwerk dominieren reli-
giöse Darstellungen, erst ab 1654 wandte er sich der Genre-
malerei zu. 1655 begann er sich auch der Portraitmalerei zu
widmen, ein Metier, das er nach 1660 ausschließlich ausübte.

Etwa 160 Zeichnungen sind von Nicolaes Maes bekannt, von
denen fast alle in die ersten zehn Jahre seiner künstlerischen
Tätigkeit, um 1650–1660, zu datieren sind. In erster Linie han-
delt es sich bei diesen Blättern um religiöse Szenen, doch sind
auch Portraits, Landschaften und Genre vertreten. Unser Blatt
ist eine von drei Vorstudien für sein Gemälde Das Milchmädchen
der Sammlung Lord Anthony de Rothschild (Ascott House,
Buckinghamshire). Eines der beiden anderen Blätter kam zusam-
men mit der gezeigten Zeichnung aus der Sammlung VanSittart
in das Fitzwilliam Museum (Nr. 3045 A), das dritte befindet sich
im Dresdener Kupferstich-Kabinett (Sumowski VIII, Nr. 1868*).
Die zweite Zeichnung der VanSittart-Sammlung ist in der glei-
chen Technik mit roter Kreide, braun laviertem Pinsel und
Weißhöhungen ausgeführt, während die Dresdener Zeichnung
nur in Feder und brauner Tusche angelegt ist. Wie Robinson
(a. a. O.) beobachtet hat, gehört das Milchmädchen zu den weni-
gen Gemälden von Maes, für die mehr als eine kompositorische
Studie erhalten ist. Das Gemälde wird allgemein um 1655
datiert.

A milk-seller at a house door

Red chalk, brush and brown wash, heightened with white,
bordered on all sides by a line of brown wash
153 x 187 mm
Given by A. A. VanSittart, 1876. No. 3045B
Provenance: unknown before VanSittart
Literature: Ms catalogue of VanSittart and Kerrich Collections,
'ob[long] 7⁴/10 x 6 Rembrandt? 8559'; A. M. Hind, Vasari Society, 2nd
Series, V, p. II, no. 12, repr.; Wilhelm R. Valentiner, Nicolaes Maes,
Berlin, Leipzig, 1924, pp. 55–56, fig. 67, p. 60; Sumowski, VIII,
p. 4022, no. 1788; William W. Robinson, 'Nicolaes Maes as a
Draughtsman', Master Drawings, 27, 1989, p. 146 ff., fig. 7
Exhibited: Cambridge, 1966, no. 44; American Tour and Cambridge,
1976/77, no. 79; London, Southbank Centre and Arts Council Tour,
1991/92, The Primacy of Drawing, no. 85

Maes' father was a Dordrecht merchant who married in 1619.
After preliminary studies with a Dordrecht master he studied
with Rembrandt (1606–1669) in Amsterdam in the late 1640s
or early 1650s but was back in Dordrecht in 1653. In 1654 he
married Adriana Brouwers, the relict of the preacher Dr Arnol-
dus Gelder. He is said to have gone to Antwerp to study the
works of Rubens (1577–1640) and van Dyck (1599–1641) and
to visit a number of artists, including Jordaens (1593–1678); this
journey probably occurred in the early or mid-1660s. By 1673 he
had moved from Dordrecht to Amsterdam, where he died. His
early work mostly depicts religious scenes but by 1654 he was
painting genre scenes. He began painting portraits in 1655 and
after 1660 he confined himself exclusively to portraiture.

About 160 drawings by Maes are known, almost all dating
from the first ten years of his career (c. 1650–1660). Most of
them are of religious subjects but there are also portraits, land-
scapes and genre scenes. This is one of three studies for the
painting, The Milkmaid at Ascott House, Bucks (Lord Anthony
de Rothschild Collection). One other is also in the Fitzwilliam
Museum, likewise from the VanSittart collection (No. 3045A),
the other is in the Kupferstich-Kabinett, Dresden (Sumowski,
VIII, no. 1868*). The other Fitzwilliam drawing is in the same
technique of red chalk, brush and brown wash heightened with
white, but that at Dresden is in pen and brown ink only. As Rob-
inson observes (loc. cit.) The Milkmaid is one of the few paintings
by Maes for which more than one compositional study survives.
The painting is generally dated c. 1655.

JAN HARMENSZ. MULLER
Amsterdam 1571–1628 Amsterdam

Phantasieportrait eines Mannes mit phrygischer Mütze

Farbige Kreiden
410 x 310 mm (oval)
Rechts von der Mitte mit dem Monogramm des Hendrick Goltzius
bezeichnet ‚HG / Ao 1591'
Vermächtnis Darcy B. Kitchen, 1913. Nr. 2367
Provenienz: H. Haendcke; dessen Versteigerung, Köln, 8. Oktober
1896, Lot 1490 (als Goltzius); Darcy B. Kitchen
Literatur: E. K. J. Reznicek, Jan Harmensz. Muller als tekenaar. *Het
Nederlands Kunsthistorisch Jaarboek* 7, 1956, S. 90 und 114, Nr. 16
Ausstellung: Cambridge 1960, Nr. 65

Jan Mullers Vater war der prominente Amsterdamer Buchhänd-
ler und Kupferstecher Harmen Jansz. Muller (um 1540–1617).
Trotz des deutlichen Einflusses des Hendrick Goltzius
(1558–1617) auf sein Werk war Muller wohl Autodidakt. Von
seiner Hand haben sich nur ein Gemälde, aber etwa 60 Zeich-
nungen und die bedeutende Gruppe von über 100 Kupferstichen
erhalten. Zwischen 1595 und 1600 bereiste er Italien, und sein
Werk spiegelt italienische Einflüsse neben denen der Arbeiten
des Goltzius und Bartholomäus Spranger (1546–1611). Nach
dem Tod des Vaters 1617 übernahmen er und seine Schwester
Marritgen das Verlagshaus der Familie.

Auf Grund des falschen Monogramms und der Datierung
wurde unsere Zeichnung früher Goltzius zugeschrieben. 1956
ordnete sie Reznicek wieder Muller zu. Er datiert sie auf 1595/98
und stellt sie in Zusammenhang mit einem ähnlichen Blatt im
Rijksprentenkabinet in Amsterdam, das der Sammler und
Künstler Cornelis Ploos van Amstel (1726–1798) mit dem
Datum 1595 bezeichnet hat. Typologisch ist die Darstellung des
Kopfes zwei Kupferstichen Jan Mullers zuzuordnen, *Harpokrates,
der Gott des Schweigens* von 1593 (Bartsch 12), und *Chilon,
Gesetzgeber und Philosoph aus Sparta* (Bartsch 13). Diese Köpfe
stehen in der Tradition der *Phantastischen Köpfe* des Hendrick
Goltzius, deren frühester (Köln) 1593 datiert ist.

Fantasy portrait of a man in a Phrygian cap

Coloured chalks
410 x 310 mm, oval
Inscribed with the monogram of Hendrick Goltzius,
lower right of centre: 'HG / Ao 1591'
Bequeathed by Darcy B. Kitchen, 1913. No. 2367
Provenance: H. Haendcke, his sale, Cologne, 8 October 1896, lot
1490 (as Goltzius); Darcy B. Kitchen
Literature: E. K. J. Reznicek, 'Jan Harmensz. Muller als tekenaar', *Het
Nederlands Kunsthistorisch Jaarboek*, 7, 1956, pp. 90, 114, no. 16
Exhibited: Cambridge, 1960, no. 65

Jan Muller's father was the prominent Amsterdam bookseller
and engraver Harmen Jansz. Muller (c. 1540–1617). Although
clearly inspired by Hendrick Goltzius (1558–1617) Muller is
thought to have been self-taught as an artist. One painting by
him survives, about 60 drawings and an important group of over
one hundred prints. He visited Italy in the second half of the
1590s, and his work displays Italian influence as well as that of
Goltzius and Bartholomäus Spranger (1546–1611). At his
father's death in 1617, Muller and his sister Marritgen took over
the family publishing house.

Previously attributed to Goltzius on the basis of the spurious
monogram and date. Reznicek reattributed the drawing to
Muller in 1956. He dates the drawing 1595/98 and relates it to a
similar example in the Rijksprentenkabinet at Amsterdam,
which was inscribed with the date 1595 by the collector/artist
Cornelis Ploos van Amstel (1726–1798). Typologically the head
is related to two engravings by Jan Muller, his *Harpocrates, God
of Silence* of 1593 (Bartsch 12) and his *Chilo, Spartan legislator
and philosopher* (Bartsch 13). Generically these heads depend on
Goltzius' *Fantastic heads*, the earliest of which, at Cologne, is
dated 1593.

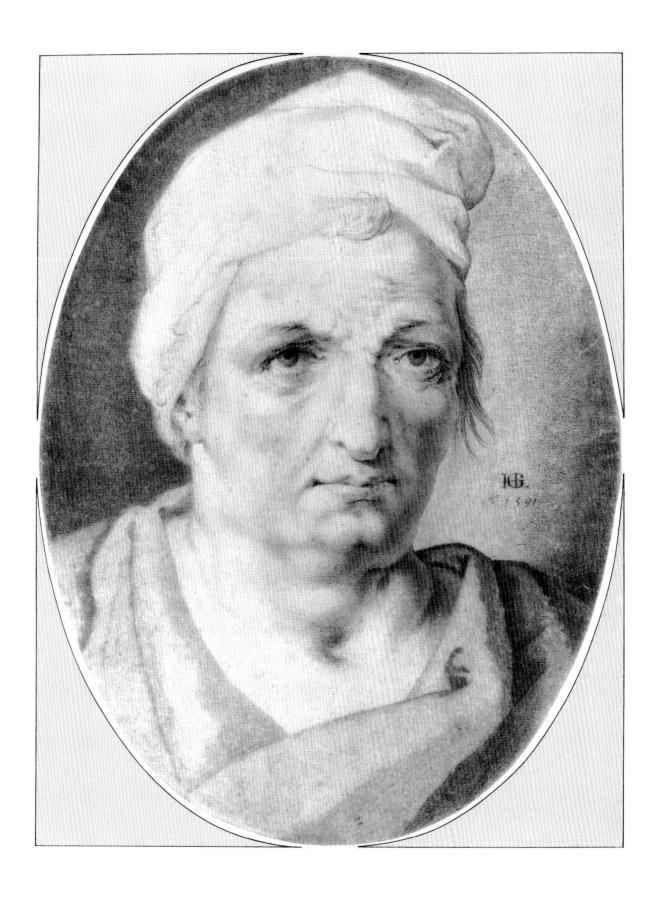

JAN HARMENSZ. MULLER
Amsterdam 1571–1628 Amsterdam

Zwei Studien des ‚Atlas'

Zirkel, Feder und braune Tusche, mit Weiß gehöht, über Spuren
von Graphit, allseitig weiße, zu Schwarz oxydierte Randlinie
178 x 247 mm (Höchstmaße)
Verso in Graphit numeriert ‚418'
Vermächtnis Sir Bruce Ingram, 1963. PD. 53–1964
Provenienz: Kunsthandlung P. & D. Colnaghi, London; hier von
Ingram (Lugt 1405 a) erworben
Bisher noch nicht öffentlich ausgestellt

Als das Museum die Zeichnung im Vermächtnis Ingram über-
nahm, galt sie als flämische Arbeit. Eine versuchsweise
Zuschreibung an Goltzius (1558–1617) wies Haverkamp-Bege-
mann zurück, der Cornelis Cornelisz. van Haarlem (1562–1638)
als Autor vermutete. Zeichnungen dieses Meisters sind selten;
seine Linienführung ist allerdings nicht so kräftig wie die Mul-
lers. Dafür ist der Zeichenstil des *Atlas* eng verwandt einigen
Muller zugewiesenen Blättern, wie der *Umarmung* (Mailand, Pri-
vatsammlung) und dem *Neptun* (New Haven, Yale University
Art Gallery; beide abgebildet in E. K. J. Reznicek, Jan Harmensz.
Muller as a Draughtsman: Addenda. *Master Drawings* XVIII,
1980, Abb. 3 und 1). Unser Blatt muß aus der – wie Reznicek
(a. a. O., S. 115 ff.) sie nennt – „Spranger-Periode" datieren, also
in den Jahren zwischen 1588 und um 1594 entstanden sein. In
dieser Zeit steht Muller stilistisch Cornelis Cornelisz. van Haar-
lem am nächsten, nach dessen Zeichnungen er stach.

Die Darstellung wird gewöhnlich als *Atlas mit der Weltkugel
auf den Schultern* identifiziert, doch thematisiert sie wahrschein-
lich *Herkules, der Atlas von seiner Last befreit*, als dieser aufbricht,
die Äpfel aus den Gärten der Hesperiden zu holen. Die Weltku-
geln sind mit dem Zirkel gezeichnet. Jaffé vermutet, daß die
Figur des Herkules auf eine Skulptur zurückgeht, eine künstleri-
sche Vorgehensweise, die durchaus im Einklang steht mit der in
Haarlem unter dem Einfluß des Cornelis Cornelisz. van Haarlem
geübten akademischen Praxis, Studien „nach dem Leben" nicht
unbedingt nach dem lebenden Modell, sondern eher nach drei-
dimensionalen Objekten wie Bronzen und Abgüssen anzuferti-
gen. Anthony Radcliffe jedoch, der den Dargestellten ebenfalls
eher für Herkules als für Atlas hält, glaubt nicht, daß diese Figur
einer real existierenden Skulptur folgte, da – er nennt dabei den
berühmten Herkules des Giambologna – die Erdkugel so plaziert
ist, daß eine solche Figur gar nicht stehen könnte.

Two studies of 'Atlas'

Compasses, pen and brown ink, brown wash, heightened with white
over traces of graphite, bordered on all sides by a line of white,
reduced to black
178 x 247 mm, maximum
Numbered in graphite, *verso*: '418'
Bequeathed by Sir Bruce Ingram, 1963, received 1964. PD. 53–1964
Provenance: with P. & D. Colnaghi, London, from whom bought by
Ingram (Lugt 1405 a)
Not previously exhibited

Attributed to the Flemish School when bequeathed to the
Museum. A tentative attribution to Goltzius (1558–1617) was
rejected by Haverkamp-Begemann who proposed Cornelis
Cornelisz. van Haarlem (1562–1638). Cornelis' drawings are
rare, but his line is less vigorous than Muller's and the style of
draughtsmanship of the 'Atlas' is perfectly compatible with sev-
eral drawings given to Muller, notably *The Embrace* in a private
collection in Milan and the *Neptune* in the Yale University Art
Gallery, New Haven (both reproduced in E. K. J. Reznicek, 'Jan
Harmensz. Muller as a Draughtsman: Addenda' in *Master Draw-
ings*, XVIII, 1980, pl. 3, pl. 1). The drawing must date from what
Reznicek (*loc. cit.*, p. 115 ff.) refers to as the 'Spranger Period',
that is 1588–c.1594, which is the moment at which Muller is
closest to Cornelis Cornelisz., after whose drawings he made
engravings.

The subject is usually identified as *Atlas with the world on his
shoulders*, but it is more likely that it represents *Hercules relieving
Atlas of his burden*, whilst Atlas goes to take the apples from the
Garden of the Hesperides. The globes of the world are drawn
with a compass. Professor Jaffé suggested that the Hercules fig-
ure is based on a sculpture. This would be in accordance with
Academic practice current in Haarlem at the time, under the
influence of Cornelis Cornelisz., whereby study from 'life' did
not imply drawing from 'live models' but rather from 'real
objects'– that is bronzes and casts – as opposed to drawing from
imagination. However Anthony Radcliffe, who endorses the
idea that the subject is Hercules rather than Atlas, thinks that
the globe is not placed in a central enough position for the fig-
ure to work in practical terms as a sculpture (he cites the well
known example by Giambologna), and concludes that this draw-
ing is not dependent on a sculptural prototype.

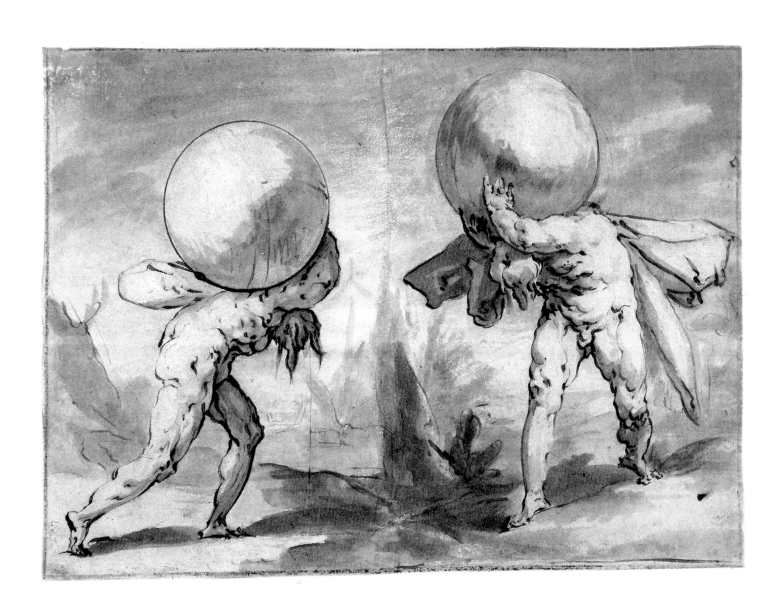

ESAIAS VAN DE VELDE
Amsterdam 1587–1630 Den Haag / The Hague

Der ‚Gnadenstoß' nach der Seeschlacht

Graphit und Holzkohle, mit Wischer (?), allseitig Randlinie mit Pinsel in Braun
176 x 285 mm
Ölfleckig, kleines Loch ganz rechts in der Mitte
Unten links in Graphit bezeichnet ‚E V VELDE f'; unten rechts in Tusche numeriert ‚85'; verso ‚No. 415'
Vermächtnis Sir Bruce Ingram, 1963. PD. 770–1963
Provenienz: A. W. M. Mensing; Auktion Mensing, Amsterdam, 29. April 1937, Lot 748; Kunsthandlung P. & D. Colnaghi, London; hier von Ingram (Lugt 1405a) im Mai 1937 erworben
Literatur: C. van Hasselt, *Rembrandt and his century*. Ausstellungskatalog Paris / New York 1977/78, S. 164–165, Anm. 1; Keyes 1984, S. 310
Ausstellungen: London, Colnaghi, 1938, Nr. 74; Cambridge, Fitzwilliam Museum, 1953 (o. Kat.); Cambridge 1982 (o. Kat.)

George Keyes, der unser Blatt Esaias van de Velde absprach (a. a. O.), bemerkte: „...wer auch immer die Beschriftung hinzufügte, vermutete den falschen [i. e. Esaias] van de Velde, obwohl die Zeichnung auch mit dem Werk Willem van de Velde d. Ä. kaum in Verbindung gebracht werden kann." In der Tat ist eine Zuschreibung an Willem van de Velde d. Ä. nicht haltbar, stilistisch zeigen sich aber bemerkenswerte Ähnlichkeiten mit der Gruppe martialischer Szenen, die Esaias gegen Ende seines kurzen Lebens zeichnete, so daß unser Blatt durchaus von seiner Hand stammen kann. Ähnlich verzerrte Gesichtszüge finden sich bei den Figuren eines *Reiterscharmützels* von 1623 (Keyes liest 1625) im Fitzwilliam Museum (PD. 769–1963). Die Technik vieler seiner Zeichnungen aus den Jahren 1622 bis 1630, bei denen er die Umrisse im Vordergrund mit Kreide kräftig anlegt und den Hintergrund fast atmosphärisch zart andeutet, kennzeichnet auch unser Blatt. Das grausige Thema des *Gnadenstosses* ist recht ungewöhnlich.

The coup de grâce after a naval battle

Graphite and charcoal, softened with [?]stump, bordered on all sides by a line of brown wash
176 x 285 mm
Oil stained, a small hole far right of centre
Inscribed in graphite lower left: 'E V VELDE f'; numbered in ink, lower right: '85'; *verso* : 'No. 415'
Bequeathed by Sir Bruce Ingram, 1963. PD. 770–1963
Provenance: A. W. M. Mensing, his sale, Amsterdam, 29 April 1937, lot 748; with P. & D. Colnaghi, London, from whom bought by Ingram (Lugt 1405a), May 1937
Literature: C. van Hasselt, *Rembrandt and his century*, Exhib. Cat., Paris / New York, 1977/78, pp. 164–165, note 1; Keyes, 1984, p. 310
Exhibited: London, Colnaghi, 1938, no. 74; Cambridge, Fitzwilliam Museum, 1953 (no handlist); Cambridge, 1982 (no handlist)

George Keyes (*loc. cit.*) who rejected this drawing, suggested: '...whoever added the inscription reckoned on the wrong van de Velde, although the drawing is equally difficult to reconcile with the œuvre of Willem the Elder.' Whilst agreeing that an attribution to Willem van de Velde is untenable, there is sufficient similarity in style with the group of drawings of martial scenes which Esaias executed towards the end of his short life to support the attribution to him. A drawing of 1623 (Keyes reads the date as 1625) showing *A Cavalry Engagement* in the Fitzwilliam (PD. 769–1963) has the same distortion of features which distinguishes the *coup de grâce*. It also shares the same feature which occurs in many of his drawings between 1622 and 1630 of using chalk with considerable pressure to reinforce outlines in the foreground, whereas in the background it is soft, almost 'atmospheric' in its handling. The gruesome subject of the *coup de grâce* is surprisingly uncommon.

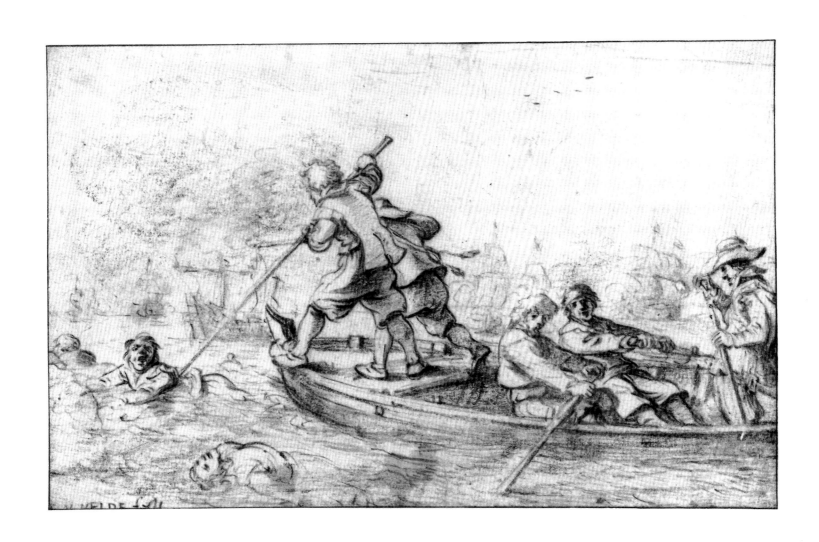

ESAIAS VAN DE VELDE
Amsterdam 1587–1630 Den Haag / The Hague

Musizierende Gesellschaft

Schwarze Kreide und hellbraune Lavierung
223 x 338 mm
Ecken oben links, rechts und unten ergänzt; Ausbesserung oben Mitte
Unten links in schwarzer Kreide signiert und datiert
‚E. V. VELDE / [16]29'
Vermächtnis Charles Brinsley Marlay, 1912. Nr. 3167
Provenienz: Charles Brinsley Marlay (aus unbekannter Sammlung)
Literatur: Keyes 1984, D. 43, S. 225, Abb. 329
Bisher noch nicht öffentlich ausgestellt

Bei unserem Blatt handelt es sich um eine besonders sorgfältig durchgearbeitete Zeichnung, die verglichen werden kann mit drei weiteren späten Arbeiten von Esaias van de Velde: *Plünderer in einem Bauernhaus* von 1628 in Budapest, Szépmüvészeti Múzeum (Keyes, a.a.O., D. 29), *Plünderer, die sich um die Beute zanken* von 1629 in Paris, Fondation Custodia (Keyes, a.a.O., D. 33), und insbesondere *Inneres einer Schänke* von 1629 in Berlin, Kupferstichkabinett (Keyes, a.a.O., D. 39).

Ungewöhnlich für die Darstellung einer musizierenden Gesellschaft ist die ausschließlich männliche Runde. Der Sänger rechts am Tisch schlägt beim Singen den Takt, zu seiner Rechten liest ein Mann, vielleicht der Besitzer der Blockflöte auf dem Tisch, während andere eine Viola da braccio und eine Viola da gamba spielen. Der Mann, der uns den Rücken zuwendet, ist vermutlich der Spieler der Laute, die im Vordergrund an einem Schemel lehnt. Auch kulturgeschichtlich ist diese Interieurszene von Interesse, denn sie zeigt den Gebrauch eines Tischteppichs und von Kissen auf den harten Holzstühlen und Schemeln. An unserem Blatt läßt sich außerdem ablesen, wie hoch Landschaftsgemälde in den späten zwanziger Jahren gehängt wurden: Die Linie des Horizontes liegt in Augenhöhe des fiktiven Betrachters.

A musical party

Black chalk and light brown wash
223 x 338 mm
Made up corners top left, top and bottom; old repair top centre
Signed and dated in black chalk, lower left: 'E.V.VELDE / [16]29'
Bequeathed by Charles Brinsley Marlay, 1912. No. 3167
Provenance: unknown before Marlay
Literature: Keyes, 1984, D. 43, p. 225, pl. 329
Not previously exhibited

A particularly elaborate and finished drawing which can be compared with three other late examples, *Men looting a farmhouse* of 1628 in Budapest, Szépmüvészeti Múzeum (Keyes, *op. cit.*, D. 29), *Men brawling over loot* of 1629 in Paris, Fondation Custodia (Keyes, *op. cit.*, D. 33) and particularly with *Interior of a tavern* of 1629 at Berlin, Kupferstichkabinett (Keyes, *op. cit.*, D. 39).

The scene is unusual for a musical party so far as all the participants are male. The singer seated towards the right of the table is beating time (Tactus) as he sings, to his right one man (perhaps the owner of the recorder on the table in front of him) is reading whilst others play a treble viol (played on the shoulder) and a bass viol, whilst the man seated on the far right, with his back to the viewer, is presumably the player of the lute resting on a stool in front of the table. This sort of interior is valuable as it shows the use of cushions on hard wooden chairs and stools and a table carpet in use, as well as giving an indication of the height at which landscapes were hung in the late 1620s: as one might expect the line of horizon is the same as that of the eyes of a standing man of average height.

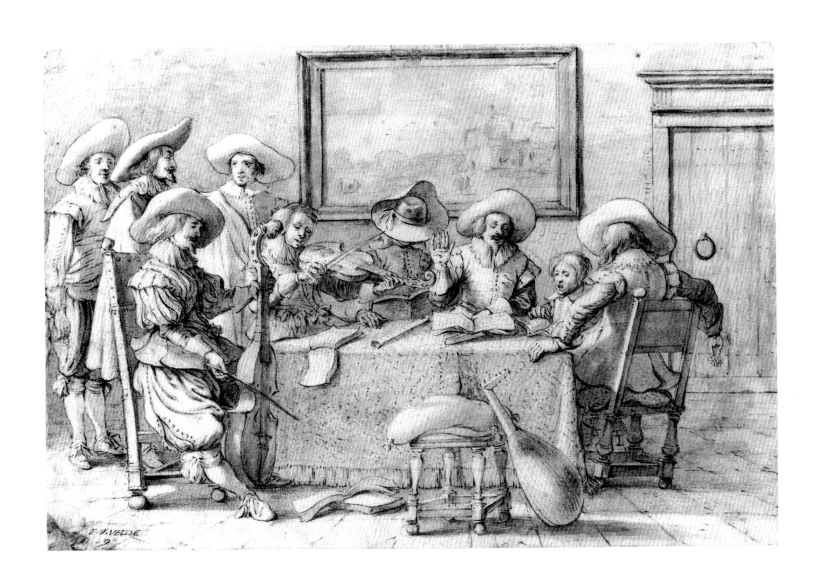

Gruppen von Soldaten, einige würfelnd

Feder und braune Tusche, grau laviert
99 x 192 mm
Vom Künstler in brauner Tusche bezeichnet ‚dat niet'; ‚gemaeckt van Teniers e[e]n stuck'
Vermächtnis Sir Bruce Ingram, 1963. PD. 817–1963
Provenienz: In der Sammlung Ingram (Lugt 1405 a) seit etwa 1952
Ausstellungen: London, Colnaghi, 1952, Nr. 56; Bath 1952, Nr. 39

Figurenstudien dieser Art finden sich in anderen Sammlungen mit unterschiedlichen Zuschreibungen; im Berliner Kupferstichkabinett sind sie zum Beispiel Jan Porcellis (1584–1632) zugewiesen. Ihre Identifizierung als Arbeiten Willem van de Veldes d. Ä. geht auf Sir Bruce Ingram zurück (s. seine Bemerkung im Ausstellungskatalog Colnaghi, London, 1937). Unser Blatt wurde ursprünglich Anthonie Palamedesz. (1601–1673) zugeschrieben. Stilistisch ist das Blatt sorgfältiger ausgeführt als einige andere Figurenzeichnungen van de Veldes d. Ä. (vgl. drei charakteristische Beispiele im Fitzwilliam Museum sowie die bekannte Gruppe von Zeichnungen in Greenwich), was Carlos van Hasselt vermuten ließ, es sei von der Hand Willem van de Velde d. J. (1633–1707). Den Grund für diese besonders sorgfältige Ausführung aber gibt uns die Beschriftung des Blattes selbst, die besagt, daß es „nach einem Stück von Teniers gemacht", d. h. eine Kopie nach David Teniers d. J. (1610–1690) ist. Bauern und Soldaten beim Würfelspiel sind ein übliches Thema im Werk Teniers', doch konnte die Vorlage für unsere Zeichnung bisher noch nicht identifiziert werden. Wahrscheinlich geht nur die Gruppe der Soldaten, die auf einer Trommel Würfel spielen, auf ihn zurück. Die andere Bezeichnung neben der Rückenfigur des Mannes im Mantel, „dat niet" („das ist nichts"), mag eine versteckte Anspielung auf die beiden Bettler-Radierungen von Rembrandt (Bartsch 177 und 178) sein, von denen eine die Bezeichnung „tis vinnich kout" (es ist verflucht kalt) und die andere „dat niet" (das ist nichts) trägt.

A group of soldiers, some playing dice

Pen and brown ink, grey wash
99 x 192 mm
Inscribed in brown ink, in the artist's hand: 'dat niet'; 'gemaeckt van Teniers e[e]n stuck'
Bequeathed by Sir Bruce Ingram, 1963. PD. 817–1963
Provenance: with Ingram (Lugt 1405 a) by 1952
Exhibited: London, Colnaghi, 1952, no. 56; Bath, 1952, no. 39

Figure studies of this kind are found in other collections with various attributions, for example Jan Porcellis (1584–1632) in the Berlin Kupferstichkabinett. The identification of the whole group as the work of Willem van de Velde the Elder is due to Sir Bruce Ingram (see his note in Exhibition, London, Colnaghi, 1937). This drawing was originally attributed to Anthonie Palamedesz. (1601–1673). The style of drawing is rather more careful than some of the other figure drawings by van de Velde the Elder (there are three characteristic examples in the Fitzwilliam apart from the well known group at Greenwich), which has led Carlos van Hasselt to suggest that this is a drawing by Willem van de Velde the Younger (1633–1707). However the inscription explains the reason for the exceptional care with which this has been drawn as it states that it is a copy 'made after the piece by Teniers', *i.e.* David Teniers the Younger (1610–1690). Figures of peasants and soldiers gambling feature regularly in Teniers' work, but the work by Teniers which is being copied has not yet been identified – it is likely that it is only the group of soldiers using a drum on which to throw dice that is taken from him. The other inscription, which relates to the man wrapped in a cloak seen from behind, 'dat niet' ('that's nothing') may be an oblique reference to Rembrandt's pair of prints of beggars executed in 1634 (Bartsch 177,178) in which one is inscribed : 'tis vinnich kout' ('it's damned cold', 'that's nothing').

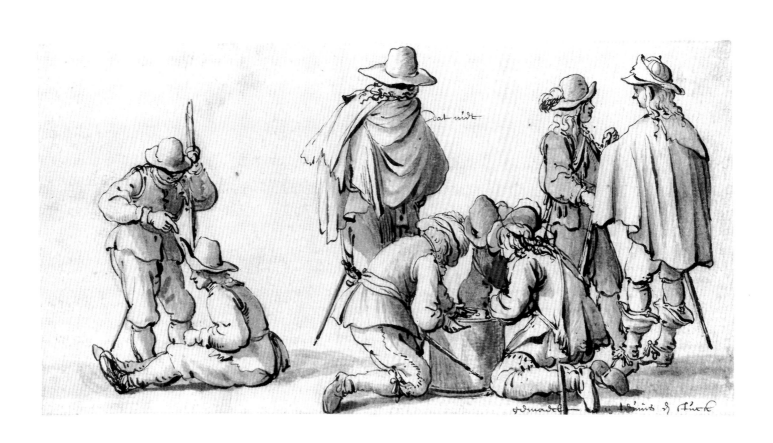

SIMON DE VLIEGER
zugeschrieben / attributed to
Rotterdam (?) um / c. 1601–1653 Weesp

Gruppe von Fischern

Feder und braune Tusche, braun laviert
170 x 230 mm
Auf der alten Montierung gestempelt ‚63' und ‚Philip de Koningh'
Gestiftet von Louis C. G. Clarke, 1948. PD. 4–1948
Provenienz: Wahrscheinlich Charles B. O. Clarke, 1935 von ihm als Vermächtnis gegeben an Louis C. G. Clarke, der es mit Sicherheit 1939 besaß
Ausstellung: Cambridge 1966, Nr. 50

Die Zeichnung hat eine alte Zuschreibung an Philips de Koninck (1619–1688) und wird damit fest in den Rembrandt-Kreis eingefügt. Otto Benesch schrieb unser Blatt 1939 de Vlieger zu und sah in ihm eine frühe, unter dem Einfluß Rembrandts entstandene Arbeit. Aus seiner reifen Schaffenszeit kennen wir nur wenige Blätter, die dem unseren unmittelbar vergleichbar wären; es zeigen sich zwar Gemeinsamkeiten mit einer Kreidezeichnung in der Sammlung Randall Davies, die „S. De Vlieger" signiert ist, doch die anderen figürlichen Vlieger-Zeichnungen im Fitzwilliam Museum (insgesamt vier Blätter) stehen stilistisch recht entfernt. Von derselben Hand wie unsere Zeichnung sind vielleicht ein Jan Porcellis (1584–1632) zugewiesenes Blatt in Berlin (Nr. 4049) und eine Zeichnung in Edinburgh (Nr. 1323), die früher de Vlieger, heute Willem van de Velde d. Ä. zugeschrieben wird. Martin Royalton-Kish schlug eine versuchsweise Zuschreibung an Govaert Flinck (1615–1660) vor, die zwar nicht restlos überzeugt, aber doch wahrscheinlicher erscheint als eine andere jüngere Zuweisung an Samuel van Hoogstraten (1627–1678) und den Autor unserer Zeichnung wieder fest im Rembrandt-Kreis etabliert. Der Mann zur Rechten scheint einen Fisch auszunehmen, während die Frau links interessiert ihren Kauf beäugt.

A group of fisher folk

Pen and brown ink, brown wash
170 x 230 mm
Stamped on the old mount: '63' and 'Philip de Koningh'
Given by Louis C. G. Clarke, 1948. PD. 4–1948
Provenance: probably Charles B. O. Clarke, bequeathed by him in 1935 to Louis C. G. Clarke, who certainly owned it in 1939
Exhibited: Cambridge, 1966, no. 50

The drawing had an old attribution to Philips de Koninck (1619–1688), which places it firmly in the orbit of Rembrandt. The attribution to de Vlieger was made by Otto Benesch in 1939, who suggested it was an early work, done under the influence of Rembrandt. Certainly there are few examples of de Vlieger's drawings from his maturity with which this bears direct comparison, although it is stylistically close to a chalk drawing from the Randall Davies collection which is signed: 'S. De Vlieger'; but the other figure drawings by him in the Fitzwilliam (there are four) have little in common with this example. A drawing attributed to Jan Porcellis (1584–1632) in Berlin (no. 4049), and one formerly given to de Vlieger at Edinburgh (now attributed to Willem van de Velde the Elder, no. 1323) may be by the same hand. Martin Royalton-Kish has proposed a tentative attribution to Govaert Flinck (1615–1660), which, whilst not entirely convincing, is more plausible than another recent attribution to Samuel van Hoogstraten (1627–1678) and again puts the artist of this drawing firmly in Rembrandt's circle. The man on the right appears to be gutting a fish, whilst the woman on the left looks intent on its purchase; one can only hope that the bucket on the child's head beside her has not been used for carrying fish!

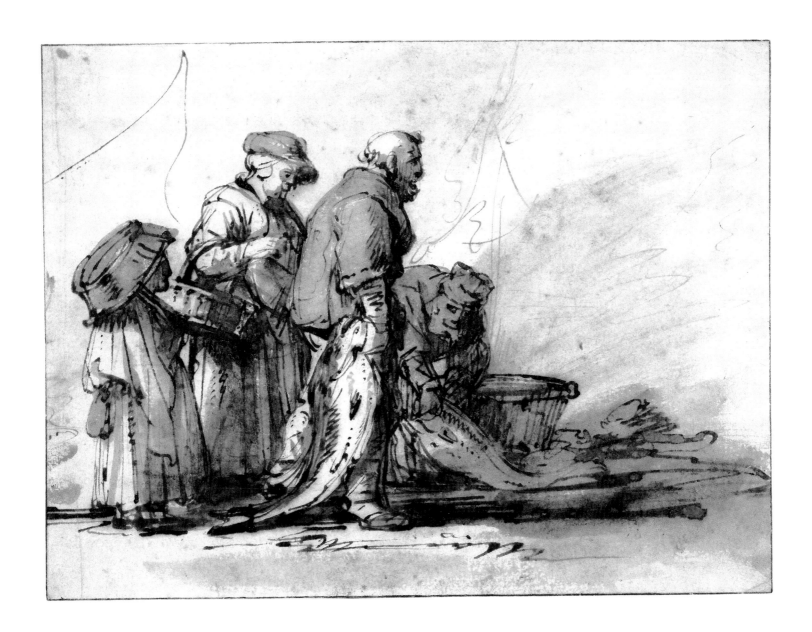

RELIGIÖSE DARSTELLUNGEN

DRAWINGS WITH
A RELIGIOUS CONTEXT

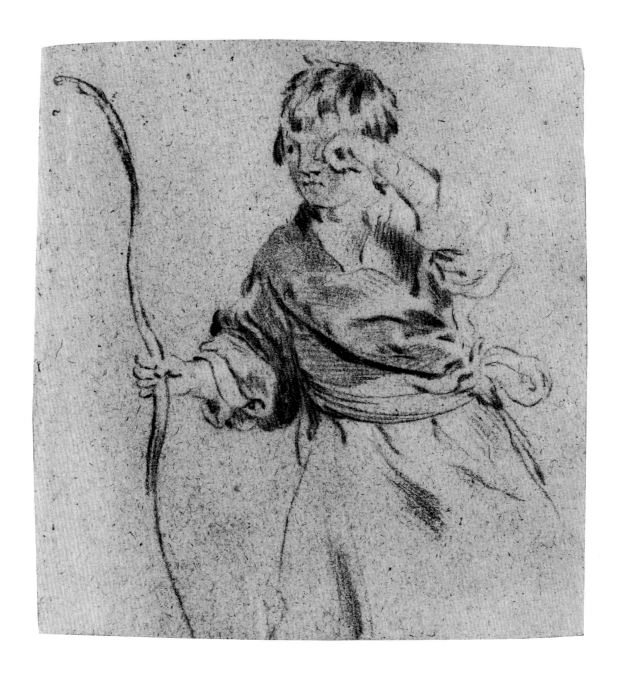

JACOB ADRIAENSZ. BACKER
Harlingen 1608–1651 Amsterdam

Der weinende Ismael für eine ,Verstoßung der Hagar'

Schwarze Kreide, weiß gehöht, auf ausgeblichenem blaugrauem Papier
197 x 191 mm (Blattgröße unregelmäßig)
Übertragen aus der University Library, Cambridge, 1876. Nr. 2972
Provenienz: University Library, Cambridge (unbekannter Herkunft)
Literatur: J. W. von Moltke, *Govaert Flinck*. Amsterdam 1965, S. 190,
Nr. D. 88 (mit Abb.); Sumowski I, S. 102, Nr. 44*
Ausstellung: Cambridge 1966, Nr. 27 (Flinck zugeschrieben)

Backer lernte gleichzeitig mit Govaert Flinck (1615–1660) im
Atelier des Lambert Jacobsz. (vor 1600–1637) in Leeuwarden,
wo er künstlerisch auch von Wybrand de Geest (1592–1659)
angeregt wurde. 1633 ließ er sich in Amsterdam nieder und kam
in den Einflußbereich Rembrandts (1606–1669). In den frühen
1640er Jahren sind in seinen Arbeiten darüber hinaus Anregun-
gen durch Bartholomeus van der Helst (1613–1670) zu bemer-
ken. In seinem Spätwerk wendet er sich einem mehr klassizisti-
schen Stil zu. Am bekanntesten wurde Backer durch seine
Portraits; daneben schuf er Historienbilder sowie biblische,
mythologische und allegorische Szenen.

Moltke schrieb unser Blatt 1965 Govaert Flinck zu, indem er
es mit einer Zeichnung dieses Meisters im Berliner Kupferstich-
kabinett (KdZ 12153), *Junger Mann mit Stundenglas* (Abb.
Sumowski IV, Nr. 882), verglich; dies wurde von Cormack
bestätigt. Sumowski hingegen, von dem die Zuweisung an
Backer stammt, hielt den Vergleich mit der Berliner Zeichnung
für unhaltbar, da ihr Zeichenduktus ein völlig anderer sei. Er
vergleicht seinerseits die hier vorgestellte Zeichnung mit
Backers *Knabe mit Gewanddraperie* (Sumowski I, Nr. 42*, Fitzwil-
liam Museum, Nr. 2970), ein Blatt, das ebenfalls 1876 aus der
University Library übertragen wurde und möglicherweise aus der
gleichen Quelle stammt. Sumowski datiert unser Blatt auf
1645/50, kann aber keinen Bezug zu einem erhaltenen Gemälde
des Künstlers herstellen. Die Vertreibung Hagars war ein belieb-
tes biblisches Sujet des 17. Jahrhunderts in Holland, wobei
Hagars Sohn Ismael stets mit einem Bogen dargestellt wurde
(vgl. Nicolaes Maes, *Die Vertreibung Hagars*, Metropolitan
Museum of Art, New York, 1971.73). Das Thema stammt aus
Gen 21, 14.

Ishmael weeping: for a 'Dismissal of Hagar'

Black chalk, heightened with white on faded blue grey paper
197 x 191 mm, irregular
Transferred from the University Library, 1876. No. 2972
Provenance: uncertain before transferred from the Library
Literature: J. W. von Moltke, *Govaert Flinck*, Amsterdam, 1965,
p. 190, no. D. 88, repr.; Sumowski, I, p. 102, no. 44*
Exhibited: Cambridge, 1966, no. 27 (as attributed to Flinck)

Backer studied at the same time as Govaert Flinck (1615–1660)
with Lambert Jacobsz. (before 1600–1637) at Leeuwarden,
where he was also influenced by Wybrand de Geest
(1592–1659). In 1633 he moved to Amsterdam, where he was
strongly influenced by Rembrandt (1606–1669). In the early
1640s he was further impressed by Bartholomeus van der Helst
(1613–1670). His late work is classicising. Best known as a por-
traitist, his work includes history pictures, scenes from the Bible,
mythology and allegories.

An attribution to Flinck, made by von Moltke in 1965 with
reference to a drawing in Berlin, Kupferstichkabinett (KdZ 12153),
A young man with an hour-glass (repr. Sumowski, IV, no. 882), was
accepted by Cormack. Sumowski, who made the attribution to
Backer, points out that the comparison with the Berlin drawing
is untenable: 'the manner of drawing of the latter is completely
different'. He compares the Fitzwilliam drawing to the *Boy with
a wrap* (Sumowski, I, no. 42*), No. 2970, also in the Fitzwilliam's
collection, likewise transferred from the University Library in
1876 and so, possibly, from the same initial source. Sumowski
dates the drawing 1645/50 but has not been able to link it to a
finished painting. The subject of Hagar's dismissal was a popular
one in seventeenth century Holland and the young Ishmael is
regularly shown with a bow (compare Nicolaes Maes' painting of
the subject in the Metropolitan Museum, New York [1971.73]).
The subject is taken from Genesis XXI, 14.

ABRAHAM BLOEMAERT
Gorinchem 1566–1651 Utrecht

Der Jesusknabe in den Armen des greisen Simeon

Feder und braune Tusche, braune Lavierung, über schwarzer Kreide, allseitig Randlinie mit Pinsel in Braun
242 x 182 mm
Erworben mit Mitteln des University Purchase Fund, 1901. Nr. 2874
Provenienz: W. Young Ottley (Lugt 2663; 2664); dessen Versteigerung, T. Philipe, London, 22. Februar 1814, Teil von Lot 175, erworben von Roscoe; Sir Thomas Lawrence (Lugt 2445); Samuel Woodburn; dessen Versteigerung, Christie's, London, 4. Juni 1860, wahrscheinlich Teil von Lot 80, erworben von Money; F. Abbott (Lugt 970); Dr. Lazarus Belleli (von ihm durch das Museum erworben)
Literatur: E. Brugerolles und D. Guillet, *Renaissance et Maniérisme dans les Écoles du Nord.* Ausstellungskatalog Paris, École des Beaux-Arts 1985, S. 206, s. v. Nr. 106; David Scrase, Besprechung: Paris, Northern Renaissance drawings and Andrea Solario. *The Burlington Magazine* CXXVIII, 1986, S. 164; Marcel G. Roethlisberger, *Abraham Bloemaert and his Sons.* Gent 1993, S. 214, s. v. Nr. 274
Ausstellungen: Cambridge 1960, Nr. 58; Wanderausstellung USA und Cambridge 1976/77, Nr. 60; Cambridge 1980 (o. Kat.)
Gestochen und verlegt von Crispijn de Passe d. Ä. (1564/65–1637)

Unser Blatt galt lange Zeit als Arbeit des Pier Francesco Mola (1612–1666); der Zusammenhang mit einem Stich nach Bloemaert wurde zuerst von Carlos van Hasselt erkannt, der dadurch die Zuweisung an diesen Meister vornehmen konnte. Roethlisberger datiert die Zeichnung um 1615/18, nach des Künstlers Übersiedelung nach Utrecht. Der Kupferstich mit der Legende „Nunc dimittis servum tuum Domine secundum / verbum tuum in pace Luc 2 / ABloemaert Inventor. Crisp. Pass / fecit et ex" ist seiner Ansicht nach vor 1625 entstanden. Insgesamt drei Zeichnungen, alle von Roethlisberger als eigenhändig akzeptiert, reflektieren die verschiedenen Stadien der Vorzeichnung für den Stich, und alle drei sind im gleichen Sinne angelegt wie dieser. Als erstes Blatt sieht Roethlisberger eine Zeichnung von „leidenschaftlicher Ausdruckskraft", die von Sotheby's, London, am 6. Juli 1992 (Lot 4) versteigert wurde; die nächste Stufe stellt unser Blatt dar, das er ebenso wie Scrase (a. a. O.) für eigenhändig hält und das im Verhältnis zur ersten Studie detaillierter ausgearbeitet ist. Die letzte, unmittelbar dem Stich vorausgehende Stufe zeigt das noch genauer durchgearbeitete Blatt der École des Beaux-Arts in Paris mit bereits durchgedrückten Linien. Es ist in der Tat ungewöhnlich, daß gleich drei Vorzeichnungen Bloemaerts für einen Stich existieren, aber die eigenständige künstlerische Handschrift unseres Blattes und die Unterschiede zu den anderen beiden Zeichnungen bestätigen Roethlisbergers Ansicht, daß die ganze Gruppe als eigenhändig anzusehen ist. Das Blatt illustriert die Erzählung von Lk 2, 25 ff.

The infant Christ in the arms of Simeon

Pen and brown ink, brown wash, over black chalk, bordered on all sides by a line of brown wash
242 x 182 mm
Bought from the University Purchase Fund, 1901. No. 2874
Provenance: W. Young Ottley (Lugt 2663; 2664), his sale, London, T. Philipe, 22 February 1814, part of lot 175, bought by Roscoe; Sir Thomas Lawrence (Lugt 2445); Samuel Woodburn, his sale, London, Christie's, 4 June 1860, probably part of lot 80, bought by Money; F. Abbott (Lugt 970); Dr Lazarus Belleli, from whom bought
Literature: E. Brugerolles and D. Guillet, *Renaissance et Maniérisme dans les Écoles du Nord*, Exhib. Cat., Paris, École des Beaux-Arts, 1985, p. 206, s. v. no. 106; David Scrase, Review: 'Paris, Northern Renaissance drawings and Andrea Solario', *The Burlington Magazine*, CXXVIII, 1986, p. 164; Marcel G. Roethlisberger, *Abraham Bloemaert and his Sons*, Ghent, 1993, p. 214, s. v. no. 274
Exhibited: Cambridge, 1960, no. 58; American Tour and Cambridge, 1976/77, no. 60; Cambridge, 1980 (no handlist)
Engraved and published by Crispijn de Passe the Elder (1564/65–1637)

Previously attributed to Pier Francesco Mola (1612–1666), the connection with the print was first noted by Carlos van Hasselt, to whom the attribution to Bloemaert is due. Roethlisberger dates the drawing c.1615/18, after the artist's move to Utrecht. The print, which bears the inscription: 'Nunc dimittis servum tuum Domine secundum / verbum tuum in pace Luc 2 / ABloemaert Inventor.Crisp. Pass / fecit et ex', he dates before 1625. This is one of three drawings, all of which Roethlisberger accepts as autograph, done in preparation to the execution of the print. All three are in the same direction as the print, Roethlisberger considers the first executed to be that sold at Sotheby's, London, 6 July 1992, lot 4, a 'vigorously drawn sheet' as he puts it, then he places the Fitzwilliam drawing, agreeing with Scrase who claimed it as autograph in 1986 (*loc.cit.*), commenting that it is more thoroughly worked out, and finally the incised drawing, directly preparatory to the engraving, and rather more precise, which is in the École des Beaux-Arts, Paris. It is unusual to find so many as three drawings by Bloemaert in preparation for a print, but the intrinsic qualities of the drawing and the differences between it and both other versions confirm Roethlisberger's opinion that, like the other two, it is autograph. The subject is taken from Luke II, 25 ff.

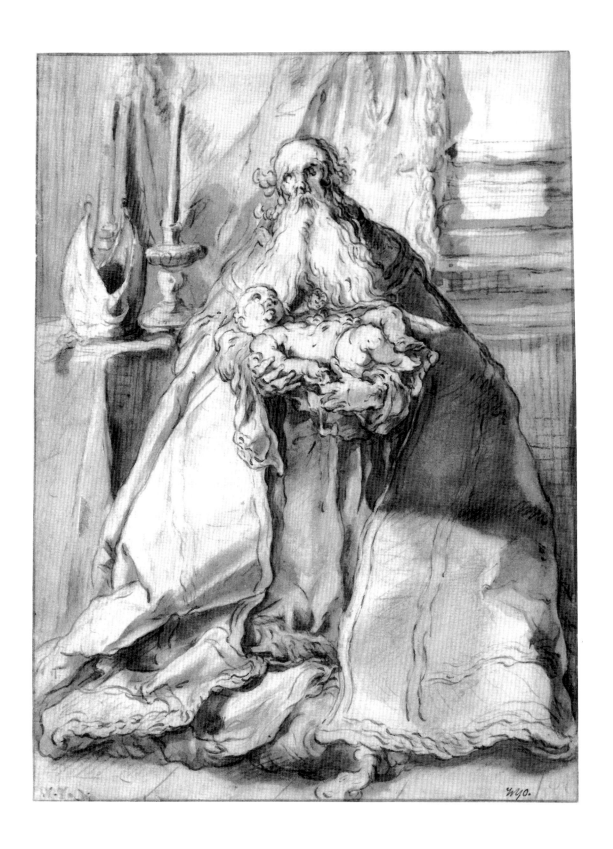

LEONAERT BRAMER
Delft 1596–1674 Delft

Die Himmelfahrt des Elija

Dünner Pinsel, schwarze Tusche, graue Lavierung auf grauem Papier
404 x 321 mm
Untere rechte Ecke fehlt; oben und unten links Löchlein
Oben rechts in schwarzer Tusche numeriert ‚45‘
Gestiftet von John Tillotson, 1968; PD. 28–1968
Provenienz: John Tillotson (aus unbekannter Sammlung)
Bisher noch nicht öffentlich ausgestellt

1614 verließ Leonaert Bramer die Stadt Delft und begab sich über Frankreich nach Italien. Die Reise führte ihn durch Artois, nach Amiens, Paris und Marseille, von dort nach Genua, Livorno, Venedig, Florenz, Mantua, Siena, Bologna, Neapel, Padua und nach Rom. Unterwegs war er auch am Hofe des Fürsten Mario Farnese in Parma tätig. 1628 finden wir ihn wieder in seiner Heimatstadt, wo er 1629 in die Lukasgilde aufgenommen wurde. Er stand in Diensten des Prinzen Friedrich Heinrich von Oranien, arbeitete mit an der Ausstattung seiner Schlösser in Honselaarsdijk und Rijswijk in den 1630er Jahren und erhielt weitere Aufträge für Fresken in den fünfziger und sechziger Jahren. Als Vorsteher der Delfter Lukasgilde fungierte er 1654, 1660 und 1664. 1669 befand er sich offensichtlich in dürftigen persönlichen Verhältnissen, da er als verarmter Bürger um Unterstützung ansuchte. Die meisten seiner erhaltenen Gemälde sind Historienbilder, oft religiösen Inhaltes. Er war auch ein produktiver Zeichner; am bekanntesten sind seine Illustrationen zu Livius und zu den Büchern des Alten und Neuen Testaments.

Die Zeichnung illustriert 2 Kön 2, 11–12: „Und als sie miteinander gingen und redeten, siehe, da kam ein feuriger Wagen mit feurigen Rossen, die schieden die beiden voneinander. Und Elija fuhr im Wetter gen Himmel. Elisa aber sah es und schrie: Mein Vater, mein Vater, du Wagen Israels und sein Gespann! und sah ihn nicht mehr. Da faßte er seine Kleider, zerriß sie in zwei Stücke." Im unteren Teil der Zeichnung sehen wir Elisa, wie er in erschrecktem Staunen niedersinkt und zu Elija im Feuerwagen aufblickt.

Unser Blatt ist Teil einer angeblich 56 Illustrationen umfassenden Folge religiöser Darstellungen, aus der sich 17 Zeichnungen im Courtauld Institute in London und zwei in der National Gallery of Canada in Ottawa befinden.

The Ascension of Elijah

Point of the brush, black ink, grey wash on grey paper
404 x 321 mm
Corner missing, lower right; holes upper left, lower left
Numbered in black ink, upper right: '45'
Given by John Tillotson, 1968. PD. 28–1968
Provenance: uncertain before Tillotson
Not previously exhibited

Bramer left Delft in 1614 to travel through France to Italy. He travelled through Artois, Amiens, Paris, Marseilles, Genoa, Leghorn, Venice, Florence, Mantua, Siena, Bologna, Naples, Padua and Rome, and whilst in Italy worked at the Court of Prince Mario Farnese in Parma. By 1628 he was back in Delft and was admitted to the Guild of St Luke there in 1629. He was patronised by Prince Frederick Henry of Orange and helped decorate his Palaces at Honselaarsdijk and at Rijswijk in the 1630s and continued to receive commissions for frescoes throughout the 1650s and 1660s. He was head of the Delft Guild of painters in 1654, 1660 and 1664. By 1669 he was clearly in straitened circumstances as he applied for funds as an impoverished citizen. Most of his surviving work consists of history painting, often of religious scenes. A prolific draughtsman, he is best known for his series of illustrations to Livy and to both the Old and New Testaments.

The subject comes from the Second Book of Kings II, 11/12. 'And it came to pass...that, behold, there appeared a chariot of fire, and horses of fire, and parted them both assunder; and Elijah went up by a whirlwind into heaven. And Elisha saw it and he cried, My father, my father, the chariot of Israel, and the horsemen thereof. And he saw him no more: and he took hold of his own clothes, and rent them in pieces.' Elisha is seen looking in wonder at Elijah in his chariot.

This is one of a series of drawings on religious themes. There are said to have been 56 in this series, seventeen of which are in the Courtauld Institute, London, and two in the National Gallery of Canada, Ottawa.

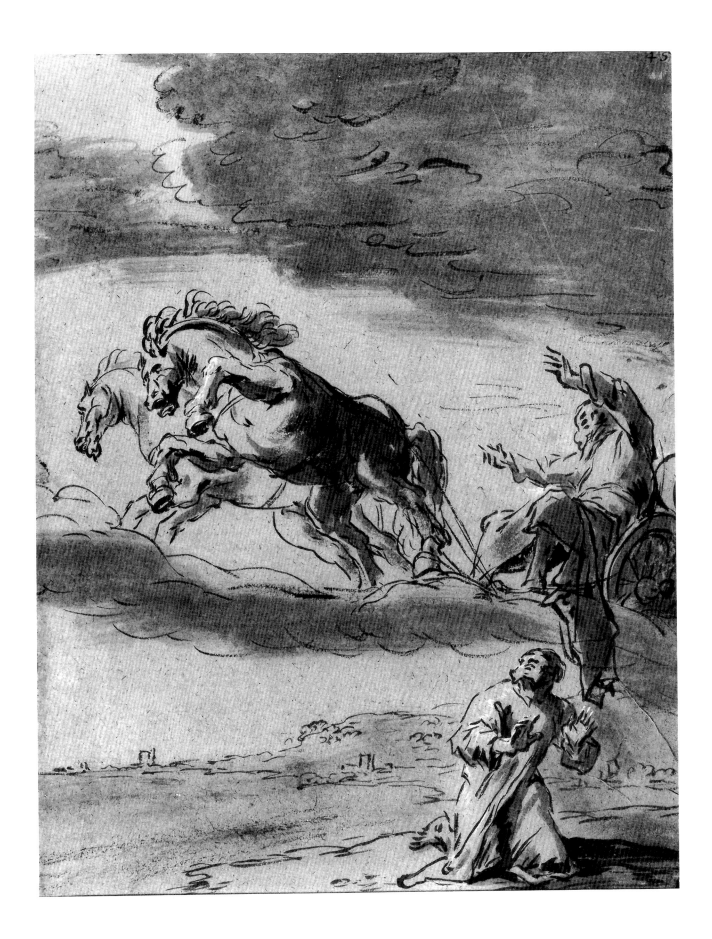

SAMUEL VAN HOOGSTRATEN
Dordrecht 1627–1678 Dordrecht

Lot und seine Töchter

Feder und braune Tusche, braune Lavierung, allseitig Randlinie
mit Pinsel in Braun
83 x 101 mm (Blattgröße unregelmäßig)
Vermächtnis Sir Bruce Ingram, 1963. PD. 416–1963
Provenienz: Marquis de Lagoy (Lugt 1710); Samuel Woodburn;
E. Utterson (Lugt 909); G. Clausen, R. A. (Lugt 539); Sir Robert
Mond (Lugt 2813 a); Basil Austin; Kunsthandlung P. & D. Colnaghi,
London; hier von Ingram (Lugt 1405 a) im Oktober 1952 erworben
Literatur: Tancred Borenius und Rudolf Wittkower, *Catalogue of the
Collection of Drawings . . . formed by Sir Robert Mond.* London 1937,
S. 106, Nr. 402, Taf. LXXI; Sumowski V, S. 2532, Nr. 1138*
Ausstellungen: Cambridge 1966, Nr. 33; Cambridge 1980 (o. Kat.)

Samuel van Hoogstraten erhielt seine erste künstlerische Aus-
bildung im Atelier seines Vaters Dirck van Hoogstraten (um
1596–1640) und arbeitete anschließend in Amsterdam bei Rem-
brandt, wo er auch Carel Fabritius (1622–1654) und Abraham
Furnerius (um 1628–1654) traf. 1648 kehrte er nach Dordrecht
zurück. 1651 finden wir ihn in Wien, wo er bis 1654 blieb, abge-
sehen von einem Rombesuch im Jahre 1652. Von 1654 bis 1662
war er wieder in Dordrecht ansässig, 1662 ließ er sich in London
nieder, wo er bis 1666 lebte. 1668–1671 war er Mitglied der
Lukasgilde in Den Haag. Die letzten sieben Lebensjahre, ab
1671, verbrachte er schließlich wieder in Dordrecht. Von ihm
stammt als bedeutendes kunsttheoretisches Werk *Inleyding tot de
Hooge Schoole der Schilderkonst* (Einführung in die Hohe Schule
der Malkunst), erschienen 1678. Anfänglich stand er stark unter
dem Einfluß Rembrandts, während seine späteren Arbeiten eher
Pieter de Hooch (1629–nach 1684) verpflichtet sind. Am
bekanntesten wurde er als Maler biblischer Historienbilder, er
fertigte aber auch Portraits, Genrebilder und ideale, die Per-
spektive betonende Architekturentwürfe. Darüber hinaus war er
als Radierer und produktiver Zeichner tätig. Zu seinen Schülern
zählen Godfried Schalken (1643–1706), Aert de Gelder
(1645–1727) und der Maler und Kunsthistoriker Arnold Hou-
braken (1660–1719).

Die Zeichnung illustriert Gen 19,33. Die Zuschreibung von
Borenius/Wittkower an Gerbrand van den Eeckhout (1621–
1674) läßt sich nicht halten, auch gibt es keinerlei Hinweise
dafür, daß Rembrandt das Blatt überarbeitet hätte. Sumowski
bestätigt Cormacks Zuweisung an Hoogstraten und datiert
unsere Zeichnung in die Mitte der vierziger Jahre.

Lot and his daughters

Pen and brown ink, brown wash, bordered on all sides by a line
of brown wash
83 x 101 mm, irregular
Bequeathed by Sir Bruce Ingram, 1963. PD. 416–1963
Provenance: Marquis de Lagoy (Lugt 1710); Samuel Woodburn;
E. Utterson (Lugt 909); G. Clausen, R. A. (Lugt 539); Sir Robert
Mond (Lugt 2813 a); Basil Austin; with P. & D. Colnaghi, London,
from whom bought by Ingram (Lugt 1405 a), October 1952
Literature: Tancred Borenius and Rudolf Wittkower, *Catalogue of the
Collection of Drawings . . . formed by Sir Robert Mond*, London, 1937,
p. 106, no. 402, repr. pl. LXXI; Sumowski, V, p. 2532, no. 1138*
Exhibited: Cambridge, 1966, no. 33; Cambridge, 1980 (no handlist)

Hoogstraten studied with his father, Dirck van Hoogstraten
(c.1596–1640) and then worked in Rembrandt's studio, where
he met Carel Fabritius (1622–1654) and Abraham Furnerius
(c.1628–1654). In 1648 he returned from Amsterdam to Dord-
recht. He travelled to Vienna in 1651 where, apart from a visit
to Rome in 1652, he was based until 1654 when he returned to
Dordrecht. In 1662 he moved to London where he stayed until
1666. He is recorded as a member of the Painters' Guild in The
Hague from 1668/71, when he went back to Dordrecht, where
he spent the rest of his life. His *Inleyding tot de Hooge Schoole der
Schilderkonst* (Introduction to the August Academy of Painting),
an important work on art theory, was published in 1678. Initially
much influenced by Rembrandt, his later work is indebted
to Pieter de Hooch (1629–after 1684). He is best known as a
painter of Biblical history paintings, but was also active as a por-
traitist, and painted genre scenes and idealised architectural
designs emphasizing perspective. He made etchings and was a
prolific draughtsman. Amongst his pupils were Godfried Schal-
ken (1643–1706), Aert de Gelder (1645–1727) and the pain-
ter / art historian Arnold Houbraken (1660–1719).

The subject is taken from Genesis XIX, 33. Borenius / Wittko-
wer's attribution to Gerbrand van den Eeckhout (1621–1674) is
unjustified, nor is there any reason to assume that it was retou-
ched by Rembrandt. Sumowski confirms Cormack's attribution
to Hoogstraten and dates the drawing in the mid-1640s.

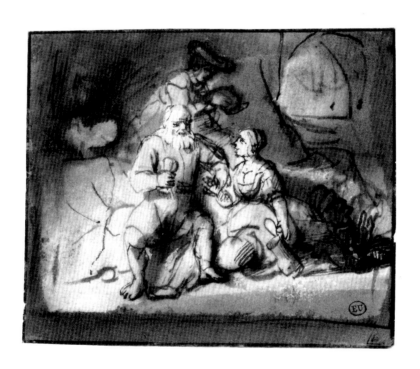

SAMUEL VAN HOOGSTRATEN
Dordrecht 1627–1678 Dordrecht

Abraham und die drei Männer im Hain von Mamre

Feder und braune Tusche, braune Lavierung, weiß gehöht
117 x 208 mm (oben bogig geschnitten)
Vermächtnis Sir Bruce Ingram, 1963. PD. 417–1963
Provenienz: John Barnard (Lugt 1420); dessen Versteigerung, Greenwood, London, 16. Februar 1787, wahrscheinlich Lot 47; Pierre Fouquet Jr.; dessen Versteigerung, 13. April 1801, Lot 13; T. Thane (Lugt 2461); dessen Versteigerung Leigh and Sotheby, London, 27. Mai 1846, Teil von Lot 176 oder 844; P. Langerhuizen Lzn. (Lugt 2095); Auktion Langerhuizen, Amsterdam, 29. April 1919, Lot 397, erworben von Muller; Auktion Comte de Robiano u. a., Muller, Amsterdam, 15. Juni 1926, Lot 387, nicht verkauft; A. W. M. Mensing; Auktion Mensing, Amsterdam, 27. April 1937, Lot 272; Kunsthandlung P. & D. Colnaghi, London; hier von Ingram (Lugt 1405 a) im Dezember 1937 erworben
Literatur: Wilhelm R. Valentiner, *Rembrandt. Des Meisters Handzeichnungen*, I. Stuttgart / Berlin 1925, S. XXIII (mit Abb.); Ders., Rembrandt and Samuel Hoogstraten. *Art in America* XVIII, 1933, S. 137; Sumowski V, S. 2610, Nr. 1176*
Ausstellungen: Oxford 1943 (o. Kat.); Cambridge, Fitzwilliam Museum, 1951/52 (o. Kat.); Montreal, Museum of Fine Arts, 1953, *Five Centuries of Drawing*, Nr. 136; Washington u. a. 1959/60, Nr. 49; Rotterdam / Amsterdam, 1961/62, Nr. 52; Cambridge 1966, Nr. 34; Wanderausstellung USA und Cambridge 1976/77, Nr. 46; Cambridge 1980 (o. Kat.)

Die Zeichnung illustriert Gen 18,10. Als sich unser Blatt in der Sammlung Langerhuizen befand, galt es als Arbeit Rembrandts. Mittlerweile ist es als charakteristisches Beispiel für die Zeichenkunst Samuel van Hoogstratens etabliert und wird von Sumowski um 1649 datiert. Er verweist auf eine Zeichnung des gleichen Themas im Dresdener Kupferstich-Kabinett (Sumowski V, Nr. 1175*) und sieht unser Blatt als deren Variante an. Im Unterschied zur Dresdener Zeichnung hebt Hoogstraten hier kompositorisch das Motiv des Dialoges zwischen Sara und dem Engel hervor, der Abraham versprach, daß die beiden Hochbetagten übers Jahr einen Sohn haben würden, worauf Sara „bei sich selbst" lachte. Doch: „Sollte dem Herrn etwas unmöglich sein? ... Da leugnete Sara und sprach: Ich habe nicht gelacht –, denn sie fürchtete sich. Aber er sprach: Es ist nicht so, du hast gelacht" (Vers 15).

Abraham entertaining the Angels

Pen and brown ink, brown wash, heightened with white
117 x 208 mm, arched top
Bequeathed by Sir Bruce Ingram, 1963. PD. 417–1963
Provenance: John Barnard (Lugt 1420), his sale, London, Greenwood, 16 February 1787, probably lot 47; Pierre Fouquet Jr, his sale, 13 April 1801, lot 13; T. Thane (Lugt 2461), his sale, London, Leigh and Sotheby, 27 May 1846, part of lot 176 or 844; P. Langerhuizen Lzn. (Lugt 2095), his sale, Amsterdam, 29 April 1919, lot 397, bought Muller; Count de Robiano and others, sale, Amsterdam, Muller, 15 June 1926, lot 387, unsold; A. W. M. Mensing, his sale, Amsterdam, 27 April 1937, lot 272; with P. & D. Colnaghi, London, from whom bought by Ingram (Lugt 1405 a), December 1937
Literature: Wilhelm R. Valentiner, *Rembrandt. Des Meisters Handzeichnungen*, I, Stuttgart, Berlin, 1925, p. xxiii, repr; W. R. Valentiner, 'Rembrandt and Samuel Hoogstraten', *Art in America*, XVIII, 1933, p. 137; Sumowski, V, p. 2610, no. 1176*
Exhibited: Oxford, 1943 (no handlist); Cambridge, Fitzwilliam Museum, 1951/52 (no handlist); Montreal, Museum of Fine Arts, 1953, *Five Centuries of Drawing*, no. 136; Washington and American Tour, 1959/60, no. 49; Rotterdam / Amsterdam, 1961/62, no. 52; Cambridge, 1966, no. 34; American Tour and Cambridge, 1976/77, no. 46; Cambridge, 1980 (no handlist)

The subject is taken from Genesis XVIII, 10. Attributed to Rembrandt when in the Langerhuizen collection, the drawing is a characteristic example of Hoogstraten's style, dated by Sumowski c.1649. He observes that it is a variant of a drawing in Dresden (Sumowski, V, no. 1175*) of the same subject, but notes that here the emphasis is on the conversation between Sarah and the angels, after she had overheard them telling Abraham that despite her great age she would bear a son: '..then Sarah denied, saying, I laughed not; for she was afraid. And he said, Nay; but thou didst laugh'.

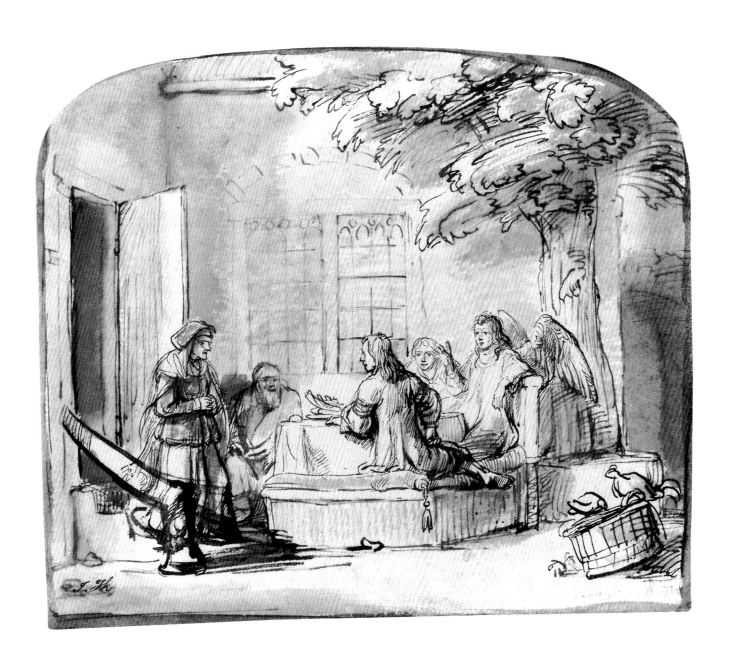

PIETER LASTMAN
Amsterdam 1583–1633 Amsterdam

Anbetung der Hirten

Feder und braune Tusche, rötlich-braun und blau aquarelliert,
über Spuren schwarzer Kreide
302 x 267 mm
Unten rechts in brauner Tusche bezeichnet ‚P Lastman', PL ligiert
Vermächtnis Sir Bruce Ingram, 1963. PD. 445–1963
Provenienz: Sir Peter Lely (Lugt 2092); Dr. E. Peart (Lugt 891); des-
sen Versteigerung, Christie's, London, 12. April 1822, wahrscheinlich
Teil von Lot 5, 6 oder 8; P. Huart (?) (Lugt 2084); R. P. Roupell (Lugt
2234); Auktion Roupell, Christie's, London, 12. Juli 1887, Lot 874;
R. Campbell; Sir Bruce Ingram (Lugt 1405 a)
Literatur: Kurt Bauch, Handzeichnungen Pieter Lastmans. *Münchner
Jahrbuch der bildenden Kunst*, 3. Folge, III-IV, 1952/53, S. 223; Astrid
Tümpel, Claes Cornelisz. Moeyaert. *Oud Holland* 88, 1974, S. 36,
Abb. 37; Dies., The Stylistic Development and Significance of the
Pre-Rembrandtists. Ausstellungskatalog *The Pre-Rembrandtists*,
Sacramento 1974, S. 16
Ausstellungen: London, Grosvenor Gallery, 1878/79, *Drawings by Old
Masters*, Nr. 377; Washington u. a. 1959/60, Nr. 53;
Rotterdam / Amsterdam 1961/62, Nr. 56; Cambridge 1966, Nr. 35;
Wanderausstellung USA und Cambridge, 1976/77, Nr. 77; Amster-
dam, Het Rembrandthuis, 1991, *From Titian to Rembrandt. Artistic
Relations between Amsterdam and Venice. Prints and Drawings*, Nr. 52;
Amsterdam, Het Rembrandthuis, 1991/92, *Pieter Lastman, Leermeester
van Rembrandt*, Nr. 27

Pieter Lastman erhielt seine Ausbildung als Maler im Atelier des
Gerrit Pietersz. Sweelinck (1566–vor 1616), eines Schülers von
Cornelis Cornelisz. van Haarlem (1562–1638). Um 1602 war er
in Italien, wo er sich hauptsächlich in Rom aufhielt und sich
hier dem Kreis um Adam Elsheimer (1578–1610) anschloß.
1607 kehrte er nach Amsterdam zurück. Zu seinen Schülern
gehörten 1617 Jan Lievens (1607–1674) und 1622/23 Rem-
brandt (1606–1669). Er starb unverheiratet.

Lastmans Nachlaßinventar von 1632 erwähnt eine Kiste voll
von Pferdezeichnungen, eine Reihe von Rötelzeichnungen und
zehn Skizzenbücher. Heute sind nur noch 14 Zeichnungen von
seiner Hand bekannt, von denen zwei mit seinem Italienaufent-
halt zusammenhängen: *Blick auf den Palatin in Rom*, datiert 1606
(Auktion Christie's, Amsterdam, 12. November 1990, Lot 5),
und unser Blatt. Dieses ist eine ziemlich genaue Wiedergabe der
Anbetung der Hirten von Paolo Veronese (1528–1588), die sich
in Venedig damals in der Chiesa dei Crociferi befand und seit
1786 in SS. Giovanni e Paolo bewahrt wird. Unsere Zeichnung
wurde lange Veronese selbst zugeschrieben, aber die alte
Bezeichnung „P Lastman" weist den richtigen Autor aus. Jacob
Matham (1571–1631) hat Veroneses Anbetung gestochen
(Hollstein 37; verlegt 1621), aber da Lastmans Zeichnung dem
Original getreuer folgt als der Stich, kann man annehmen, daß
dieser die Zeichnung vor dem Original anfertigte und daher in
Venedig gewesen sein muß. Die Zeichnung illustriert Lk 2, 8 ff.

The Adoration of the Shepherds

Pen and brown ink, reddish-brown and blue wash, over traces of black
chalk
302 x 267 mm
Inscribed in brown ink, lower right: 'P Lastman', P and L conjoined
Bequeathed by Sir Bruce Ingram, 1963. PD. 445–1963
Provenance: Sir Peter Lely (Lugt 2092); Dr E. Peart (Lugt 891), his
sale, London, Christie's, 12 April 1822, probably part of lot 5,6 or 8;
P. Huart (?) (Lugt 2084); R. P. Roupell (Lugt 2234), his sale, London,
Christie's, 12 July 1887, lot 874; R. Campbell; Ingram (Lugt 1405 a)
Literature: K. Bauch, 'Handzeichnungen Pieter Lastmans', *Münchner
Jahrbuch der bildenden Kunst*, 3rd series, III/IV, 1952/53, p. 223; Astrid
Tümpel, 'Claes Cornelisz. Moeyaert', *Oud Holland*, 88, 1974, p. 36,
fig. 37; A. Tümpel, 'The Stylistic Development and Significance of
the Pre-Rembrandtists', Exhib. Cat. ‚*The Pre-Rembrandtists*, Sacra-
mento, 1974, p. 16
Exhibited: London, Grosvenor Gallery, 1878/79, *Drawings by Old
Masters*, no. 377; Washington and American Tour, 1959/60, no. 53;
Rotterdam / Amsterdam, 1961/62, no. 56; Cambridge, 1966, no. 35;
American Tour and Cambridge, 1976/77, no. 77; Amsterdam, Het
Rembrandthuis, 1991, *From Titian to Rembrandt. Artistic Relations
between Amsterdam and Venice. Prints and Drawings*, no. 52; Amster-
dam, Het Rembrandthuis, 1991/92, *Pieter Lastman, Leermeester van
Rembrandt*, no. 27

Lastman studied with Gerrit Pietersz. (Sweelinck) (1566–before
1616), a pupil of Cornelis Cornelisz. van Haarlem (1562–1638).
He visited Italy c.1602, where he was based in Rome and came
under the influence of Adam Elsheimer (1578–1610); he re-
turned to Amsterdam in 1607. Amongst his pupils, the most
notable were Jan Lievens (1607–1674) in 1617 and Rembrandt
(1606–1669) in 1622/23. He died unmarried.

Although the inventory of his possessions drawn up in 1632
mentions a box full of drawings of horses, a quantity of red draw-
ings and ten books of drawings, only fourteen drawings are now
known by him. Two of these can be dated to his period in Italy,
a *View of the Palatine Hill in Rome*, dated 1606 (sold Christie's,
Amsterdam, 12 November 1990, lot 5) and the Fitzwilliam
example. This is a fairly close approximation of the composition
of a painting by Paolo Veronese (1528–1588) formerly in the
Church of the Crociferi and now in the Church of SS Giovanni
e Paolo in Venice (since 1786). The drawing was previously
attributed to Veronese himself, but the old attribution to Last-
man correctly identifies the artist. A print by Jacob Matham
(1571–1631) after the painting exists, published in 1621 (Holl-
stein 37), but that is less true to the painting than Lastman's
drawing, so it can be assumed that Lastman based his copy on
the painting itself and that he must have visited Venice. The
subject is taken from Luke II, 8ff.

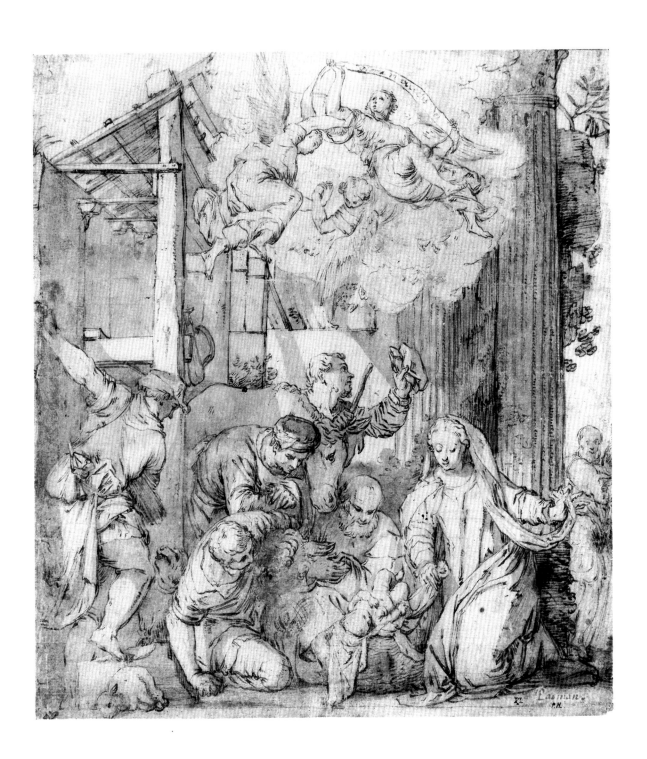

NICOLAES MAES
Dordrecht 1634–1693 Amsterdam

Joseph erzählt seine Träume

Feder und braune Tusche, braune Lavierung, allseitig Randlinie
mit Pinsel in Braun
199 x 320 mm
Vermächtnis Sir Bruce Ingram, 1963. PD. 837–1963
Provenienz: Jan Hulswit (?); dessen Versteigerung, Amsterdam,
28. Oktober 1822, Lot 46 (als Rembrandt); Jacob de Vos (Lugt 1450);
Auktion de Vos, Muller, Amsterdam, 22.–24. Mai 1883, Lot 188;
A. W. M. Mensing; Auktion Mensing, Amsterdam, 27.–29. April 1937,
Lot 573; Kunsthandlung P. & D. Colnaghi, London; hier von Ingram
(Lugt 1405 a) im September 1937 erworben
Literatur: Keith Roberts, Current and forthcoming Exhibitions. *The
Burlington Magazine* XCVII, 1966, S. 216, Abb. 61; Sumowski VIII,
S. 4280, Nr. 1913*
Ausstellungen: Washington u. a. 1959/60, Nr. 89; Cambridge 1966,
Nr. 45; Cambridge 1980 (o. Kat.)

Unser Blatt wurde ursprünglich Aert de Gelder (1645–1727)
und dann Jan Victors (um 1619/20 – nach 1679) zugeschrieben;
Sumowski (a. a. O.) reiht es in eine Gruppe von Zeichnungen
ein, die er die „Pseudo-Victors-Gruppe" nennt und Nicolaes
Maes zuweist. Die Zeichnung illustriert Gen 37,10, wo Joseph
von seinem Traum erzählt, in dem sich Sonne und Mond und elf
Sterne vor ihm neigten: „Und als er das seinem Vater und seinen
Brüdern erzählte, schalt ihn sein Vater und sprach zu ihm: Was
ist das für ein Traum, den du geträumt hast? Soll ich und deine
Mutter und deine Brüder kommen und vor dir niederfallen?"
(Vers 10). Wie Cormack bemerkt, setzt unser Blatt die Kenntnis
sowohl von Rembrandts Radierung von 1638 (Bartsch 37) als
auch der dazu gehörenden Grisaille im Rijksmuseum in Amster-
dam voraus. Eine Variante der Komposition befindet sich in
Darmstadt (Sumowski VIII, Nr. 1914*). Sumowski gibt keine
genaue Datierung der ausgestellten Zeichnung, weist aber darauf
hin, daß Maes noch um 1655 in dieser Manier arbeitete.

Joseph recounting his dreams

Pen and brown ink, brown wash, bordered on all sides by a line of
brown wash
199 x 320 mm
Bequeathed by Sir Bruce Ingram, 1963. PD. 837–1963
Provenance: ?Jan Hulswit, his sale, Amsterdam, 28 October 1822, lot
46 (as Rembrandt); Jacob de Vos (Lugt 1450), his sale, Amsterdam,
Muller, 22–24 May 1883, lot 188; A. W. M. Mensing, his sale, Amster-
dam, 27–29 April 1937, lot 573; with P. & D. Colnaghi, London, from
whom bought by Ingram (Lugt 1405 a), September 1937
Literature: Keith Roberts, 'Current and forthcoming Exhibitions',
The Burlington Magazine, XCVII, 1966, p. 216, repr. fig. 61; Sumowski,
VIII, p. 4280, no. 1913*
Exhibited: Washington and American Tour, 1959/60, no. 89; Cam-
bridge, 1966, no. 45; Cambridge, 1980 (no handlist)

Previously attributed to Aert de Gelder (1645–1727) and then
to Jan Victors (c.1619/20–after 1676), this is one of a group of
drawings which Sumowski (*op. cit.*) refers to as the 'Pseudo-Vic-
tors' group all of which he attributes firmly to Nicolaes Maes.
The scene is taken from Genesis XXXVII,10, after Joseph had
dreamed that the sun and the moon and the eleven stars made
obeisance to him: 'And he told it to his father and to his breth-
ren: and his father rebuked him, and said unto him, What is this
dream that thou hast dreamed? Shall I and thy mother and thy
brethren indeed come to bow down ourselves to thee to the
earth?' As Cormack noted, it presupposes knowledge of Rem-
brandt's etching of 1638 (Bartsch 37) and the grisaille belonging
to it in the Rijksmuseum, Amsterdam. A variant of the compo-
sition is at Darmstadt (Sumowski, VIII, no. 1914*). Sumowski
does not date the series exactly but comments that Maes was still
drawing in this manner in c.1655.

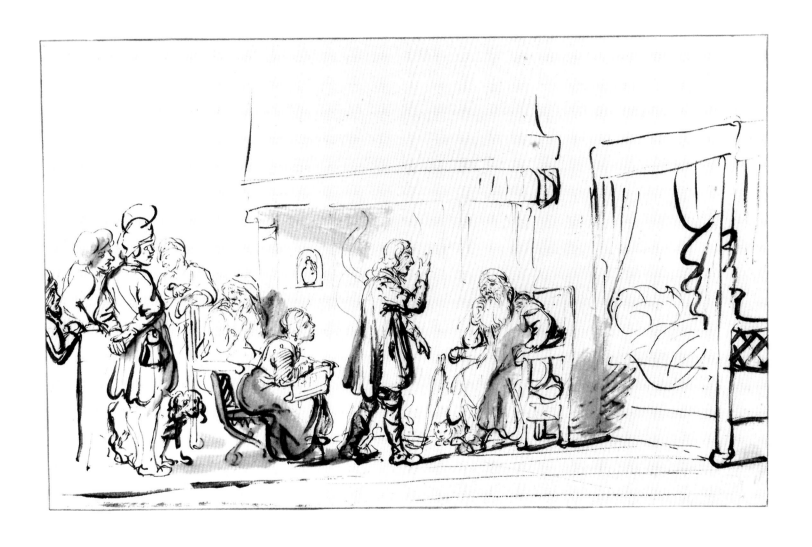

CLAES CORNELISZ. MOEYAERT
Durgerdam 1590/91–1655 Amsterdam

Jakobs Kampf mit dem Engel

Feder, braune Tusche, braune Lavierung, weiß gehöht, über Graphit
150 x 220 mm
Tintenfraß an einigen Stellen, Ausbesserungen
Gestiftet von G. T. Clough, 1913. Nr. 3192
Provenienz: G. T. Clough (aus unbekannter Sammlung)
Literatur: *List of the Old Master Drawings in the G. T. Clough Gift.*
Ms. 1913, S. 15; *cf.* Astrid Tümpel, Claes Cornelisz. Moeyaert.
Oud Holland 88, 1974, S. 1–163 und 245–290
Ausstellung: Cambridge 1980 (o. Kat.)

Im Alter von vierzehn Jahren kam Claes Cornelisz. Moeyaert aus Durgerdam nach Amsterdam, aber wir wissen nicht, bei wem er gelernt hat. 1617 heiratete er Grete Claes. In den dreißiger und vierziger Jahren erhielt er zahlreiche Aufträge, und es ist nachgewiesen, daß er bei seinem Tode ein reicher Mann war. 1640 und 1641 gehörte er dem Vorstand des Amsterdamer Theaters an. Moeyaert ist als Radierer, Maler und Zeichner bekannt. Zu seinen Schülern gehörte Nicolaes Berchem (1620–1683).

Unser Blatt galt ehemals als Arbeit Claude Lorrains (1600–1682); die Zuschreibung an Moeyaert, die mittlerweile allgemein akzeptiert ist, nahm 1931 als erster van Regteren Altena vor. Die Zeichnung illustriert Gen 32,25–29: „Da rang ein Mann mit ihm, bis die Morgenröte anbrach. Und als er sah, daß er ihn nicht übermochte, schlug er ihn auf das Gelenk seiner Hüfte, und das Gelenk der Hüfte Jakobs wurde über dem Ringen mit ihm verrenkt. Und er sprach: Laß mich gehen, denn die Morgenröte bricht an. Aber Jakob antwortete: Ich lasse dich nicht, du segnest mich denn. Er sprach: Wie heißest du? Er antwortete: Jakob. Er sprach: Du sollst nicht mehr Jakob heißen, sondern Israel; denn du hast mit Gott und mit Menschen gekämpft und hast gewonnen."

Die Zeichnung muß aus einer frühen Phase Moeyaerts stammen, da sie noch den Einfluß Adam Elsheimers (1578–1610) verrät. Sie ist zwar keine direkte Vorzeichnung, aber doch die Grundlage für einen Stich (Hollstein 13) im Gegensinn, erschienen als vierte Tafel in Moeyaerts *Geschichte Jakobs* mit deutlich detaillierterer Landschaft. Man kann davon ausgehen, daß zwischen unserem Blatt und dem Kupferstich noch eine weitere Vorzeichnung angefertigt wurde.

Jacob wrestling with the angel

Pen and brown ink, brown wash, heightened with white, over graphite
150 x 220 mm
Several repairs, where the ink has bitten through the paper
Given by G. T. Clough, 1913. No. 3192
Provenance: unknown before Clough
Literature: *Mss. list of the Old Master Drawings in the G. T. Clough Gift,* 1913, p. 15; *cf.* Astrid Tümpel, 'Claes Cornelisz. Moeyaert', *Oud Holland,* 88, 1974, pp. 1–163, 245–290
Exhibited: Cambridge, 1980 (no handlist)

At the age of 14 Moeyaert moved from Durgerdam to Amsterdam, but we do not know with whom he studied. In 1617 he married Grete Claes. He received many commissions in the 1630s and 1640s and there is evidence that he died a wealthy man. In 1640 and 1641 he was a member of the Amsterdam theatre board. Moeyaert is known for his etchings as well as his paintings and drawings. Amongst his pupils was Nicolaes Berchem (1620–1683).

Previously attributed to Claude Lorrain (1600–1682), the attribution to Moeyaert, which has been accepted universally, was proposed first by van Regteren Altena in 1931. The subject is taken from Genesis XXXII, 24ff.: 'And Jacob was left alone; and there wrestled a man with him until the breaking of the day. And when he saw that he prevailed not against him, he touched the hollow of his thigh; and the hollow of Jacob's thigh was out of joint, as he wrestled with him. And he said, Let me go, for the day breaketh. And he said, I will not let thee go, except thou bless me. And he said unto him, What is thy name? And he said, Jacob. And he said, Thy name shall be called no more Jacob, but Israel: for as a prince hast thou power with God and with men and hast prevailed.'

The drawing must date from the earlier part of Moeyaert's career, showing the influence on him of Adam Elsheimer (1578–1610). Although the drawing is not incised it is the basis of the engraving (Hollstein 13), plate 4 of Moeyaert's *History of Jacob,* which is in the opposite direction and has a much more detailed landscape. One can presuppose that another drawing was made intermediate between this preliminary idea and the completed print.

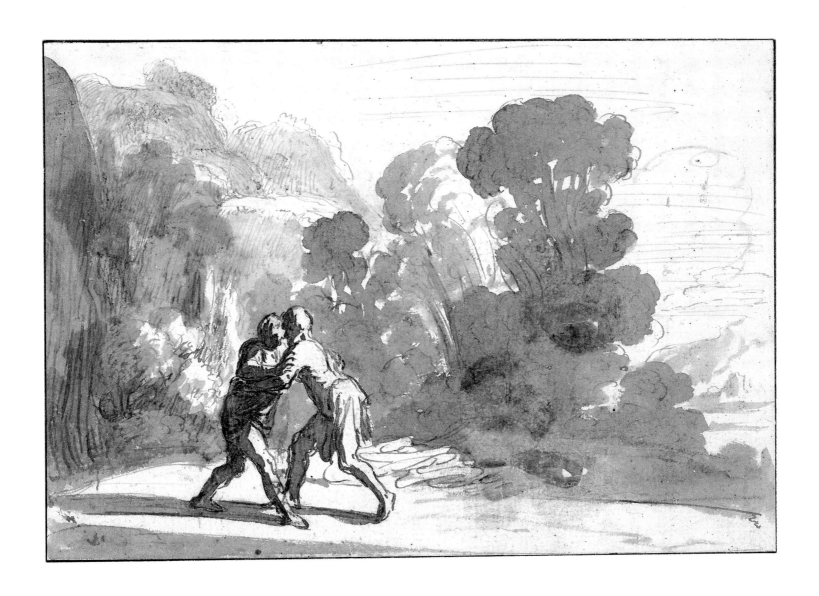

CLAES CORNELISZ. MOEYAERT
zugeschrieben / attributed to
Durgerdam 1590/91–1655 Amsterdam

Hiob in der Asche

Feder und braune Tusche, graubraune Lavierung über Graphit
148 x 157 mm
Ecken oben links, unten links und oben rechts ergänzt; in der oberen Mitte alter Einriß
Unten rechts in brauner Tusche numeriert ‚2‘,
verso bezeichnet ‚by van Vliet‘
Vermächtnis Sir Bruce Ingram, 1963. PD. 882–1963
Provenienz: Sir Bruce Ingram (Lugt 1405 a) (aus unbekannter Sammlung)
Bisher noch nicht öffentlich ausgestellt

Die alte Zuschreibung an Jan Jorisz. van Vliet (tätig um 1628–1637), einen Schüler Rembrandts, ist nicht haltbar, wie Martin Royalton-Kish als erster beobachtete. Als Alternativen schlug er Moses van Uytenbroeck (um 1590–1648), eventuell Gerrit Bleker (gest. 1656) und Moeyaert vor. Royalton-Kishs Hinweise bestätigen sich im Vergleich mit Uytenbroecks *Abraham und Isaak* (Berlin, Kupferstichkabinett, KdZ 14 067) und mit Blekers *Predigt Johannes des Täufers* (London, Courtauld Institute, Witt Library, Nr. 4142). Obwohl eine Zuschreibung an Bleker nicht ausgeschlossen werden kann, steht unser Blatt Moeyaert stilistisch näher. Es illustriert sehr wahrscheinlich Hiob 2,8: „Und er nahm eine Scherbe und schabte sich und saß in der Asche."

Job lying in the ashes

Pen and brown ink, grey-brown wash over graphite
148 x 157 mm
Corners replaced upper left, lower left, upper right. An old tear left of centre
Numbered in brown ink, lower right: '2';
inscribed *verso*: 'by van Vliet'
Bequeathed by Sir Bruce Ingram, 1963. PD. 882–1963
Provenance: unknown before Ingram (Lugt 1405 a)
Not previously exhibited

The attribution to Jan Jorisz. van Vliet (active *c.* 1628–1637), one of Rembrandt's pupils is untenable as Martin Royalton-Kish first observed. He proposed alternative attributions to Moses van Uytenbroeck (*c.* 1590–1648) or perhaps Gerrit Bleker (died 1656) or Moeyaert. Comparisons with Uytenbroeck's *Abraham and Isaac* at Berlin (Kupferstichkabinett, KdZ 14067) and with Bleker's *Preaching of St John the Baptist* in the Witt Collection, London (no. 4142) show the justice of Royalton-Kish's alternative proposals. On balance, although an attribution to Bleker is not impossible, the drawing is closer, stylistically, to Moeyaert. The subject may represent Job, lying in the ashes (Job II, 8).

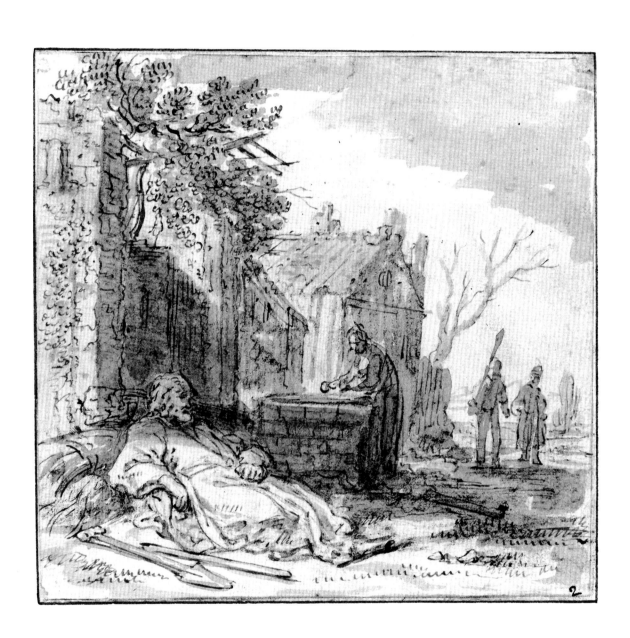

CLAES CORNELISZ. MOEYAERT
Durgerdam 1590/91–1655 Amsterdam

Die Anbetung des Lammes

Feder und braune Tusche, braune Lavierung, weiß gehöht,
über Spuren von Graphit
447 x 354 mm
Unten links in brauner Tusche monogrammiert und datiert
‚CL M. fe 1651'
Gestiftet von Sir Frank Brangwyn, R. A., 1943. Nr. 2602
Provenienz: A. Chariatte (Lugt 88 a); Sir Frank Brangwyn
Literatur: Astrid Tümpel, Claes Cornelisz. Moeyaert. *Oud Holland* 88,
1974, S. 269, s. v. Nr. 192, Abb. 264
Ausstellung: Cambridge 1980 (o. Kat.)

Unsere Zeichnung ist eine Vorstudie für das früher Adriaen van Nieulandt (1587–1658) zugeschriebene Gemälde im Pastorat der Sint Jacobskerk in Den Haag, ursprünglich für die dortige Neue Sakristei der Oude-Molstraat-Kerk geschaffen. Die zentrale Gestalt Johannes des Täufers weist auf das Lamm Gottes, das in der oberen linken Ecke erscheint. Maria thront in Anbetung zur Rechten des Lammes; hinter ihr erscheint der Chor der weiblichen Heiligen und Märtyrer, am rechten Rand unter ihnen Petrus, Paulus, Andreas, Stephanus und Laurentius und andere, nicht identifizierbare Heilige. Die Wolke unter den Füßen des Täufers stützend, halten Engel die Passionswerkzeuge und das Schweißtuch. Zur Linken thronen David, Moses mit den Gesetzestafeln und die vier Kirchenväter Hieronymus, Ambrosius, Augustinus und Gregor der Große. Unten weist ein Mönch einen Lahmen auf die Vision hin, umgeben von zahlreichen Beobachtern dieses himmlischen Geschehens, die in staunender Verehrung nach oben blicken. Stilistisch hängt die Zeichnung deutlich von Bloemaert ab, insbesondere in der Darstellung der Figuren.

The Adoration of the Lamb

Pen and brown ink, brown wash, heightened with white,
over traces of graphite
447 x 354 mm
Signed with initials and dated in brown ink, lower left:
'CL [in monogram] M.fe 1651'
Given by Sir Frank Brangwyn, R. A., 1943. No. 2602
Provenance: A. Chariatte (Lugt 88 a); Sir Frank Brangwyn
Literature: Astrid Tümpel, 'Claes Cornelisz. Moeyaert', *Oud Holland*,
88, 1974, p. 269, *s.v.* no. 192, fig. 264
Exhibited: Cambridge, 1980 (no handlist)

A study for the painting, previously attributed to Adriaen van Nieulandt (1587–1658), now in the Pastorat der St Jacobskerk in The Hague, but originally commissioned for the New Sacristy in the Oude-Molstraat-Kerk in The Hague. The central figure of St John the Baptist points to the Lamb of God in the upper left corner. Mary is seated in adoration to the Lamb's right and beyond her is a line of female saints and martyrs, further down are St Peter, St Paul, St Andrew, St Stephen and St Lawrence with other unidentified saints. Below them, beneath the feet of the Baptist, are angels holding the Instruments of the Passion and the Vernicle. On the left are King David, Moses with the tablets of the Ten Commandments and the four Fathers of the Church, Jerome, Ambrose, Augustine and Gregory. Below a monk points out this vision to a crippled man and a multitude of people look upwards in astonished admiration. Stylistically this drawing depends strongly on Bloemaert's example, particularly in the drawing of the figures.

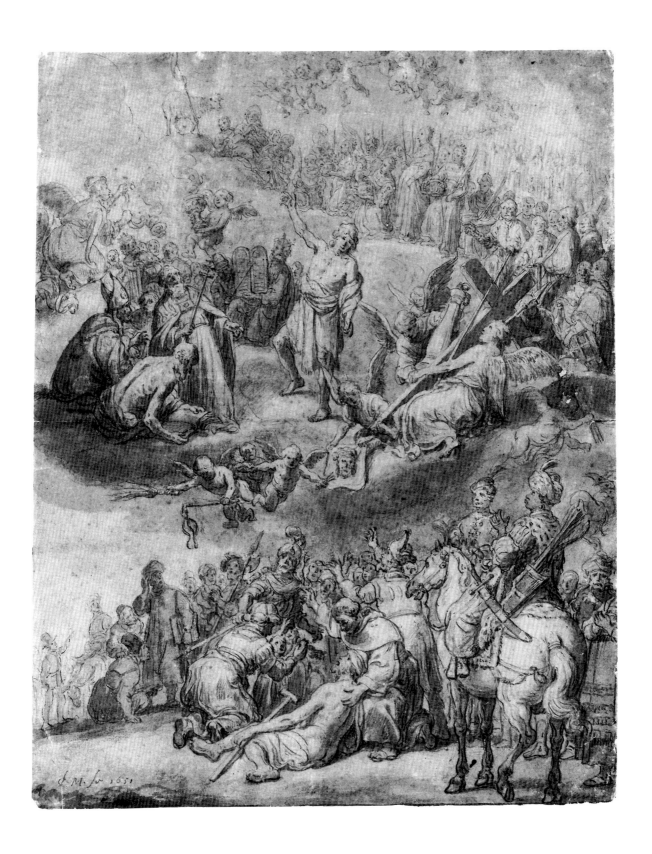

Das Mahl zu Emmaus

Feder und braune Tusche, braune Lavierung, weiß gehöht, allseitig
Randlinie mit Pinsel in Braun
199 x 182 mm
Verso in brauner Tusche bezeichnet ‚Rembrant [sic]‘ und numeriert
‚2328‘; in ähnlicher Handschrift auf der alten Montierung
‚de Emausgangers‘
Vermächtnis Charles Shannon, R. A., 1937. Nr. 2139
Provenienz: Frans van de Velde; dessen Versteigerung, Amsterdam,
16. Januar 1775, Lot 146, erworben von Grebe; J. Goll van Francken-
stein; dessen Versteigerung, Amsterdam, Juli 1833, erworben von de
Vries; J. L. C. van den Berch de Heemstede; Auktion van den Berch de
Heemstede, Muller, Amsterdam, 19. Januar 1904, Lot 291, erworben
von Kunsthandlung Artaria, Wien; möglicherweise Edward Cichorius;
Eisler (?); Versteigerung Christie's, London, unbekannten Datums;
Charles Ricketts und Charles Shannon
Literatur: C. Hofstede de Groot, *Quellenstudien zur holländischen
Kunstgeschichte*. Den Haag 1893, I, S. 193; *Onze Kunst* 3, 1904, S. 91;
Hind I, s. v. 137; *Vasari Society*, Second Series, 1920, Nr. 7; Heinrich
Wichmann, Ein verschollener Rembrandt. *Festschrift für Adolph Gold-
schmidt*. Leipzig 1923, S. 102 ff.; A. M. Hind, *Old Master Drawings* III,
1928, S. 42; Wilhelm R. Valentiner, *Rembrandt. Des Meisters Hand-
zeichnungen*, II. Stuttgart / Berlin 1934, Nr. 528; Arthur M. Hind, *Rem-
brandt*. London 1932, S. 64, Abb. Taf. XLIII; W. Stechow, Rembrandts
Darstellungen des Emmausmahles. *Zeitschrift für Kunstgeschichte* 3,
1934, S. 329 ff.; I. Q. van Regteren Altena, Rembrandt's way to
Emmaus. *Kunstmuseets Årsskrift*, 1948/49, S. 12, Abb. 9; H. M. Roter-
mund, Begegnungen mit dem Auferstandenen. *Die Neue Schau*, März
1951, S. 62, Abb. Umschlag; S. Slive, *Rembrandt and his Critics*. Den
Haag 1953, S. 178, Nr. 3, S. 179, Nr. 1 und Abb. 43; Benesch IV, C. 47,
Abb. 1017; Jakob Rosenberg, Besprechung. *The Art Bulletin* XLI, 1959,
S. 116; Hans-Martin Rotermund, *Rembrandt's Handzeichnungen und
Radierungen zur Bibel*. Stuttgart 1963, S. 266, Taf. 245; H. van de
Waal, Rembrandt's Faust Etching. *Oud Holland* 79, 1964, S. 41; Aus-
stellungskatalog Chicago, The Art Institute, *Rembrandt after 300
Years*, 1969/70, Nr. 122; C. van Hasselt, *Rembrandt and his century*.
Ausstellungskatalog Paris / New York 1977/78, S. 126, Anm. 5; J. G. van
Gelder, Falconet op bezoek bij de Goll van Franckensteins. *De kroniek
van het Rembrandthuis*, 1979, S. 2 ff.
Ausstellungen: Leiden 1850; London, Royal Academy, 1929, *Dutch
Art*, Nr. 589; London 1938, Nr. 554; Cambridge 1966, Nr. 4;
Cambridge, Fitzwilliam Museum, 1979, *All for Art*, Nr. 165; Wander-
ausstellung USA 1989/90, Nr. 88
Nachstiche: Radierung mit Aquatinta von J. Buys, 1765; Kupferstich
von Ploos van Amstel und C. Josi in: *Collection d'Imitations de Dessins*,
1821, I

The Supper at Emmaus

Pen and brown ink, brown wash, heightened with white,
bordered on all sides by a line of brown wash
199 x 182 mm
Inscribed in brown ink, *verso*: 'Rembrant [sic]' and numbered: '2328';
on the old mount, in a similar hand: 'de Emausgangers'
Bequeathed by Charles Shannon, R. A., 1937. No. 2139
Provenance: Frans van de Velde, his sale, Amsterdam, 16 January
1775, lot 146, bought Grebe; J. Goll van Franckenstein, his sale,
Amsterdam, July 1833, bought de Vries; J. L. C. van den Berch de
Heemstede, his sale, Amsterdam, Muller, 19 January 1904, lot 291;
bought Artaria, Vienna; possibly Edward Cichorius; ?Eisler, sold, Lon-
don, Christie's, date unknown, bought Charles Ricketts and Charles
Shannon
Literature: C. Hofstede de Groot, *Quellenstudien zur holländischen
Kunstgeschichte*, The Hague, 1893, I, p. 193; *Onze Kunst*, 3, 1904, p. 91;
Hind, I, *s.v.* 137; *Vasari Society*, Second Series, 1920, no. 7; Heinrich
Wichmann, 'Ein verschollener Rembrandt', *Festschrift für Adolph Gold-
schmidt*, Leipzig, 1923, p. 102 ff.; A. M. Hind, *Old Master Drawings*, III,
1928, p. 42; Wilhelm R. Valentiner, *Rembrandt. Des Meisters Hand-
zeichnungen*, II, Stuttgart, Berlin, 1934, no. 528; Arthur M. Hind, *Rem-
brandt*, London, 1932, p. 64, repr. pl. XLIII; W. Stechow, 'Rembrandts
Darstellungen des Emmausmahles', *Zeitschrift für Kunstgeschichte*, 3,
1934, p. 329 ff.; I. Q. van Regteren Altena, 'Rembrandt's way to
Emmaus', *Kunstmuseets Årsskrift*, 1948/49, p. 12, fig. 9; H. M. Roter-
mund, 'Begegnungen mit dem Auferstandenen', *Die Neue Schau*,
March 1951, p. 62, repr. on cover; S. Slive, *Rembrandt and his Critics*,
The Hague, 1953, p. 178, n. 3, p. 179, n. 1, repr. fig. 43; Benesch, IV,
C. 47, pl. 1017; Jakob Rosenberg, Review in *Art Bulletin*, XLI, 1959,
p. 116; Hans-Martin Rotermund, *Rembrandts Handzeichnungen und
Radierungen zur Bibel*, Stuttgart, 1963, p. 266, pl. 245; H. van de Waal,
'Rembrandt's Faust Etching', *Oud Holland*, 79, 1964, p. 41; Exhib.
Cat., Chicago, The Art Institute, *Rembrandt after 300 years*, 1969/70,
no. 122; C. van Hasselt, *Rembrandt and his century*, Exhib. Cat.,
Paris / New York, 1977/78, p. 126, note 5; J. G. van Gelder, 'Falconet
op bezoek bij de Goll van Franckensteins', *De kroniek van het
Rembrandthuis*, 1979, p. 2 ff.
Exhibited: Leiden, 1850; London, Royal Academy, 1929, *Dutch Art*,
no. 589; London, 1938, no. 554; Cambridge, 1966, no. 4; Cambridge,
Fitzwilliam Museum, 1979, *All for Art*, no. 165; American Tour,
1989/90, no. 88
Engraved, etching with aquatint by J. Buys, 1765; engraved by Ploos
van Amstel and C. Josi, *Collection d'Imitations de Dessins*, 1821, I

Das Emmaus-Thema hat Rembrandt ein Leben lang in Gemälden, Zeichnungen und Radierungen beschäftigt. Unser Blatt illustriert Lk 24, 30–31 und steht in Zusammenhang mit einer Radierung von 1634 (Hollstein 43), die möglicherweise nach einem verlorenen Gemälde entstand; im Verhältnis zur Radierung ist das Thema jedoch kompositorisch dramatischer aufgefaßt. Die Zuschreibung an Rembrandt fand nicht allgemeine Zustimmung. Benesch lehnte sie zuerst ab, hat sie aber später akzeptiert, und Martin Royalton-Kish hält die Zeichnung nicht für Rembrandt, aber auch nicht für eine Kopie nach der Radierung. Zumindest zwei gezeichnete Kopien nach unserer Zeichnung sind bekannt, eine in der National Gallery of Scotland, Edinburgh (Nr. 2762), und eine im Dresdener Kupferstich-Kabinett (Abb. in van Gelder, a.a.O., Abb. 5), die beweisen, daß sie bereits früh berühmt war. Darüber hinaus kennen wir zwei Drucke nach unserer Zeichnung sowie eine Radierung von Arnold Houbraken (1660–1719), die viel mit unserem Blatt gemeinsam hat und angeblich auf ein verlorenes Gemälde von 1628/29 zurückgeht. Zweifellos war es unser Blatt, das Falconet in der Sammlung Goll van Franckenstein (vgl. van Gelder, a.a.O.) sah und beschrieb, da es die einzige Version ist, in der das angedeutete Antlitz Christi in dem Schein zu erkennen ist, in dem er verschwindet. Die *pentimenti* und die Psychologisierung der Szene sprechen für eine selbständige Zeichnung, auch wenn die Lavierung möglicherweise aus dem 18. Jahrhundert, vielleicht von Houbraken, stammt. Geht man von einer Autorschaft Rembrandts aus, so läßt sich unser Blatt am ehesten in die Zeit um 1640/41 oder später datieren, also in die Epoche des Schaffens, in der auch der *Stern der Heiligen Drei Könige* (London, British Museum, Hind I, S. 22, Nr. 31) entstand.

The Emmaus scene is one which preoccupied Rembrandt throughout his career in paintings, drawings and etchings. The subject is taken from Luke XXIV, 30/31. The drawing is related to a print, possibly after a lost painting, dated 1634 (Hollstein 43) but differs in its more dramatic presentation of the event. The attribution has not been accepted by all scholars, Benesch initially rejected it but later reinstated it and Royalton-Kish does not believe it to be by Rembrandt, but neither does he consider it a copy. At least two copies are known: Edinburgh (National Gallery of Scotland, no. 2762) and Dresden (reproduced, van Gelder, *op.cit.*, fig. 5), which attest to its early renown as do the two prints which reproduce it, as well as the print by Arnold Houbraken (1660–1719) which has much in common with it and is said to be based on a lost painting of 1628/29. That this is the drawing seen by Falconet in Goll van Franckenstein's collection (*v.* van Gelder, *loc. cit.*) there can be no doubt, as this is the only version of the drawing in which it is just possible to discern the faintly depicted features of Christ above the splash of light in which he is disappearing; a feature on which Falconet specifically comments. The *pentimenti* and the psychological interpretation of the scene argue in favour of an original drawing, although the wash may have been added in the 18th century, possibly by Houbraken. Assuming the author to be Rembrandt, a date of *c.*1640/41 or later, that is to say coeval with the *Star of the Kings* in the British Museum (Hind, I, p. 22, no. 31) is most probable.

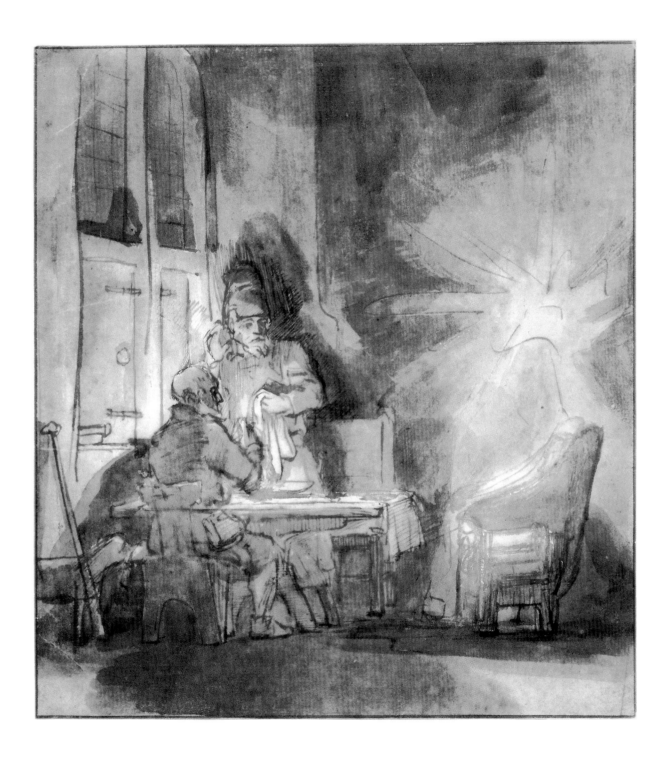

REMBRANDT HARMENSZ. VAN RIJN
Leiden 1606–1669 Amsterdam

Die schlafende Heilige Familie mit den Engeln, die Joseph im Traum erscheinen

Feder und braune Tusche, weiß gehöht und korrigiert
175 x 214 mm
Auf der alten Montierung bezeichnet ‚R. v. R. / No. 8 / lot 286 / no. 5'
Vermächtnis Louis C. G. Clarke, 1960, erhalten 1961. PD. 42–1961
Provenienz: Auktion Christie's, London, 17. Juli 1911, Teil von Lot 70, erworben von Parsons; Sir E. J. Poynter, P. R. A. (Lugt 874); Auktion Poynter, Sotheby's, London, 25. April 1918, Lot 286, erworben von der Kunsthandlung Agnew & Sons, London, für Charles B. O. Clarke; in dessen Vermächtnis (1935) an Louis C. G. Clarke
Literatur: H. Gerson, Europeesche Kunst van de 17de eeuw te London. *Maandblad voor Beeldende Kunsten* XV, 1938, S. 112; Benesch 1947, Nr. 139; Benesch III, Nr. 569, Abb. 699; *Life*, Weihnachten 1958, mit Abb.; Anne W. Lowenthal, *Rembrandt's Holy Family with Angels.* Toledo 1987, Abb. 2
Ausstellungen: London 1938, Nr. 553; Cambridge 1966, Nr. 3; Wanderausstellung USA und Cambridge 1976/77, Nr. 81; Cambridge 1980 (o. Kat.)

Die Anlage von Josephs rechtem Arm und rechtem Bein ist nachträglich verändert. Thematisch sah Benesch unser Blatt im Zusammenhang mit der *Hl. Familie in der Werkstatt des Zimmermanns* in Bayonne (Benesch III, 567), einer Vorzeichnung für das Gemälde der *Hl. Familie mit den Engeln* in der Eremitage in St. Petersburg von 1645. Das Gemälde und die Vorzeichnung in Bayonne verwenden das Motiv von Joseph bei der Arbeit und, im Unterschied zu unserem Blatt, dasjenige der wachenden Maria, die sich über das schlafende Kind beugt. Allen dreien gemeinsam sind die Engel in der Darstellung; doch während sie im Gemälde in St. Petersburg und in der Zeichnung in Bayonne in bloßer Anbetung erscheinen, nehmen sie in unserer Zeichnung eine „sprechende" Körperhaltung ein in Form des Kreuzes und weisen damit voraus auf die Passion; sie erscheinen Joseph im Traum, um ihn vor dem bevorstehenden bethlehemitischen Kindermord zu warnen (Mt 2,13).

The Holy Family sleeping, with angels appearing to Joseph in a dream

Pen and brown ink, heightened and corrected in white
175 x 214 mm
Inscribed on the old mount: 'R.v.R. / No. 8 / lot 286 / no. 5'
Bequeathed by Louis C. G.Clarke, 1960, received 1961. PD. 42–1961
Provenance: London, Christie's, 17 July 1911, part of lot 70, bought Parsons; Sir E. J. Poynter, P. R. A.(Lugt 874), his sale, London, Sotheby's, 25 April 1918, lot 286; bought Thomas Agnew & Sons for Charles B. O. Clarke, by whom bequeathed (1935) to Louis Clarke
Literature: H. Gerson, 'Europeesche Kunst van de 17de eeuw te London', *Maandblad voor Beeldende Kunsten*, XV,1938, p. 112; Benesch, 1947, no. 139; Benesch, III, no. 569, fig. 699; *Life*, Christmas 1958, repr.; Anne W. Lowenthal, *Rembrandt's Holy Family with Angels*, Toledo, 1987, fig. 2
Exhibited: London, 1938, no. 553; Cambridge, 1966, no. 3; American Tour and Cambridge, 1976/77, no. 81; Cambridge, 1980 (no handlist)

The positions of Joseph's right arm and right leg have been altered. Benesch connected this drawing in theme with another at Bayonne, *The Holy Family in the carpenter's workshop* (Benesch, III, 567), which is the preparatory study for the painting of 1645, *The Holy Family with angels*, Hermitage Museum, St Petersburg. The painting, like the Bayonne drawing, uses the motif of Joseph at work and in it, unlike the Fitzwilliam drawing, Mary is awake, leaning towards the sleeping child. The St Petersburg painting and Bayonne drawing share with the Fitzwilliam drawing the presence of angels, but whereas in them the angels appear purely adoring, in the Cambridge drawing they are clearly admonitive, forming as they do the symbol of the Cross, looking forward to Christ's passion, and presumably appearing in Joseph's sleep to advise him of Herod's anticipated Massacre of the Innocents (Matthew II,13).

JACOB DE WIT
Amsterdam 1695–1754 Amsterdam

Moses sammelt die siebzig Ältesten

Feder und schwarze Tusche, graue Lavierung, weiß gehöht,
über Spuren von Graphit, auf grauem Papier
269 x 560 mm
Beträchtliche Bereibung der Weißhöhung links
Verso in Graphit bezeichnet ‚Mozes striking the Rock / Drawing by
J. D. Hertz-... / b. Augsburg 1693 d. 1754' und ‚J. D. Hertz del'
Vermächtnis Sir Bruce Ingram, 1963. PD. 919–1963
Provenienz: Frederick Izant; Auktion Izant, Sotheby's, London,
14. Dezember 1939, Teil von Lot 137; Kunsthandlung P. & D. Colnaghi, London; hier von Ingram (Lugt 1405 a) im Dezember 1939
erworben
Literatur: A. Staring, *Jacob de Wit*. Amsterdam 1958, Abb. 116
Ausstellungen: Rotterdam / Amsterdam 1961/62, Nr. 118; Amsterdam,
Paleis op de Dam, 1986, *Jacob de Wit – De Amsteltitiaan*, Nr. 27

Moses choosing the Elders

Pen and black ink, grey wash, heightened with white, over traces
of graphite on grey paper
269 x 560 mm
Considerable abrasion to the white heightening on the left
Inscribed, in graphite, *verso*: 'Mozes striking the Rock / Drawing by
J. D. Hertz-... / b. Augsburg 1693 d. 1754' and 'J. D. Hertz del'
Bequeathed by Sir Bruce Ingram, 1963. PD. 919–1963
Provenance: Frederick Izant, his sale, London, Sotheby's, 14 December 1939, part of lot 137; with P. & D. Colnaghi, London, from whom
bought by Ingram (Lugt 1405 a), December 1939
Literature: A. Staring, *Jacob de Wit*, Amsterdam, 1958, pl. 116
Exhibited: Rotterdam / Amsterdam, 1961/62, no. 118; Amsterdam,
Paleis op de Dam, 1986, *Jacob de Wit -- De Amsteltitiaan*, no. 27

Jacob de Wit war der Sohn des Weinhändlers und Schankwirts Christiaan de Wit und seiner Ehefrau Annetien Slootmans, beide katholischen Bekenntnisses. Im Alter von neun Jahren wurde er zu Albert van Spiers (1666–1718) in die Lehre gegeben. Später zog er zu seinem Onkel Jacomo de Wit nach Antwerpen, wo er in das Atelier des Jacob van Hal (1672–1750) eintrat und Aktstudien in der Antwerpener Akademie betrieb. Wahrscheinlich im Jahre 1715 kehrte er nach Amsterdam zurück und erhielt im Jahr darauf den ersten von zahlreichen Aufträgen für die Moses-und-Aaron-Kirche. Gleichzeitig war er auch ein sehr gefragter Portraitist, eine Spezialisierung, die er jedoch um 1718 zugunsten von Dekorationsprogrammen und Historienbildern aufgab. 1724 ehelichte er Cornelia Leonora van Neck; die Ehe blieb kinderlos. Seine ersten bedeutenderen Aufträge erhielt er von Glaubensgenossen; sein Erfolg war so groß, daß bald auch Protestanten zu seinen Auftraggebern gehörten. 1736 erreichte ihn der erste einer Reihe von Aufträgen des Statthalters Prinz Wilhelm IV.

Unsere Zeichnung ist eine Vorstudie für das Gemälde im neuen Amsterdamer Rathaus, ein bedeutender Auftrag, der 1735 an de Wit vergeben wurde. Es illustriert Num 11, 16–17 und 24–25, wo erzählt wird, wie Moses die siebzig Ältesten auswählt, und entspricht inhaltlich genau – wie alle Gemälde des Rathauses – der Funktion des Raumes, für den es bestimmt war. Der Stadtrat trat im Ratszimmer zur Besprechung von Anträgen zusammen. So wie die siebzig Ältesten Moses beistanden, beriet der Stadtrat die Bürgermeister. De Wit bereitete die Ausführung der riesigen Leinwand (5,20 x 12,55 m) sorgfältig vor. Sieben Stadien, die dem endgültigen Kompositionsentwurf vorausgehen, haben sich erhalten (s. Amsterdam 1986). Die fünfte Stufe der Vorarbeiten gibt unsere Zeichnung wieder: Rechts von der Mitte steht Moses auf einer kleinen Anhöhe in einigem Abstand zur versammelten Menge. Eine Gruppe der Ältesten hat sich um ihn im Vordergrund gedrängt, die übrigen stehen um den Schrein im Hintergrund, während einige Zuschauer im Schatten der Palme zur Linken das Geschehen beobachten. Die letzte Vorstudie gibt ein Tafelbild im Rijksmuseum in Amsterdam wieder. Das endgültige Leinwandbild wurde 1737 vollendet.

Jacob de Wit was the son of a wine-seller and inn keeper, Christiaan de Wit and Annetien Slootmans, who were Catholic. At the age of nine he was apprenticed to Albert van Spiers (1666–1718). Later he went to live with his uncle, Jacomo de Wit in Antwerp, where he studied with Jacob van Hal (1672–1750) and drew from the life at the Antwerp Academy. He returned to Amsterdam probably in 1715 and in 1716 received the first of many commissions for the Church of Moses and Aaron. At this time he was also much in demand as a portrait painter, but he abandoned this in favour of decorative schemes and history painting by about 1718. He married Cornelia Leonora van Neck in 1724, but remained childless. His first important patrons were Catholic, but his success was such that he was soon patronised by Protestants as well and in 1736 he received the first of several commissions for the Stadtholder, Prince William IV.

This is a preparatory study for the painting in the Council Chamber of Amsterdam's 'new' Town Hall, an important commission awarded to de Wit in 1735. The subject, taken from Numbers XI, 16/17 and 24/25, in which Moses selected the Seventy Elders, was carefully chosen, and like all the paintings in the Town Hall it was related to the function of the room in which it hung. The City Council was an advisory body, and gathered in the Council Chamber to discuss the proposals put before it. Just as the seventy elders helped Moses to govern, so the council advised the burgomasters. De Wit made careful preparations for this huge canvas which measures 5.20 x 12.55 metres. Seven stages survive before his final study for the composition, all illustrated and commented upon in the catalogue of the exhibition held in Amsterdam in 1986 (*op. cit.*). The fifth stage is that represented by the Fitzwilliam drawing: Moses is shown to the right of centre, standing on a low mound some distance from the court. One group of Elders is clustered about him in the foreground, the remainder are by the tabernacle in the background, whilst a group of onlookers are on the left beneath the shade of a palm tree. The final study for the painting is a panel in the Rijksmuseum, Amsterdam; the finished canvas was completed in 1737.

ANHANG/APPENDIX

BIBLIOGRAPHIE / BIBLIOGRAPHY

Kurztitel / Short Titles

Bartsch
Adam Bartsch, *Le peintre graveur*. Wien/
Vienna 1802/21 (21 Bde./vols.).

Beck
Hans-Ulrich Beck, *Jan van Goyen 1596–1656*.
Amsterdam 1972/73 (2 Bde./vols.).

Benesch
Otto Benesch, *The Drawings of Rembrandt.
A critical and chronological Catalogue*. London
1954/57 (6 Bde./vols.).

Benesch 1947
Otto Benesch, *A Catalogue of Rembrandt's
selected Drawings*. Oxford/London 1947.

Bock-Rosenberg
Elfried Bock und Jakob Rosenberg, *Staatliche
Museen zu Berlin, Die Zeichnungen alter Meister
im Kupferstichkabinett zu Berlin. Die nieder-
ländischen Meister*. Frankfurt a. M. 1931
(2 Bde./vols.).

Hind
Arthur M. Hind, *Catalogue of Drawings by
Dutch and Flemish Artists preserved in the
Department of Prints and Drawings in the British
Museum*. London 1915/32 (5 Bde./vols.).

Hofstede de Groot
C. Hofstede de Groot, *Beschreibendes und kri-
tisches Verzeichnis der Werke der hervorragend-
sten holländischen Maler des XVII. Jahrhunderts*.
Esslingen/Paris 1907/28 (10 Bde./vols.).

Hollstein
F. W. H. Hollstein, *Dutch and Flemish Etchings,
Engravings and Woodcuts ca. 1450–1700*.
Amsterdam 1949 ff. (Bd./vol. 1 ff.).

Keyes 1984
George S. Keyes, *Esaias van de Velde 1587–
1630*. Doornspijk 1984.

Lugt
Frits Lugt, *Les marques de collections de dessins
et d'estampes*. Amsterdam 1921. Supplement
Den Haag 1956.

Nagler
G. K. Nagler, *Neues allgemeines Künstler-Lexi-
kon*. Linz 1904/14 (2. Aufl./ed., 25 Bde./vols.).

Steland
Anne Charlotte Steland, *Die Zeichnungen des
Jan Asselijn*. Fridingen 1989.

Sumowski
Werner Sumowski, *Drawings of the Rembrandt
School*. New York 1979 ff. (Bd./vol. 1 ff.).

Thieme-Becker
Ulrich Thieme und Felix Becker, *Allgemeines
Lexikon der bildenden Künstler von der Antike
bis zur Gegenwart*. Leipzig 1907/50 (37 Bde./
vols.).

TIB
The Illustrated Bartsch, hrsg. von/ed. Walter
L. Strauß. New York 1978 ff. (Bd./vol. 1 ff.).

Wegner
Wolfgang Wegner, *Kataloge der Staatlichen
Graphischen Sammlung München, Bd./vol. 1:
Die niederländischen Handzeichnungen des
15.–18. Jahrhundert*. Berlin 1973 (2 Bde./
vols.).

Wurzbach
Alfred von Wurzbach, *Niederländisches
Künstler-Lexikon*. Wien/Leipzig 1906/10
(2 Bde./vols.).

Ausstellungen / Exhibitions

American Tour and Cambridge, 1976/77
New York, Pierpont Morgan Library, Fort Worth, Kimbell Art Museum a.o., and Cambridge, The Fitzwilliam Museum, 1976/77, *European Drawings from the Fitzwilliam.*

American Tour, 1983/84
Palm Beach, Florida, Society of the Four Arts, Washington, National Academy of Sciences a.o., 1983/84, *Flowers of three centuries.*

American Tour, 1989/90
Washington, National Gallery, Fort Worth, Kimbell Art Museum a.o., 1989/1990, *Treasures from the Fitzwilliam.*

Bath, 1952
Bath, The Holburne of Menstrie Museum of Art, 1952, *Loan Exhibition of Old Master Drawings from the Collection of Sir Bruce Ingram.*

Bedford, 1958
Bedford, The Cecil Higgins Museum, 1958, *Exhibition of Old Master Drawings. Flemish and Dutch Schools, lent by Sir Bruce Ingram.*

Birmingham, 1953
Birmingham, City Museum and Art Gallery, 1953, *Animal Drawings through three centuries. Loan Exhibition from the Collection of Sir Bruce Ingram.*

Cambridge, Fitzwilliam Museum, 1951 ff.
Cambridge, The Fitzwilliam Museum: Temporary Exhibitions of a part of the Drawings from the Collection of Sir Bruce Ingram (no handlists) / Wechselausstellungen mit einem Teil der Zeichnungen aus der Sammlung des Sir Bruce Ingram (o. Kat.).

Cambridge, 1960
Cambridge, The Fitzwilliam Museum, 1960, *Fifteenth and Sixteenth Century Drawings.*

Cambridge, 1966
Cambridge, The Fitzwilliam Museum, 1966, *Drawings by Rembrandt and his Circle.*

Cambridge, 1977
Cambridge, The Fitzwilliam Museum, 1977, *Landscape Drawings from Sir Bruce Ingram's Collection.*

Cambridge, 1980
Cambridge, The Fitzwilliam Museum, 1980, *The Bible* (no handlist).

Cambridge, 1982
Cambridge, The Fitzwilliam Museum, 1982, *Dutch Seascapes* (no handlist).

Cambridge, 1985
Cambridge, The Fitzwilliam Museum, 1985, *Rembrandt and his Contemporaries.*

Cambridge, 1990
Cambridge, The Fitzwilliam Museum, 1990, *Paradise of Exiles.*

Cambridge, 1993/94
Cambridge, The Fitzwilliam Museum, 1993/94, *Rembrandt Landscapes.*

Cirencester, 1951
Cirencester, Arts Club, 1951, *Dutch Drawings from Sir Bruce Ingram's Collection.*

Cirencester, 1953
Cirencester, Arts Club, 1953, *Animal Drawings through three centuries. Loan Exhibition from the Collection of Sir Bruce Ingram.*

London, 1938
London, The Royal Academy, 1938, *Seventeenth Century Art in Europe.*

London, 1946/47
London, Arts Council, 1946/47, *Exhibition of Drawings from the Collection of Sir Bruce Ingram.*

London, 1953
London, The Royal Academy, 1953, *Drawings by Old Masters.*

London, Colnaghi, 1936
London, P. & D. Colnaghi, 1936, *Masters of Maritime Art. 1rst Loan Exhibition of Drawings from the Collection of Captain Bruce Ingram.*

London, Colnaghi, 1937
London, P. & D. Colnaghi, 1937, *Masters of Maritime Art. 2nd Loan Exhibition of Drawings from the Collection of Captain Bruce Ingram.*

London, Colnaghi, 1938
London, P. & D. Colnaghi, 1938, *Masters of Maritime Art. 3rd Loan Exhibition of Drawings from the Collection of Captain Bruce Ingram.*

London, Colnaghi, 1949
London, P. & D. Colnaghi, 1949, *Old Master Drawings.*

London, Colnaghi, 1952
London, P. & D. Colnaghi, 1952, *Loan Exhibition of Old Master Drawings from the Collection of Sir Bruce Ingram in aid of the London Federation of Boys Club.*

London, Colnaghi, 1953
London, P. & D. Colnaghi, 1953, *Animal Drawings through three centuries. Loan Exhibition from the Collection of Sir Bruce Ingram in aid of the London Federation of Boys Club.*

London, Colnaghi, 1956
London, P. & D. Colnaghi, 1956, *Watercolour Drawings of three Centuries, in aid of the London Federation of Boys Club.*

Nottingham, 1982
Nottingham, The Castle Museum, 1982, *The Women's Art Show 1550–1970.*

Oxford, 1943
Oxford, The Ashmolean Museum, 1943, *Loan Exhibition of Drawings from the Collection of Sir Bruce Ingram (no catalogue).*

Rotterdam/Amsterdam, 1961/62
Rotterdam, Museum Boymans-van Beuningen, and Amsterdam, Rijksprentenkabinet, 1961/62, *150 tekeningen uit vier eeuwen uit de verzameling van Sir Bruce en Lady Ingram.*

Washington and American Tour, 1959/60 / Washington u.a. 1959/60
Washington, National Gallery, 1959/60, *Old Master Drawings from the Collection of Sir Bruce Ingram, circulated by the Smithsonian Institution.*

Wanderausstellung USA und Cambridge 1976/77 siehe American Tour and Cambridge, 1976/77.

Wanderausstellung USA 1983/84 siehe American Tour, 1983/84.

Wanderausstellung USA 1989/90 siehe American Tour, 1989/90.

KÜNSTLERVERZEICHNIS / INDEX OF ARTISTS

Die fettgedruckten Zahlen beziehen sich auf Werke des Künstlers mit Abbildungen im Katalogteil (Cat.).
The numbers printed in bold type refer to works by the artist concerned that are reproduced in the catalogue.

Aelst, Willem van Cat. 67
Arent Arentsz. (van der Cabel) Cat. 77
Asselijn, Jan 20, 23, 30, 33; Cat. 17, **36, 37, 38, 76**
Avercamp, Barent Cat. 77
Avercamp, Hendrick 22, 32; Cat. **77, 78, 79**

Backer, Jacob Adriaensz. de 12, 13; Cat. **96**
Backhuizen, Ludolf 20, 30; Cat. 21, 45, **50, 51**
Beer, Joos de Cat. 2
Bega, Cornelis Cat. **80**, 88
Begeyn, Abraham Cat. 76
Begijn, Pieter Jansz. Cat. 80
Bemmel, Willem van Cat. 24
Berckheyde, Gerrit Cat. 1, 80
Berckheyde, Job Adriaensz. 19, 29; Cat. **1**
Berchem, Nicolaes 20, 30; Cat. 9, 36, **38, 39**, 43, 44, 49, 76, 103
Bisschop, Jan de 12, 13; Cat. 46, **81, 82**
Bleker, Gerrit Cat. 104
Bloemaert, Abraham 12, 13, 14, 15, 19, 21, 22, 24, 29, 31, 32, 34; Cat. **2, 3, 62, 83, 97**, 105
Bloemaert, Cornelis Cat. 83
Bloemaert, Frederick Cat. 2
Bloemen, Pieter van Cat. 43
Bol, Ferdinand Cat. 18
Bologna, Giovanni Cat. 91
Borch, Gerard ter Cat. 17
Borssom, Anthonie van Cat. 6, 21
Both, Andries Cat. 36
Both, Jan Cat. 4, 17, 36, 37, 38, 44
Boucher, François Cat. 38
Bramer, Leonaert 14, 15, 24, 34; Cat. **98**
Bray, Jan de 12, 13, 22, 33; Cat. **84**
Bray, Salomon de Cat. 84
Breenbergh, Bartholomeus Cat. 36
Bril, Paul Cat. 48, 60
Bruegel, Pieter d. Ä./the E., Cat. 30, 34, 77
Burg, Adriaen van der Cat. 66
Buytewech, Willem 14, 15; Cat. 24, 29, 87

Cabel, Adriaen van der Cat. 52, 53
Casembroot, Abraham 21, 31; Cat. **52, 53**
Coninxloo, Gilles van Cat. 27
Cooghen, Leendert van der Cat. 80
Coornhert, Dirck Volkertsz. Cat. 86
Cornelis Cornelisz. van Haarlem Cat. 80, 91, 101

Cuyp, Aelbert 19, 21, 29, 31; Cat. **4, 5**, 23, **63, 64**
Cuyp, Jacob Gerritsz. Cat. 4

Doomer, Lambert 20, 30; Cat. **40**
Dou, Gerrit Cat. 18
Dubbels, Hendrick Cat. 31, 50
Du Bois, Guillam Cat. 80, 88
Dürer, Albrecht Cat. 62
Dujardin, Karel Cat. 36, 37, 38, 44
Dyck, Anton van Cat. 89

Eeckhout, Gerbrand van den 19, 29; Cat. **6**, 18, 19, 41, 99
Eeckhout, Jan Pietersz. van den Cat. 6
Elsheimer, Adam Cat. 101, 103
Esselens, Jacob 20, 30; Cat. 6, 21, **41, 42**
Everdingen, Allaert van 20, 30; Cat. **7**, 16, 32, **43**, 47, 50

Fabritius, Carel Cat. 18, 99
Flegel, Georg 22, 32
Flinck, Govaert Cat. 18, 95, 96
Fragonard, Jean-Honoré Cat. 38
Francken, Hieronymus I. Cat. 2
Furnerius, Abraham 19, 29; Cat. **8**, 21, 99

Geest, Wybrand de Cat. 96
Gelder, Aert de Cat. 18, 99, 102
Gerrit Pietersz. (Sweelinck) Cat. 101
Gheyn, Jacques I. de Cat. 85
Gheyn, Jacques II. de 21, 22, 31, 32; Cat. 58, 62, **85**, 86
Goltz, Jan Cat. 86
Goltzius, Hendrick 22, 23, 32; Cat. 2, 29, 85, **86**, 90, 91
Goyen, Jan van 17, 19, 27, 29; Cat. 4, **9, 10, 11, 12, 13**, 24, 25, 27, 28, 38
Graff, Johann Cat. 70
Grebber, Pieter de Cat. 38, 88

Hackaert, Jan Cat. 44
Haestens, Hendrick Cat. 58
Hal, Jacob van Cat. 107
Hals, Dirck 23, 33; Cat. **87**
Hals, Frans Cat. 87
Haverman, Margaretha Cat. 67
Heem, Jan Davidsz. Cat. 70
Helmbreecker, Theodoor Cat. 80, **88**
Helst, Bartholomeus van der Cat. 98
Hendriks, Wybrand Cat. 69
Hillegaert, Paulus d. J./the Y. van Cat. 31
Hobbema, Meindert Cat. 45
Hoefnagel, Joris 7, 9, 21, 22, 32
Hogenberg, Frans 20, 30
Hondecoeter, Melchior d' Cat. 66

Hooch, Pieter de Cat. 38, 99
Hoogstraten, Dirck van Cat. 99
Hoogstraten, Samuel van 23, 34; Cat. 8, 18, 95, **99, 100**
Houbraken, Arnold Cat. 99, 106
Huyghens, Constantijn d. Ä./the E. 19, 29; Cat. 81, 85
Huyghens, Constantijn d. J./the Y. Cat. 81
Huysum, Jan van 22, 32; Cat. **67, 68, 69**
Huysum, Justus van Cat. 38, 67

Jonghe, Ludolf de Cat. 23
Jordaens, Jacob Cat. 88, 89

Koninck, Philips de Cat. 8, 18

Laer, Pieter van Cat. 43
Lambert Jacobsz. Cat. 96
Lapp, Jan Willemsz. 20, 30; Cat. **44**
Lastman, Pieter 24, 34; Cat. 6, 14, 18, **101**
Leupenius, Johannes Cat. 21
Liefrinck, Cornelis Cat. 54
Lievens, Jan d. Ä./the E. 19, 29; Cat. **14, 15**, 101
Lievens, Jan Andrea Cat. 14
Lingelbach, Johan Cat. 48
Lorrain, Claude Cat. 103

Maes, Nicolaes 12, 13, 24, 34; Cat. 18, **89**, 96, 102
Marrel, Jacob Cat. 70
Martszen, Jan d. J./the Y. Cat. 36
Matham, Jacob Cat. 29, 86, 101
Merian, Dorothea Cat. 70
Merian, Maria Sybilla 12, 13, 21, 22, 32; Cat. **70, 71, 72, 73**
Merian, Matthäus 22, 24, 32, 34; Cat. 70
Mieris, Frans van Cat. 82
Moeyaert, Claes Cornelisz. 12, 13, 24, 34; Cat. 38, **103, 104, 105**
Mola, Pier Francesco Cat. 97
Molijn, Pieter Cat. 7, **16**, 25, 27, 28, 47
Moucheron, Frederick de Cat. 45, 88
Muller, Harmen Jansz. Cat. 90
Muller, Jan Harmensz. 12, 13, 22, 32; Cat. 86, **90, 91**

Naiwyncx, Herman Cat. 49
Nieulandt, Adriaen van Cat. 105

Ostade, Adriaen van Cat. 80

Palamedesz., Anthonie Cat. 94
Passe, Crispijn d. Ä./the E. de Cat. 97
Peeters, Bonaventura Cat. 53
Perelle, Gabriel Cat. 36

Pieter Claesz. Cat. 38
Pieter Isaacsz. Cat. 77
Pijnacker, Adam 12, 13, 19, 29; Cat. **17**, 36, 37
Ploos van Amstel, Cornelis Cat. 3, 90
Porcellis, Jan Cat. 31, 61, 94, 95
Post, Pieter Cat. 1
Pynas, Jacob Cat. 18

Rembrandt Harmensz. van Rijn 12, 13, 14, 15, 18, 19, 21, 23, 24, 25, 28, 29, 31, 33, 34, 35; Cat. 6, 8, 14, **18**, 21, 40, 52, 89, 94, 95, 96, 99, 100, 101, 102, 104, **106, 107**
Roghman, Hendrick Lambertsz. Cat. 19
Roghman, Roelant Cat. 6, **19, 20**, 23, 31
Romeyn, Willem Cat. 76
Rubens, Pieter Paul 12, 13; Cat. 89
Ruisdael, Jacob van Cat. 7
Ruisdael, Salomon van 19, 29
Rutgers, Abraham d. Ä./the E. 19, 29; Cat. **21, 22**

Saenredam, Pieter Cat. 1
Saftleven, Abraham Cat. 23
Saftleven, Cornelis 21, 31; Cat. **23**, 24, **65**
Saftleven, Herman d. Ä./the E. Cat. 23, 24
Saftleven, Herman d. J./the Y. 19, 29; Cat. 1, 23, **24, 25, 26**, 65
Savery, Roelandt 20, 30; Cat. 7, 19, 34, 47
Schalken, Godfried Cat. 99
Schellinks, Willem Cat. 40
Scheyndel, Gilles van Cat. 30
Schilperoort, Coenraet Adriaensz. Cat. 9
Schoten, Joris van Cat. 14
Schouman, Aert 21, 31; Cat. **66**
Schouman, Martinus Cat. 74
Schriek, Otto Marseus van Cat. 74
Sichem, Christoffel van Cat. 58
Spierincx, François Cat. 60
Spiers, Albert van Cat. 107
Spranger, Bartholomäus Cat. 90, 91
Steen, Jan Cat. 9, 82
Stimmer, Tobias 24, 34
Storck, Abraham 20, 30; Cat. **45**
Swanenburgh, Isaac Claesz. Cat. 9
Swanenburgh, Jacob Isaacsz. Cat. 18

Teniers, David d. J./the Y. Cat. 94

Ulft, Jacob van der 20, 30; Cat. **46**
Uytenbroeck, Moses van Cat. 104

Vaillant, Wallerant Cat. 32
Velde, Adriaen van de Cat. 54
Velde, Esaias van de 12, 13, 19, 22, 29, 32; Cat. 9, 24, **27, 28**, 29, 36, **92, 93**

Velde, Hans van de Cat. 27
Velde, Jan I. van de Cat. 29
Velde, Jan II. van de 19, 29; Cat. 24, **29**, 30
Velde, Jan (III.) Jansz. van de Cat. 29
Velde, Willem d. Ä./the E. van de 13, 14, 21, 22, 31, 32; Cat. 31, **54, 55, 56**, 92, **94**
Velde, Willem d. J./the Y. van de 13, 14, 21, 31; Cat. 31, 50, 54, 55, **57**, 94
Venne, Adriaen van de Cat. 30
Verbeeck, Pieter Cat. 64
Veronese, Paolo 24, 34; Cat. 101
Vianen, Paulus van Cat. 47
Victors, Jan Cat. 102
Vinckboons, David Cat. 27, 77
Vinne, Vincent Laurensz. van der Cat. 80
Visscher, Claes Jansz. 21, 31; Cat. 24, 29, **30, 58**
Visscher, Jan de Cat. 39
Visscher, Nicolaes Cat. 30
Vlieger, Simon de 13, 14, 19, 20, 22, 30, 31, 32; Cat. 19, **31**, 34, 57, **59**, 61, **95**
Vliet, Jan Jorisz. van Cat. 104
Vorstermans, Jan Cat. 24
Vroom, Cornelis Hendricksz. Cat. 60
Vroom, Frederick Cat. 60
Vroom, Hendrick Cornelisz. 20, 31; Cat. **60**, 61

Waterloo, Anthonie 19, 30; Cat. 17, 19, 31, **32, 33, 34, 35**, 41, **47**
Weenix, Jan Cat. 66
Weenix, Jan Baptist Cat. 38
Wet, Jacob Willemsz. de Cat. 1
Wieringen, Cornelis Claesz. van 20, 30, 31; Cat. **61**
Wilkens, Theodoor Cat. 49
Willem Gerritsz. Cat. 9
Wils, Jan Cat. 38
Wit, Jacob de Cat. **108**
With, Pieter de Cat. 6
Withoos, Alida Cat. 74
Withoos, Jan Cat. 74
Withoos, Matthias Cat. 74
Withoos, Pieter 22, 32; Cat. **74, 75**
Worst, Jan 20, 30; Cat. **48**
Wyck, Jan Cat. 49
Wyck, Thomas 20, 30; Cat. 48, **49**

Aus dem Englischen übersetzt von Claudia List
Translation of English texts into German: Claudia List

© 1995 by The Fitzwilliam Museum, Cambridge, und den Autoren
© 1995 by The Fitzwilliam Museum, Cambridge, and the authors

Die Deutsche Bibliothek – CIP-Einheitsaufnahme
Das goldene Jahrhundert : holländische Meisterzeichnungen
aus dem Fitzwilliam Museum Cambridge ; deutsch / englische
Ausgabe / Staatliche Graphische Sammlung München.
Katalog von David Scrase. Mit Beitr. von David Scrase und
Thea Vignau-Wilberg. Hrsg. von Thea Vignau-Wilberg. – München :
Schirmer/Mosel ; München : Staatliche Graph. Sammlung, 1995
Ausstellungskatalog
ISBN 3-88814-789-1 (Schirmer/Mosel)
ISBN 3-927803-14-6 (Staatliche Graphische Sammlung)
NE: Vignau-Wilberg, Thea [Hrsg.]; Scrase, David; Staatliche
Graphische Sammlung <München>

Graphische Gestaltung / Designed by:
Ingeborg Geith & Willem Weijers
Litho / Separations: Repro Bayer, München
Satz / Typeset by: Max Vornehm GmbH, München
Druck und Bindung / Printed and bound by: EBS, Verona

ISBN 3-927803-14-6
(broschierte Katalogausgabe / paperback catalogue edition)
ISBN 3-88814-789-1 (gebundene Ausgabe / cloth)

Eine Schirmer/Mosel Produktion
A Schirmer/Mosel Production